From the Ocean of
Painting

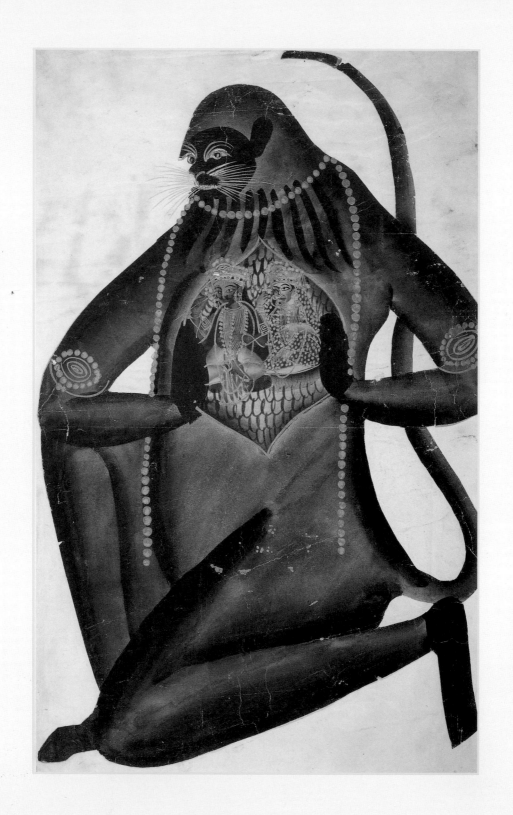

From the Ocean of Painting

INDIA'S POPULAR PAINTINGS
1589 TO THE PRESENT

Barbara Rossi

With Contributions by Roy C. Craven, Jr.
and Stuart Cary Welch

New York Oxford • Oxford University Press • 1998

Oxford University Press

Oxford New York
Athens Auckland Bangkok Bogotá Bombay
Buenos Aires Calcutta Cape Town Dar es Salaam
Delhi Florence Hong Kong Istanbul Karachi
Kuala Lumpur Madras Madrid Melbourne
Mexico City Nairobi Paris Singapore
Taipei Tokyo Toronto Warsaw

and associated companies in
Berlin Ibadan

Book design by Nicola Ferguson

The publication of this book has been supported in part by grants from
the Illinois Art Council, a State agency, and the Trustees of the ILA Foundation
and by funds from The School of the Art Institute of Chicago.

Library of Congress Cataloging-in-Publication Data
Rossi, Barbara
From the ocean of painting: India's popular paintings, A.D. 1589 to the present
/ Barbara Rossi; with contributions by Roy C. Craven, Jr., and Stuart Cary Welch.
p. cm. Based on an exhibition presented by The University of Iowa Museum
of Art, which traveled to The David and Alfred Smart Museum of Art, The
University of Chicago, and the Santa Barbara Museum of Art during 1994–95.
Includes bibliographical references and index.
ISBN 0-19-511193-1 (cloth) ISBN 0-19-511194-x (paper)
1. Folk art—India—Exhibitions. 2. Patas (Art)—Exhibitions.
3. Tribal art—India—Exhibitions
I. Craven, Roy C. II. Welch, Stuart Cary.
III. University of Iowa. Museum of Art.
IV. David and Alfred Smart Museum of Art.
V. Santa Barbara Museum of Art. VI. Title.
NK1476.A1R67 1998 745'.0954'07473—DC21 97-15810

Frontispiece: A pilgrim's souvenir painting depicting Hanuman revealing Rama
and Sita in his heart (no. 19), West Bengal, Kalighat, CA. 1880, transparent and
metallic water-based pigments on paper. Chester and Davida Herwitz Collection.

9 8 7 6 5 4 3 2 1

Printed in Hong Kong
on acid-free paper

Contents

Preface

When I first traveled at length in India in 1986 in search of painting traditions relevant to my work as an artist, I was both uplifted and overwhelmed by seemingly endless discovery. I found myself describing my dizzying experience as that of a swimmer in an "ocean of painting." The vastness and depth and complexity of this ocean with its multitude of intermingling currents were not—and could not have been—perceived from afar. I realized that I would not touch bottom nor even see the shoreline. Yet I was happy, even elated, to paddle along, with a sense of the ocean's plenitude, in contact with a few of its riches at a time. My image of India as an "ocean of painting" arose from personal experience and reflection; the particular kinship of this image with Indian expression would later become apparent to me when I chanced upon the title of an eleventh-century Indian collection of narrative poems called the *Ocean of Story* (*Katha Sarit Sagera*) in which the ever-resonant word ocean is similarly employed as a metaphor for unfathomable abundance.

Particularly exciting to me among the currents in the "ocean of painting" were several forms of folk, tribal, and urban popular painting. Generally unknown outside India, these paintings are not merely poor imitations of miniatures and classical murals as they have sometimes been considered. Rather, they are entities clearly distinct from the sophisticated traditions, usually with less refined styles and with different sets of functions and formats, creators and viewers, and places of origin and histories. Like the so-called high art forms, in each type of the folk, tribal, and urban popular painting there can be found a full range of works embodying various levels of artistic accomplishment, from ordinary to superlative.

As I sought out particular forms of popular and sophisticated painting in 1986 and again in 1989, I felt increasingly obliged to share in a broadly accessible way at least a portion of this extraordinary experience. The breadth and specificity of information generously given to me as I visited numerous public and private collections all over India and traveled to villages where painting traditions are still in practice seemed to ask for more than just assimilation or

transformation in my own painting, however challenging the process of synthesizing the newly seen can be. The idea of making an exhibition formed and evolved: Originally conceived as a presentation of my documentation of some forms of India's popular painting, the project was first planned to take place within the exhibition galleries of the School of the Art Institute of Chicago, where I have taught for many years. The project gradually expanded to include more traditions and types of painting and to comprehend older as well as contemporary examples drawn from public and private collections in the United States and Great Britain. The project thus became a far more complex endeavor requiring organization by a museum and additional research. The exhibition was presented by the University of Iowa Museum of Art and traveled to the Smart Museum of Art, the University of Chicago, and the Santa Barbara Museum of Art during 1994–95.

Close study of the paintings presented in the exhibition over the past several years has not only helped me to clarify and to name what it was my privilege to see in India but also augmented my awe at the dimensions of the phenomenon—or better, the phenomena—of popular painting in India. It is my hope that this publication, which is based on the exhibition, will bring to its readers a similar sense of exhilarating wonder at the number, variety, diversity, vitality, and beauty of the popular traditions that constitute a part of India's great "ocean of painting."

Note on Indian Words

Many Indian words appear in the text of this book. These Indian words, drawn from the published research of numerous scholars as well as from the field notes of the author, are transliterated from several different, uniquely scripted languages. These words are not marked with diacriticals but have rather been italicized and spelled to facilitate pronunciation for the general English-speaking reader. As far as possible and with the advice and assistance of Philip Lutgendorf of the University of Iowa, the author has attempted to achieve consistency while following common practice in spelling transliterated words, though readers conversant with the source language will undoubtedly note irregularities. If variant spellings and diacritical marks are employed in cited works, they are observed by the author in quotations, notes to the text, and the bibliography.

The dates for many festivals in India are determined by a lunar calendar of twelve months that do not coincide with the months of the solar calendar in international use but extend from the end part of one solar month through the beginning part of the next; to facilitate understanding of references to times of the year, the practice of identifying lunar months by the hyphenated names of solar months through which they partly extend has been followed here.

Acknowledgments

This publication, and the exhibition it documents, have been my thank-you to India and to the many individuals and institutions that assisted me in seeing Indian popular paintings in their own contexts. In the course of selecting and researching the paintings to be presented in the exhibition and in this book, I have incurred additional debt to many other persons and institutions that contributed to the realization of the project.

My primary debt is to the Indo-U.S. Subcommission on Education and Culture and to the American Institute of Indian Studies for funding my travels and research in India in 1986 and 1989, which led me to encounter for the first time many of the traditions presented in this publication. In India, P. R. Mehendiratta, Director General of the American Institute of Indian Studies, New Delhi, and his staff graciously and generously facilitated my fellowship research in both years.

In the United States, prior to my departure for India in 1986, Pradumna Tana, Leah Bowman, Vishakha N. Desai, and Edward C. Dimock, Jr., took an interest in my studies and made valuable suggestions that aided my travel and research in India.

In India, M. K. Pal (formerly of the Crafts Museum, New Delhi) served as my adviser in 1986, shared his extensive knowledge of India's arts and crafts, and encouraged my undertaking an exhibition as a consequence of my studies. Raja Dinkar Kelkar (Raja Dinkar Kelkar Museum, Pune), O. P. Tandon, Sarla Chopra, and T. N. Mishra (Bharat Kala Bhavan, Varanasi), Daljeet Khare (National Museum, New Delhi), M. S. Nanjunda Rao and M. J. Kamalakshmi (Karnataka Chitrakala Parishath, Bangalore), and Shyamalkanti Chakravarti and Sipra Chakravarti (Indian Museum, Calcutta) graciously facilitated my access to reserve collections. Jyotindra Jain (Crafts Museum, New Delhi) helped me to see reserve materials and to meet traditional artists and discussed particular traditons with me. D. D. Mane and N.G.B. Ankolekar, Tapan Ghosh, and Jagdish Prasad (Office of Development Commissioner for Handicrafts, Mumbai [formerly Bombay], Calcutta, and Jaipur) offered special assistance in meeting traditional artists in their respective regions.

In India, the late J. Swaminathan, Jyoti Bhatt, Lotika Varadarajan, J.K. Reddiyya, Pepita Seth, and Joanna Williams discussed particular traditions with me or recommended meeting particular traditional painters. Deokinandan Sharma and Bhavanishankar Sharma, Surendra Patel (Utensils Museum, Ahmedabad), Shyamsundar Pattanaik (Orissa State Museum, Bhubaneswar), Gulam Mohammed Sheikh, Nahar Singh, Sandra Maheshwari, Saroj Dhruvu, and Pawan Kumar Jha generously assisted me in meeting traditional artists or in visiting sites of popular painting. Jasleen Dhamija made recommendations for my research, assisted me in visiting certain sites of popular painting, and facilitated my work in India in many other ways. Deborah Thiagarajan facilitated my viewing of aspects of popular visual culture (and subsequently helped identify an artifact presented in the exhibition and in this book). Sabita Ranjan Sarkar (Indian Museum, Calcutta), Shridhar Andhare (L.D. Institute of Indology Museum, Ahmedabad), and Haku Shah discussed various traditions with me and helped me to meet traditional artists or to visit sites of popular painting. Amit Ambabal not only introduced me to several traditions and traditional artists but also showed me many splendid paintings in his personal collection (and subsequently provided invaluable information on popular forms of Nathadwara painting). Conversations with Anand Krishna and K.G. Subramanyam illuminated for me the relationship between tradition and change in Indian culture and art. Jagdish Mittal shared his insights on the relationship between the popular and the sophisticated in Indian art, discussed several traditions with me, and graciously showed me many superb examples in his collection (while subsequently visiting Chicago, he reviewed the dating of works selected for the exhibition and this publication).

The Madhubani painters Yamuna Devi, Sashi Kala Devi, Mahasundari Devi, Godawari Dutta, the late Sita Devi, and the late Ganga Devi; the Warli painters Jivya Soma Mashe, Balu Mashe, and Sadasivy Jivya Mashe; the Puri painters Jagannath Mohapatra, Arjuna Maharana, Benudhar Mohapatra, and Bhagabata Maharana; the Tanjore painter T. Venkatesa Raja; the Mysore painters Y. Subramanya Raju and M. Ramanarasaiah; the Andhra scroll painters D[analakota] Chandraiah and Vaikuntam Chandraiah; the Bengali scroll painters Shyamsundar Chitrakar, Dukhushyam Chitrakar, Gurupada Chitrakar, Gauri Chitrakar, and Kanan Chitrakar; the *par* painters Rajendra Prasad Joshi, Durgesh Kumar Joshi, and Pradip Mukerjee; the Nathadwara painters Chiranjeevelal Sharma, Dwakalalji Jangid, Vithaldas Jangid, Reva Shanker Sharma, and Narottam Narayan Sharma; the reverse glass painter R. Eswarlal; the Srikalahasti *kalamkari* artists Aithur Muni Krishnan, R. Sundara Raju, and Mallipedu Kailasam; the Tanjore *kalamkari* artist R. Emberumal (Naidu); and the Ahmedabad temple cloth artists Vaghi Lakshman Chitara and Dilip Vaghi Chitara demonstrated the enduring vitality and artistry of their respective traditions.

Katharine Lee (formerly of the Art Institute of Chicago and presently of the Virginia Museum of Fine Arts, Richmond) personally encouraged me to undertake the initial stages of this project upon my return from India in 1986. Stuart Cary Welch (now retired from the Harvard University Art Museums), whose exhibition "A Flower from Every Meadow" provided my first encounter with actual Indian paintings, took a generous interest in this project in 1988 and,

through inspiring example and conversation, showed me how to curate; his several invaluable contributions include his essay in this publication. The late Stella Kramrisch, of the Philadelphia Museum of Art, whose exhibition catalogue *Unknown India: Ritual Art in Tribe and Village* guided my first steps toward seeing popular painting in India in 1986, enthusiastically endorsed the concept of the project and its organization in 1990.

The administrators of the School of the Art Institute of Chicago, through its faculty enrichment grant program, funded various aspects of my research on four occasions including travel to London in 1988 to select work from British collections, as well as generously facilitating other matters related to this publication. I am especially indebted to Carol Becker, Dean of Faculty, for her encouragement and support.

Both private collectors and the curators of museum collections warmly welcomed my viewing of their treasures and graciously agreed to share them with a larger audience in the exhibition and this publication. Nancy Baxter (Philadelphia Museum of Art) gave special help in many matters. Chester and Davida Herwitz attentively followed this project's progress, while understanding the personal cost in studio time to an artist undertaking curatorial tasks, research, and writing.

An enthusiastic supporter of this project from its onset, the late Roy C. Craven, Jr., informed me of Indian materials in Florida collections, discussed several works with me, and also contributed an essay to this publication. Mary C. Lanius discussed the Madhubani tradition with me and showed me many outstanding examples in her personal collection and also informed me of Indian materials in Denver collections. Robert Skelton, T. Richard Blurton, Vasudha Narayanan, and Manu Doshi discussed various traditions or kinds of popular paintings with me or made contributions to the identification of particular works. Joseph C. Miller, Jr., Patricia Mumme, David Buck, Alf Hiltebeitel, Sheldon Pollock, James Lindholm, Philip Lutgendorf, Fred Smith, and Samuel Sudanandha examined inscriptions and provided transliterations and translations of them, as well as making other contributions. Art historian friends in Chicago were especially helpful: Marion Covey identified the stories on several scrolls and made contributions to the bibliography; Michael Rabe transliterated and translated inscriptions on several works, assisted in identifying iconography, secured the help of other scholars, and read and discussed a number of entries; Woodman Taylor assisted in the identification of Nathadwara and other paintings, transliterated and translated inscriptions, read and discussed several entries, and greatly encouraged me in undertaking certain aspects of this project. Roland Hansen of the Flaxman Library of the School of the Art Institute of Chicago and Maureen Lasko of the Ryerson Library of the Art Institute of Chicago were untiring in locating references for the bibliography. Suzanne Frank and Dorothy Valintis provided translations of various research materials in German and French.

Gerald R. Singer gave me invaluable advice, facilitating the publication of my research. Susan L. Huntington also encouraged me in pursuing publication and gave me unfailing support. Carla Borden also encouraged me in pursuing publication, gave sound advice on many matters, and critically read several sec-

tions of the manuscript. McKim Marriot critically read several sections of the manuscript and made important suggestions for its improvement. Stan Cohen and Paul Riedl shared their computer expertise in helping me ready the manuscript for Oxford University Press. Ruta Daugavietis spent many extra hours in preparing the maps in this book. With consummate care and good humor, Joyce Berry and Helen B. Mules of Oxford University Press saw the manuscript through the publication process. Generous grants from the Illinois Arts Council, a State agency, and from the Trustees of the ILA Foundation provided respectively the special funding required for the publication of this book and the funding required for certain aspects of this presentation.

To all these contributors, I am deeply grateful. I must finally acknowledge my great indebtedness to many friends and to the members of my family, especially my sister Mary Jo Furgal, for their patient understanding and good wishes for this project as it evolved over many years. Without the help of all named here as well as those who remain unnamed, this project could never have been completed.

From the Ocean of Painting

Scholarly Interest in India's Popular Painting:
A Short Overview

Folk painting is assuredly the oldest traditional art still being created in India. The earliest examples—images of animals and hunters found on rock shelters in the region of modern Bhopal in central India—date back more than seven thousand years. One cannot help but wonder how other early, but now lost, Indian folk paintings may have looked—for example, those painted on mud walls during the reign of the great Mughal emperor Akbar in the sixteenth century. Today it seems reasonable to believe that the paintings presented here still carry the lively imprint of ancient and inventive minds.

As the third millennium A.D. approaches, it is distressing that this great Indian tradition of popular art, which has maintained its vitality for centuries, is beginning to display signs of depletion. It is also ironic that most scholars of Indian art history have generally ignored folk art. This neglect has its roots with Western art historians of the last century who insisted on measuring Indian aesthetic excellence by European standards. They found classical Indian art lacking in virtue, and they easily dismissed the humble creations of the village and folk traditions as rude and ephemeral curiosities.

It was only after the second decade of the twentieth century, following the revolutionary developments of Cubism and nonobjective art in Europe, that Western eyes began to find a new lens through which to view the art of other cultures, including that of India. What had been considered ethnographic artifacts could now be perceived as art. Not only was the value of sophisticated Indian art enhanced, but avenues toward the appreciation of folk and village creations opened. Even so, scholarly interests have remained focused chiefly upon court and temple traditions in architecture, sculpture, and painting, and research in these areas has outdistanced the attention directed toward folk art traditions, the ultimate source of all visual forms in India.

European awareness of the arts of India began in the sixteenth and seven-

3

teenth centuries, when many Western countries competed commercially in Asia during the Age of Exploration. England's early interest in India began on the last day of the year 1600, when Queen Elizabeth I issued a charter establishing the East India Company to promote commerce. Eventually, after overcoming their Portuguese, Dutch, and French competitors on the subcontinent, the English pursued a profitable trade in textiles and other handmade Indian products. By the 1780s the company was including architecture and archaeology in its economic resource surveys. Ultimately, the expanding concerns of the English led to interest in and scholarly research of ancient Indian languages, literature, and religious texts. These, in turn, stimulated additional investigations into the iconography of sculpture and, eventually, the subjects illustrated in hand-rendered manuscripts.

The English produced the first volume of *The Journal of Indian Art* by 1886, and about this same time, the Indian artifacts originally collected by the East India Company were transferred from the India Office to the South Kensington Museum (today's Victoria and Albert Museum) in London. George C. M. Birdwood, in his guide to these collections, *The Industrial Arts of India* (1880), wrote that the Ajanta cave frescos "are sufficient proof of the ancient aptitude of the natives of India for painting." He continued, however, in the following manner: "Pictorial painting of a rude kind is practiced everywhere in India, and is produced in extraordinary quantities on the occasion of the annual festivals of the different gods . . . but the best, the widest known of all are the Delhi paintings on ivory, *in the style of European miniatures*" [emphasis added].[1]

Such remarks reflect the Victorian bias for judging Indian culture by European standards. Some Indians, emulating their British rulers, absorbed this bias against native folk expressions. T. N. Mukharji, an officer at the Indian Museum (Calcutta), for example, writing in 1888, discounts several forms of popular painting as "rude" or "very rude" or without artistic merit.[2]

Early in this century, however, the great Ananda Coomaraswamy, the father of Indian art history, called attention in his 1909 book *The Indian Craftsman* to the key role played by Indian artisans in the arts of India. He pointed out that the great masses who lived in villages had "not worshiped the abstract deities of priestly theology but [rather] the local genii, *yakshas* [semideities], and *nagas* [snake gods], and the female divinities of increase."[3] One can be certain that such devotees venerated vibrantly painted folk icons and images. Coomaraswamy was also one of the first art historians to write about the itinerant storytellers who showed pictures in synchrony with a narrative, in his essay of 1929, "Picture Showmen." The vast folk art production by the artisan castes, which for millennia served the ritual and educational needs of the millions in Indian villages, constitutes the rich cultural subsoil from which the hybrid and sophisticated arts of India developed and grew. The complex and sophisticated icons of Hinduism, as well as the miniature paintings for courts, could never have been conceived, and would not have flowered, without this rich, vital matrix. These creations of a refined craftsmanship materialized under elite patronage, but they grew out of humble origins. Also, the craft techniques that evolved in the villages provided a basis for those mature skills ultimately practiced by temple guilds and palace workshops.

In addition to Coomaraswamy, a number of scholars who addressed folk art subjects were active in the years just prior to and following the Second World War. The earliest and most intensive research centered around the folk traditions of Bengal and were allied with an intense regional pride and Bengali nationalism. By 1926, Ajit Ghose, an early student of Bengali folk arts, had published his study "Old Bengal Paintings" in the Calcutta art journal *Rupam*; other studies on folk arts of that region followed.

Especially noteworthy were the activities of Gurusaday Dutt, a pre-Independence civil servant and magistrate who was a passionate lover of the traditional folk arts and crafts of Bengal. He was especially enamored of Bengal folk singing and dancing but also established a museum where one of the first major collections of folk artifacts from across India was housed. Between 1932 and 1940 he wrote at least eighteen articles on various aspects of Bengali folk arts and staunchly propagated what he referred to as the "art language" of the country, stressing its importance as a central ingredient of nationalism.

Outstanding among those who followed Gurusaday Dutt as serious students of Bengali folk art was Ajit Mookerjee. In its 1946 edition, his book *Folk Art of Bengal* (originally published in 1939) brought worldwide attention not only to the popular arts of Bengal but to those of India in general. His early activities were associated with the Crafts Museum of the Indian Institute of Art in Industry (established in Calcutta in 1945) and its journal, *Art in Industry,* and later he served as the director of the Crafts Museum in New Delhi (established in 1956 and today known as the National Handicrafts and Handlooms Museum). He continued to publish important works, especially concerning folk aspects of yogic and Tantric arts, into the 1980s.

The Asutosh Museum of Indian Art, which was established at the University of Calcutta about 1939 by its founding director, Deva Prasad Ghosh, has been particularly active in folk art studies over the years. From the time of its creation, through the war years of the 1940s, Ghosh energetically amassed the museum's various collections, which are extremely strong in the folk art of Bengal and other regions neighboring the state. When Ghosh retired in the early 1960s he was succeeded by Kalyan K. Ganguli, as acting director, who served there until the early 1970s. Actively interested in folk arts, Ganguli later followed Ajit Mookerjee at the Indian Institute of Art in Industry in Calcutta, coordinating its museum's activities, writing on folk arts and crafts, and editing the Institute's journal, in which articles on folk art were frequently featured.

Another preeminent pioneer in the study of India's folk traditions was William George Archer, who in the 1930s was a pre-Independence official of the Indian Civil Service. Prior to his departure for India in 1931, he saw and was deeply impressed by two Kalighat paintings (souvenir images made for pilgrims to the temple of the goddess Kali) on exhibit at the Victoria and Albert Museum; in 1932, when visiting Calcutta, he went to the Kalighat temple. Thereafter, he purchased several Kalighat paintings and soon became excited by other forms of Indian folk art. During his subsequent years of Indian service, Archer traveled the bazaars and remote villages of Eastern India, collecting various items of folk art and miniature painting. He passionately acquired and wrote about the folk arts and poetry of tribal peoples, especially in Bihar; his

first publication in 1936, with his wife, Mildred Archer, was in fact a short note on Santal tribal painting in Bihar.[4] In 1934, after a destructive earthquake in the Madhubani subdivision of Bihar, Archer had observed the marvelous, brightly colored murals painted on the fallen mud walls of Maithil Brahmin and Kayasth houses. In 1940 he photographed and collected models for these now renowned wall paintings, which until that time had been completely unknown to the outside world. Following Indian independence and his return to England, Archer was appointed keeper of the Indian section of the Victoria and Albert Museum in 1949. There he continued to write splendid landmark essays on both the sophisticated and the popular arts of India, including Pahari miniatures and his first interest—the pilgrim paintings of Kalighat.

Mildred Archer shared her husband's life in India and his enthusiasm for its folk arts. An outstanding scholar and a specialist on the art of the British Raj period, she also contributed significantly to the literature on India's popular arts. As keeper of prints and drawings at the India Office Library and Records, London, from 1954 to 1980, she solidly catalogued the unique holdings of folk paintings (including important gifts from the Archers) in that institution, publishing her research as the fine *Indian Popular Painting in the India Office Library* (1977).

Verrier Elwin was an anthropologist who spent almost four decades in India studying its rich and complex tribal life and culture. After India won its independence, Verrier became an Indian citizen; he died in India in 1964. His profound scholarship and his humanistic understanding of tribal peoples are expressed in nineteen books that focus upon tribal myths, poetry, and arts. He shared the Archers' enthusiasm for these arts, and his publications *The Tribal Art of Middle India* (1955) and *The Art of the North-East Frontier of India* (1959) are unique cornerstone essays.

Following India's independence from Great Britain in 1947, and as a dimension of the new nation's pride, several institutions were created to stimulate interest in and to provide support for India's traditional arts and crafts activities. Established in 1949, the National Museum, New Delhi, inaugurated its permanent building in 1960. There a splendid array of traditional art objects from all historic periods is on view, along with galleries housing ethnographical and folk art items. In addition, three national academies were established in 1953–54 to foster literature, painting, and the performing arts. Most important for India's folk arts and crafts, however, was the formation of the All India Handicrafts Board, with its Cottage Industries Emporium and, especially, the Crafts Museum in New Delhi. This museum, known today as the National Handicrafts and Handlooms Museum, continues to be the primary center for the active display and dissemination of information and scholarship about all of India's folk arts.

Over the years Pupul Jayakar has been intimately associated with the activities of several of these governmental agencies. She has been a central, urgent force for sensitizing and educating her compatriots, and the world, about the richness of India's folk traditions. Her positions as chairperson of the Handicrafts and Handlooms Export Corporation of India, the All India Handicrafts Board, and the Cottage Industries Corporation, as well as her membership on

the governing board of the National Institute of Design, several committees for sponsoring India's arts abroad, and the various Festivals of India in several Western countries and in Russia, have made it possible for her to be an effective advocate for India's folk traditions. Her book *The Earthen Drum: An Introduction to the Ritual Arts of Rural India* (1980) has been a cardinal contribution to the field.

The National Institute of Design, which was established in Ahmedabad in 1950, has over the years actively supported research and documentation of folk arts, especially those of Western India. In recent decades, many scholars have been associated with the institute's folk arts activities, but Haku Shah and Eberhard Fischer come to mind as notably productive both in publishing and in mounting exhibitions of Indian folk art. Fischer is the director of the Museum Rietberg, Zurich, which also continues a rigorous interest in all aspects of Indian art. Jyotindra Jain, currently the director of the National Handicrafts and Handlooms Museum in Delhi, is another active scholar. Jain has written extensively on folk art and has participated in organizing exhibitions of both folk and traditional Indian arts, collaborating on several occasions with Eberhard Fischer.

Today it is heartening to note, some fifty years after Independence, that publications on many aspects of Indian folk art have proliferated. Only a select few of these publications are mentioned here because of the limited nature of this essay; however, it would be a grave omission not to acknowledge the major contribution made over the years by the art journal *Mārg* published in Mumbai (formerly Bombay). This publication has dedicated complete issues to particular Indian folk art subjects across a wide geographical and historical spectrum and has been a catalyst for new folk art scholarship.

Unlike in England, where a historical relationship between Britain and India had engendered a direct and national curiosity about Indian culture, in America interest began to grow only in the postwar years and was, to a degree, stimulated by the hippie and flower children movements, and even the guru and Beatles phenomena of the 1960s. Still another important influence during this time was the publication of a well-illustrated paperback book, *The Everyday Art of India,* by Robert F. Bussabarger and Betty D. Robins. Issued in 1968, this popular volume was the result of Fulbrighter Bussabarger's direct experience with native artisans in Indian villages.

Also contributing to America's expanding knowledge of India and its folk arts, especially in California, was the work of J. LeRoy Davidson, professor of Indian art at UCLA. Davidson organized "Art of the Indian Subcontinent from Los Angeles Collections" for the UCLA Art Galleries in 1968. This exhibition included folk art. Another catalyst for interest in Indian folk art in California has been the (formerly called) Mingei International Museum of World Folk Art in La Jolla, which has offered several excellent exhibitions on the subject.

Stella Kramrisch was a pioneer on two continents in the study and exhibition of the arts of India. Born in Austria, she came to the United States in 1950 after living in India for twenty-seven years. Her lengthy stay there resulted from a 1919 meeting with the poet Rabindranath Tagore, who invited her to become a faculty member of his newly established school in Santiniketan. Dur-

ing her years in India she became one of the world's leading scholars of Indian art, including popular arts, and her writings were extensive. Her two-volume book *The Hindu Temple* (1946) remains the definitive study on the subject. In Calcutta, she became the friend and colleague of many of India's leading artists and scholars, including Jamini Roy and Gurusaday Dutt. Her inspired teaching produced some of India's finest art scholars. She also served, with Tagore, as an editor of the *Journal of the Indian Society of Oriental Art* (formerly known as *Rupam),* which published many articles on folk arts. In 1950 W. Norman Brown invited Kramrisch to join the faculty of the University of Pennsylvania, in Philadelphia, where this exemplary mentor and teacher trained many of America's leading scholars of Indian art history. She also served as curator of Indian art at the Philadelphia Museum of Art, where she organized several celebrated exhibitions. There her major contribution to expanding knowledge of Indian folk art was her exhibition and catalogue *Unknown India: Ritual Art in Tribe and Village* (1968). The breadth and scholarship of this effort continues to provide a standard of excellence even today.

The recently retired Harvard scholar Stuart Cary Welch, who has provided an essay for this publication, has been another intellectually energetic contributor to America's understanding of Indian art. Since the 1960s he has written catalogues and curated major exhibitions of Indian art for a number of American museums. While making a particular contribution to the study of Mughal painting, Welch has always been aware of currents outside the mainstream of India's sophisticated arts and has consistently seen the virtue of including Indian folk art in his exhibitions. And, as a special consultant in Islamic art to New York's Metropolitan Museum of Art, he devoted a significant section of his relatively recent major catalogue and exhibition, *India: Art and Culture, 1300–1900,* to India's tribal and popular arts. The Metropolitan exhibition was an aspect of the nationwide Festival of India of 1985–86, the centerpiece of which was "Aditi: The Living Arts of India" at the Smithsonian Institution in Washington, D.C. Mounted by the government of India, this exhibition and its accompanying catalogue provided the most complete and substantial showing of extant traditions of Indian folk art, including the performing arts, ever seen in North America.

Over the past three or four decades, in addition to these major presentations, a number of other smaller but select exhibitions of Indian folk art have been assembled in museums and galleries across the United States. The current publication, *From the Ocean of Painting: India's Popular Paintings,* A.D. *1589 to the Present,* now makes a singular contribution in documenting an exhibition that presented a wide selection of Indian folk paintings. Its exclusive focus upon painting sets this presentation apart from other previous American presentations of Indian folk art. Its purpose in surveying more than twenty distinct traditions and categories of popular painting from various locales makes it unique. Drawing from collections both in America and Britain, this publication offers approximately one hundred works spanning more than four hundred years. Professor Barbara Rossi, the curator and driving force behind this presentation, has commented on the staying power of folk arts, noting that these "neglected areas of Indian creativity, the folk and the popular, are the real roots of

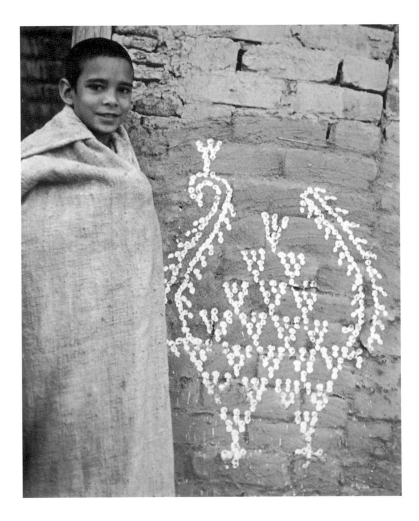

Young boy with a ritual wall painting of
the auspicious peacock, beside the en-
trance door of his family's house in a vil-
lage near Palwal, south of Delhi, 1964

the great, flowering tree of high classical accomplishments. . . . [They are] far
more extensive and pervasive than the tree . . . [and] more enduring and, fortu-
nately, continuing to evolve, while the tree's life, alas, is over."[5]

I would like to conclude by providing here a vignette of the most ephem-
eral of India's folk paintings, those created upon earthen walls. About thirty-
some years ago, in a small village forty miles or so southwest of Delhi, I came
upon a smiling young man standing before his adobe house, freshly refurbished
following the monsoon. He stood in a handwoven wrap beside a doorway
flanked by auspicious images of the peacock, which is a symbol of immortality,
of the Lord Krishna, of love, and of Karttikeya, a lord associated with war.
These votive markers had recently been wrought upon a fresh coating of cow
dung by his mother, the woman of the house, who simply dipped her fingertips
into a liquid of white rice flour and dotted them directly upon the wall. The
forms, arranged into patterns of triangular shapes and dotted lines, came ele-
gantly and logically together in a stylized and sure design that any student of
contemporary art would have been proud to have created. Yet this image, a

legacy of the family's matriarchal lineage, was a traditional one worked onto the wall by an unlettered peasant woman. She had learned this indispensable household ritual when she was a child, from her mother, who had in turn, learned it from her mother. The story stretches on back through time, to the hands and minds of other ancient mothers, who had assuredly rendered similar elegant and propitious designs on the walls of their adobe houses.

—Roy C. Craven, Jr.

Reflections upon Barbara Rossi's "Ocean"

One bleak day in Rajasthan, locked into a large room by an eager collector, I was forced to examine and discuss thousands of intensely boring Indian folk—or, better, *popular*—pictures. The experience was instructive. It convinced me that one indeed could be bored to death (a few more minutes of this exercise would have ended me). It also underscored the fact that stimulating, rewarding folk pictures are in short supply. Indeed, they are at least as rare as "masterpieces" from that considerably smaller "ocean" of art from more elevated social or cultural levels. In India, as elsewhere, art for the "higher- (or nobler-) browed" usually, somehow, captures the eye, if only because we have been taught to respect the many hours, weeks, or months required to enrich it with so many tiny figures, squiggles of arabesque, flowers, elephants, burnished golden highlights, or whatever. Only later, perhaps, do we come to our senses and yawn. Nevertheless, we feel sorry for those with no eye for popular art, which at its best, as here, can be exhilarating and profound. We particularly regret their unawareness of its essential, nourishing interrelationship with "higher" art. For Indian culture, from top to bottom, is rooted in its villages, the focal point not only of the much admired joint family system but of its peoples' understanding of nature, human and otherwise. A high percentage of Indian artists, including those employed by the major shrines and temples and at the great Muslim and Hindu courts, were village born and bred. Holidays were spent in the family village, surrounded by wondrously cacophonous relatives and a virtual zoo of wildlife—all close enough to study and touch intimately. When a powerful Mughal or Rajput patron wished to bestow largesse upon an artist or artisan, he was likely to grant a village, *in perpetuo*. To understand Indian art on any level, the nurturing village connection cannot be overemphasized.

Regardless of cultural level, works of art or craft must be lively and instilled with conviction. If their creators were bored, tired, or hungrier for food than art, the observer senses that something is missing. Too often, when one is

inspecting sets of Indian pictures painted at the same time and place by the same artist, one or two stand out as inspired. The paintings in this presentation, sensitively and intelligently selected by a curator/artist deeply aware of and attuned to Indian art, demonstrates that there is a consensus with regard to the ups and downs of artistic quality. Everyone, from open-eyed uninitiates to specialists, who sees this publication (or who saw the exhibition upon which it is based) is likely to share Barbara Rossi's enthusiasm for the works of art discerningly culled from many thousands.

For whom were the many works of art assembled here created? Who were/are the folksy populace? Everyone, we suspect, regardless of socioeconomic position, belongs to this catch-all. Many years ago, an aristocratic New Yorker told me that his mother—surely one of the elite—composed "popular" songs. ("'Popular' with whom?" I asked.) One of the works of art here (no. 87) is identical to the first picture shown me from his royal collection by a great Rajput prince, the late Maharao of Kotah. I remembered this while inspecting other royal collections in Rajasthan, in which cheek-by-jowl with "high culture" pictures were folkloristic ones. I also recall being shown works of art "popular" in every respect, painted in the early nineteenth century by a Rajput of bluest blood. In India, as elsewhere, it is at times difficult to differentiate between the lowly and the elevated. This became very clear to us one day when we drove from a grand royal palace to a village. In twenty minutes we had gone from an essentially international, contemporary, high-tech ambiance to one far simpler. The clock had been turned back at least forty years. Two hours on camelback crossing scrubby desert brought us into a delightful village reminiscent of the nineteenth century. Lacking electricity, hence protected from the contamination of TV and movies (*filums*), it welcomed us into the world we relate to popular art. Demonstrating folkloristic innovativeness was a row of ornamental finials atop the mud-brick walls—light bulbs! More pertinent to these investigations was the unexpected fact that our "popular" hosts in this "medieval" village were cousins of the Oxonian maharajah whose palace we had left a few hours before. Both the maharajah and his village cousin, of course, were Rajputs, members of the Kshatriya or knightly caste, which is not ordinarily thought of as popular. This publication, however, contains works of art created for and sometimes by members of India's other three castes, from the priestly Brahmins (nos. 4, 9), to the business-oriented Vaishnavites (nos. 66–70) and the agricultural Shudras (nos. 15–16). It also contains many pictures from the humblest of social levels, most of whom are animists by religion. Members of no caste, these "untouchables"—now, thanks to Mahatma Gandhi, known as Harijans (Children of God)—form a vast population, among whom are powerfully wealthy individuals and prestigious politicians. Mostly, however, they are agriculturalists and menial workers. Paradoxically, many of them are descended from India's original landholders, proud tribal peoples who were forced by waves of conquerors from their lush domains into remote areas where survival was hard. Their arts, like their patrons, tend to be humble. At best, they are as movingly spare and sensitively designed as objects made by the Shakers or the Inuits.

In India, as everywhere, the mighty inevitably tumble. A few years ago, a direct descendant of the supremely grand Mughal emperors—who conquered and controlled much of India from the early sixteenth century until they were

weakened in the eighteenth century and deposed by the British after the Mutiny of 1857—camped out on the pavement in the Calcutta railway station, barely surviving on a dole from the Indian government. If, as Muslims, the Mughals were unaffiliated with the essentially Hindu caste system, they nevertheless conformed to it in many respects. One hears, therefore, of high- or low-caste Muslims, depending upon their status and activities. For assorted reasons, artists and artisans were/are often Muslims, and they were often employed by Hindus or other religious communities, such as the Jains, Parsees, or Harijans. Hindu artists, on the other hand, were among the most admired at Mughal (Muslim) courts.

From the Ocean of Painting underscores the variety of India's artistry. It excludes, however, works of art from the lowermost levels, things of primal, almost chaotic simplicity, unlikely to engage readers' attention. Much popular art, from India and elsewhere, falls into two categories, the emergent—equivalent to the creations of the young and eager, experimental and intent upon discovery—and the senescent, which can be likened to incoherent work by the forgetful senile. In their extreme forms, these two "flavors" of art, hardly worthy of the word, are unappealing as drool. Usually, however, India's folkloristic art is neither purely emergent nor senescent. Its subjects conform to traditional—that is, already discovered, codified, and clearly remembered—patterns, most of which are religious in subject. This is demonstrated by the catch from Barbara Rossi's ocean. Images or icons of the Hindu gods, especially of Lord Krishna (nos. 66–69) abound, as do sacred diagrams, schematic charts by which to approach the divine (nos. 1–4, 61, 63, 87, 88, 94), illustrations to Hindu epics, in which gods and mortals sometimes meet (nos. 36–37, 40–41, 43, 55, 76, 79), games (no. 96), representations of animals real and imaginary (nos. 18–19, 21–23, 42, 53, 54). Even portraits are rarely—if ever—secular, most owing their existence to belief or faith: portraits such as those by Jadupatuas (magic painters) (nos. 49–51) served a magical ritual purpose. Several of the works of art here were believed by their makers and patrons to be therapeutic or apotropaic. In India, ingrained ways of thought softened the lines between religious and secular. Film starlets have been elevated into mother goddesses; *dacoits* (armed robbers) have taken on attributes usually associated with divinities. Might not the owner of the depiction of the courtesan playing a sitar (no. 80) have ascribed to her the powers of Sarasvati, the goddess of music? Perhaps, too, the rose-bearing Muslim courtesan (no. 81) enriched some humble apartment or mud hut with powers beyond her mundane role.

If many of the pictures here were believed to vanquish evil spirits, cure ailments, bring wealth, or promote fertility, they must also have been enjoyed for other reasons. However foreign was the concept of beauty for its own sake, surely the artists and possessors took pleasure in the intrinsic, often decorative artistic qualities of these eye-catching works. Artistic motifs survive longer toward the bottom of the socioeconomic scale than at the top. At court, fashions and art styles change constantly and speedily. Mughal, Deccani, and Rajput pictures can be dated with impressive accuracy on grounds of stylistic factors. In remote villages, uninfluenced by the trendiness of courts and cities, motifs, compositions, and techniques survive for astonishingly long periods. Although

painted in the nineteenth century, the section of a scroll painting depicting a story from the *Virata Parva* (no. 36) retains stylistic elements that were already antique in the sixteenth century. More voguish are the Kalighat pictures (nos. 17–23) made by and for Calcutta "city slickers." In these nineteenth-century pictures from the major metropolis of British India, nontraditional materials (watercolor washes and machine-made paper) were employed by lowly artisans to churn out cheap ephemera for the urban poor and for others fascinated by India, such as the Tagores and Rudyard Kipling. Although the creation of entire pantheons of Hindu divinities was their stock-in-trade, the artists clustering at the *ghats* (riverbanks) dedicated to the shrine of the goddess Kali also depicted tropical subjects. Their agents—or, more likely, the artists themselves—hawked newsy renderings of *crimes passionelles* and other gossipy tidbits, hot off the drawing board. They not only purveyed sacred images as souvenirs for pilgrims but served the sort of clientele now addicted to movie magazines, TV, comic strips, and scandal sheets.

Pictures in *From the Ocean of Painting* represent many of India's myriad traditions. Most descend from and are empowered by an ancient pan-Indian style, so vital and potent that it permeated every cultural level. Hints of it can be identified in revered wall paintings and miniatures from temples and courts. When in the 1560s the Mughal emperor Akbar recruited talented apprentices for his painting studios, some of them had been trained in this still mighty tradition, as can be seen in such manuscripts as the Cleveland Museum of Art's *Tuti-Nameh* (*Tales of a Parrot*). In the popular paintings seen here, it is represented with particular brilliance by folios from several so-called Paithan sets of pictures painted in about 1850 in Maharashtra or northern Karnataka (nos. 53–57). Akin in their dramatic narrative style to works from areas as widely apart geographically as the Punjab Hills and Kerala, they rank as folkloristic classics. Numerous examples from the nineteenth century attest to their invariable technical masterfulness, vitality, and consistently high levels of dramatic projection. Among the many that have survived, few fail to delight. Drawn in a sure, wiry hand and vividly colored, they illustrate their fantastic tales with persuasive gusto. Animals, monsters, and figures conform to ancient characterizations, never approaching true portraiture. Heroic women and men, kings, and priests, inhabitants of a magical world burgeoning with boldly patterned trees and blossoms, are identifiable from iconographic formulae reminiscent of those seen in Andhra cut-leather puppets (nos. 98–99) and—from farther afield—of those still made for the Javanese puppet theater. Like the leather puppets, which were large enough in scale to be shown in village squares, the Paithan pictures were boldly legible. Professional storytellers held them up to enlighten and entertain audiences who never tired of their ancient legends, which combined comedy, heroism, wickedness, and tragedy, laced with psychological insights. After bellowing, hissing, and stage-whispering the fantastic tales shown in a picture, the storyteller flipped it over, without missing a beat, and howled his way through the antics depicted on the other side of the page. Performances of this sort, comparable to those of traditional dance-dramas, went on far longer than we who are used to two-hour-long entertainments might expect. Like Kerala's Kathakali dance troops, these peripatetic describers of pictures roamed

from village to village, entrancing audiences evening after evening. Imagine the intensity of these raucously tragicomical cycles of Hindu epics, performed for gesticulatingly responsive villagers by the flickering light of oil lamps!

Regrettably, performances of this sort are now hard—or impossible—to find. The vociferous bards of the paintbrush have been replaced by films and TV. Although filmed Hindu epics continue to attract tens of millions of viewers, one wonders about the impact from the current invasion of U.S.-style detective dramas and sitcoms. When will Californian teenyboppers in baseball caps, hip-hop jeans, and electrified sneakers be raised to god-dom? If and when this happens, solace might be found in India's ability to transform and Indianize everything that enters its world, from kitsch to football hooliganism. Anyone fortunate enough to have roamed Indian streets recently knows that popular art is far from dead. Painters who have suffered the patronage of well-intentioned handicraft committees, ever eager for watered-down art for tourists and homegrown champions of the artsy-craftsy, can survive anything.

—Stuart Cary Welch

An Introduction to India's Popular Paintings

India's genius for painting is manifest in the myriad traditions and types of painted images that have emerged in various places and regions over the centuries and that collectively constitute a great "ocean" of visual form. Exhibitions and studies of Indian art in the Western world, especially in the United States, have revealed something of the exquisite beauty and richness of miniature paintings commissioned by India's rulers but only rarely presented examples of any of the varieties of painting prepared for its common people. Though much less well known, popular paintings—in India as elsewhere—have always been produced in greater quantities than paintings created for aristocratic patrons, and, while all of India's miniature traditions have become virtually extinct with the demise of its royal patrons, some plucky vernacular traditions continue to evolve. *From the Ocean of Painting*, featuring twenty-one forms of Indian popular painting plus a related form of popular printmaking, is the first major overview of this important, diverse, abundant, and enduring material.

India's many forms of popular painting sprang up to serve a very broad range of common people living in rural villages, tribal settings, and urban centers. Even today, the vast majority of India's population dwells in rural communities, as it has for millenia; peasant villagers on the whole follow time-honored Hindu or Muslim customs in matters related to worship, family life, social organization, and work; most are engaged in agriculture, including those who are craft practitioners and traders supplying the specialized necessities of daily life. A large portion of India's population is probably of aboriginal descent—some of these peoples remain as non-Hindu "tribals" who, following their own customs, are less than fully participant in the caste division of labor; some of these tribal peoples worship distinct deities and speak different languages; many continue to live in remote hilly or heavily forested areas where they have infrequent contact with other Indian groups. The smallest segment of India's population is found in towns and cities, although, because of industrialization and political changes over the past two centuries, the urban centers contain the greatest diversity: today, towns and cities may count among their inhabitants villagers

and "tribals" resettled for economic betterment as well as government workers, shopkeepers, various types of laborers, and university-educated middle-class professionals.

However different the circumstances of these various types of common people, the word "popular" is used here for nonelite forms of Indian painting from all three contexts—folk, tribal, and bourgeoisie: "popular" is the most inclusive term, while the word "folk," though commonly used as inclusively, primarily connotes the single circumstance of peasant origin. The use of "popular" here does not necessarily mean being widely available or known, as "popular" can sometimes imply, especially in Western culture with its broadcasting media of radio, film, and television. Rather, the adoption of the term "popular" follows Mildred Archer's usage in her catalogue of a collection of Indian popular paintings, as she states that paintings made "by the people for the people . . . are best described as popular."[1]

It may also be important to point out a second reason that the term "folk" is not being used here. Recently in the United States, "folk" has come to refer, somewhat inaccurately, to self-taught—and frequently socially isolated—artists who create out of inner necessity unique visual forms conveying singular, personal visions. This relatively new connotation of the term "folk" has little application to the two types of practitioners of Indian popular painting, that is, nonprofessional artists creating in a domestic or private context and professional artists or artisans creating artifacts for broader use. In traditions involving the former, artistic conventions are transmitted from mother to daughter, from father to son, and from guru to student. In traditions involving the latter, the professional popular painter generally inherits the task of painting from birth into a painting caste and acquires the requisite training, often considerable, through apprenticeship to a master of the same caste, sometimes one's own kin.[2] Unlike the self-taught visionaries, both kinds of practitioners of Indian popular painting work within a shared cultural context informed and maintained by group wont and need. This is not to say that there are no instances of self-expression, innovation, formal invention, and adaptation or assimilation of content but simply to emphasize that traditional forms of art require, in fact, a relation of reciprocal interaction and mutual dependence between individual and group—not only to be traditional expressions but also to endure. For it is only the individual artist, creating afresh with the cultural property of his or her respective group, who makes the superb example—simultaneously reinforcing and renewing the tradition and ensuring its continuance into the future. This accomplishment is evident in the work itself and is recognized by both artist and community.

Most popular painting traditions originate in specific regions formed by geography and climate; these traditions are almost always shaped by distinct regional cultures. The artists and patrons of these popular painting traditions are identified with particular communities residing in specific locales. In those traditions that involve professional artists, the artists and their families belong to a specific group or caste, defined by the work they customarily do for their own communities or for other specific groups. The paintings of these traditions are thus not universally produced throughout India. For example, *par* painting,

which narrates the deeds of regional hero-gods, is practiced primarily in certain villages of Rajasthan by members of the Joshi (astrologer) clan of the Chhipa caste, which is traditionally involved in printing and dyeing cotton and which claims to be a subgroup of Brahmins (the priestly caste); Joshis make their paintings for performers-priests of different social groups, who in turn display the paintings and perform the stories, in some instances for their own communities and in other instances for other social groups (nos. 58–60). Likewise, Puri painting is carried out only in the pilgrimage town of Puri and at other sites in the state of Orissa by a painter caste known as Chitrakars (painters), who make religious images for devotees of Lord Jagannatha, a form of the god Vishnu (nos. 25–30).

Each of India's popular painting traditions can consequently be said to have its own history. Although the initial developmental stages of many traditions are beyond tracing, literary or other evidence attests to the existence of certain traditions within various historical periods, some noted as early as the second century B.C.[3] Survival of popular paintings of great antiquity, however, is rare because of India's extreme climates and the hard use that portable popular paintings undergo, and most of the traditions believed to have originated in remote times can be represented by examples dating back only to the nineteenth century. Not all traditions have survived. As part of cultural ecosystems in centuries marked by great change, the popular painting traditions are both stimulated by and vulnerable to the twists and turns of events around them: aptly remarking on their precarious nature, the Indianist scholar Stuart Cary Welch has said, "A folk tradition is very fragile: it can be killed as instantly as a peasant knocked off his bicycle by a truck."[4] Other popular painting traditions have endured because they fulfill continuing cultural needs or have adapted to changing ones. Moreover, since India's independence from British rule in 1947, other popular painting traditions have been revived through government intervention, which has encouraged the production of traditional and nontraditional items for sale to culturally elite consumers in India and abroad.[5]

India's popular painting traditions are further characterized by the cultural functions they serve; of particular significance are traditions with ritual, iconic, or narrative ends. These cultural functions inextricably connect traditional popular paintings to the real-life needs of various communities and are generally understood by both creators and users to be more significant than the considerable aesthetic aspects of the paintings. While painters in India have, of course, employed traditional ornamentation in their work, they have done so not so much to beautify their paintings but to more fully express their devotion to their deities.[6] While Indian painters have created works pleasing in color and design, in no instances have they intended to make paintings "for art's sake" or for aesthetic reasons alone, that is, primarily to be put on a wall or other support and admired as beautiful visual forms.[7] It is therefore not surprising that, at least in the past, castes of professional popular painters have been known not as artists but as craft practitioners, and, accordingly, their work has not been considered "art."

In Indian ritual traditions, the activity of painting auspiciously effects certain material or spiritual benefits, such as fertility, good health, a big harvest, or

the presence of a diety. Ritual paintings are for the most part ephemeral, environmental images, featuring diagrammatic or more or less abstracted pictorial images; they are created only at astrologically or personally appropriate times, usually on the dirt floors and walls of village and tribal dwellings or on temple floors. For their creators, who are mostly nonprofessional artists, making such paintings is as important as the painted images themselves—because it is the act of painting at just those auspicious times that "magically" ensures the desired good fortune. Ritual paintings are physically fragile, since they are "painted" with nonpermanent materials (rice paste or colored powder, which decays or is worn away by the monsoon rains); when ritual paintings on walls and floors have fulfilled their particular purposes, they are often plastered over with a fresh coating of mud and cow dung, and the creation of new paintings— or the renewal of the old paintings—may be required according to the demands of a new time. It is not known how long ritual painting has been practiced in India, but some of its present-day motifs have prototypes in archaeological finds.[8]

As most ritual paintings exist *in situ*, they are neither portable nor able to be collected and exhibited. This circumstance excluded from the exhibition documented by this publication examples of the many regional varieties of Hindu domestic ritual art[9] as well as tribal ritual traditions. Among the latter are ephemeral pictographs made by members of the Saora tribe through which the spirits of ancestors are assuaged.[10] More permanent wall paintings are ritually created by members of the Rathva tribe to fulfill an individual's vow to honor the tribal deity Pithora (see ill., p. 22).[11] There are, however, some kinds of ritual paintings that may, in fact, be made on paper, as well as works on paper that have served as models for domestic ritual wall paintings. Such ritual paintings are represented here by works related to the celebration of various festivals in different regions (nos. 1–4) and to the celebration of marriage in the Mithila region of Bihar (nos. 5–7). Another kind of ritual painting on paper, one that has emerged in the past thirty years, involves the transfer of traditional images and idioms from their customary support, the mud walls and floors of domestic dwellings, to paper for marketing to sophisticated urban classes in India and throughout the world. This development in India's long history of ritual painting was encouraged by the Indian government as a way of maintaining and enlarging the traditions and as a way of increasing the earning power of peoples in depressed areas; this development is represented here by some of the paintings from the Mithila region of Bihar (nos. 8–10) and by all of the Warli paintings from the Thane district of Maharashtra (nos. 11–15). Mali paintings (so-called after the gardening and garland-making caste in Bihar who produced them) exemplify yet another kind of ritual painting on paper that is also represented here: portable paintings made to be offered as ritual appeasement to deities, especially at certain festival times (nos. 15–16).

Iconic traditions provide pictures of deities for public and private worship. The creation of these pictures is considered an act of devotion for which artists may prepare with rituals of purification; production and sale of these pictures are frequently associated with particular cults and temples that are pilgrimage destinations. Such sacred pictures may be painted on paper, cloth, or wooden pan-

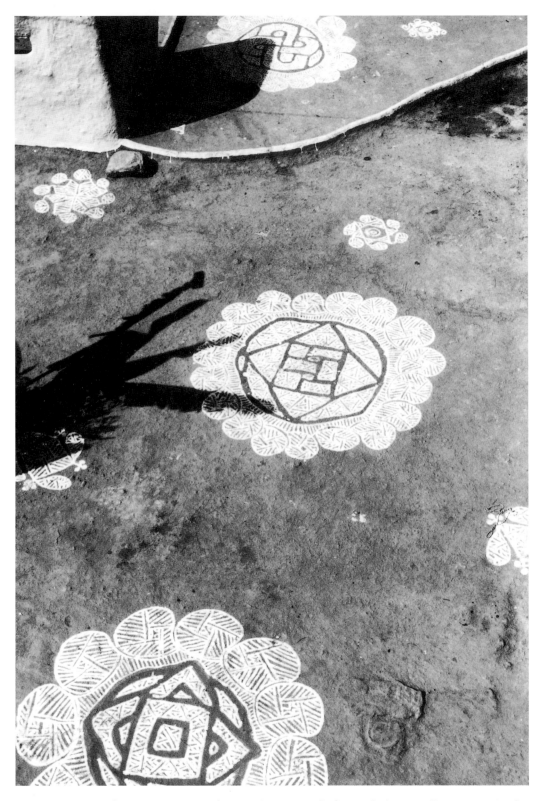

Auspicious ritual floor paintings (*mandana*) in the courtyard of a Hindu house, village Diggi, Tonk district, Rajasthan, 1986

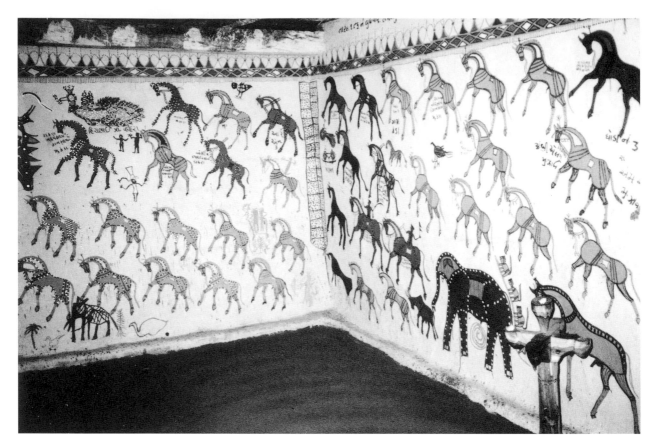

Section of a ritual wall
painting honoring the god
Pithora, in a Rathva tribal
house, Jambughoda dis-
trict, Gujarat, 1986

els; they are made in a great variety of sizes and degrees of refinement in order to
be available to the devout of every economic situation. The pictures are regarded
as substitutes for sculptural images of deities installed in temples and worshiped
as divine living presences; installed in home shrines, they are the focus of devo-
tees' daily ritual offerings of flowers, water, food, incense, the light of a ghee-
filled lamp, betel nuts, and cloth. The painted icons may be displayed in a corner
of a room, high on the walls close to the ceiling, or in a separate small room given
over to meditation and worship. The individual devotee may ritually bid the de-
ity to descend into the icon before making an offering and afterwards will dis-
miss the divine presence. The icon provides the devotee with a daily opportunity
to glimpse one's god.[12] Although the use of hand-painted icons declined at the end
of the nineteenth century when mechanically printed images became available at
cheaper prices, some iconic traditions endure, some having been aided by gov-
ernment intervention. Among the iconic traditions represented here are Puri
painting of Orissa associated with the Jagannatha temple in Puri (nos. 25–30), Bat-
tala woodcuts (no. 24) and Kalighat painting associated with the temple dedi-
cated to the goddess Kali at the southern edge of Calcutta (nos. 17–23), and a
form of South Indian painting, commonly known as Tanjore and Mysore paint-
ing after its past principal centers of production (nos. 31–35).

Narrative traditions disseminate India's heritage of sacred stories through illustrations of regional legends and favorite sequences in local versions of the universal epics, the *Ramayana*[13] and the *Mahabharata*.[14] The illustrations, however, are not intended to be seen apart from performance of the stories; that is, the narrative pictures are displayed only in conjunction with chanting or singing of specially composed narrative verses, often accompanied by instrumental music and sometimes dancing. These performances are conducted by the members of the professional painter castes or the professional performer castes associated with the various narrative traditions. The performances educate and entertain their varying audiences but are not without religious and ritual aspects, not only because the stories are overwhelmingly religious but also because ritual worship of the paintings or invocation of deities is customarily incorporated into the narration and display of pictures, occurring at specified times. Attendance is widely believed to impart religious merit. The stories frequently embody strong moral lessons and thus may also fulfill a didactic function. The antiquity of India's narrative painting and performance traditions is evident in early sculptural friezes that appear to be modeled on storytellers' scrolls.[15] The survival of these age-old narrative traditions is today, however, threatened by the increasing presence and popularity of modern instruments of storytelling—cinema and television.

The performers of each narrative tradition use—or have used—a characteristic visual prop for storytelling. Six traditions and their props are represented here. In the Warangal district of Andhra Pradesh, in many districts of Bengal, and in north Gujarat, storytellers gradually unroll a vertical cloth or paper scroll, proportioned according to custom and divided into panels, to show the episodes of the story in sequence (nos. 36–37, 38–41, and 43, respectively); performers of the "Paithan" or Chitrakathi (picture-story) tradition of Maharashtra utilize a series of pictures on paper sheets of the same size, pasted back-to-back, which they display one at a time (nos. 53–57); the performers of the *par* tradition of Rajasthan employ a very wide cloth on which all the story's episodes are painted, and they illuminate one episode at a time as they perform the story throughout the night (nos. 58–60). Among these narrative traditions, the Jadupatua (magic painter) tradition of Bengal and Bihar is exceptional in having both a narrative function in its vertical scroll paintings (nos. 44–48) and ritual functions in its mortuary portraits and images of the death-delivering demon (nos. 49–52).

Besides paintings from popular traditions that serve distinctive ritual, iconic, or narrative ends and originate in particular sites for mostly folk and tribal groups, other types of popular painting may be noted. These paintings fulfill yet other cultural functions and are harder to classify as distinct entities because they may be stylistically informed by sophisticated traditions or may not be clearly identified with singular sites or regions or with singular groups or castes of artists and patrons.

Some of these types of popular painting are derived from sophisticated traditions for use by common people, particularly the bourgeoisie. These derivatives usually serve the same special narrative, iconic, or ritual functions as their parent forms. They may do so, however, in a related but less refined mode, or

they may constitute entirely new but subsidiary painting formats developed principally for nonelite patrons. These popular expressions of sophisticated traditions may consequently be much more than just poor or immature imitations, as they have sometimes been considered. Included here are popular works informed by the Jain painting tradition, which evolved primarily in Western India to serve adherents of Jainism, an ancient religion (nos. 61–65); popular works informed by the Nathadwara painting tradition associated with a Krishna sect based in Nathadwara, Rajasthan (nos. 66–70); and popular works informed by miniature painting traditions, which evolved to serve Indian royalty and later served Europeans residing in India (nos. 71–78).

Paintings executed on the reverse side of glass constitute another popular form. Most glass paintings feature iconic images of deities, but secular portraits are also found (nos. 79–81). Produced in many regional styles by many kinds of artists and artisans, glass paintings were widely available for cheap prices; they appealed to many economic classes but especially to the bourgeosie. Other kinds of popular paintings serve didactic, divinatory, documentary, and other functions; these forms are also not indigenous to any one site or region but occur rather in many regional styles and are the products of many different classes of artists; also appealing especially to the bourgeosie, these types include ritual images and genealogies employing calligraphy (nos. 82–86), visual aids for meditation (nos. 87–88), pages from books illustrating punishments for various sins in various hells (nos. 89–90), pages from books of omens used by fortune-tellers (nos. 91–92), calendars (no. 93), horoscopes, game boards (no. 94), playing cards (no. 96), and erotica (no. 95).

Finally, painting in India is frequently employed with other media in the creation of popular traditional artifacts, which may be either two- or three-dimensional. Represented here are artifacts whose functions correspond to the ritual, iconic, and narrative functions of two-dimensional popular painting traditions; the examples include a painted and printed cloth used by the so-called lower castes of Gujarat in worship of the Mother Goddess (no. 97), painted leather shadow puppets of Andhra Pradesh used to narrate the epics in performances of puppet plays (nos. 98–99), and folkish painted three-dimensional works: a wooden folding shrine from Puri used in domestic worship (no. 100) and a doll of wood and other materials from Andhra Pradesh, representing a goddess who presides over storytelling with other dolls and is ritually worshiped at the conclusion of the narrative (no. 101).[16]

An enormous stylistic range is evident among the traditions and types of popular painting presented here, from crudely drawn essential contours to painstaking, miniature-like rendering of details to the precise, geometrized figural abstractions reminiscent of India's prehistoric painting. Though each tradition is recognizable by certain features, some may also display clear stylistic changes over time, as well as differences in the execution of contemporaneous works. There are several reasons for this latitude and these shifts. The broad stylistic range generally reflects the broad range of nonelite patrons and artists connected with the varieties of popular painting. Moreover, these traditions and types have evolved, and some continue to evolve, by adapting to changing demands and cultural circumstances, a fact reflected in continuous stylistic trans-

formations. Last, a greater range of skill is evident among the practitioners of popular painting than is found among those who principally worked under aristocratic patronage (sometimes in guilds); in addition, the artists themselves, whether working for elite or nonelite patrons, might also work more or less exactingly according to their expectations of higher or lower fees. All these variables suggest that in any discussion of stylistic ranges in Indian art, it is important to postulate continua—in this case, a large number of graduations between the conceptual poles of so-called "popular art" and "sophisticated art"—rather than employ hard and fast antithetical definitions.

It is the goal of this presentation to capture something of the amazing spectra of these continua and to provide a framework for understanding the whole. Works have been selected for their aesthetic appeal as well as for their representative value, and, wherever possible, to show the evolution of a tradition and even the contrasts within it. Undoubtedly, the use of so few examples from so many kinds of painting can hardly do justice to the riches of each; for full elucidation, each tradition or type of popular painting could deservedly be—as some have been—the subject of a separate exhibition and monograph. This survey necessarily charts a wide-ranging rather than a narrow course, celebrating and paying a due homage to the enlivening and abundant waters of the numerous popular forms in India's great "ocean of painting."

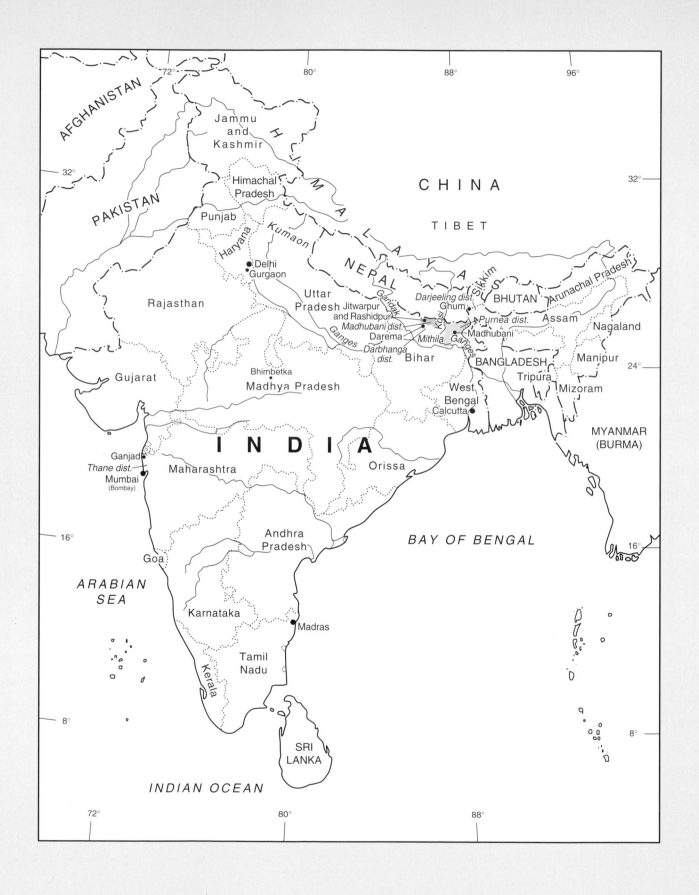

I

Paintings from Popular Ritual Traditions

Ritual Paintings on Paper for Various Festivals from Three Regions

Introduction

In thousands of villages in India, Hindu women regularly renew their earthen homes and, as a religious ritual required of them as housewives, paint the floors and walls with a variety of designs. While such painting, which is ephemeral, enhances—sometimes stunningly—the mud architecture of rural India, the women undertake the task of domestic painting primarily to ensure the well-being of their households. They enact the ritual of painting only on particular occasions: for certain annual festivals honoring deities, for ceremonies marking important life events (such as marriage or the naming of a child), for fasts and other austerities performed in conjuction with personal vows (*vratas*), and, in some areas, for daily morning worship. When painting for these occasions, women customarily employ the special compositions and characteristic forms and materials of their particular area, district, or even village, as numerous traditions of nonpermanent ritual painting on floors and walls have evolved and continue to evolve in India's many geographically and culturally distinct regions. Not surprisingly, the paintings on floors are known in different regions by different names that emphasize varying aspects of the domestic art; for example, floor painting is called *mandana* (decoration) in Rajasthan after its aesthetic effect (see ill., p. 21),[1] *sathiya* (swastika) in Gujarat and *rangavali* (creepers painted in colors) in Maharashtra after favored designs, and in Bengal *alpana*, perhaps derived from the regional term *alipana* (the art of making *ails* or walls, embankments), after the magical function of floor painting (the linear compositions on the ground, like embankments around a village, are believed to keep the household both safe and fertile).[2] Local adaptations of such names abound; for example, *aipan* is used in place of *alpana* in the Kumaon, a region of

Uttar Pradesh.[3] The process of making such paintings at festivals and other appropriate times is as important as the images being painted. For it is the process of creating the image of a desired reality at just these times that magically brings it about in fact. Many kinds of good fortune, including the benefic presence of deities and boons such as household prosperity, many offspring, a large crop, and deliverance from snakebite, are visualized in ritual painting—sometimes by direct representation, sometimes abstracted or symbolized by other realities. Some traditions feature figurative imagery in their wall paintings (which, it may be noted, are sometimes known by yet other regional names); many traditions favor geometric forms or geometrized abstractions of visible forms (like flowers) in both floor and wall paintings. The nonfigurative or highly abstracted images are visually similar to geometric diagrams, called *yantras*, that are used in meditation to harness the imagination and are also worshiped because they represent deities or their powers (see nos. 87–88). Ritual paintings in villages are created most often with ground rice grains or colored, mineral–derived powders mixed with water, but wheat and rice flour mixed with dry colored powders and water are also used, as are powders mixed with milk or oil. Depending on the region, a housewife may use her finger tip, a twig, a small rag tied to a stick, or a brush to execute the images on mud surfaces, which have been freshly covered with a mixture of mud and cow dung and sometimes whitewashed.

Only a few ritual traditions appear to utilize the alternative support of paper mounted on the wall. One such tradition is that of the Kumaon region of Uttar Pradesh, where special compositions are executed on walls, or on paper to be mounted on walls, principally for the birthday of the god Krishna in early August; for Dashahara, the festival of the Great Goddess Durga in September-October; and for Diwali (also transliterated Divali), the festival of lights that honors Lakshmi, the goddess of wealth, in October-November (no. 1).[4] In other areas, images are apparently created on paper for ritual installation on walls only in conjunction with singular festivals such as Naga Panchami, a celebration in early August that honors snakes (no. 4).

In some regions, village women draw and sometimes color models of their wall painting compositions on paper, usually in reduced scale. These works on paper, which serve as models or patterns, are distinct in function from paintings on paper intended for installation on walls, which serve as the focus of offerings and as the physical forms into which deities are asked to descend; patterns or models on paper are rather aide-mémoire or memory devices that are saved from year to year and from generation to generation by housewives to review while painting at festival times (nos. 2–3; also see Mithila or Madhubani paintings, nos. 5–7). In the past, members of households frequently presented their aide-mémoire, treasured like family recipes, to young women when they married and went to live, as is still customary, with their husbands and in-laws in other villages.[5]

Presented here as examples of ritual paintings on paper are compositions related to the festivals of Diwali (nos. 1–2) and of Naga Panchami (nos. 3–4). All but one painting (no. 4) were created by housewives as one of the ordinary tasks they performed for the well-being of their households. The nature of these

ritual works on paper is not to be confused with some examples of Mithila or Madhubani paintings on paper (nos. 8–10) and all the Warli paintings on paper (nos. 11–14): these paintings on paper represent the transfer of traditional ritual wall and floor painting compositions (or adaptations of them) to a portable support or the employment of entirely new compositions rendered in the traditional idiom, produced for sale to nonvillage patrons.

Representative Works: Ritual Paintings on Paper for Various Festivals from Three Regions, nos. 1–4

1. Ritual painting depicting Lakshmi, to be mounted on a domestic wall for the *Maha Lakshmi Puja* (ritual offering honoring the great Lakshmi) during the festival of Diwali
Inscribed in Devanagari script
Uttar Pradesh, Kumaon
Late 19th century
Ink and transparent and opaque water-based pigments on paper
25¼" x 19" (64.1 cm x 48.3 cm)
Greg and Natalie Davidson

This ritual painting was created for the annual festival of Diwali (from *Dipawali*, literally, a row of lights) celebrated in the lunar month of Kartik (October-November) in honor of Lakshmi, the goddess of wealth.[6] The painting, which depicts the goddess, was made to be mounted on a domestic wall; the image may also be painted directly on the wall. The image functions as the focus of special ritual offerings to the great Lakshmi (*Maha Lakshmi Puja*) by members of the household during Diwali. The painting of Lakshmi's image and her worship at the auspicious time of her festival invokes her benefic presence and ensures good luck and prosperity throughout the year to all within the household.

The image of Lakshmi is highly stylized in a geometric manner. Extending her arms and wearing an elaborate gold crown with gem-studded pinnacles, a large gold nose-ring, and other jewelry, Lakshmi is centrally enshrined under an arch composed of parrots and surmounted by a pair of fish, creatures associated with fertility, prosperity, good luck, and happiness. Lakshmi, who, like many other deities, is usually pictured standing or sitting on a lotus, here stands or sits on a squarish form patterned with eight-petaled geometrized lotuses, representing her *chowki* (seat of power).[7]

Many forms of worship of the goddess are illustrated throughout the composition. The faint silhouettes of lamps used in the celebration of Diwali and oblation vessels used in ritual worship surround Lakshmi's head. On the middle left, a female devotee offers a betel leaf (a mild stimulant chewed with betel nut and mineral lime) to the goddess, while another presents the goddess with an ear of corn or grain, presumably fresh from the field, since Diwali follows harvesting. In the upper left corner, the household's gold coins and jewelry— which are ritually worshiped and displayed in the course of the festival[8]—are perhaps represented by three tied-up sacks enclosed in a frame suggesting a

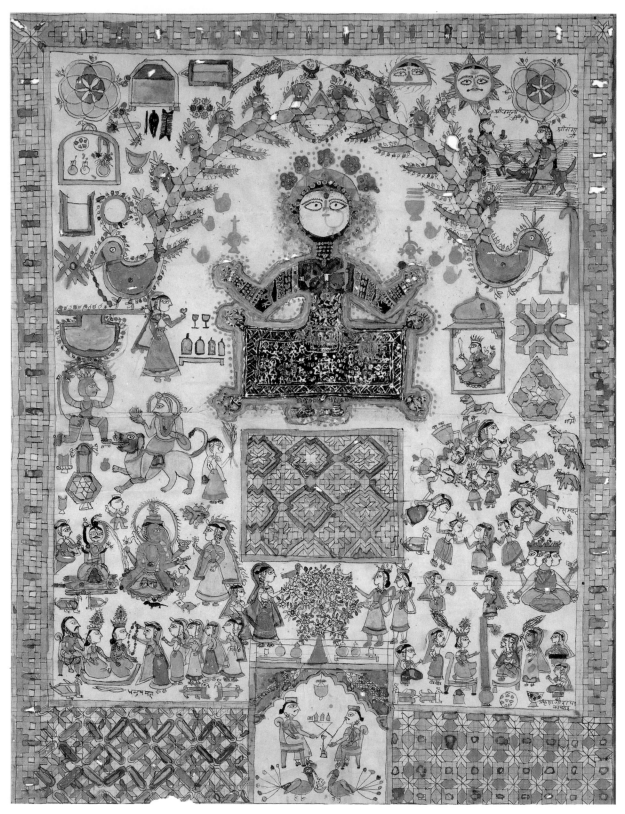

I

treasure chest. Below Lakshmi's *chowki*, the hero-god Rama (an incarnation of Vishnu), his wife, Sita, and his brother, Lakshmana, venerate a holy *tulsi* (basil) plant, sacred to Lakshmi and to Vishnu, her consort.

The auspicious presences of the many deities also invoked for the festival include, on the left, the monkey Hanuman, Shiva seated on a lion, Shiva seated in meditation posture and accompanied by his consort Parvati, and the elephant-headed Ganesha enthroned and accompanied by his consort or a devotee. In the lower left corner, Rama and Lakshmana, with a bow and arrow at their feet, are being garlanded; the narrative scene is inscribed "the bow ritual" (*dhanush yajna*),[9] referring to the breaking of Shiva's bow, a test of strength required of Rama in order to win Sita's hand in marriage, recounted in Valmiki's version of the *Ramayana* (bk. 1, chaps. 66–67). Personifications of the sun and the moon deities appear at the upper right. Nearby are the sacred river goddesses Yamuna seated on a tortoise and Ganga seated on a *makara* (a mythic aquatic animal), though here both mounts resemble crocodiles; the names of the goddesses are inscribed with the honorific prefix *shri* (illustrious) and have the suffix-like term of respect -*ji* appended. Other deities appearing on the right are the four-headed Brahma and the Great Goddess Durga enthroned in a pavilion, which is guarded by her animal mount, a lion. The hero-god Krishna (an avatar of Vishnu) and his consort, Radha, appear in two narrative scenes on the right. They dance in the center of a circle of dancers, inscribed "*circle dance*" (*rasa ma{n}dala*), in which Krishna has multiplied himself to dance with each of his devotees, who are female cowherds (*gopis*). To the right of the circle dance are the cowherds' charges, inscribed *gayan* (cows), the explicit reference perhaps recalling for Kumaon villagers that cows are specially worshiped during the festival of Diwali.[10] In the bottom right corner, Radha and Krishna, face to face and gesticulating, sit on low chairs of Indian origin on either side of a vertical pole; with flowers and betel leaves spread out before them, they are attended by whisk bearers and others; this scene is inscribed "Shri Krishnaji [and] Radha [reciting] poetry" (*Shri Krishnaji Radha kavyaha*).

Several pictorial references to the extensive floor and wall painting that accompanies the celebration of this festival occur in the composition. In each of the upper corners is a design based on a six-petaled lotus, which is ritually painted on the floor to honor Lakshmi, especially during Diwali.[11] The geometric patterns that border the composition suggest the enclosing walls of an architectural structure, perhaps the house in which this image of Lakshmi was ritually installed; the patterns are related to allover repeat designs, formed with dot-based grids and solidly filled with color, which are painted on entire walls in Kumaon for festive occasions.[12] The patterned border along the bottom of the composition is larger than those on the other three sides; it displays two different patterns utilizing geometrized eight-petaled lotuses, one design similar to that on the goddess's *chowki*; at this bottom border's center is an arched pavilion or gate attended by peacocks and enclosing two men, perhaps members of the household, who sit at leisure on English chairs—a sign of wealth—and smoke a hookah (water pipe). Dots, frequently employed in ritual floor painting to also create geometrized figural images, appear to have been used here to form the straight-sided birds found throughout the composition.[13]

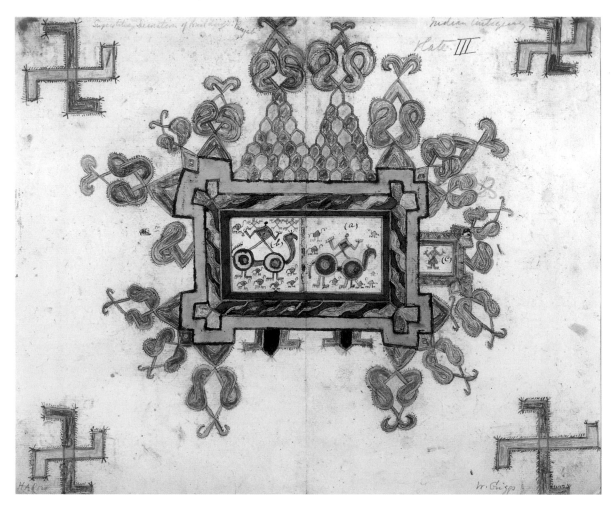

2

Reproduced: J. LeRoy Davidson, *Art of the Indian Subcontinent from Los Angeles Collections*, exh. cat. (Los Angeles: UCLA Art Council, UCLA Art Galleries, and Ward Ritchie Press, 1968), p. 116, no. 194; Gerald James Larson, Pratapaditya Pal, Rebecca P. Gowen, *In Her Image: The Great Goddess in Indian Asia and the Madonna in Christian Culture*, exh. cat. (Santa Barbara: UCSB Art Museum, University of California, Santa Barbara, 1980), p. 58, no. 23.

2. Design for a ritual domestic wall painting depicting three goddesses, to be created for their worship during the lunar month of Kartik (October-November) and the festival of Diwali
 Inscribed in English: *Superstitious Decoration of Buildings: Panjab. Indian antiquary, Plate III. H. A. Rose. W. Griggs.* Inscribed within the squares containing figures: *(b)*, *(a)*, and *(c)*.
 Haryana, Gurgaon
 CA. 1905, by a Brahmin or a Bania woman
 Ink and transparent and opaque water-based pigments on paper
 13½" x 16½" (34.4 cm x 42.0 cm)
 The British Library, Oriental and India Office Collections, Add Or 752

This work is a design for a domestic mural created during the lunar month of Kartik (October-November) and the festival of Diwali, which occurs during Kartik. The mural functions as the focus of the ritual offerings to three goddesses, specially worshiped during Kartik and Diwali, by members of the household. The goddesses are (a) Radha, the god Krishna's consort, venerated on the eighth of the month by an offering of sweets; (b) Amanashya, venerated at noon on Diwali day with an offering of rice and milk; and (c) Lakshmi, the goddess of prosperity and the principal deity honored during Diwali festival, venerated at midnight of Diwali day with an offering of money and an all-night vigil. Amanashya and Radha, standing on the backs of stylized peacocks, are enclosed in a double panel within a rectangle, while Lakshmi is placed in a square appended to its right side. The ritual wall painting is traditionally started on the fourth and finished on the eighth of Kartik.[14]

The design suggests the floor plan and elevations of a Hindu temple, with sanctuaries enshrining the goddesses. Twin pyramidal structures with a honeycomb pattern, found over the large double panel containing the figures of Radha and Amanashya, probably represent temple towers (*shikharas*), which are typically placed over sanctuaries ensconcing sculptural icons of deities. Three smaller pyramidal structures (probably also towers) surmount the appended square (or smaller sanctuary) in which Lakshmi stands. Three towerlike structures are also placed at each of the elaborated corners of the rectangle that probably represent the temple's outer walls. Snakelike interlaced abstractions arise from all the towers. Swastikas, traditionally painted on temple doors to convey auspiciousness, are here placed in the four corners of the painting. Although this image was made to be used as design or model for wall painting, it is nevertheless very richly colored in dark blue and yellow ochre with red and blue outlines.

3. Design for a ritual domestic wall painting depicting the snake god in his dwelling, to be created for Naga Panchami (snake festival)
Inscribed in English: *Superstitious Decoration of Buildings: Panjab. Indian antiquary. Plate III. H. A. Rose. W. Griggs.*
Haryana, Gurgaon
CA. 1905, by a village woman
Ink on paper
13½" x 8¼" (34.4 cm x 21.0 cm)
The British Library, Oriental and India Office Collections, Add Or 751

A design for a domestic wall painting, this work represents the *naga* or snake god in his house. Created during the Naga Panchami festival, which honors snakes and is celebrated in the lunar month of Shravana (July–August), the mural functions to keep snakes from entering the household.[15] The custom of installing a painted image of the snake god at the time of his festival for protection from various evils is one of the many practices connected with the worship of snakes, a folk cult in existence in India from ancient times.

The design depicts the front of a shrinelike structure with a pitched roof from which seven snakes are suspended; interlaced abstractions, like those in the previous work (no. 2), are here appended to the top and to both sides of the architectural form. Swastikas, placed in all corners of the composition as in the previous work, auspiciously mark the snake god's dwelling.

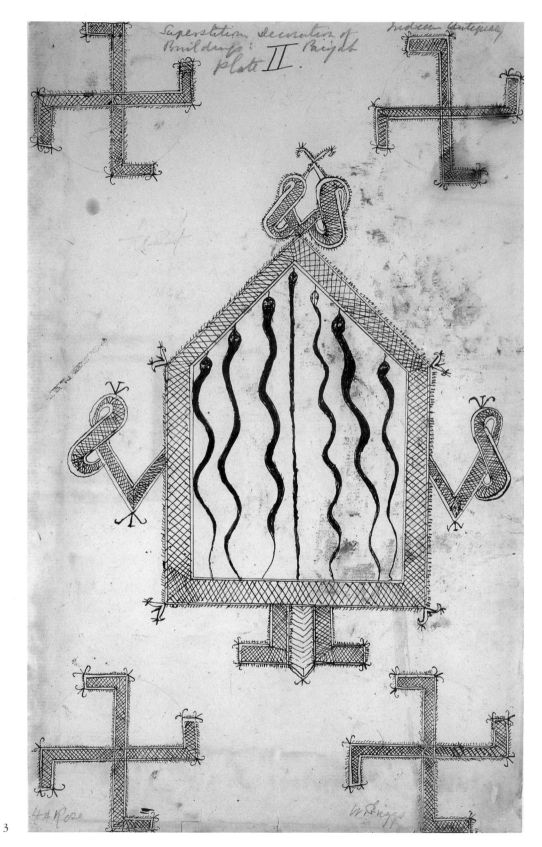

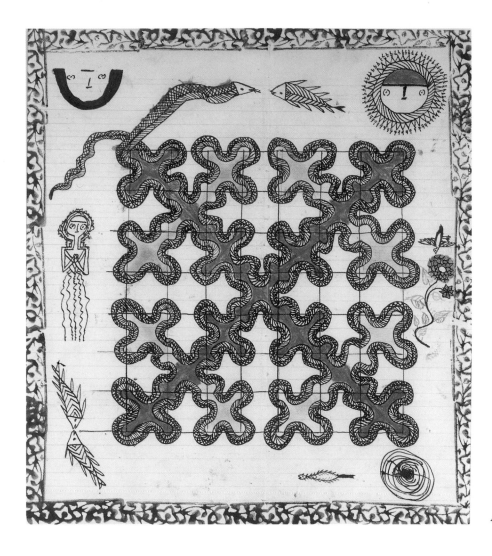

4

4. A ritual painting depicting the king of snakes, to be mounted on a household
 door for Naga Panchami (snake festival)
 West Bengal, Darjeeling district, Ghum
 CA. 1938, by a Brahmin man
 Ink and transparent water-based pigments with printed woodblock border on
 lined paper
 13" x 11¾" (33.0 cm x 30.0 cm)
 The British Library, Oriental and India Office Collections, Add Or 2397

Made by a member of the Brahmin (priestly) caste to be sold for alms to local
Hindus during the annual *naga* (snake) festival in July–August, this picture
was designed to be hung on the door of a domestic dwelling to keep out disease
and evil spirits. According to the wife of its maker, the picture represents the
king of snakes (*naga raja*), who eats all other snakes.[16] The picture is dominated
by the great snake whose elongated and writhing body forms an elaborated X
shape overlaying a grid, suggesting the extent of his territory. The snake is sur-

rounded by the sun and moon, fishes, a bird and a rose, a spider, a centipede, and a water sprite, all auspicious emblems. The drawn image is framed by a printed woodblock border with an abstracted floral pattern.

Mithila or Madhubani Paintings

Introduction

A tradition of domestic ritual painting has perdured, apparently from ancient times, in Hindu households in the villages of Mithila, a region in north Bihar, bounded by the Himalayas and Nepal on the north and by the rivers Gandek on the west, Ganga (Ganges) on the south, and Kosi on the east.[17] The tradition, practiced and transmitted from generation to generation by nonprofessional women artists who paint on the floors and walls of their homes to make daily life and special events auspicious, is variously called Mithila or Maithil painting after the region and Madhubani painting after a modern-day district in the region that has become an important painting center.

In Mithila, floor paintings (regionally known as aripana[18]) are created either as part of prescribed domestic rites for important life events, such as birth, first cutting of hair, and death, or in conjunction with fasts, undertaken on personal vows (*vratas*), on certain days of the year as part of the annual cycle of celebrations honoring various deities. Executed with a white liquid paste of ground rice mixed with water (and sometimes also with colored pigments) on the earthen floor planes of the courtyard, the threshold, or other places in the house, *aripana* designs feature linear and diagrammatic abstractions of visible realities, such as lotuses, as well as purely geometric forms.[19]

Wall paintings are created in the corridors of the home and in the room or area containing the family shrine for the sacred thread ceremony (a caste initiation rite for young males), for the dedication or renovation of the family shrine, and for various festivals. Wall paintings are also created on the occasion of marriage. Special compositions, unique to Mithila, are traditionally executed on walls of the *kohbar ghar*, a chamber within the bride's house that is reserved for two traditional marriage ceremonies and that is also the place where the bride and groom spend the first several days of their marriage. The subjects of these paintings include the gods and goddesses whose auspicious presences are invoked to make the marriage a happy and fruitful one, the bride and groom and their attendants, and a host of fertility symbols, such as turtles, parrots, blossoming trees, lotuses, and bamboo.[20] The custom of painting the *kohbar ghar* is cited in ancient writings and in contemporary folklore.[21] Other wall paintings related to marriage are created on the verandah outside the marriage chamber, where, in a kind of a sitting area for friends of the bridegroom, special themes or subjects are presented. These include a didactic narration of episodes in the life of two young women, one happily married, the other not, related in consecutive registers or panels. Another subject is the family pool with different kinds of fish, turtles, and also handprints. Other subjects painted on the verandah are scenes from rural life in Mithila and symbols of fertility, as well as mythological

themes, such as the hero-god Krishna (an incarnation of Vishnu), shown playfully stealing the clothes of female cowherds.[22]

Wall paintings are executed on mud surfaces freshly covered with a mixture of cow dung and mud and sometimes also with whitewash. Many years ago, vegetable colors mixed with oil and milk or gum were employed for wall painting; commercially produced colored powders, which have been available since the 1940s, are now mixed with milk. Black is still made, as it was in the past, from burnt straw, and white is still made from rice powder mixed with water. Brushes are made from rags tied to twigs; a bamboo sliver frayed at end is used for fine line work. The process of painting is a task shared by women of all ages in the household, and skilled painters from other households are invited to make a contribution.[23]

This village painting tradition has been principally practiced by the women of two castes, Maithil Brahmins and Maithil Kayasths. Each group has a distinctive style. The work of Maithil Brahmin women is characterized by an emphasis on intense colors applied flatly in shapes marked by thin contour lines. The work of Maithil Kayasth women is essentially very refined drawing, characterized by complex but elegant linear structures and dense linear patterning in black and red. In the past, some families utilized patterns and models on paper or aide-mémoire executed in pen and ink and sometimes in watercolor to help them remember the variations of traditional images that had evolved within their own households (nos. 5–7). Frequently backed with cloth, these models were treasured possessions, something like family recipes. Before leaving her home for that of her husband and his family, a young bride would be presented with models of her family's designs, presumably for developing even more variations by synthesis with those of her husband's family. Because the Kayasth designs are more complex and harder to remember, the women artists of this caste have tended to have more use for aide-mémoire.[24]

In the late 1960s, Mithila's village women were encouraged to transfer their painting compositions to paper for circulation to viewers beyond the region's immediate borders as part of a famine relief effort.[25] Initially, they replicated the themes and subjects that had traditionally been employed in the ritual painting of the region (no. 8); they quickly developed, however, other kinds of presentations with other functions that include narration of myths and even of personal life events and histories.[26] In the transformation of Mithila painting from a village tradition to a phenomenon known throughout the world, some gifted individuals from both the Brahmin and the Kayasth castes have emerged as artists with unique and personal styles (see nos. 9–10). In addition, the work of Maithil painters belonging to other social groups has been recognized. Harijan women (of the so-called outcaste group or untouchables) produce paintings on paper with simplified and flatly colored shapes that are bounded by thick contour lines and embellished with a secondary line of dots; the subject of Harijan paintings frequently concerns the adventures of Lord Salhesh, a historic robber bandit now revered as a god. Although it is not customary for Hindu men to participate in domestic ritual painting, some male devotees who follow the esoteric practices of Tantrism in their worship of the Goddess, have painted on paper in the Maithil idiom and have introduced Tantric images of deities. Changes in materials include the use

of a pen for making fine lines. Most documentation of this tradition has dealt with paintings on paper, attesting to the success of the tradition's commercial development; considerably less attention has been given to the tradition's base in domestic rituals.

Representative Works: Mithila or Madhubani Paintings, nos. 5–10

5. Aide-mémoire for a ritual domestic wall painting depicting a veiled bride with fish and flowers, to be created at the time of marriage
Bihar, Darbhanga district, village Darema
CA. 1920–30, by a Maithil Kayasth woman of the household of Sabhapati Das
Ink and transparent and opaque water-based pigments on paper
13" x 9⅛" (33.0 cm x 23.2 cm)
The British Library, Oriental and India Office Collections, Add Or 3321

This work is a model or aide-mémoire for a wall painting that the women in a household create in the bridal chamber (*kohbar ghar*) at the time of marriage. Executing the image of the bride standing under a six-pointed sun and surrounded by fish and flowers, all traditional symbols of fertility, ensures many offspring to the newlywed couple.[27] The bride is represented with one arm upraised and with her face partially veiled, perhaps in shyness. The pictorial elements are tightly enclosed in a nichelike panel, typically employed in murals by women of the Kayasth caste.[28] The design is boldly colored in flat planes of brilliant magenta and yellow.

Reproduced: W. G. Archer, "Maithil Painting," *Mārg* (Bombay) 3, no. 3 (1949): 26, pl. 1; Ajit Mookerjee, *Modern Art in India* (Calcutta and New Delhi: Oxford Book and Stationery Co., 1956), no. 48; Mildred Archer, *Indian Popular Painting in the India Office Library* (London: Her Majesty's Stationery Office, 1977), col. pl. D, opp. p. 85.

6. Aide-mémoire for a domestic ritual wall painting with nine panels depicting deities, to be created at the time of marriage
Inscribed in Devanagari script[29]
Bihar, Darbhanga district, village Darema
CA. 1920–30, by a Maithil Kayasth woman from the household of Bangali Das
Ink on paper
13" x 15¹⁵⁄₁₆" (33.0 cm x 40.5 cm)
The British Library, Oriental and India Office Collections, Add Or 3330

This work, with nine panels enshrining deities, is a model for a wall painting executed by women in the *kohbar ghar* (marriage chamber) where a newlywed couple spent the first several days of their married life. The gods are introduced into the marriage chamber to bless the newlyweds with their presence. From left to right in each row, top to bottom, the deities are identified as follows: Shiva and his wife, Parvati, with his bull, Nandi; Kali trampling on her consort, Shiva; Varaha, the boar incarnation of Vishnu; Brahma depicted with two heads (instead of the customary four); Ganga on a water monster, surrounded by turtles and fish; Kurma, the tortoise incarnation of Vishnu; two unidentified crowned composite

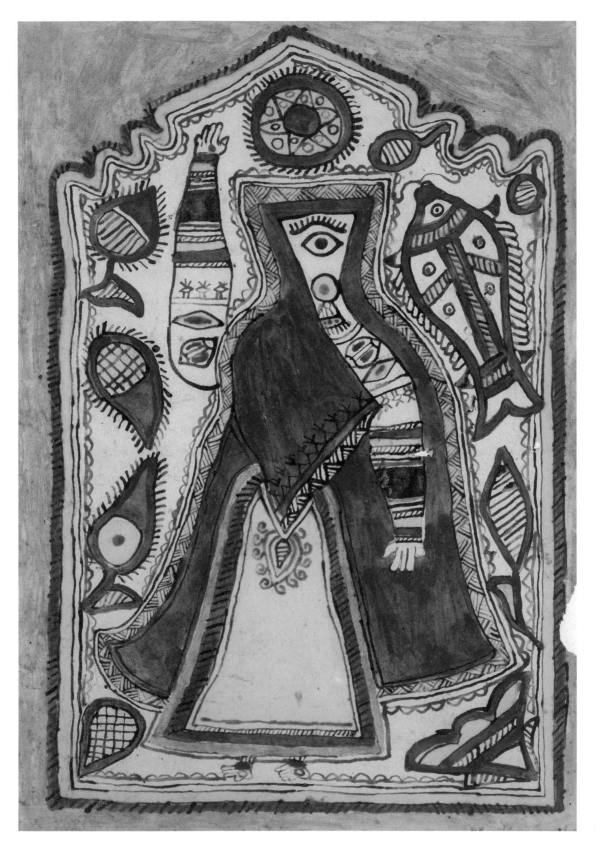

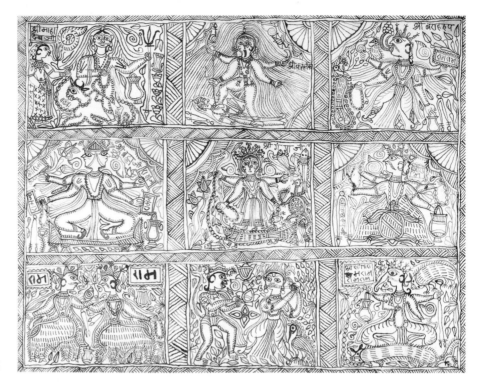

6

male figures whose upper bodies are human and lower bodies are quadruped; the monkey Hanuman and Krishna, an incarnation of Vishnu, playing his flute; and the elephant-headed Ganesha with his rats.[30] Framed inscriptions in each panel contain mantras (spoken invocations) of either the enshrined deity or Rama, an incarnation of Vishnu, or of both. Though not pictorially represented, Rama, when invoked, is almost always invoked repeatedly. Rama's wife, Sita, especially beloved to the women of Mithila because she is reputed to have been born there, is also invoked in the last panel. More than identifying labels, these inscriptions indicate how the mural functioned for the new couple: as an aid to ritually invoking the deities and benefiting from their presence at the beginning of married life. The design is executed in a deep crimson, perhaps indicating that red, considered auspicious for marriage, was also employed in painting the mural.

Reproduced: Mildred Archer, *Indian Popular Painting in the India Office Library* (London: Her Majesty's Stationery Office, 1977), ill. 36.

 7. Aide-mémoire for a domestic ritual wall painting depicting a ring of lotuses and the "bamboo tree," to be created at the time of marriage
 Bihar, Madhubani district
 Inscribed in Devanagari script
 CA. 1920–40 by a Maithil Kayasth woman
 Ink on paper
 16¾" x 16⅝" (42.6 cm x 42.2 cm)
 Chester and Davida Herwitz Collection

This work is a model for a domestic wall painting created by women in a household on the occasion of a marriage. This design is placed in the *kohbar ghar* or marriage chamber where the bride and groom stay for their first several days together; its function is to ensure an auspicious union with the blessing of many offspring.

The design represents a ring of six lotus circles around a seventh central lotus circle, pierced by a vertical form representing a "bamboo tree" bearing a human face. The lotus and bamboo, plants that propagate rapidly, are symbolically associated with fertility. They also function as highly abstracted representations of the human genitals, which are sometimes drawn separately and sometimes, as here, presented in union. The lotus and the "bamboo tree" are surrounded by other symbols of fertility, such as flowers, leaves, parrots and

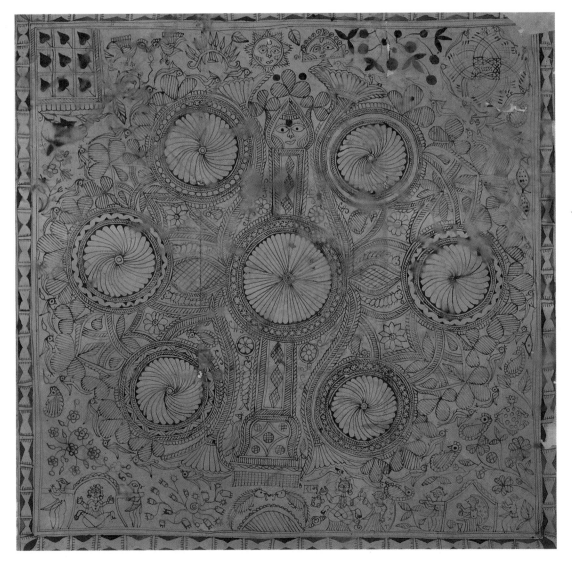

7

other birds, fish, a turtle, and segmented serpents, and by the auspicious presences of a yogic deity or yogi (ascetic) seated in meditation posture (inscribed *Rama*) and accompanied by his consort, devotee, or follower; of personifications of the sun and moon; and of the nine planets. In the upper right is an *aripana* (ritual floor painting) design, peculiar to Mithila, representing a bamboo grove, a symbol of fertility and of family life, undoubtedly created on the occasion of a marriage. In the right and left bottom corners, the bride and the groom, for whom fertility and conjugal happiness are visualized, are being carried to their marriage in separate palanquins.[31] The design is rendered almost entirely in ink that was deep red (and is now faded), just as red, regarded as auspicious for marriage, is reported to be traditionally used in creating this mural.[32]

8. A nonvillage patron's image perhaps depicting a deity enclosed in a square sanctuary surrounded by four parrots and flanked by two attendants enclosed in lotus circles, probably derived from a ritual painting composition
Bihar, Madhubani district
CA. 1966
Ink and opaque water-based pigments on paper
20⁹⁄₁₆" x 30⅜" (52.2 cm x 77.2 cm)
Chester and Davida Herwitz Collection

This painting dates from the late 1960s, when the women of Mithila were encouraged to transfer their ritual tradition of floor and wall painting to paper for sale to patrons beyond their villages. The central image in the composition consists of three figures enclosed in geometric shapes, one in a square form and the others in circles. The exact significance of the composition remains unknown; it

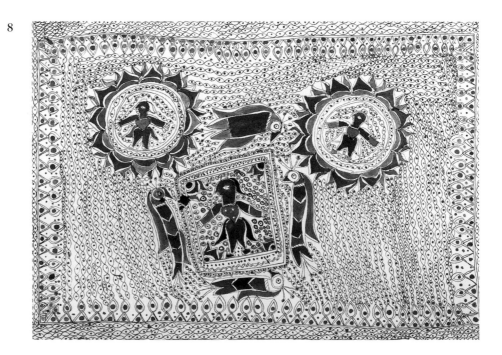

8

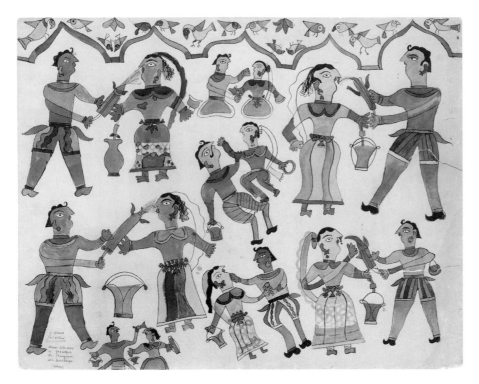

9

may be derived from a ritual painting design peculiar to the celebration of a festival or life event in Mithila. Four parrots, the mounts of Kama, the god of erotic love, frame and appear to protect the *chowk* (square enclosure), which, like a temple sanctuary, seems to enclose a deity; quadrants of a lotus are found in the corners of the square, while the circles are actually twelve-petaled lotuses. Networks of abstract chains of lines around dots, similar to those found in *aripana* (floor painting), idiosyncratically fill the space around the geometric forms; they also are employed in the picture field's outer border. Dots are also enclosed in triangles and in the vertical eyelike shapes that crown them and that with them constitute the picture's inner border. The painting is executed on bright yellow paper; although atypical of contemporary Maithil paintings made for sale to nonvillage patrons, the yellow effectively charges the mostly linear image; black, green, and magenta solidly fill the dots and planes in selected areas of the figurative forms.

9. A nonvillage patron's image illustrating the celebration of Holi, a spring festival
 Inscribed in English: *Bhaskar Kulkarni, Sita Devi, V. Jetwapur, P.O. Mangrowni, Dist. Darbhanga*
 Bihar, Madhubani district, village Jitwarpur
 CA. 1966, by Sita Devi, a Maithil Brahmin woman
 Ink and transparent and opaque water-based paint on paper
 22" x 28" (55.9 cm x 71.1 cm)
 Chester and Davida Herwitz Collection

This painting depicts the revelry of Holi, a spring festival exuberantly cele-
brated throughout India, in which all individuals merrily spray one another
with colored water or throw handfuls of colored powder at one another—
familiar or not and regardless of sex, age, caste, or social class. Eight pairs of
figures, distinguished by varied garments and varied shades of ochre-colored
skin, carry ready buckets, spray magenta-colored water, or apply colored pow-
der directly to each other's faces; all have magenta-stained hands. The celebra-
tion takes place in front of an architectural structure, minimally represented
by a front plane with ogive arches on which several birds perch. The inscrip-
tion on the painting dates it to the time when Mithila women were encour-
aged to transfer the compositions of their tradition of domestic wall painting
to paper for viewers and patrons beyond Mithila's villages: Bhaskar Kulkarni
was the government representative sent to the area to distribute paper; Sita
Devi, the artist, would subsequently emerge as one of the area's most gifted
practitioners of the newly transferred art form. The narrative theme of this
picture is not found in published examples of ritual wall paintings of the
region.

10. A nonvillage patron's image honoring the god Vishnu, probably derived from a
 Maithil domestic ritual floor painting composition depicting an eight-petaled
 lotus (*ashtadala aripana*)
 Bihar, Madhubani district, village Rashidpur
 CA. 1980, by Ganga Devi, a Maithil Kayasth woman
 Ink on paper
 22" x 30" (55.9 cm x 76.2 cm)
 Ethnic Arts Foundation Literacy Project, P-79-614

This precisely rendered image in black and red ink on paper, created for nonvil-
lage viewers, is probably derived from the eight-petaled (*ashtadala*) lotus com-
position of a ritual floor painting (*aripana*) peculiar to Mithila.[33] When made
on ceremonial occasions honoring Vishnu, the composition typically contains
some of the deity's various incarnations; as exemplified here, the image includes
two mythic heroes who became avatars of Vishnu—Krishna with his consort,
Radha, at the center of the lotus blossom and Rama with his wife, Sita, under a
tree in the lower left corner. Like the floor painting composition, this painting
is filled with ritual objects associated with the worship of Vishnu, such as the
tulsi (basil) plant, a shrine, and an offering tray with, among other things, a
gourd and a betel leaf (a mild stimulant that is chewed with betel nut and min-
eral lime), seen in the upper left corner. Special to this painting, and giving the
image a narrative cast, are the male and female figures on the right side of the
lotus, who appear to be villagers in the midst of their tasks, venerating their de-
ity with humbler offerings of agricultural tools, including a winnowing tray
and a scythe. Two cows in mirror symmetry sprout like leaves on either side of a
tree trunk. One petal of the lotus becomes the stem supporting the stylized
blossom. This relatively recent work is the creation of Ganga Devi, a master
artist who emerged from the Mithila village painting tradition to worldwide
recognition.

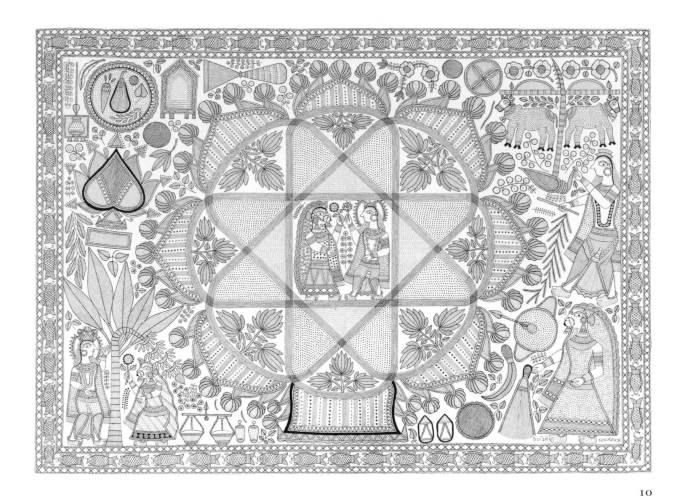

Warli Paintings

Introduction

The Warlis, a tribal people living in areas of the Thane district north of Mumbai (formerly Bombay), in the state of Maharashtra, follow a long-standing tradition of ritually painting on the occasion of marriage.[34] Featuring Palaghata, the goddess of vegetation, the distinctive Warli composition—known as the marriage painting (*lagnace chitra*)—is communally created on the interior walls of village huts. Its execution is initiated and supervised by two or three female artists, expert in ritual painting, who must be *savasinis* (women whose husbands are alive); the details of the painting are supplied by other village women and children. The marriage painting is the focus or backdrop of numerous wedding rituals, including singing by the wedding priestesses (*dhavleries*) and an animation of the painted goddess by village priests. In the course of rituals, which extend over three days, the image of the goddess is also ceremoniously covered and revealed to the bride and groom.

The pictorial elements in the marriage painting are relatively few. The most important figure is Palaghata, whose name (*pal*, plants; *ghata*, pot) suggests fertility and abundance and an association with the more universal Indian symbol of an overflowing pot. The goddess is portrayed enclosed in a square (*chaukat*) and accompanied by Panchashiriya, a guardian god usually depicted as a horse enclosed in a smaller square (*deva chauk*). Surrounding these squares are representations of Warli activities celebrating marriage, including joyous music making and dancing and the carrying and drinking of toddy, in a verdant outdoor setting.

A survey of marriage paintings in Warli villages in the Thane district reveals an enormous variety in the ways in which each of these basic elements is presented. The goddess herself, for example, may enclose two massive horses or buffaloes in the upper and lower sections of her torso, or she may contain in her lower torso a rider couple on a horse. She may be headless. Her body may be patterned with a series of diagonal lines and gashlike marks (replicated in no. 12) or by a network of diagonally crossing lines, both patterns suggesting bark. She may fill up the square that houses her, or she may be relatively small in relation to the enclosure and to other figures and forms that may accompany her. The border of the square containing the goddess may be more or less broad; considered the jewelry of the goddess, this border is composed of decorative patterns that are actually abstractions of various objects associated with the marriage ceremony and that symbolically suggest sexual union and fertility. The guardian god may be represented as a horse or as a horse and rider or as a horse bearing the wedding couple, or it may be replaced entirely with a human figure. When represented as a horse and rider, the form on the horse may be an inverted triangle with five projections or heads (replicated in no. 12) or two handlike shapes.

Although the marriage painting is not created for aesthetic effect, it nevertheless has a powerful aesthetic presence. Much of that power is due to the fact that the figures are finely and sparely painted in light value on a dark ground and emerge as shimmering apparitions. The figures are conceptually rendered as flat shapes composed of elementary geometric forms with thin straight lines for arms and legs. The torsos of human figures, which bear a clear resemblance to the prehistoric images of man at Bhimbetka and other sites of early rock painting in India, are formed by two triangles whose points touch or slightly intersect. There is no articulated ground line or plane. Only the front plane of architectural forms is shown. The marriage painting is executed with a paste of pulverized rice grains and water, applied with small sticks to the earthen walls of village huts freshly coated with cow dung.

Members of the Warli tribe practice a primitive form of agriculture, using handmade plows. They worship, besides Palaghata, elemental nature gods, the Mother Goddess (a form of which is Kansari, the corn goddess), their household deities, the spirits of their ancestors, the guardians of their villages, and the tiger god. They have their own language containing words from an archaic tongue as well as assimilations from Sanskrit, Gujarati, Marathi, and Hindi, perhaps indicative of a migratory past.[35] Their ritual wall painting tradition, of unknown duration, was discovered only in the 1970s, and shortly thereafter its transfer to paper for presentation and sale to nonvillage patrons was encouraged

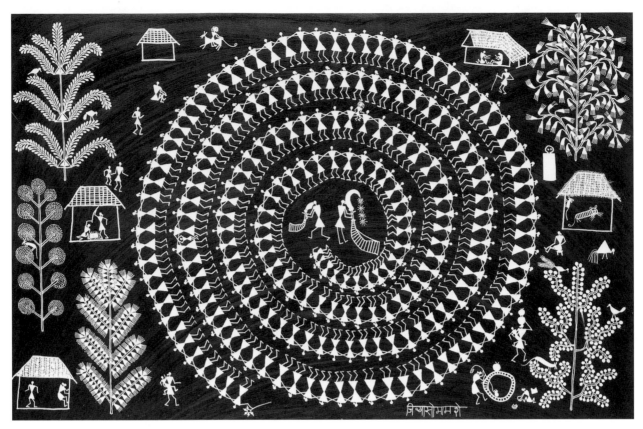

through government efforts. Warli artists working on paper replicate the marriage painting (no. 12) but now also illustrate many other rituals, myths, stories (no. 14), and everyday activities and festivals in tribal life (nos. 11, 13). The paintings on paper are now mostly executed in poster paint and are made by both men and women. The ritual execution of the traditional marriage painting, initiated by expert women artists and completed by village women and children, continues. In 1988, a comprehensive study of the Warli tribe's cycle of rituals and its traditional marriage painting was published.

Representative Works: Warli Paintings, nos. 11–14

11. A nonvillage patron's image illustrating the Warli tribe's celebration of the festival of Diwali
 Maharashtra, Thane district, village Ganjad
 CA. 1985, signed by Jivya Soma Mashe
 Rice paste or tempera on paper
 23" x 35⅞" (58.4 cm x 91.1 cm)
 Chester and Davida Herwitz Collection

This image of dancers, arm in arm, spiraling around two tribal musicians playing the Warli pipe (*tarpa*) represents the festival activities of a Warli village on the night of Diwali, the festival of lights, honoring Lakshmi, the goddess of wealth, and celebrated throughout India in October-November. On Diwali night, the Indian peoples in villages and cities illuminate their houses and courtyards with oil lamps, candles, or electric lights to welcome the goddess and to ward off evil. It is also customary to set off firecrackers. According to the explanation accompanying an almost identical example of this theme by the same artist (or his son), the Warli tribe traditionally celebrates Diwali with lights, firecrackers, and a communal dance.[36] Although the narrative composition is not documented in studies of Warli wall paintings, the image of group dancing is found as an element in published photographs of marriage paintings in the Thane district. This image on paper was created by the most celebrated artist of the transferred Warli tradition, Jivya Soma Mashe, a man who took up a painting idiom formerly employed exclusively by women.

12. A nonvillage patron's image replicating the marriage painting (*lagnace chitra*),
 the domestic ritual wall painting of the Warli tribe
 Maharashtra, Thane district, village Ganjad
 CA. 1986, signed by Devu Rama Dhodhade
 Tempera on paper
 42½" x 43½" (107.9 cm x 110.5 cm)
 Private collection

This painting on paper replicates, in the idiom characteristic of the village of Ganjad,[37] the essential elements of the wall painting that is ritually created at the time of a Warli marriage. On the left a large square (*chaukat*) with an elaborated border encloses Palaghata, the goddess of vegetation, whose presence must be invoked for a fruitful marriage. On the right a smaller square (*deva chauk*) encloses her guardian, the god Panchashiriya, represented as a horse and five-headed rider. In the surrounding landscape, Warli activities related to marriage are represented.

The body of the goddess is composed of two slightly intersecting triangles covered with a pattern of parallel lines and marks that suggest bark. The goddess stands on pencil-thin lower limbs and has arms and a second set of feet that terminate in forms like harrows. Surrounding the goddess within the square are a ladder, a comb, a mouse (considered her dowry), and the sun and the moon in the upper corners. The body of the horse is also composed of two triangles, these meeting point to point, while the rider is abstractly figured as an inverted triangle with five projections on its top side. Above the horse and rider are household gods suspended from a line.

Above these squares, the wedding activities of the village are illustrated. The bride and groom stand within a *mandapa* (pavilion), specially constructed for the wedding. They wear elaborate wedding crowns, which are also employed as independent motifs elsewhere in the composition. The couple is being feted by tribe members engaged in making music and dancing and drinking in an outdoor setting whose variety of plant and animal life is pictorially conveyed by four different kinds of trees and by monkeys, peacocks, a tiger, and a crane.

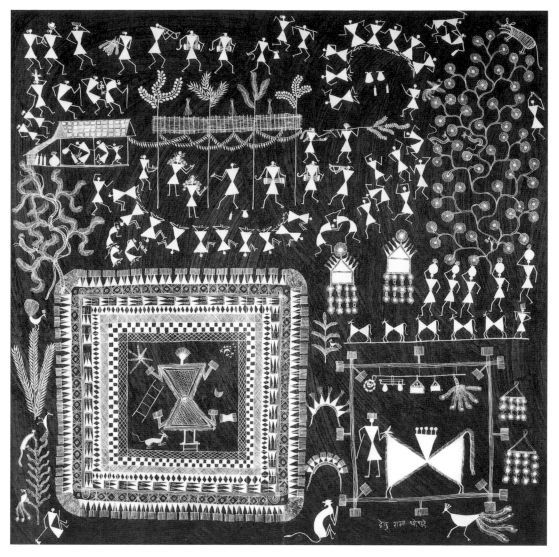

12

13. A nonvillage patron's image illustrating the Warli tribe's celebration of the
tiger god festival
Maharashtra, Thane district, village Ganjad
CA. 1986, signed by Balu Jivya Mashe
Tempera on paper
42½" x 43½" (107.9 cm x 110.5 cm)
Private collection

This painting records the activities of the Warlis during the tiger god festival,
which is celebrated for three days in November after harvest but before thresh-
ing begins. The ritual involves a narration of the story of the tiger god through
song, a communication with the deity, a presentation of offerings including the
sacrifice of goats, and much communal dancing, drinking, and feasting. Warlis

Mali Paintings

Introduction

In the Purnea district of Bihar, members of the Mali (gardener or garland-making) caste, whose principal task in Bihar is providing flowers and garlands for worship and other celebrations, have also traditionally made paintings for incorporation in caskets used in various religious rituals.[41] These paintings are called Mali paintings after their creators. Each casket consists of four paintings on paper that are pasted to the sides of a simple framework of bamboo strips. The framework, which may be up to four feet in height, is square and may also taper at the top to form a pyramid. The Malis have produced these caskets for rituals honoring two deities: the Great Goddess, variously known in Bihar as Bhagavati, Durga, and Jagdami, and the snake goddess Bishahari, the Bihari equivalent of the better-known Manasa, the snake goddess of neighboring Bengal.

Durga caskets have been produced to be hung as votive offerings in shrines or temples of the Great Goddess throughout the year but especially during the annual Durga festival, which takes place in September-October. These caskets traditionally feature on each of their sides a painting of the Goddess, a tiger depicted as her mount or vehicle, a horse or elephant as the vehicles of royalty, and pigeons as offerings (no. 15).

More common, Bishahari caskets have been made for use in rituals performed during the annual snake goddess festival, which occurs in August during the monsoon, when the danger of snakebite is especially prevalent. The function of the rituals is to ward off the danger and also to heal the afflicted, as the snake goddess is understood to both inflict and cure snakebite. In one of the rituals, the caskets are filled with offerings, tied to rafts, and placed in water in a reenactment of a legendary raft journey emphasized in the local version of the Manasa myth—the trip on the Ganges that Behula, a devotee of Manasa, undertakes in a raft with the corpse of her husband to rescue him from his death from snakebite. The images on the sides of the Bisharari caskets show the snake goddess in a variety of postures, sometimes holding snakes or lotuses (no. 16); snakes and lotuses, or snakes paired with a single elephant, horse, deer, or pigeon may also be featured. Behula, the supplicating devotee of the snake goddess, is sometimes portrayed, as is a fisherman or ferryman encountered in Behula's ride down the Ganges. Moreover, Bishahari is sometimes represented not as a single figure but as five sisters, also known as the Bisharari, according to local versions of the myth.

The images for the caskets are rapidly painted in transparent water-based pigments on unprimed paper. Formerly, the Malis made their own colors; in the recent past, they have purchased powdered colors. Figures are summarily stylized and outlined by a freely flowing brush line of varying widths. No modeling is employed, and there is no attempt to define forms in recessed space. Figures are frequently enclosed in panels with patterned borders. The paintings are executed in brilliant colors, some almost fluorescent, most often including bright yellow, magenta, and nile and dark greens, as well as black. Stylistic variations can be detected from family to family.

15

Mali paintings have been documented, at least in English, by only one scholar.[42] It is not known to what extent the tradition continues.

Representative Works: Mali Paintings, nos. 15–16

15. A section of a votive casket to be hung in a shrine or temple of the Great Goddess, depicting the Goddess's tiger
 Bihar, Purnea district, village Madhubani
 1938, by the family of Chedi Mali
 Probably tempera on paper
 16⁹⁄₁₆" x 10¼" (42.0 cm x 26.0 cm)
 The British Library, Oriental and India Office Collections, Add Or 3565

This painting is one of four sections of a paper casket designed to be ritually hung as a votive offering in a shrine or temple dedicated to the Great Goddess Durga, who is also known as Bhagavati or Jagdami in Bihar. This section of the casket depicts the Goddess's mount or vehicle—a tiger, with a pigeon (or perhaps a peacock) pecking at the tiger's open mouth, and a stylized plant form,

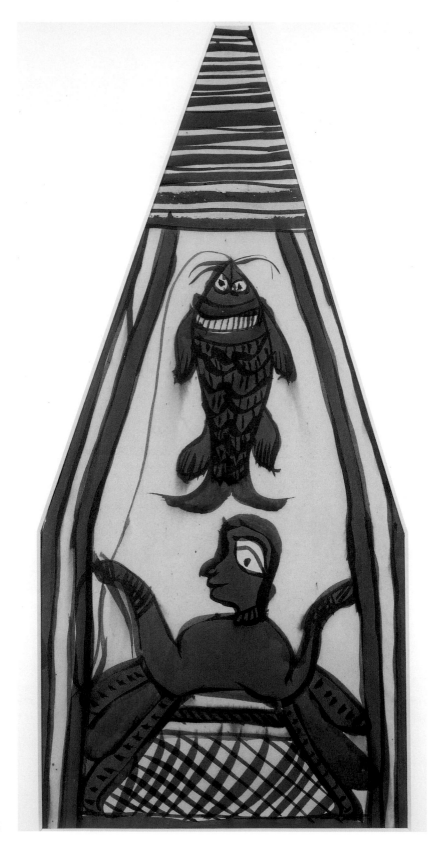

16

perhaps a palm. The tiger is spotted rather than striped, a practice common in Bihari and Bengali village painting traditions. The tiger's spots are daubed in both magenta and dark green in the spontaneous manner characteristic of this lively folk style. The background plane of the pavilion that encloses the figures is a brilliant yellow and is bordered by special patterning: a close diagonal grid executed in narrow lines of dark green crossing broader bands of magenta, a stylistic variation peculiar to artists in this Mali family. Other sections of the casket show the Goddess as Bhagavati (as she is sometimes called in Bihar), an elephant with a pigeon, and a pigeon with a palmette.[43]

16. A section of a votive casket for use in rituals performed during the snake goddess festival, depicting the snake goddess
 Bihar, Purnea district, village Madhubani
 1938, by Chedi Mali
 Probably tempera on paper
 21¼" x 9¹⁄₁₆" (54.0 cm x 23.0 cm)
 The British Library, Oriental and India Office Collections, Add Or 3568

This painting is one of four sections of a paper casket intended for worship of the snake goddess Bishahari. The casket is used in certain local rituals performed during the festival of the snake goddess to ward off the danger of snakebites. The snake goddess Bishahari is shown seated with a fish on a string, suspended above her; the figures have been rapidly painted in magenta with dark green contour lines on a bold yellow background. Bishahari's sari is patterned with the diagonal grid of magenta and green characteristic of this Mali family; the upper section of the picture area is horizontally striped with the same colors; and a magenta band edged with green borders each side of the picture. Other sections of the casket portray a peacock with a snake in its mouth and a snake and a lotus above it, a snake with four lotuses, and a snake with three lotuses.[44]

Reproduced: Mildred Archer, *Indian Popular Painting in the India Office Library* (London: Her Majesty's Stationery Office, 1977), ill. 27.

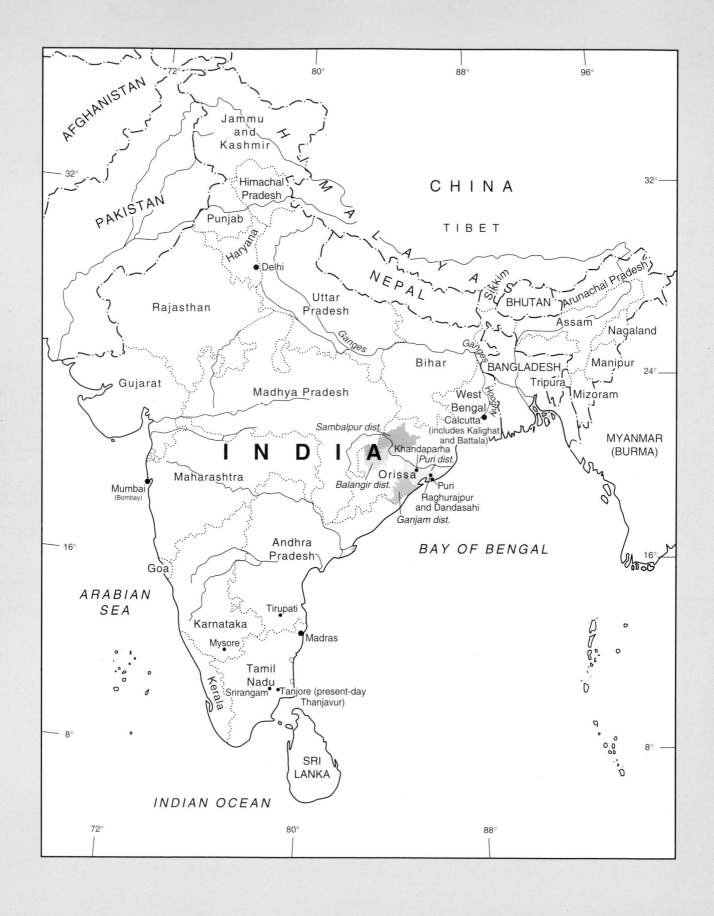

2

Paintings from Popular Iconic Traditions

Kalighat Paintings and Battala Woodcuts

Introduction

The Kalighat painting tradition, which originated to provide icons of Hindu deities for private worship but came to provide many other kinds of images as well, is associated with the famous pilgrimage site of Kali temple on the southern edge of present-day Calcutta, on the bank of a canal of the Hooghly River. The tradition appears to have sprung up in the early nineteenth century to serve the needs of pilgrims who flocked to Calcutta when a new temple structure dedicated to Kali, the goddess of death and destruction, was built by the British in 1809. Kalighat paintings, so called after the area immediately around the temple (Kali; *ghat*, landing place), were sold at shops and stalls around Kali temple as well as at other temples in the Calcutta area as souvenirs of pilgrimage.[1] The development of the tradition, a relatively recent phenomenon when compared to pilgrim traditions associated with temple towns like Puri or Nathadwara (see discussion of Puri paintings in this chapter and Nathadwara paintings in Chapter 4), was greatly affected, because of its urban setting, by competition from printed forms of pilgrim pictures as well as by its exposure to British forms of art.

According to at least one scholar, the first documentation of Kalighat paintings is found in an Englishwoman's drawing published in 1832 showing the interior of a village hut outside Calcutta with a Kalighat-style image of Shiva on the wall.[2] The drawing demonstrates the primary function of Indian painting traditions connected with pilgrimage sites, that is, to supply the pilgrim, from the lowest to the highest caste, with an inexpensive religious icon that could be carried back home for display and private worship; the icon is both a memento and a catalyst for renewal of the most significant aspect of the pilgrimage experience: the auspicious viewing of—and being viewed by—a deity.

Like the Kalighat image said to be found in the Englishwoman's drawing, most Kalighat paintings depict religious subject matter, that is, Hindu gods and goddesses (nos. 19, 22) in typical postures and garments and with characteristic attributes, usually in an iconic mode. In the evolution of this painting tradition, however, subject matter diversified to include many other subjects and themes, among them sacred Muslim subjects, historical and current events (no. 21), Indian flora and fauna (no. 18), Bengali proverbs (nos. 23–24), and aspects of everyday Bengali life, including marital friction and the presence of prostitutes in urban Calcutta and Kalighat (nos. 17, 20).[3] Also represented are the activities of the English who resided and worked in Calcutta, as well as secular portraits and perhaps events from nineteenth-century literary works that have been lost to contemporary awareness.[4] Apart from Muslim and historical themes, some subjects presented opportunities for humorous or scathing social criticism; some of the categories overlap, inviting a variety of interpretations (nos. 18, 23–24). Portrayal of courtesans trampling their lovers or leading them on a leash like sheep, for example, is indeed satirical, but these images may also glorify the female principle and as such be related to the cult of Kali herself. The image of the sheep-lover may, in addition, illustrate a Bengali tradition that has the mother-in-law saying to the bridegroom at his wedding: "I have purchased you with cowries. I have tied you with a rope. I have put a spindle in your hand. Now bleat like a sheep." Other images document and lampoon newly rich Indians of the period for their adoption of English ways of dress and behavior and for the consequence of such behavior, a hybrid Anglo-Indian culture. A famous series of paintings deplores religious hypocrisy and "the evilness of the age" by illustrating episodes in a real-life scandal of 1873 known as the Tarakeshwar case; the images trace the seduction of a young Bengali wife by the head priest of a temple, her murder by her deceived and enraged husband, and the court trials of both the husband and the priest.[5]

This diversification of subject matter may indicate that Kalighat paintings came to be made for purely aesthetic as well as didactic and rhetorical ends. The range of expanded subject matter makes clear that Kalighat paintings served many levels in Bengali society, from Hindu villagers to the educated urban classes, as well as Muslims and even the English. The nature and treatment of some of the secular themes have led some scholars to infer that Kalighat paintings were influenced by forms of British visual art, particularly scientific illustration of flora and fauna, known as natural history painting, and caricature.[6]

The watercolor-like medium in which the paintings are executed—that is, application of transparent rather than opaque water-based pigments (the latter favored by Indian artists)—is generally considered further evidence of British or European influence. If the European watercolor tradition was indeed an influence on Kalighat painting, the result is not, however, a European or even a synthesized European and Indian look. Rather, in the hands of the Kalighat painters, transparent water-based pigments are used in a distinctly Bengali manner, especially in the abbreviated representation of volume.

Unfinished paintings indicate that the painters created their work in a number of steps. First, they drew the composition in light pencil lines over which they laid down transparent washes of color; then, they selectively em-

ployed shading in the form of a narrow band of graduated value, a characteristic strategy that throws the abundant volume of Kalighat figures into shallow relief; finally, the artists added facial features and accentuated the edges of certain shapes and certain details of dress, such as jewelry, with contour lines of black or "silver" paint (actually a colloidal form of tin).[7] Kalighat paintings usually feature one or two figures in semiprofile against a minimally described interior or exterior setting. The background plane is seldom painted. The pictures are with very few exceptions in a vertical format (for an exception, see no. 22) and are on unprimed, newsprint-quality, mill-made paper, usually about seventeen inches by eleven inches in size.

Despite an almost assembly-line process geared to rapid production, Kalighat paintings underwent change as artists struggled with the competition of cheaper printed pilgrim pictures. Always vigorous, Kalighat paintings became increasingly simplified and even abstracted after 1870 as competition from woodcuts, produced locally, and colored lithographs, either imported from Germany or produced locally, challenged the Kalighat artists to produce paintings in greater volume with greater speed. Even earlier (from the 1840s to the 1860s, according to some scholars) painters had turned to occasionally using faint lithographed contours (instead of individually drawn pencil lines) to guide their rapidly moving brushes. In the 1880s and 1890s Kalighat artists started creating images consisting of only contour lines, that is, paintings that are essentially line drawings, an economizing strategy that condensed the energy of Kalighat paintings with elegant effect.[8] Around the same time, they also painted miniature Kalighat *patas* on hardboard.[9]

The group of artists responsible for Kalighat paintings is not as clearly defined as are the practitioners of other traditions. Scholars have usually pointed to descendants of members of the Bengali caste of scroll painters and performers (variously called Patuas, Patidars, or Chitrakars). (See discussion of Bengali scroll and single-image paintings in Chapter 3.) These artists may have migrated to Calcutta at the end of the eighteenth century to take up their alternate caste work of producing votive figures of clay and wooden dolls as demand for scroll production and story performance diminished in rural communities. But there are other castes, such as the Sutradhars (architectural carpenters), who have engaged in various painting activities and could have joined in the artists' settlement(s) where Kalighat paintings were produced.[10]

In competition with Kalighat paintings were the relief display prints produced in Battala, an area encompassing many neighborhoods in the northern section of Calcutta; there, after the introduction of the printing press in Eastern India in 1777–78 and a period during which presses were exclusively European-owned and -operated, a native Bengali publishing industry emerged at the beginning of the nineteenth century.[11] Book illustrations were produced here at first and then, in the second half of the nineteenth century, also display prints for sale to pilgrims.[12] The latter are sometimes referred to as Chitpur prints, presumably after the north Calcutta neighborhood around Chitteswari temple called Chitpur (part of Battala), where they were produced in competition with the paintings produced in the south Calcutta neighborhood of Kalighat. Although scholars have generally assumed that the Indian-produced prints were

pulled from wooden blocks, some impressions may have also been pulled from metal plates, a technical adaptation perhaps forced by competition.[13] The subject matter of the display prints is similar to that of Kalighat paintings, and many of the prints borrow heavily from favored Kalighat compositions, especially those with secular themes (no. 24). There are also prints with horizontal compositions that have figures set in detailed interiors or exteriors enclosed in decorative borders; these reflect the influence of miniature traditions and of the mixed style of concurrent painting commissioned by the British from miniature painters formerly employed by Indian courts. The display prints were frequently hand-colored in selected areas with transparent water-based pigments quickly and crudely applied with a cotton swab, a feature that doubled their price—which, nevertheless, remained considerably less than what was being charged for a Kalighat painting. The artisans practicing this craft came from a variety of castes and almost always signed their work, either as an expression of pride in their election of a nonhereditary task or in an effort to stop the pirating of their images by rival presses.[14] Woodcut display prints have been characterized as an art form possessing "a strange and haunting beauty" and reflecting the eclecticism of nineteenth-century Calcutta.[15]

The demand for woodcut display prints declined in the last two decades of the nineteenth century, while woodcut book illustrations continue to be made in Battala even to this day.[16] The longer-lived Kalighat tradition, which evolved in several stages, was in decline by 1885 and was virtually extinct by 1930.[17] In competition with each other for a time, both Kalighat paintings and Battala woodcuts—with function and much else in common—succumbed to the greater popularity of less expensive chromolithographs, in a Western representational style, which were produced abroad and locally.

Over the years, Kalighat paintings have been extensively collected and studied by both Indians and Westerners and may be the best-known Indian popular tradition in the Western world. In the nineteenth century, European missionaries, scholars, and travelers carried portfolios of paintings by Indian artists, many depicting the Hindu pantheon in the Kalighat idiom, back to Europe for study or display in accordance with their varied interests. In the early twentieth century, Indian and European intellectuals found much to admire in the "modernity" of the Kalighat style, which appeared to anticipate or parallel the developments of abstraction that were occurring in Western art. Battala or Chitpur woodcuts have only recently become the subject of extensive scholarly study.

Representative Works: Kalighat Paintings and Battala Woodcuts, nos. 17–24

17. A dandy's souvenir painting depicting an idealized courtesan adjusting her sari
 West Bengal, Kalighat
 Mid-19th century
 Transparent and metallic water-based pigments on paper
 17" x 11" (43.2 cm x 27.9 cm)
 Chester and Davida Herwitz Collection

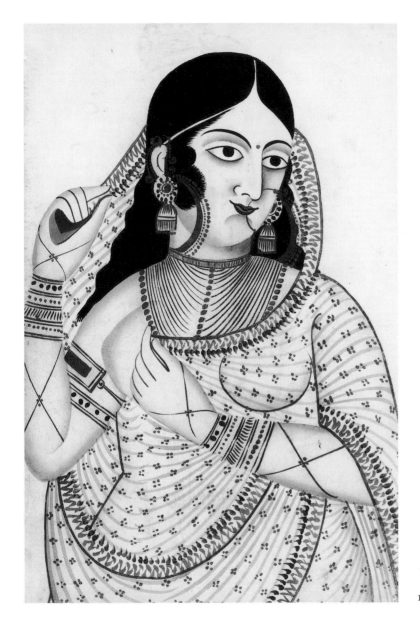

17

Courtesans are depicted in a variety of ways in Kalighat paintings. They are some-
times presented in idealized portraits—as beautifully exemplified here—and
sometimes bear a rose, the sign of their profession; such representations may
constitute idealizations of the female principle and may be connected with the
cult of the goddess Kali. Courtesans may hold a musical instrument to indicate
their cultured state and possibly their identification with Sarasvati, the goddess
of speech, learning, and music, one of whose customary attributes is a *vina*
(lute).[18] (Compare the idealized courtesans portrayed in reverse glass paintings,
nos. 80–81.) Courtesans may also be portrayed engaged in the activities of their
profession, for example, meeting a lover client or preparing to do so with rituals

of grooming (no. 20); these representations may neutrally record, humorously satirize, or didactically disparage their behavior and that of their clients.

This courtesan is shown covering or exposing her right breast with the upper part of her sari. The sari fabric is semitransparent and embellished with fine stripes and a delicate floral pattern carefully rendered with metallic paint, undoubtedly representing Indian cloth woven with threads of real gold. The courtesan wears a nose-ring, elaborate earrings, many bracelets, and a necklace of many strands. Magnificently attired and perhaps a mature woman, the courtesan appears composed, grave, benevolent, and inviting.

> 18. A souvenir painting depicting a prawn and a fish
> West Bengal, Kalighat
> Inscribed in Tamil: *ni-r 703, me a-ru me* ([the letters] "ni-r 703," [the letters] "me a-ru me")[19]
> CA. 1860–70
> Transparent water-based pigments on paper
> 18¼" x 11¼" (46.3 cm x 28.6 cm)
> Chester and Davida Herwitz Collection

Though many examples of the Kalighat composition of a prawn juxtaposed with a fish survive, its significance remains unknown. The image may be an illustration of a Bengali proverb or folk tale. Or it may be a folkish emulation of the kind of scientific illustration of flora and fauna, known as natural history painting, that was introduced into India by British professional and amateur artists and also commissioned in great quantities by the British of sophisticated Indian artists—formerly miniature painters—especially in Calcutta.[20] If an emulation, the composition demonstrates the painter's awareness of concurrent painting for the British and an adaptation of it for a broader clientele. This particular example is almost lyrical in its sensitive rhyming of the fish's tail and the prawn's antennae and of the parallel curves of their bodies.

> 19. A pilgrim's souvenir painting depicting Hanuman revealing Rama and Sita in his heart
> West Bengal, Kalighat
> CA. 1880
> Transparent and metallic water-based pigments on paper
> 17½" x 10½" (44.5 cm x 26.7 cm)
> Chester and Davida Herwitz Collection

Hanuman, the monkey demigod, who aided the hero-god Rama in rescuing his wife, Sita, from abduction by the demon Ravana, is depicted here kneeling and opening his heart to reveal Rama and Sita enshrined. Around Hanuman's neck is a broken strand of beads, and on his lap are fragments of broken beads. The image condenses an episode recounted in some versions of the *Ramayana*. When Sita gives her pearl necklace to Hanuman at court, he examines it and bites into it, breaking many of the beads and declaring that he is trying to discover if Rama dwells in them. When ridiculed for the literalness of his search, Hanuman—to the surprise of all—tears open his chest to reveal Rama and Sita abiding in his heart.

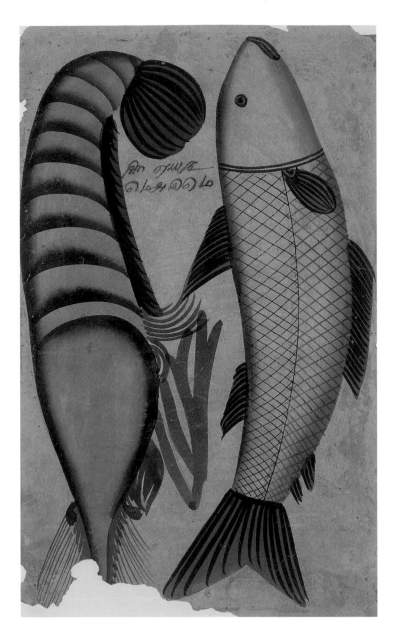

18

Although naturalistic light and shadow are not typical of Kalighat paintings, the creator of this magnificent version of the theme has handled the schematic volumetric modeling in such a way that Hanuman's heart seems to glow, dramatically illuminating from below the monkey's expression of total devotion to his lord and god.

Reproduced: Pratapaditya Pal, "Kali, Calcutta, and Kalighat Pictures," *Calcutta: Changing Visions, Lasting Images through 300 Years* (Bombay: Marg Publications, 1990), p. 119, fig. 11.

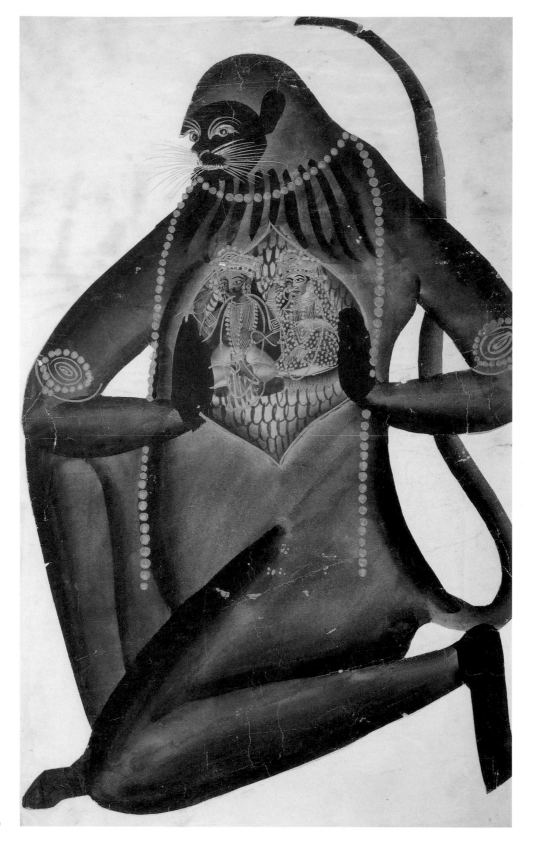

19

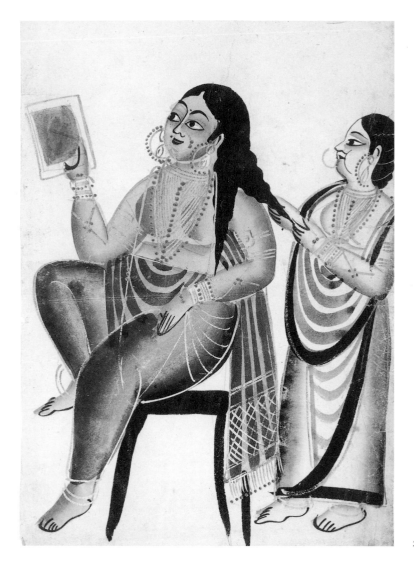

20

20. A dandy's souvenir painting depicting a courtesan admiring herself in a mirror
 while her maidservant combs her hair
 West Bengal, Kalighat
 CA. 1880
 Transparent and metallic water-based pigments on paper
 15½" x 11½" (39.4 cm x 29.2 cm)
 Chester and Davida Herwitz Collection

A bare-breasted courtesan, in loose pajamas and with the suggestion of a stole-
like garment over her shoulder, admires herself in a mirror while her maidser-
vant, represented in smaller scale, dresses her hair. The mirror and the jewelry
of maid and mistress are delineated with metallic paint. The simplified render-
ing of the folds of the garments is indicative of a late production.

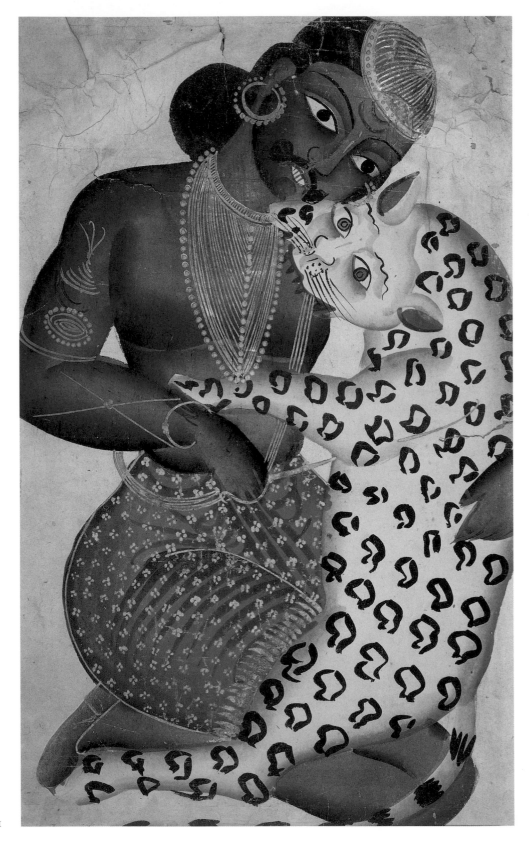

21

21. A souvenir painting depicting a yogi (ascetic) wrestling with a tiger
 West Bengal, Kalighat
 Late 19th century
 Transparent and metallic water-based pigments on paper
 17¼" x 10" (43.8 cm x 25.4 cm)
 Chester and Davida Herwitz Collection

The theme of fending off tigers, a real threat to public safety in certain parts of nineteenth-century Bengal, found representation in early Kalighat paintings in the image of a man in wrestler's shorts, sitting on his heels and holding a dagger to a tiger that is biting his chest. Early images may celebrate the bravery of Bengali tiger hunters, who received rewards from a grateful government and whose names were published in local newspapers.[21] Early images may also represent the natural danger transformed into a popular spectator sport, that is, the phenomenon of tiger wrestling in circuses and fairs. In the late nineteenth century, the theme of the tiger wrestler seems to have been adapted to portray a certain yogi or ascetic, Shyamakanta Banerjee (1858–1925), who performed in circuses for large audiences, putting his head inside the tiger's mouth and rolling with the tiger on the floor of its cage. Shyamakanta distinguished himself by founding his own circus in 1897 and by also establishing a religious hermitage in 1904.[22] In this painting, the rather loose rendering of the wrestler and tiger, as well as the addition of headgear and blue-cast skin to the image of the wrestler, indicate a late version of the theme, that is, a representation of Shyamakanta. According to the painting tradition of Eastern India, the tiger is represented spotted rather than striped (a convention also seen in nos. 15 and 44).

22. A pilgrim's souvenir painting depicting Krishna as a boy milking a cow, while his foster mother, Yashoda, offers grain to the cow from her hand
 West Bengal, Kalighat
 CA. 1890
 Transparent water-based pigments on paper
 10¼" x 14¾" (26.0 cm x 37.5 cm)
 Chester and Davida Herwitz Collection

Krishna, an avatar of Vishnu, spent his youth as a cowherd and is accordingly known to devotees as *Gopala* (cowherd) and *Gopinatha* (lord of the cowherds). Represented here as a young boy, he sits on a bamboo stool and milks a cow. Krishna, whose proper name—meaning "the dark one"—refers to the darkness of his skin, is typically portrayed with a blue body. His foster mother, Yashoda, stands on the left, offering her henna-decorated hand, perhaps with some grain, to the cow, whose calf is on a lead.

This Kalighat picture is exceptional not only for its horizontal format and its articulated landscape with a foreground, middle ground, and a narrow band of sky but also for its frankly narrative treatment of the theme. All these aspects bring to mind the Bengali scroll tradition, probably one of the sources of the Kalighat style (see discussion of Bengali scroll and single-image paintings in Chapter 3). This Kalighat picture is also exceptional for its extremely dark-valued, schematic modeling of volumes, which makes the figures stand out in re-

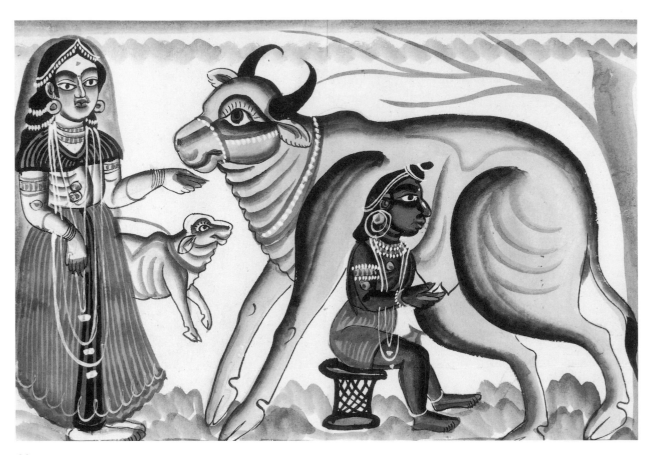

22

lief more dramatically than usual. The picture is one of a series of paintings with the same stylized modeling, only some of which have a horizontal format.[23]

23. A souvenir painting depicting a cat with a prawn in its mouth
 West Bengal, Kalighat
 CA. 1900
 Transparent water-based pigments on paper
 8" x 11½" (20.3 cm x 29.2 cm)
 Chester and Davida Herwitz Collection

The image of a calico cat with black and orange spots on a yellow body and with a prawn in its mouth has been interpreted as an illustration of the proverb "Fair game" and as a satire on the hypocrisy of some religious mendicants who were Vaishnavas (devotees of the god Vishnu) and who professed to be vegetarians but in fact ate meat and fish in private. The cat's yellow body may be a reference to the yellow garment (*pitambara*) that the Vaishnavas customarily wear while eating.[24] The iconography has variations in images of the cat holding other kinds of fish, a mouse, and even a parrot in its mouth. When interpreted as satire, the image is sometimes titled "The false ascetic."

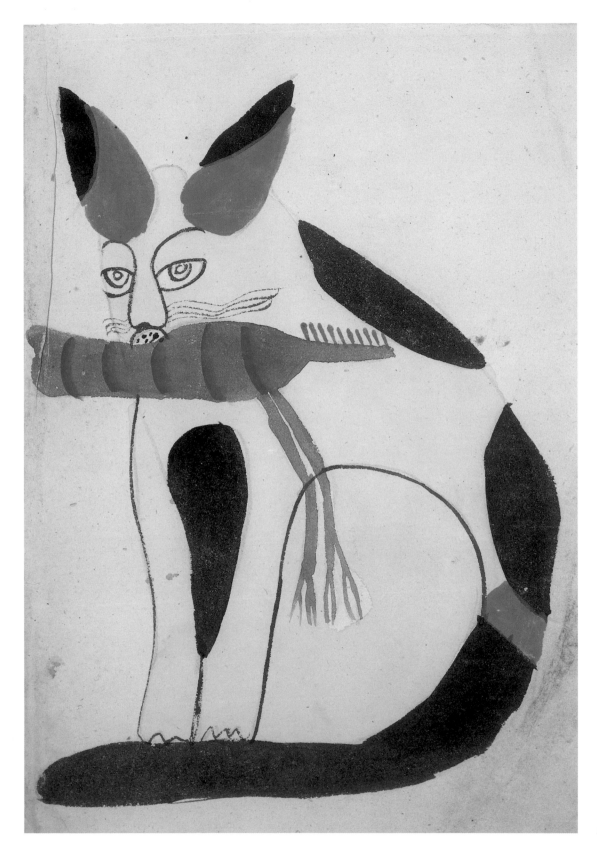

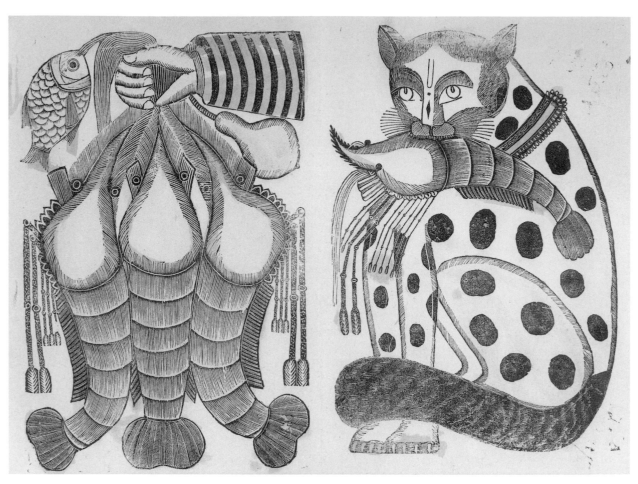

24

This example is a remarkably sophisticated abstraction of feline form. None of the schematic modeling typical of the Kalighat style is employed. A single continuous line functions as contour for both front and back legs in profile view. The planar separation of inner and outer ear is established by only a shift in color. The representation of the cat's body is conventional and conceptual rather than naturalistic; its simplicity of form is belied by the animal's cunning gaze.

24. Two Battala woodcut display prints, employing images derived from Kalighat painting
 a. A hand holding prawns (left)
 b. A cat with a prawn in its mouth (right)
 West Bengal, Calcutta, Battala
 Each: Woodcut print on paper, hand-colored with transparent water-based pigments
 CA. 1880
 Each: 24" x 18½" (60.9 cm x 46.9 cm)
 Samuel P. Harn Museum of Art, University of Florida, Gift of Mr. and Mrs. Thomas J. Needham, PR-71-28

In the second half of the nineteenth century, inexpensive woodcut display prints were produced in Battala in north Calcutta, in intense competition with the religious and secular souvenir paintings of Kalighat produced at the city's southern edge. These two woodblock prints represent the very close adoption of the two popular satirical images in Kalighat painting. Both prints involve images of fish and ridicule certain classes in Calcutta society. Both are typically handcolored with washes of transparent water-based pigments.

The image on the left shows a hand holding a bunch of prawns, a bottle gourd, and another fish. In the past, the composition has been tentatively identified as an illustration of a Bengali proverb. A recent interpretative title is "Bengalis addicted to fish," the fish and the bottle gourd constituting a favorite Bengali meal, while the hand that holds up this temptation to culinary indulgence is probably that of a half-Westernized Indian dandy, since his striped sleeve reflects the English style of dress.[25]

The print on the right of a cat with a prawn in its mouth is a variation on the Kalighat theme of a cat as a hypocritical ascetic (no. 23); the satirical interpretation is strengthened in the woodcut by the addition of religious beads around the cat's neck and by certain religious markings on its forehead that indicate a follower of Vishnu, albeit one who does not keep his promises to abstain from eating meat or fish.

These particular woodcuts are especially noteworthy because they were formerly in the collection of the Bengali modern artist Jamini Roy, who found inspiration for his own creative work in many of India's folk traditions, especially those of Bengal. Roy presented these prints to Mr. and Mrs. Thomas F. Needham who, while living in Calcutta, collected his paintings as well as examples of Indian folk art.[26]

Reproduced: University Gallery and Jacksonville Museum, *Jamini Roy and Bengali Folk Art* ([Gainesville]: University Gallery, University of Florida, 1971), [n.p.], no. 53.

Puri Paintings

Introduction

Puri painting, one of India's oldest popular iconic traditions, is associated with the regional cult of Jagannatha, a manifestation of the god Vishnu, and with the ancient pilgrimage center of Puri in Orissa on the eastern coast of India on the Bay of Bengal, where the cult took hold. The cult apparently evolved from a synthesis of local tribal gods and Hindu deities and, according to some scholars, from featuring at first a single male deity, then a divine couple, and finally a holy trinity of two brothers and a sister, worshiped today as Jagannatha, Balabhadra, and Subhadra.[27] The painting tradition evolved to serve the cult, with painters playing an important role by performing certain tasks at particular times in the elaborate cycle of rituals. While it is not known how long the tradition has been in practice, scholars suggest an early dating—perhaps contemporary with (or even preceding) the current temple, which was built in the

twelfth century—on the basis of the importance of painting in temple rituals and the paintings' "primitive" style.[28] A somewhat later dating has also been suggested on the basis of iconographic and literary evidence from the thirteenth and fourteenth centuries that documents the temple's need for painting service at the time.[29] The spread of the cult to the low-lying areas beyond Puri ensured the spread of the painting tradition as newly constructed Jagannatha temples, which follow Puri's rituals as faithfully as possible, drew traditional painters from Puri into their service.[30]

The Puri painters' most important task in relation to temple rituals is to supply substitute pictorial icons for the wooden images of the three deities when they are removed from public view for annual conservation. This period in the ritual cycle is popularly understood as a time of ailing for the deities; the period is called *anasara* (illness or resting), and the substitute icons used during the period are known as *anasara pati* (literally, time of illness painting) (no. 25). Puri painters are also charged with painting the great chariots used in the cult's most important ritual, its famous car festival (*ratha yatra*), to transport the sculptural images of deities from their principal shrine to and from a "summer residence"; this painting task is major, honorable, but less prestigious than supplying the substitute icons. For fulfilling these painting responsibilities and other prescribed services connected with temple rituals, master artists are specially chosen from among the male members of the painter families: paintings made for temple rituals require the highest level of artistry, as they strictly conform to prescribed iconography, are exacting in detail, and tend to be precisely rendered.[31]

Other members of the painter families, including women, children, and young male apprentices, produce souvenir images known as *jatri patis* (pilgrim paintings) to be sold to pilgrims for private worship. Pilgrim pictures are made in great quantities and in a great variety of sizes and shapes and, most important, in many degrees of finish, from highly refined to roughly rendered, so that they can be offered at a range of prices. The most popular themes are the representation of the trio in the final ceremonial costume of the day, known as *bada* or *bara singhara vesha* (literally, exceedingly beautiful costume) (no. 29) and the trio within a schematic representation of Jagannatha temple—by itself or further elaborated by enclosure in the image of a conch shell identified with the town of Puri (no. 26). Other themes, determined by popular taste, include the trio in its festival chariots and in other ceremonial costumes worn by the deities at varying times (no. 30); mythological scenes, especially those featuring the amorous adventures of Krishna, an avatar of the god Vishnu; composite animals or vehicles made up of devotees bearing Krishna (no. 28); and the *navagunjara*, a fantastic creature composed of parts of various animals, especially elaborated in Orissan culture. In addition, multipaneled pictures with the episodes of a mythological narrative depicted around a central image, usually the hero or deity subject, are popular with Puri pilgrims.[32]

Puri painters also produce subsidary works for sale, such as small painted toys, portable shrines and altars (no. 100), dowry boxes, playing cards (no. 96) and boxes for playing cards, and erotica (no. 95). They also contract to paint murals in a variety of settings and may paint traditional images for sale in local bazaars at the time of certain festivals (no. 27).

Puri paintings are characterized by rich, full-strength colors, used opaquely. Shapes are given great emphasis; edges are reinforced by contour lines of contrasting value and varying width; though unmodeled, shapes nevertheless convey a strong sense of volume and, though geometrically abstracted, have notable organic vitality. Most figures are represented in profile, but the Jagannatha trio is always depicted frontally, ready to engage its devotees in direct eye contact, in a blessed glimpse of the divine (*darshana*). There is a compressed quality in the spatial construction of most pictures: the background plane, frequently painted a vivid Indian red, seems to advance rather than recede. Compositions are clear, forceful, symmetrical, and schematic. Allover patterning enriches the unmodeled forms and flat application of paint; the total image is often bordered by additional bands with patterned motifs.

Puri paintings are called *patachitras* (picture cloths) or simply *patis* ([paintings on] cloth, or paintings) because they are usually created on layered cotton cloth primed with a mixture of chalk and gum that is then polished. Alternately, artists may use supports of layered paper (usually newsprint) or wooden boards. Artists formerly made their pigments from locally available plants and minerals; today, many use commercially produced colors. After artists completely paint their images, they typically lacquer their work; this practice gives additional luster to the brilliant colors of Puri paintings.

The painters of this tradition belong to a so-called low caste known as Chitrakars (painters) and inherit their vocation from birth. Their surnames are usually Mahapatra or Maharana. In the Puri district, painter families principally reside and work in two villages, Raghurajpur and Dandasahi, close to Puri, though they are also found in Puri proper. In addition, concentrations of painters are found in areas of the Ganjam, Balangir, Sambalpur, and some other districts.[33]

Like many traditions connected with pilgrimage sites, that of Puri experienced a decline in demand when commercially printed chromolithographs became available at the turn of the century and could be sold more cheaply than hand-painted images. The Puri tradition was revived in the 1950s through private and governmental efforts.[34] The cult of Jagannatha has been extensively studied by scholars, with attention to its painting component, an essential part of its cycle of rituals.

Representative Works: Puri Paintings, nos. 25–30

25. Substitute icons, known as *anasara pati,* depicting the Jagannatha trinity in alternate manifestations, Balabhadra as Balarama, Subhadra as Bhubaneshvari, and Jagannatha as Narayana,[35] seated in meditation posture
 Orissa
 Early 19th century
 Opaque water-based pigments and lacquer on cotton cloth
 14" x 34¼" (35.7 cm x 87.0 cm)
 Courtesy of Arthur M. Sackler Museum, Harvard University Art Museums,
 Loan from Private Collection, 409.1983

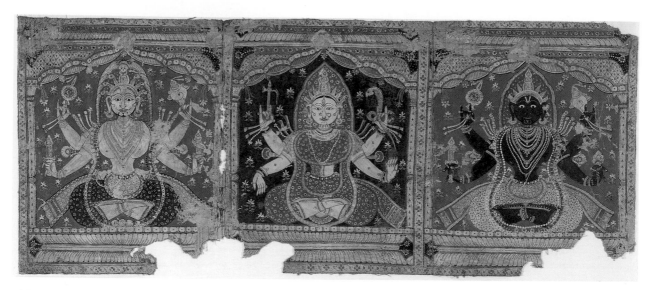

25

The sculptural icons of the Jagannatha trio installed in the sanctuary of Puri temple are carved and painted wood; the hauntingly primitive forms and seemingly unfinished quality of the icons—with masklike faces, stumps for arms, and no legs—probably reflect a tribal origin.[36] This painting of the trio portrays the deities not in their sculptural form but as fully articulated human figures seated in meditation posture. The portrayal (described from left to right) also manifests an alternate aspect of each deity: Balabhadra is depicted as Balarama, Subhadra as Bhuvaneshvari, and Jagannatha as Narayana. All three figures are four-armed, holding typical attributes: Balabhadra/Balarama holds a mace, wheel, conch shell, and plow; Subhadhra/Bhuvaneshvari holds an elephant goad and a coiled snake, while her hands are posed in various gestures (*mudras*) signifying protection (*abhaya mudra*) and grace (*varada mudra*); Jagannatha/Narayana holds a mace, wheel, conch shell, and lotus. Each figure is seated on a shallow throne, which is composed of lotus petals, in a pavilion under a multi-cusped arch decorated with bound drapery. The garments of the deities, the architectural settings, and the border around the entire painting are richly patterned with delicate floral designs in different scales. Though rendered without modeling, the organically stylized shapes of the deities swell with ecstatic and elegant vitality.

This painting, called an *anasara pati* (literally, time of illness painting), was made to substitute pictorially for the wooden temple icons during the fifteen days they are removed from public view for annual restoration, a state popularly referred to as the deities' *anasara* (sickness or resting). This period follows the ritual bath given to the icons on a special bathing platform outside the temple and precedes the car festival (*ratha yatra*) during which the icons are placed on huge chariots and taken in procession to a smaller temple for a stay of seven days. This *anasara pati* was made not for Puri temple, whose substitute icons are much larger in scale, but probably for one of the many Jagannatha temples in

74

the surrounding countryside. The substitute pictorial icons receive the same worship from the devout as the wooden icons. The painting of the sacred images is the chief task, honor, and privilege of the Puri painter, for which he prepares with rituals of purification. When he ceremoniously completes the images by painting in the deities' eyes—a ritual that invokes the deities to reside in the icons—they are taken in procession from the painter's house to the temple, according to the dictates of tradition.[37]

26. A pilgrim's souvenir painting depicting the Jagannatha temple and other sacred
 sites in Puri within a stylized shell (*shankhalavi pati*)
 Orissa, Puri district
 Early 20th century
 Opaque water-based pigments and lacquer on cotton cloth
 24¾" x 30¾" (62.9 cm x 78.1 cm)
 Chester and Davida Herwitz Collection

This complex image represents the great Jagannatha temple at Puri and other sacred sites in the temple town within an abstracted shell form. The composition constitutes a conceptual map of the entire pilgrimage center and is consequently known locally as a "sacred places painting" (*shankhalavi pati*). In addition, the composition is a visual compendium of the temple's ritual activities and of mythological themes in the Puri tradition.[38] This type of painting is produced for pilgrims to carry home for display and private worship of the Jagannatha trinity. The image also provides pilgrims with a visual aid to remembering and renewing the entire pilgrimage experience, that is, visiting not only Jagannatha temple but also other shrines in the environs and being present for various daily or festival ritual activities. This extensively detailed version of the *shankhalavi pati*, undoubtedly created for a pilgrim of means, reveals the importance of pilgrimage in Indian cultural life.

Jagannatha temple is centrally represented as a thrusting tower shape, here composed of three coinciding vertical rectangles progressively increasing in size and probably respectively symbolizing the inner sanctuary where the Jagannatha trio is housed, the temple building itself, and the outer walls of the temple compound. This portion of the painting's image, frequently represented independently of the shell enclosure, is known as a "vertical temple plan" (*thia badhia*) and constitutes by itself a very popular composition among pilgrims. When the temple plan is incorporated into the conch shell of a "sacred places painting," the final and largest shape representing the outer walls of the temple compound may also be rendered as a square. In either case, the composition imaginatively combines both ground or floor plans and elevations of the temple structure (with eye-level views of the multitude of activities taking place within the compartmentalized architectural spaces).

The visual metaphor of the shell enclosing Jagannatha temple and Puri town is said to be derived from an early literary description of the ancient pilgrimage center on the eastern coastline of India as a conch shell with its "abdomen" in the ocean.[39] Since its adoption into Puri iconography at an unknown date, the device of the conch shell has allowed the artist to effectively include more sacred (and secular) scenes and sites beyond the walls of the temple com-

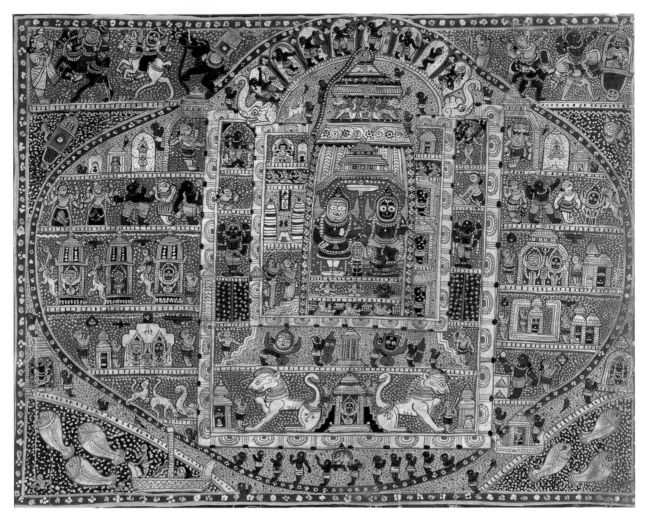

26

pound. The numerous sites in a "sacred places painting" are sometimes identi-
fied with inscriptions.

A brief description of selected images in this painting—which are not in-
scribed with identifications—follows.[40] At the heart of the painting is the tem-
ple sanctuary where the sculptural images of the three deities are enshrined; the
two males in the trinity are represented with attached ceremonial limbs used
for certain festivals (see no. 30).

Immediately below the sanctum are painted images of the deities known as
anasara pati, similar to no. 25, installed when the sculptural icons are removed
for annual restoration; the pictorial substitutes are being ritually worshiped by
three Brahmin priests.

Represented around the sanctuary, to the immediate left and right, are
other areas within the temple, including a shrine to the elephant-headed god
Ganesha; portrayed here are also a royal couple, ascending the steps to the sanc-

tuary to auspiciously view and be viewed by the deities (*darshana*) and tribal priests, with hands joined in prayer, individually worshiping within small shrines.

Below the temple proper, tribal priests carry the wooden temple icons to a special part of the temple for their annual repair; represented below them is the eastern gate of the temple courtyard with an image of Jagannatha, guarded by lion statuary and gunmen.

On either side of the temple compound within the shell are registers replete with shrines and temples in Puri, the first containing temples of Shiva on the left and Brahma on the right. Other registers on the left portray the car festival and the special platform where the temple icons are ritually bathed; those on the right depict additional temples in Puri and the Puri bazaar.

Around the conch shell, the fish-filled waters of the Bay of Bengal are represented, traversed by a boat carrying pilgrims. The sandy coastline on which the temple town rests is also illustrated, both within and beyond the curving contour line of the bottom of the conch shell; here numerous tribal devotees are shown, prayerfully carrying a sacred image and walking in a procession to the temple.

Within this map of Puri, many mythological themes related to the god Vishnu are also illustrated, including his ten incarnations (*dashavatara*) (across the second register within the shell) and eight episodes in the life of Krishna, the avatar of Vishnu with whom Jagannatha is especially identified (within a frieze composed of lotus petals above the main temple tower). Also shown in a band across the top of the painting beyond the conch shell are Jagannatha and Balabhadra on horseback being given curds by a milkmaid (the single narrative subject of no. 28) on the left and the hero Rama, another avatar of Vishnu, and his brother Lakshmana defeating the demon Ravana on the right.

A narrow decorative border of abstracted white lotus blossoms surrounds the whole.

27. A painting depicting Durga slaying the buffalo demon and Jagannatha as Madhava (*Durga Madhava pati*), to be mounted on a household door for display and worship during festivals of the Goddess
 Orissa, Puri district, Khandaparha
 Mid-20th century, by a member of the Maharana family[41]
 Opaque water-based pigments on unprimed newspaper
 6" x 8¾" (15.2 cm x 22.2 cm)
 Private collection

This evenly divided composition features on the left Jagannatha as Madhava, a form of Vishnu, and on the right the Great Goddess Durga, shown slaying Mahisha, the buffalo demon. Jagannatha as Madhava is four-armed and holds a bow and arrow in one pair of arms, which have fully articulated hands and are painted green; his other two upper limbs, which are upraised, represent the stumps found on the temple icon; he stands on fully articulated legs, also painted green.[42] Durga is also four-armed and holds a wheel and a conch shell, emblems also associated with Vishnu, as well as a sword with which she strikes

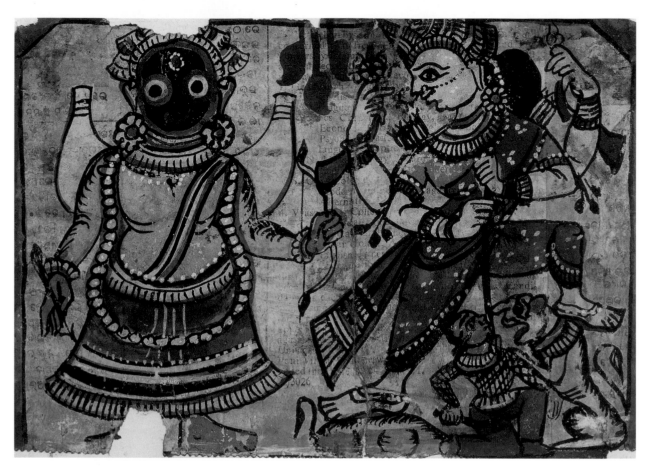

27

28

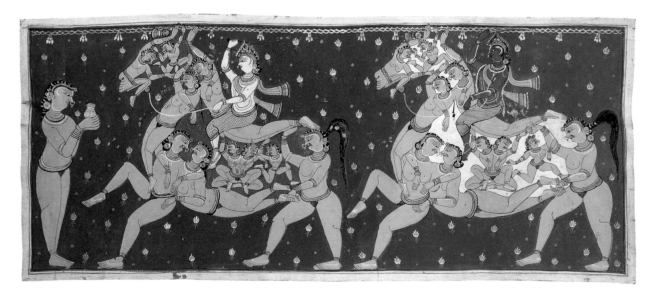

the demon as it emerges from the carcass of the buffalo. Durga stands with one foot on the carcass and the other on the shoulder of her crouching lion who, open-mouthed, confronts the demon.

Durga, the Great Goddess created from the conjoined strengths of the male gods to deliver the world from evil, is an embodiment of warrior power and of independent feminine action. Her juxtaposition with Jagannatha as Madhava, a form of Vishnu, suggests an equivalence in their divine powers and functions in the cosmos. This painting was made to be mounted on a household door for special worship during the auspicious times of seasonal festivals honoring the warrior goddess.

28. A pilgrim's souvenir painting depicting the milkmaid Manika offering curds to
 Jagannatha and Balabhadra mounted on horses composed of human figures
 Orissa, Puri district
 Before 1952
 Opaque water-based pigments and lacquer on cotton cloth
 13⅛" x 30⅜" (33.3 cm x 77.2 cm)
 Nesta and Walter Spink

The blue-skinned Jagannatha and his white-skinned brother Balabhadra are depicted as soldiers on horses made up of ten golden-skinned, seminude human figures, all drawn with their bodies contorted to fit the various parts of equine anatomy. Standing at the far left, the milkmaid Manika, also golden-skinned, offers the soldiers a bowl of curds. The figures are dramatically set against a vivid red background plane; the strongly contrasting colors used in figure and ground and the picture's horizontal extension give the composition a friezelike quality.

The incident of Manika offering curds to the soldiers is part of the legendary story of King Purushottama of Orissa (1466–97). In one variation of the story, Purushottama, wishing to marry the daughter of the king of Kanchi but without his agreement to the union, prays to Lord Jagannatha for help and is told in a dream to wage war on Kanchi. When the milkmaid Manika comes to him with a ring from two soldiers, one light- and one dark-skinned, to whom she has given a bowl of curds, Purushottama recognizes the ring as Jagannatha's and realizes that his lord is already on his way to the battlefield to help his devotee win the desired bride. This favored composition, peculiar to the Puri area, is called *Kanchi Kaveri* ([expedition between] Kanchi [and] Kaveri). The image is typically employed in paintings for pilgrims (*jatri patis*). It is customary to present the scene independently as is done here and also to incorporate it into the upper left hand corners of the complex iconography of depictions of Puri temple and town (no. 26).

A special feature of this version of the composition is the treatment of the horses as composite animals, an apparently recent development in the iconography of the theme. The artist has combined the theme of *Kanchi Kaveri* with another favored in Puri, that of Krishna mounted on a horse composed entirely of human figures.[43] The conflation of the two themes visually reinforces the identification of Jagannatha with Krishna in the Jagannatha cult.

29. A pilgrim's souvenir painting of the Jagannatha trinity, Balabhadra, Subhadra,
and Jagannatha, attired in the final ceremonial dress (*bada singhara vesha*) in the
daily cycle of temple rituals
Orissa, Puri district
CA. 1975
Opaque water-based pigments and lacquer on newspaper
5⅜" x 5⅝" (13.7 cm x 14.3 cm)
Lorna and Roy Craven

This small souvenir painting (*jatri pati*), made for pilgrims to Puri to carry
home for private worship or to distribute to friends and relatives, shows the
Jagannatha trio garlanded and its two male members with upraised rudimen-
tary arms against a plain red background. The image represents the temple
icons in their final ceremonial dress (*bada singhara vesha*; literally, exceedingly
beautiful costume) at the end of each day, when they are covered with floral or-
naments and decorations and draped with silk on which the *Gita Govinda*, a
twelfth-century poem that celebrates the love of Radha and Krishna, has been
inscribed. This sacred image is one of the most popular representations of the
trio, and its iconography remains relatively unchanged from the earliest to the

29

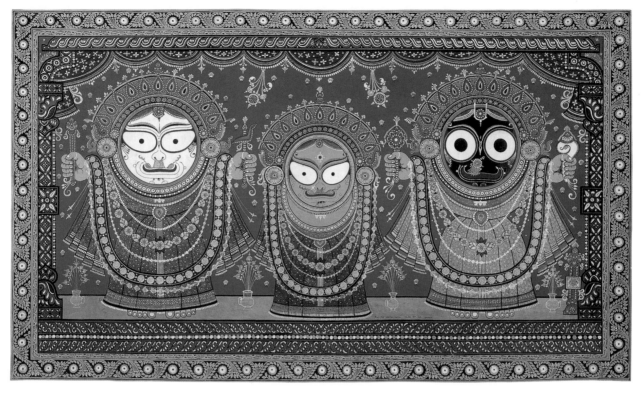

most recently collected examples. Such images are produced very quickly, as in-
dicated by the brush marks, and in great quantity in almost assembly-line fash-
ion, so the pictures can be sold inexpensively to even the poorest of pilgrims;
requiring less skill and training, these pictures are created by female members[44]
and young male apprentices in most painter families.

30. A pilgrim's souvenir painting of the Jagannatha trinity, Balabhadra, Subhadra,
 and Jagannatha, in the ceremonial king costume with attached golden limbs
 (*raja vesha*)
 Orissa, Puri district, village Dandasahi
 CA. 1986, signed by the artist, *Arjuna Maharana Puri* [district] *Orissa 752012*
 [pin code]
 Opaque water-based pigments and lacquer on cotton cloth
 36¼" x 61" (92.1 cm x 154.9 cm)
 Private collection

This composition, employed in paintings for pilgrims (*jatri patis*), represents
the Jagannatha trio in a special ceremonial costume that includes arms and
legs fitted to the icons of Jagannatha and his brother. Three different sets of
ceremonial limbs are kept in readiness like props for use in seasonal festivals;
one set is made of wood and covered with gold, another of pith (an extremely
light and easily carved reed), and a third set—black in color—is made of cane

and wood. Featured here are the gold-plated arms and legs as part of the king costume (*raja vesha*), which is employed on three different full moon days and also on Dashahara day, part of a longer festival by the same name commemorating the victories of the Great Goddess Durga over the buffalo demon and of the hero-god Rama over the ten-headed demon Ravana. Jagannatha holds a wheel and a conch shell, while Balabhadra holds a mace and a plow, attributes typically connected with this *vesha*. The gold limbs are also used as part of another costume called golden dress (*suna vesha*), which the deities wear as they are taken back to the main temple after the car festival and their stay at a smaller temple.[45]

Tanjore and Mysore Paintings

Introduction

Tanjore and Mysore paintings, highly ornamented forms of iconic painting, were designed to express[46] and inspire devotion and to serve as the focus of private ritual offerings by the faithful. The ancient pilgrimage site of Tirupati (in present-day Andhra Pradesh) has been suggested as a possible place of origin of these related traditions.[47] Similar forms of painting, however, are known to have been produced in many places in South India[48] to fulfill an increasing demand for icons, prompted by religious movements of the time that emphasized private devotion over temple rituals regulated by priests. All the South Indian traditions have come to be known after two principal sites—Tanjore (present-day Thanjavur) in Tamil Nadu and Mysore in present-day Karnataka—where the iconic styles flourished for approximately two hundred years, from CA. 1700 to CA. 1900. The traditions have been characterized as being midway between the poles of the classical and the popular, since they exhibit both sophisticated and folkish elements and appealed to a variety of classes of people.[49] The most typical pictures of these traditions feature Hindu deities and were made to be hung on the interior walls of the household area given over to private veneration of deities, sometimes located in a separate room known as a *puja* (worship) room, or on the interior walls of a neighborhood prayer hall.

In traditional Tanjore compositions, a plump deity exuding well-being, most often Krishna as a child or young boy, is centrally placed and surrounded with devotees and symbolic objects. This hieratic arrangement is then enclosed in an architectural frame suggesting a curtained alcove or a small, arched pavilion. Typical subjects for Tanjore compositions emphasize the deity's emotive appeal to his devotees and include baby Krishna in his foster mother's arms (*Krishna Yashoda*), the child Krishna as a mischievous butter thief (*Navanita Krishna*) (no. 35), and Krishna the youthful cowherd with his flute (*Krishna Venugopala*) (no. 32). Other religious subjects include Shiva dancing (*Nataraja Shiva*) and Rama with consorts. There are, moreover, compositions that are divided into compartments; small panels containing figures or symbolic forms are

arranged around a large central panel enshrining, like a temple sanctuary, the principal deity subject.

In Tanjore paintings, surfaces are opulent and both visually and tactilely attractive. Certain areas of the cloth-covered wood support are built up with limestone paste (*sukkan*), embellished with gold leaf, and embedded with colored glass or jewels.[50] The shimmering, gilded relief punctuated by gems is traditionally utilized to represent the deity's pavilion and jewelry; these raised representations contrast with two kinds of painted areas not in relief, the illusionistically modeled volume of the deity's body and the flat, planar background of intense, opaque blue, red, or green. The theatrical sensuousness of these paintings is increased when they are seen in their devotional contexts—densely hung and illuminated by the flickering light of oil lamps.

Though closely related to Tanjore paintings as a manifestation of a shared South Indian cultural milieu, Mysore paintings differ from them in several ways, the most immediate being that their overall effect is more subtle. The relief is not as high, and the jewels worn by the subjects are represented by a series of equal-sized, raised dots of semiglossy white paint, rather than embedded glass. The support for the painting is frequently paper rather than cloth stretched over wood. The paint is more thinly applied; colors are frequently subdued. Volumes are not quite as roundly drawn. Many Mysore compositions present a number of figures in hieratically ordered narrative scenes. The most popular themes in Mysore paintings are the enthronement of Rama (*Shri Rama Pattabhisheka*) (no. 33) and a representation of the Goddess as the Supreme Mother (*Shri Raja Rajeswari*).[51]

In both the Tanjore and the Mysore traditions, the paint is water-based; in both traditions, the subject matter extended beyond sacred subjects to include secular portraiture. In both, the style also found application in a variety of other forms of painting such as murals, painted wooden shrines, painted wooden book covers, and playing cards. An especially popular adaptation of the distinctive Tanjore style is evident in reverse glass paintings from Tamil Nadu (see nos. 79–80).

The artisans who produced these paintings were orthodox Telegu-speaking Hindus, from the Raju caste; they considered their work of creating icons for the private devotional needs of rulers and the merchant and professional classes to be an act of devotion, and they followed certain religious rituals in the practice of their art.[52] At the end of the nineteenth century much less expensive images of the deities, in the form of imported and locally produced chromolithographs, came to replace hand-painted Tanjore and Mysore icons.

Over the past twenty-five or so years, there has been a renewal of interest in these traditions, though scholarly attention has been more limited than in other areas of Indian popular painting. More recently, India's growing middle class has taken to the collection of old Tanjore and Mysore paintings, albeit for what seem to be secular purposes—for example, preservation of fragments of a vanished past or decoration of urban middle-class homes. The phenomenon has in turn stimulated contemporary popular demand, which is reviving production, especially of Tanjore paintings—at least in Madras and Thanjavur—after a long period of decline.

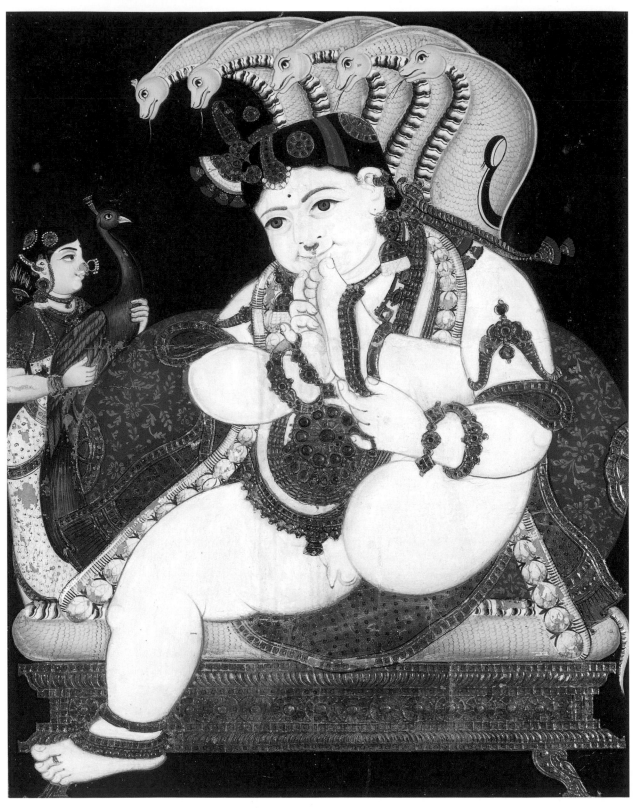

31

31. A devotee's icon of the child Krishna protected by the serpent Ananta, for use in
a domestic shrine or communal prayer hall
Tamil Nadu, Tanjore
Late 19th to early 20th century
Opaque water-based pigments, gold leaf, and *sukkan* (limestone paste) on cloth
stretched over wood
20¾" x 16⅝" (52.7 cm x 42.2 cm)
Beatrice Wood

In this traditional iconic composition, the child-god Krishna, garlanded and
bejeweled, sits and sucks his toe on a low, backless chair-throne supported by a
wine-red bolster; the protective hood of a five-headed serpent, Ananta, rises up
behind the head of Krishna; a female devotee holding a green peacock stands in
profile to the left of Krishna. The figures are presented against a flat, opaquely
painted background. As is customary in Tanjore paintings, Krishna is repre-
sented with white- rather blue-toned skin. The icon was made to be installed in
a domestic setting or communal prayer hall and to serve as the focus of a devo-
tee's offerings.

The composition synthesizes two mythic images of the god Vishnu as related
in the *Puranas* (writings comprising myths and legends).[53] One image is that of
his avatar Krishna who, as a child sucking his toe while floating on a leaf on the
cosmic sea, reveals himself to a seer as ultimate reality or Vishnu. Another image
is that of the high god Vishnu himself who, while asleep on the hundred-headed
serpent Ananta and floating on the cosmic sea of milk between successive periods
of dissolution and creation, dreams the illusion of reality. The conflation of these
images points simultaneously to multiple manifestations of Vishnu's mythic be-
ing: his charm and appeal in his incarnation as a playful child as well as his su-
premacy as the creator of the illusory world in which humans live. Selecting and
condensing, this hybrid Tanjore image transcends the constraints of ordinary sin-
gular conceptualization and of ordinary chronological time.

32. A devotee's icon of the youth Krishna as cowherd, holding a flute (*Krishna Venu-
gopala*), for use in a domestic shrine or communal prayer hall
Tamil Nadu, Tanjore
Late 19th to early 20th century
Opaque water-based pigments, gold leaf, and *sukkan* (limestone paste) on cloth
stretched over wood
18" x 15¼" (45.7 cm x 38.7 cm)
Cynthia Robinson Ingalls

Here Krishna, as a handsome young cowherd holding a diminutive flute, stands
on a many-petaled lotus throne under a draped arch. The mythic hero, who came
to be regarded as an avatar of Vishnu, is represented as light-skinned, rather than
dark-skinned, as is typical in Tanjore paintings. He towers over the female
cowherds (*gopis*) standing beside him. One *gopi* appears to be offering her devotion,
while the other looks out at us as if inviting us to do the same. All three figures
are elaborately adorned with fine garments and much ornate jewelry, opulently rep-

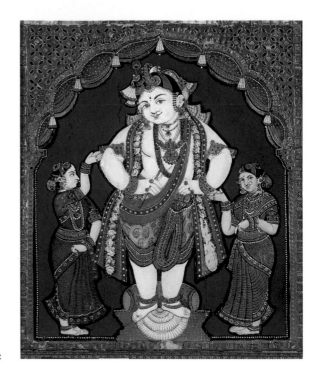

32

resented in typical Tanjore gilded relief; the background plane, by contrast, is a plain, opaque bright blue. Intended for installation in a home shrine or communal prayer hall, the painting, with its attractive subjects and surfaces, was designed to inspire reverence in believers and also acts of devotion.

33. A devotee's icon depicting the coronation of Rama (*Shri Rama Pattabhisheka*),
 for use in a domestic shrine or communal prayer hall
 Karnataka, Mysore
 Opaque water-based pigments and gold leaf on paper mounted on wood
 Late 19th to early 20th century
 19½" x 23⅝" (49.5 cm x 60.0 cm)
 Private collection

This painting, intended for private veneration in a home shrine or communal prayer hall, depicts the coronation of the hero-god Rama, as related in the epic *Ramayana*. Rama, heavily jeweled and crowned, is centrally placed and seated on a throne. In most other Indian painting traditions, Rama is portrayed with blue (or dark) skin, but in the Mysore tradition, as seen here, he is fair. Rama is surrounded by his wife, Sita, his brother, Lakshmana, and a royal retinue of relatives, courtiers, and seven topknotted sages. Below, Hanuman, the monkey warrior, kneels and clasps with both hands one of Rama's feet to show his total devotion and reverent subservience. Three other monkey warriors stand in profile with folded hands in the lower left. Toward center right, a monkey displays the necklace given to Hanuman by Sita (the same one broken by him in no. 19). Three courtiers, in miniature scale, stand with folded hands in the lower right. A canopy

hovers over the crowned head of Rama. A draped garland of stylized lotuses, similar to that around Rama's neck, forms the upper border of the picture. All areas in the painting representing gold jewelry or accoutrements are in shallow relief and gilded; jewels are represented by the raised white dots of paint typical of the Mysore tradition. These areas in relief and the modeled flesh tones of the figures emphatically contrast with the brilliant, opaque green background.[54]

34. A devotee's icon depicting a Shrivaishnava guru delivering a discourse to his followers, for use in a domestic shrine
 Inscribed in Tamil and Sanskrit
 Tamil Nadu, Srirangam
 Early 20th century
 Opaque and transparent water-based pigments and lacquer on a lithograph on paper
 17⅝" x 23¼" (44.8 cm x 59.1 cm)
 Ms. S. S. Sarna

The Shrivaishnava community, which emerged as a distinct Hindu religious group around the eleventh century A.D., worships the god Vishnu and his consort, Shri. This image depicts a leader of a Shrivaishnava subsect, the religious teacher Manavalamamuni (1370–1443), seen delivering a theological discourse to his disciples, in the lower right.[55] The discourse was part of his famous year-long series of lectures on a Tamil poem celebrating Vishnu (*Tiruvaymoli* by Nammalvar) at the Garuda pavilion of Shri Ranganatha temple in Srirangam, Tamil Nadu. Lord

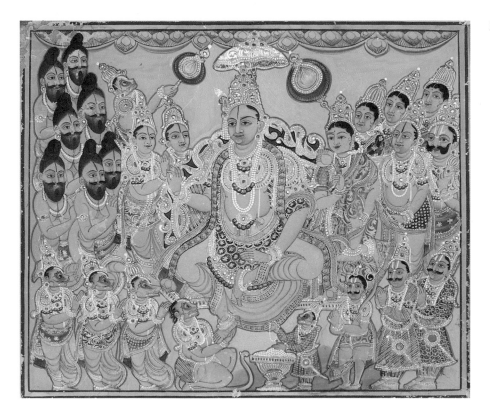

33

Ranganatha, the form of Vishnu permanently enshrined in the sanctum of the temple, is believed to have attended the lectures, making himself present in his portable festival sculpture of bronze used in processions and other celebrations, represented in the painting at the top center; the deity is standing under a canopy with his two consorts seated beside him, while Garuda, his eagle mount, is on the left. The image records an event that, according to legend, occurred during one of the lectures—a small boy, shown close to the center, was inspired by the deity to praise Manavalamamuni in a Sanskrit verse. In an alternate version of the story from oral tradition, Vishnu manifested himself in the form of the young boy. The event is important to members of the subsect as a sign of divine approbation in a dispute with another subsect. The religious master holds a long, narrow inscribed palm leaf that is part of the manuscript resting on a low stand; his hand gesture (*mudra*) is that of teaching. Five trays heaped with various foodstuffs and fabrics are laid out as votive offerings in front of the shrine of Vishnu. The inscriptions in Tamil below the image indicate that the disciples would meet every day to listen to the guru's exposition; the central legend contains the opening words of the Sanskrit verse in praise of Manalavamamuni; it is likely that the palm leaves contain a key verse in the Tamil poem.

The image shows some evidence of Western influence in the converging lines of the grid pattern on the floor and in the use of transparent paint in the dark green floor and pink lower garments (*veshti*) worn by most of the figures. The brilliant red background plane is typically opaque so that it contrasts strongly with the figured areas. Not an original composition, this work is a sen-

34

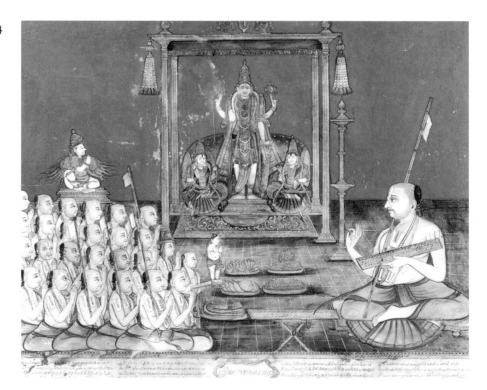

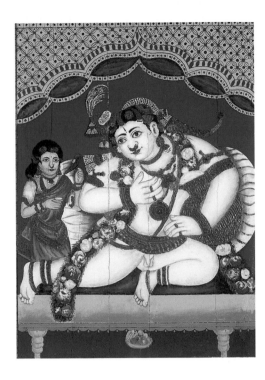

35

sitively painted lithographic copy of a larger commemorative painting that survives in a restored state within the temple not far from where the discourses were given.[56] It may have been prepared as a souvenir image for a pilgrim to the Shri Ranganatha temple in Srirangam.

35. A devotee's icon of the child Krishna as butter thief (*Navanita Krishna*), for use in a domestic shrine or communal prayer hall
 Tamil Nadu, Tanjore
 First half of the 20th century
 Opaque water-based pigments, gold leaf, and *sukkan* (limestone paste) on cloth stretched over wood
 24½" x 17⅝" (62.2 cm x 44.8 cm)
 Private collection

Designed for private worship, this image of Krishna as a mischievous child, holding a stolen jug of butter and a butter ball, represents a very folkish version of one of the most popular themes in Tanjore painting. The proportions of Krishna's body do not conform to traditional Tanjore canons. Krishna's head and stout, short-limbed corpus are barely childlike, and his facial features, especially his prominent nose and heavy eyebrows, seem more like those of an adult. The artist may have been influenced by figural types common in Tanjore glass painting (see nos. 79–80), which are squattier than those of Tanjore painting. Nevertheless, there is a vitality in this presentation that other, more "correct," and more obviously charming pictures cannot match. Krishna is attended by a single female devotee, perhaps Yashoda, his foster mother. The architectural enclosure is represented not in relief and gilded, as is typical in the Tanjore tradition, but rather as painted pattern.

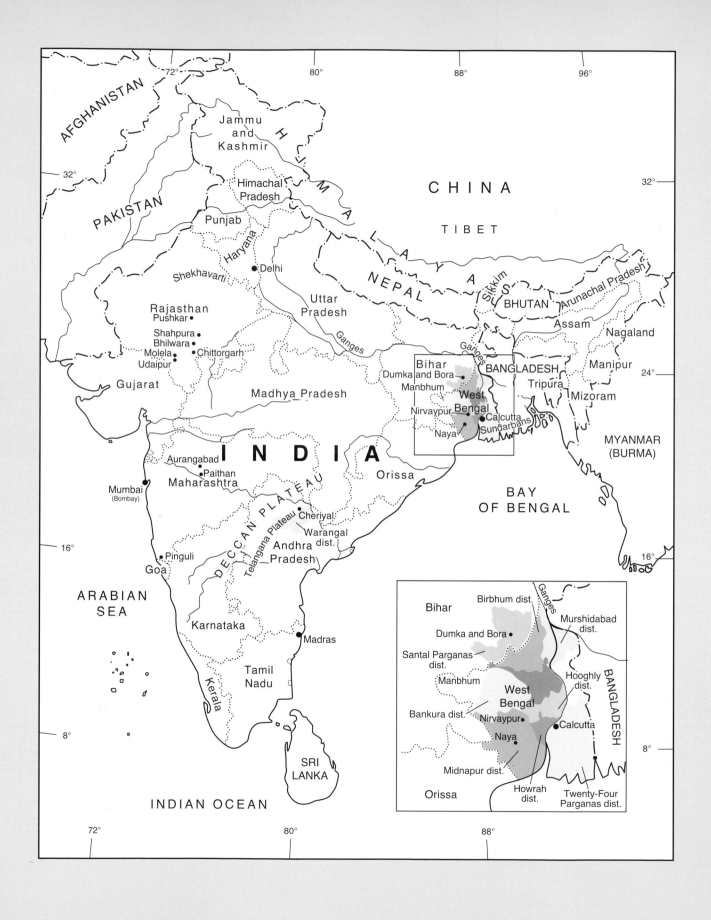

3

Paintings from Popular Narrative Traditions

Andhra or Telangana Scroll Paintings

Introduction

The Andhra or Telangana painting tradition, which is based in the boulder-strewn region of Telangana (the northwest section of present-day Andhra Pradesh) in the heart of the Deccan Plateau, provides scrolls as a visual aid to storytelling. The tradition culturally links its caste of professional painters with other castes who perform the narratives for audiences of yet other social backgrounds.[1] For example, scrolls illustrating legends from the *Markandeya Purana*,[2] including the origin of the weavers' caste, are produced upon request for the Konapuli caste, a storytelling community that serves the Padmasalis, who are weavers,[3] while scrolls illustrating the *Ramayana* are made for the Arthapodu community, who use them in telling the story of Rama to the Mangali caste, and scrolls with stories from the *Mahabharata* are made for the Kakipadika caste, who entertain the Muthras.[4] It is the tradition of the audience that determines not only the stories themselves but also the stories' episodes, chronology, and distinctive pictorial layouts.[5] The stories that feature characters from the great Indian epics (or characters whose iconography resembles those in the Indian epics) are frequently not found in the classic Sanskrit versions of these stories but exist, rather, in the oral tradition of different social groups in Telangana where Telegu is the principal language. Identification of the episodes on scrolls is consequently difficult, as many of the regional variations of epic stories have not been recorded in Telegu (or regional dialects), let alone translated into English.

The performers, who are usually male, may be Hindu or tribal[6] and are professional itinerant storytellers by caste or tradition. They perform at the invitation of their respective audiences, traveling from village to village and giving

performances that can last as long as a week. The performers hang their scroll between two poles or against a wall and unroll it from the top so that the image shown coincides with the narration. The performance is begun in the evening with an invocation of the elephant-headed god Ganesha for blessings at the onset. In the tradition of some audiences, the image of Ganesha appears in the first panel of the scroll; in others, the first image is that of the Hindu trinity (Brahma, Vishnu, and Shiva). The narration is half-prose, half-poetry, and is spoken, sung, and chanted, accompanied by instrumental music. The audience pays the performers with cash or clothing and food; if especially pleased with the presentation, the audience may make contributions for the painting of a new scroll.[7]

Andhra scrolls may be horizontal or vertical, though vertical scrolls predominate. Horizontal scrolls are divided in the center into two horizontal panels. Vertical scrolls, which may be as long as thirty feet and are generally about three feet wide, are divided into a great number of horizontal bands or registers of varying height.[8] The edges of these picture panels are marked by narrow yellow bands enriched with floral designs, and the color of the panel background is a deep Indian red. The panels have a friezelike quality; the figures are rhythmically distributed and placed to avoid overlapping and are compressed against a flatly painted, opaque background without indication of a floor plane. Energetic human figures are drawn in profile, and architectural structures are represented by only their front planes. In older examples, sumptuous and elaborately patterned fabrics are depicted in a highly stylized manner. The scroll tradition has stylistic antecedents in the mural painting of the Vijayanagara period of the fifteenth and sixteenth centuries and in forms of painting that developed in South India under later Nayak rule from the sixteenth to the eighteenth century; the tradition has many stylistic affinities with the painted and printed temple cloths of the region, which are known as *kalamkari*.[9] On the whole, older examples are more refined and closer to these sophisticated regional traditions of Hindu painting than are recent examples, a fact that strongly suggests that the same artists who painted murals for the small courts of Hindu rulers or powerful hereditary Hindu landlords in Telangana also worked for common people.[10] The two examples of Andhra scrolls presented here (nos. 36–37), separated by a little more than a century, reflect something of the evolution of the tradition from a more sophisticated style to a more folkish one.

The narrative images are painted on cotton fabric that has been specially grounded with several applications of a gum, starch, and chalk mixture that is burnished with a smooth stone between layers. Most colors (except for black), while formerly prepared by the artists, are purchased today as ready-made powders, which are then mixed with water and a gum binder. Old scrolls are repaired and repainted until unusable. When a storyteller needs a new scroll, he may bring the old scroll to the artist for copying, or he may dictate the story to the artist, who sketches the episodes.[11] The storyteller supplies the artist with the cloth support for the new scroll and pays for the painting in cash or with clothing, grain, and a goat. The old painting, believed to no longer be able to function as the material form into which the deity descends, is given a ritual cremation and immersed in a river. Some scrolls are inscribed in Telegu

with the names of the donors, artists, witnesses, and date of gift; if the owner-ship of a scroll is transferred, the original inscription is effaced and a new one written.

The artists of this tradition are Telegu-speaking Hindus of the Nakash caste. Besides producing scrolls, the artists also paint murals, palanquins, and wooden dolls used by narrators of the Katamraju (also called Karihavala Raju) legend (no. 101), as well as portable shrines with narrative panels used by other professional storytellers.

The tradition, of unknown duration, has only recently been discovered. The earliest collected examples date from 1625 and from 1775 to 1875. Until the late 1930s, there were apparently painter families in many villages and temple towns throughout Telangana. Today, the increasing popularity of modern forms of entertainment has diminished the demand for Andhra scrolls, which never-theless continue to be made by at least one family in the village of Cheriyal in Warangal district.[12]

Representative Works: Andhra or Telangana Scroll Paintings, nos. 36–37

36. Fragment of a scroll painting perhaps illustrating the story of Virata (*Virata Parva*) in a Telegu version of the *Mahabharata*, for use as a visual prop in story-telling performances
Andhra Pradesh, Telangana
1860–70[13]
Opaque water-based pigments on cotton cloth
64½" x 36" (163.8 cm x 91.4 cm)
Subhash Kapoor

This fragment of an Andhra scroll painting has been conserved by attaching it to two other fragments of the same narrative work, which perhaps illustrates the story of Virata or *Virata Parva* (literally, Book of Virata) from a Telegu ver-sion of the *Mahabharata*.[14] In this part of the epic, the five Pandava brothers set out to reclaim their kingdom after twelve years of exile in the forest. This part of the story is named after King Virata, with whom the Pandavas and their joint wife, Draupadi, though in disguise, seek refuge and employment. Their assumed identities include Yudishthira posing as a Brahmin games-master, Bhima (also transliterated Bheema) as the king's cook, Arjuna as a transvestite dance teacher, and Draupadi as the queen's chambermaid.

The characters in the story can be identified on the scroll fragments as fol-lows: Yudishthira, brown-haired with a beard and topknot and dressed in a yel-low or pink *dhoti* (lower garment); Bhima, blue-skinned and dressed in a turban and yellow *dhoti* with red dots; Arjuna, white-skinned and crowned; Draupadi, dressed in a pink or white sari and a white, pink, or dark blue *choli* (bodice); King Virata, pink-skinned, crowned, often dressed in a dark blue or pink *dhoti*; and Kichaka (also transliterated Keechaka), his minister and brother-in-law, yellow-skinned, usually dressed in dark blue *dhoti*.

In its present sequence, the first fragment or section of the scroll (which has six registers) narrates the story of Kichaka being killed by Bhima for his unto-

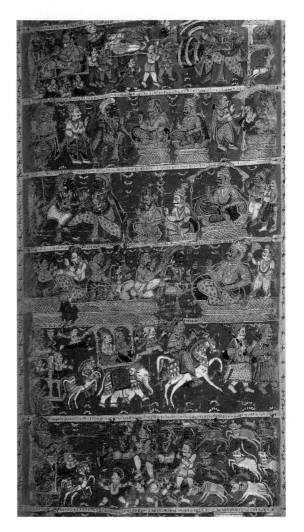

36

ward advances to Draupadi. The iconography suggests a local version of the story: Kichaka is shown decapitated and dismembered, rather than reduced to a ball of flesh and bone as recounted in the Sanskrit version.[15]

The second fragment or section of the scroll, chosen for illustration here, may portray the heroes of the *Mahabharata* in episodes also peculiar to local oral tradition; the scenes on its six registers—which do not correspond to narratives in the Sanskrit version—are described from right to left. 1. Bhima swirls two uprooted trees; Draupadi and a man are carried on a litter; Yudishthira speaks with Bhima. / 2. Draupadi speaks with the queen; King Virata and Yudishthira receive a brown-skinned wrestler; King Virata departs. / 3. King Virata, Yudishthira, and other royal figures watch Bhima fight the wrestler. / 4. The wrestler talks with King Virata; three Pandava brothers, disguised as sages, look on, while Arjuna, also disguised as a sage, talks with a Brahmin man(?). / 5. From left to right: preceded by foot soldiers and followed by three crowned figures in a chariot, King

Virata and Yudishthira ride into battle on an elephant. / 6. Herders, followed by cattle, confront in battle two crowned figures in a chariot.

The third fragment or section of the scroll has seven registers illustrating processions into battle, cattle raids, and victory celebrations in a palace.

The style of this nineteenth-century scroll is highly refined and is related to sophisticated mural and miniature painting traditions of the region, particularly those that developed in South India under the Nayak rulers from the sixteenth to the eighteenth century.[16] The style suggests a close connection between the artists who served the Hindu aristocracy (landlords) of the region and the storytellers who carried scrolls to villages to entertain common people. All registers have background planes that are characteristically painted a rich red and are typically bordered by narrow yellow bands embellished with a small scrolling floral pattern. Draupadi's pink sari, exquisitely rendered with a purple red geometric and floral design, is an example of the careful attention given to the attire of the figures.

37. Fragment of a scroll painting perhaps illustrating the story of Virata (*Virata Parva*) in a Telugu version of the *Mahabharata*, for use as a visual prop in story-telling performances
Andhra Pradesh, Warangal district, village Cheriyal
CA. 1975, by D[analakota] Chandraiah[17]
Opaque water-based pigments on cotton cloth
34¼" x 47¼" (87.0 cm x 120.0 cm)
Chester and Davida Herwitz Collection

This fragment of a scroll is one of six sections of the same narrative work, all found in the same collection; the fragments appear to relate to the story of Virata (*Virata Parva*; literally, the book of Virata) in a Telugu version of the *Mahabharata*, as described in the previous entry (no. 36). Other narratives from

37

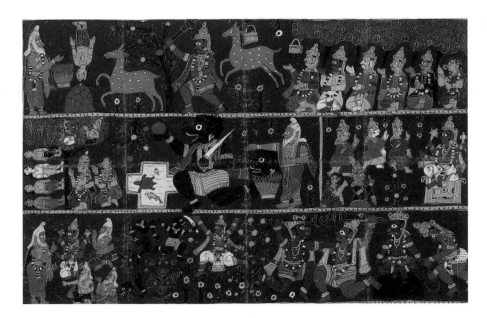

local versions of the *Ramayana* and from the local legend of Krishna have also possibly been interpolated.[18] (It is also feasible that the familiar iconography of the characters from several universal Indian epics has been adapted to illustrate an unidentified local legend, perhaps recounting the origin of a social group or caste in the region, with its own heroes and villains.)

Pictorial elements relating to the story of Virata include the apparent presence of the Pandava brothers and their joint wife, Draupadi, in several registers of the various fragments of the scroll. For example, in one section the brothers and Draupadi, all in disguise, appear to approach King Virata for employment as previously described (see no. 36). The famous incident of Draupadi being disrobed by her husbands' rivals (while her sari is continuously restored by the god Krishna) is probably found on another fragment. Throughout the sections of the scroll, the throne of King Virata is clearly marked with an image of a fish—in Sanskrit *matsya*—which is also the name of his kingdom.

The scroll fragment with three registers chosen for illustration here may represent a local version of the story of Virata, that is, it may be a folk tale with *Mahabharata* characters that occurs only in the oral tradition of Telangana and is not found in the classic Sanskrit version of the epic. The narrative scenes on the registers are described from right to left. 1. The Pandavas and Draupadi sit in the forest; a blue-skinned wrestler chases a spotted deer; a sage addresses a man, near a sacrificial fire and a body of water. / 2. Four Pandavas, without Bhima (also transliterated Bheema), sit with Draupadi around Krishna; a sage burns the severed head of a dark-skinned demon; the same demon holding a ball and a sword runs past a pond; a royal couple converses with four Pandavas under a tree in which Krishna and the king appear. / 3. A blue-skinned wrestler pulls the tail of a monkey-bird demon; the same figures engage in a fight; Krishna battles and dismembers the dark-skinned demon; Krishna sits with sages before a sage.

The background plane of all registers is typically painted a deep red; the narrow yellow bands separating the registers display an abstracted design of dots probably representing flowers. The figures are more coarsely drawn than are those of the previous scroll fragment (no. 36). A comparison of the two fragments, one from CA. 1860–70 and the other from CA. 1975, demonstrates something of the evolution of the Andhra scroll tradition from a courtly to a folkish style.

Bengali Scroll and Single-Image Paintings

Introduction

Bengali scroll painting, a narrative pictorial tradition linked with performance, disseminates India's rich cultural heritage of sacred and secular stories to village peoples throughout the present-day state of West Bengal. The tradition, which is apparently ancient, has flourished in many districts of Bengal, including Midnapur, Twenty-Four Parganas, Hooghly, Howrah, Burdwan, Bankura, Birbhum, and Murshidabad.

The most characteristic artifact of the tradition is the vertical scroll known as a *jarano pata* (rolled painting) or simply as *pata* ([painting on] cloth or paint-

ing, pronounced like the English word "pot"), which functions as a visual prop in storytelling. Composed of a varying number of panels sequentially depicting the story's episodes, the scroll is attached to bamboo poles at beginning and end to facilitate rolling. The story literally and visually unfolds as the performer rolls and unrolls the scroll, showing a few registers at a time and chanting or singing *a capella* specially composed lyrics that recount the episodes of the story. In the Bengali tradition, the painter may or may not also compose these lyrics; moreover, he may or may not serve as the itinerant storyteller who travels from village to village with a cloth bag filled with scrolls, ready to perform for a small remuneration a variety of requests for different stories as he knocks on many doors.[19]

The scrolls illustrate mythological stories in Bengali versions of the epics, the *Ramayana* (nos. 40–41) and the *Mahabharata*, as well as other local legends (nos. 38–39) and secular narratives of social, political, or historical interest. These stories, whether religious or secular, often have a strong moral message. In recent centuries, scrolls have been produced for Hindu and Muslim and even Christian audiences. Religious subjects include episodes in the lives of Rama and Krishna (incarnations of the god Vishnu) and of Chaitanya (1485–1533), the inspirational founder of a devotional movement that fostered worship of Krishna. Religious scrolls may also celebrate the powers of deities such as the Great Goddess Durga or the snake goddess Manasa (revered by both Hindus and Muslims) with stories of the miraculous deliverance of their devotees. Of special importance in stories of deliverance are Bengali scrolls honoring Yama, the god of death, and his power to punish sinners, reward the just, and occasionally release souls from the fate of death; known as *Yama patas*, these scrolls are a regional manifestation of a broad-based didactic Indian tradition of depicting the punishments of hell meted out by the god of death to those who have sinned; whole scrolls or the final panels (no. 39) may be devoted to this theme. Secular scrolls may illustrate historical events, such as the nineteenth-century uprisings against the British or the profound changes in India after the withdrawal of the British in 1947, a common present-day theme. Secular subjects may also deal with social issues such as in-law problems and the evils of the dowry system, family planning, education of the masses, and financial planning and saving. Sometimes secular and religious themes are hybridized in a single scroll: a 1986 scroll on the life and times of Indira Gandhi glorifies the assassinated political leader, showing her apotheosis in the final panel as she is lifted into heaven by the god Vishnu.[20]

The Bengali scroll is typically divided into a number of mostly horizontal panels, which are bordered by a decorative band with scrolling, stylized pink or red flowers and green foliage. Scroll lengths vary. Exceptional length (more than forty feet) is required for certain themes, such as the legend of the tigers' god (no. 39). Most scrolls run from twelve to sixteen feet and are one to two feet wide. Scroll narratives are generally painted on sheets of paper that have been pasted together end to end and then mounted on cloth for greater durability. In recent production the paper may be commercially produced or may even be inexpensive newsprint that has been coated with a paste of lime or chalk and then smoothed. Scrolls made of thin paper that are not mounted on cloth suffer

greatly from the rough use they endure in performance and may require periodically mending on their reverse sides; all manner of paper scraps, including sheets from old ledgers and newspapers, may be used for repair. Although it is traditional for the artists to prepare their own colors, some painters report at least partial use of purchased colors,[21] a fact evident in many contemporary scrolls' employment of a harsh new crimson (achieved by mixing red and white) and chartreuse green.

The style of Bengali scrolls varies considerably, according to district and time of origin. For example, scrolls from the district of Midnapur frequently feature a single monumental seated figure, usually a deity, at beginning and end, while scrolls from Hooghly display abstracted profile figures, archaic in feeling, arranged in a friezelike manner against a dark orange background.[22] Scrolls surviving from perhaps the beginning of the nineteenth century and collected in Murshidabad (nos. 38–39) are characterized by a hieratic quality, a miniature-like refinement, extremely rich color, and a strong red background, possibly reflecting the influence of Rajasthani court painting. Scrolls created at the end of the nineteenth century, also collected in Murshidabad, portray the human body more realistically but with less careful attention to detail, less patterning, and less subtle coloring—an influence perhaps from concurrent Kalighat painting in Calcutta (see nos. 17–23). Finally, in recent scrolls, figures are stylized, but their rendering is relatively loose; the painting has evidently been produced more hastily than in the distant past, and the palette has been affected by the introduction of commercial pigments.[23] The contemporary mode in scroll painting is generally cruder, though no less vital, dramatic, and appealing than its antecedents.

Despite these stylistic differences, certain compositional similarites in the use of lively figural arrangements, minimal architectural descriptions, and certain iconographic conventions for the representation of deities and other subjects are common in scrolls from various locales. According to one scholar, these common compositional features are also found in the narrative terra-cotta friezes of brick temples—at least those dating from the eighteenth and nineteenth centuries—that are situated in the same rural areas where scroll painters worked. (An alert viewer can also note a remarkable overall similarity in the panel organization of narratives and in the banding of panels with scrolling floral designs in the two forms.) It is difficult to determine, however, whether these aspects of narrative scroll painting for the village peoples of Bengal were derived from the relief sculpture of its rural temples or whether scroll painting was, in fact, the latter's source.[24]

The artists, performers, and lyric composers of this painting tradition belong to a so-called low caste that occupies an ambiguous position in relation to both Hindu and Muslim orthodoxy. Their exact origin is unknown. Apparently Hindu at some time in the past, members of this group converted to the Muslim faith to escape caste discrimination, but, without full acceptance into Muslim communities through intermarriage, they have remained outside both Hinduism and Islam, adapting a mixture of religious and social customs from both faiths. In the early 1970s, many caste members were reported to have two names: exercising their Muslim identity, they were known as Patuas (scroll

painters) or Patidars; exercising their Hindu identity, they were known as Chitrakars (picture makers).[25] The scroll painters and performers of this caste are usually male, while women traditionally make clay dolls and toys.

In the past, when the style of the scrolls was closer to that of miniature paintings, the caste may have illustrated handwritten manuscripts known as *puthis* for scribes and also produced painted wooden covers known as *paataas* for these manuscripts.[26] Related stylistically to Bengali scroll paintings are single-image iconic and narrative paintings that are known as *chaukas* or *chaukash patas* (square paintings) but in fact are almost always rectangular; unlike scroll paintings, which are retained by Patua or Chitrakar families for use as visual props in their storytelling performances, single-image paintings are made for sale at fairs, marketplaces, and holy places (no. 42). A form of painting also akin to Bengali scroll paintings in style, though ritualistic in function, is the *chalachitra* (literally, top painting), executed on a semicircular band (currently of paper) divided into rectangular panels and intended to adorn the space above clay images of deities, such as Durga, that are installed for worship at certain festival times.[27] Some of the latter types of paintings may, however, be produced by artisan castes other than the Patuas or Chitrakars.[28]

As part of the culture of Eastern India, Bengali scroll paintings have been appreciated, documented, and collected since at least the 1920s. Though threatened by the new narrative media of film and television and by economic and social changes, the Bengali scroll tradition endures even to this day in remote rural areas.

Representative Works: Bengali Scroll and Single-Image Paintings, nos. 38–42

38. Fragment of a scroll painting (*pata*) illustrating a folk legend, for use as a visual prop in storytelling performances
 West Bengal, Murshidabad district
 CA. 1800
 Opaque water-based pigments on paper
 75⅝" x 14³⁄₁₆" (192.0 cm x 36.0 cm)
 Victoria and Albert Museum, I. S. 106-1955

Collected in Murshidabad, this finely painted fragment of a narrative picture scroll with only ten panels or registers has been variously identified as depicting the legend of Krishna,[29] the legend of Rama,[30] and an unknown folktale.[31] More recently, it has been suggested that the fragment was perhaps originally part of a much longer scroll, also collected in Murshidabad, that illustrates both Hindu and Muslim themes but chiefly concerns a tigers' god who is a Muslim holy man.[32] The longer scroll is discussed in the following entry (no. 39).

Descriptions of the scenes on this fragment follow; the fifth panel is illustrated. 1. A Brahmin man weighs a woman, portrayed miniaturized, in a balance; three Brahmin men look on. / 2. The same woman, portrayed in normal scale, is carried in a palanquin by four bearers led by a Brahmin man holding a sword. / 3. The woman, guarded by tigers and cobras, lies on a low bed in a

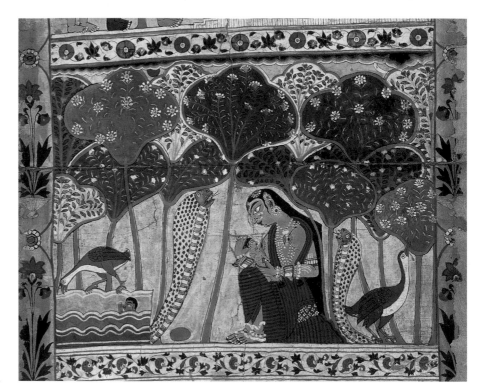

38, detail

forest. / 4. A soldier (?), a tribal man, and a Brahmin man converse with a ruler seated in a palace. / 5. The woman, sitting on the forest floor under flowering trees and guarded by cobras, cuddles a newborn baby; a male child swims nearby (illustrated). / 6. The woman, lying on a low bed under a sun and a moon and guarded by tigers and cobras, breast-feeds the baby. / 7. A Brahmin man, holding a sword and perhaps directed by another Brahmin man sitting within a pavilion, confronts a Muslim man. / 8. Four Brahmin men beat the same (or another) Muslim man; the same (or another) Muslim sits under a tree. / 9. Under a moon, three Brahmin men sit, conversing, outside the ruler's pavilion; a woman and a man, also outside, address a Brahmin man who is being held with bound hands inside the palace. / 10. Under a moon, five Brahmin men worship a four-armed, blue-skinned god seated in yogic posture.[33]

The detailed presentation of pictorial elements and their refined execution place this scroll fragment at the beginning of the nineteenth century and connect it with courtly traditions of painting. Throughout the registers, the bounty of nature is lovingly observed and painstakingly recorded, though in a highly stylized manner. Of particular interest is the depiction of trees; each tree's foliage and trunk, or whole, are enclosed by a distinctive leaf shape, or part, and the macrocosm is seen in the microcosm—repeatedly. The clouds of the approaching monsoon are represented by neatly scalloped swaglike forms, occasionally punctuated by daggerlike shapes; these abstractions of clouds are

banded with graduated values of deep blue and run along the entire top edge of many registers. A sympathetic interest in animals, enlivening many kinds of Indian art, here informs the portrayal of entirely benign snakes and tigers and anthropomorphizes especially the latter. For example, in the third register, two tigers sit in profile in mirror symmetry, their smiles and posture derived from a human model and their paws rendered like human hands and feet; in the sixth register, one of the tigers is shown with his mouth half-opened as he watches and perhaps mimics the breast-feeding baby. The registers are bordered by bands with varied floral motifs of Mughal origin; the designs on the vertical bands are in larger scale and are more realistically representative than those on the horizontal. These bands, as well as many other stylistic features, are very similar to those of the scroll in the following entry (no. 39). If not originally part of that scroll, this fragment was undoubtedly produced by the same artist(s) or artist family.

Reproduced (details): regs. 5–6, Stella Kramrisch, *Unknown India: Ritual Art in Tribe and Village*, exh. cat. (Philadelphia: Philadelphia Museum of Art, 1968), p. 113, no. 366; regs. 2–3, Robert Skelton and Mark Francis, eds., *Art of Bengal: The Heritage of Bangladesh and Eastern India*, exh. cat. (London: Whitechapel Art Gallery, 1979), front and back cover; regs. 2–3, Deva Prasad Ghosh, *Mediaeval Indian Painting, Eastern School (13th Century A.D. to Modern Times Including Folk Art)* (Delhi: Sundeep Prakashan, 1982), pl. 60.

39. Scroll painting illustrating the legend of a tigers' god as a *ghazi* (Muslim saint) and scenes from Death's kingdom (*ghazi pata*), for use as a visual prop in story-telling performances
West Bengal, Murshidabad district
CA. 1800
Opaque water-based pigments on paper
520½" x 14⅟₁₆" (1322.0 cm x 35.8 cm)
Trustees of the British Museum, OA.1955.10-8.095

Although this extraordinary Bengali picture scroll is missing its opening and probably also its final registers, it is still more than forty-three feet in length and comprises fifty-seven registers.[34] Its main subject is a tigers' god—one of the many tigers' gods in India, locally venerated in many areas for their power and their control over the tigers that threaten the lives of humans and cattle. Known by a multitude of names and propitiated by different social groups, these tigers' gods (and one documented goddess) are variously identified as demons, divine or deified beings, or the spirits of dead tigers or of humans killed by tigers that, according to their varying natures, may prevent further depredation of human life—or of the tiger population. Such tigers' gods are given anthropomorphic or zoomorphic forms. Control of tigers for the benefit of humans may also be wielded by living (or fictional) persons with special spiritual powers, such as Muslim fakirs, Hindu yogis (ascetics), and tribal priests.[35] Accordingly, it is not surprising that these exceptional human beings have come to be regarded as gods and have been propitiated for protection from tigers.

In Bengal, one such person, celebrated as a tigers' god, was known as a *ghazi* (Muslim holy man or religious mendicant; also, a brave man or hero-

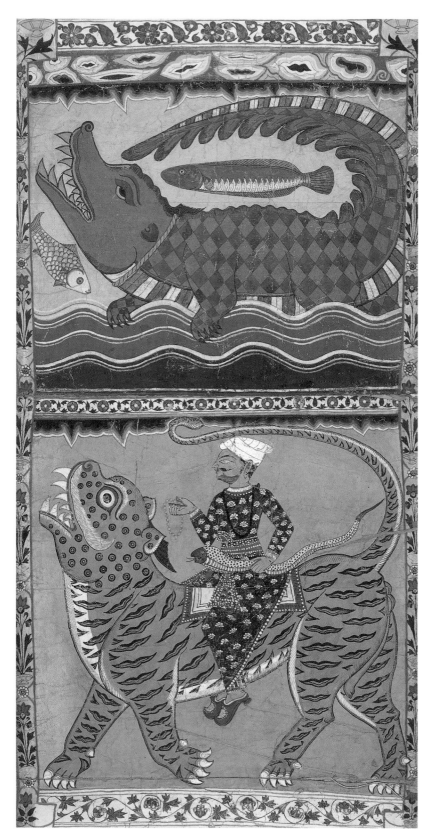

39, detail

defender of the Muslim faith). The cult of this saint or *pir* (literally, elder; also, religious leader, guide), called Barekhan Ghazi, was popular among both Hindus and Muslims and is said to have originated in the tiger-infested jungles of the Sundarbans region (part of the present-day district of Twenty-Four Parganas, West Bengal, and of Bangladesh) where the Muslim saint is believed to have feuded with a Hindu tigers' god Dakshin Ray (lord of the South) for supremacy. Unlike the cults of other tigers' gods, that of Barekhan Ghazi manifested itself in the creation of special scroll paintings (called *ghazi patas*) in which the Muslim holy man is represented riding on a tiger and carrying a string of prayer beads and a specially shaped staff, actually a double axe, known as an *asha danda* (staff of hope) and also called a *ghazir danda*. These scrolls are said to depict Barekhan Ghazi's deeds and especially the punishments he inflicts on those who refuse to make offerings to him. The painting practice of the cult of Barekhan Ghazi apparently spread to other parts of Bengal and also to Bihar, where scrolls came to feature different tigers' gods (see no. 44).[36] According to other accounts, *ghazi patas* were created for use by Muslims in proselytizing among Hindus, as such scrolls relate the miraculous powers of a Muslim saint.[37] *Ghazi patas* are also said to reflect the triumph of Islam orthodoxy over Hindu folk cults in Bengal, as they portray the *ghazi* victoriously mounted on a tiger—a symbol of the tigers' god Dakshin Ray, propitiated by various so-called low-caste Hindus who worked in the jungles as lumbermen and collectors of wild honey.[38] This "victory" may have rested on an economic foundation: the figure of the *ghazi* with control over tigers is presumed to have emerged around the same time as the initial expansion of Muslim settlements in the Sundarbans.[39] According to yet another scholar, *ghazi patas* narrate the struggle for ascendancy between a Muslim holy man and the tiger-worshiping Hindu ruler of the Sundarbans, where the royal Bengal tiger itself was propitiated with food offerings by both Muslims and Hindus; *ghazi patas*, representing the victorious Muslim saint symbolically riding a tamed tiger, are said to be popular principally with Muslims and are hung like a festoon, providing the visual backdrop for the sung narration of the tale.[40]

The details of the legend of the particular tigers' god as *ghazi* that this scroll illustrates are not fully known.[41] Study of the legend and its variations in Bengali folk ballads and literature, in conjunction with further study of narrative scrolls illustrating the same subject, may reveal something more of this *ghazi*'s life and deeds, even if the exact verses that were chanted while this scroll was displayed in the early nineteenth century may never be discovered.[42] The forty-third register of this *ghazi pata* features an emblematic, quasi-iconic profile presentation of the tigers' god as a bearded Muslim saint, wearing a white turban, a dark green fitted coat embellished with a floral pattern, and striped trousers; the saint holds a string of prayer beads in one hand and a snake in the other while he rides a tiger that displays both spots and stripes and that is also drawn in profile (illustrated).[43] The preceding register (the forty-second) (also illustrated) shows a magnificent crocodile in profile. The pairing of these profile images creates a powerful visual rhyme, reinforced by the parallel placement of the animals' open mouths, bared teeth, and highly held tails that coil headward. More than a visual device, the artist's sensitive juxtaposition may

symbolize the *ghazi*'s power over not only tigers but also crocodiles.[44] Besides an occasional register showing tigers offering obeisance to their mendicant-god, the scroll has a number of registers that depict men and women, many of whom can be identified as Hindus, presenting food and drink to the *ghazi*, as well as greeting or hailing him or prostrating themselves before him. Other registers show pilgrims, including an ascetic, venerating the *ghazi* (or other saints) interred in Islamic tomb shrines. Portrayal of incidents of childbirth and childcare, including a woman squirting milk from her breast, perhaps as a demonstration of her ability to nurse a child, may be related to the wonder-working powers of the *ghazi*; certain Muslim saints (not all of whom are re-garded as tigers' gods) are traditionally invoked by devotees seeking, among other requests, a cure for barrenness and for the inability to produce milk in both humans and cows.[45] The eighteenth register of this scroll, in fact, shows this *ghazi* putting his finger in the nostril of a cow; it is the *ghazi*'s healing touch that is probably causing milk to flow from the cow's udders.[46] Scenes showing incidents of catastrophic fire, the death of a herd of cows, and the fall of a Hindu bearer from snakebite may illustrate punishments inflicted by the *ghazi* on those who did not make offerings to him.[47] Yet other registers por-tray a Hindu ruler within his palace, with whom the *ghazi* may be vying for power.

The scroll's fifty-seventh and final register shows a river filled with severed heads and limbs, representing the mythical river Vaitarni, which is crossed by the dead on their way to Death's kingdom. It is probably not the original final register, since *ghazi patas*, which typically conclude with scenes of the afterlife and of punishments inflicted on sinners in hell, usually show further scenes of Death's kingdom with a feature peculiar to Bengal: the image of the boiling and eating of sinners' heads by the mother of Yama, the god of death.[48]

The scroll may originally have had the ten registers of the scroll described in the previous entry (no. 38), also collected in Murshidabad, attached to what is currently its first panel;[49] if so, the scenes on those ten registers may deal with the *ghazi*'s early life. Stylistically similar in their description of figures and landscapes and both painstakingly painted, these two narrative scrolls have antecedents in Mughal and Rajasthani court painting traditions.[50] As previ-ously pointed out, the registers of both scrolls are similarly bordered with bands with varied floral motifs in two widths. The choice coloring of this scroll (with emphasis on deep Indian red) is the work of a master artist.

Reproduced (details): selected regs. (including 42–43, 57), T. Richard Blurton, "Continuity and Change in the Tradition of Bengali Paṭa-Painting," in *Shastric Traditions in Indian Arts*, ed. Anna Libera Dallapiccola et al. (Stuttgart: Steiner Verlag Wiesbaden GMBH, 1989), vol. 2, figs. 152–61; se-lected regs. (including 42–43), T. Richard Blurton, "Scroll-Paintings in the British Museum from Murshidabad District," in *Patua Art: Development of the Scroll Paintings of Bengal Commemorating the French Revolution*, by Alliance Française of Calcutta and Crafts Council of West Bengal (Calcutta: Alliance Française, [1991]), pp. 32–37.

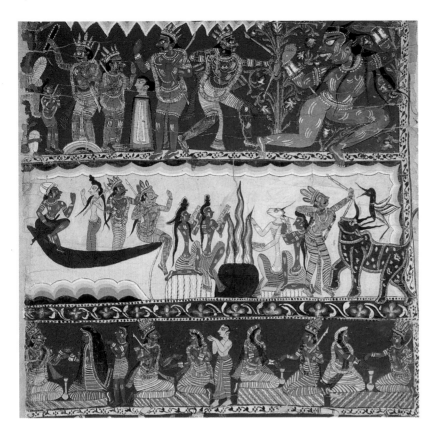

40, detail

40. Fragment of a scroll painting depicting episodes in a Bengali version of the *Ra-
mayana* (*Ramayana pata*), for use as a visual prop in storytelling performances
West Bengal
Early 19th century
Opaque water-based pigments on paper
51¾" x 23"" (131.4 cm x 58.4 cm)
Trustees of the British Museum, 1994.4-13.01

The eight registers of this beautifully drawn and richly colored fragment of a
narrative scroll illustrate important episodes in the first three books of the *Ra-
mayana*. The order of the registers and their depicted episodes from top to bot-
tom does not correspond to the sequence established in the Sanskrit version of
the epic by Valmiki or in any of the several Bengali versions of the story, the
more likely source of the illustrations on this scroll fragment.[51]

Most of the registers illustrate more than one episode. Descriptions of the
scenes on the registers follow; the first three registers are illustrated. 1. From
right to left: Rama slays the female demon Tataka; Rama and Lakshmana ob-
serve the nymph Rambha, who has been turned to stone by the sage Vishvami-
tra; Rama holds a vertical form over a small sage (unidentified episode). / 2.
From left to right: Rama, Lakshmana, and Vishvamitra traverse a sacred river;
the sage Bharadvaja and his disciples, reading scriptures, sit around a sacrificial

fire; Rama aims his bow upward, confronted by a bird astride a bull (unidentified episode). / 3. King Dasharatha's four sons, Rama, Bharata, Lakshmana, and Shatrughna (also transliterated Satrughna), marry four princesses on the same day. / 4. Musicians play and dancers perform at the wedding festivities. / 5. The brides and grooms are carried in wedding palanquins. / 6. From right to left: Rama, challenged by Parashurama, bends Vishnu's bow; a Brahmin blesses Sita as Rama takes her out of the women's quarters and his father's three wives look on. / 7. From left to right: Rama, Lakshmana, and Sita, dressed as ascetics, depart for exile; a Brahmin laments; women lament. / 8. From right to left: Rama and Sita, seated, watch Lakshmana cutting off the female demon Shuparnaka's nose; Rama and Lakshmana confront a warrior (unidentified episode).

Particularly noteworthy in the stylization of the figures are the elongated torsos of twin sages who sport topknots and undulant hanks of uncut hair and sit near a fire whose flames coil like their own hair. Architectural and landscape elements are minimally described and highly abstracted: for example, mountains, waves of water, and cloud cover are defined by bands of calibrated shades of blue, the first in a jagged zigzag, the latter two in refined scallops. All but two registers, which are painted a cool white, have plain background planes of deep red. The patterned bands that typically border each panel are here narrow and very crisply executed; those that are horizontal are varied from register to register in motif and scale. The artist's meticulous rendering places this scroll fragment in the early nineteenth century.

Reproduced: J. LeRoy Davidson, *Art of the Indian Subcontinent from Los Angeles Collections*, exh. cat. (Los Angeles: University of California, 1968), p. 115, no. 193.

41. Two fragments of a scroll painting illustrating episodes in a Bengali version of the *Ramayana* (*Ramayana pata*), for use as a visual prop in storytelling performances
West Bengal, Birbhum district
Late 19th century
Opaque water-based pigments on paper
Left: 84½" x 21¼" (214.6 cm x 54.0 cm)
Right: 86¼" x 19¼" (219.1 cm x 48.9 cm)
Philadelphia Museum of Art, Gift of Stella Kramrisch, 64-169-4 (left), 64-169-3b (right)

These two scroll fragments depict with extraordinary visual power many significant episodes of the *Ramayana* as related in one of several Bengali versions, perhaps that of Krittivasa (mid-fifteenth century).[52] The episodes on the fragment on the right precede those of the fragment on the left; identification of these episodes follows. 1. From right to left: Sita and Rama sit in their forest hut; Lakshmana cuts off the nose of female demon Shuparnaka, Ravana's sister; Shuparnaka entreats Ravana to abduct Sita. / 2. From left to right: Sita and Rama sit in their hut; Rama pursues the demon Maricha disguised as a golden deer. / 3. From right to left: Protected by a magic line or circle, Sita urges Lakshmana to leave her side to look for Rama; two men stand on either side of a tree (unidentified episode). / 4. From left to right: Rama stands to the right of a hut;

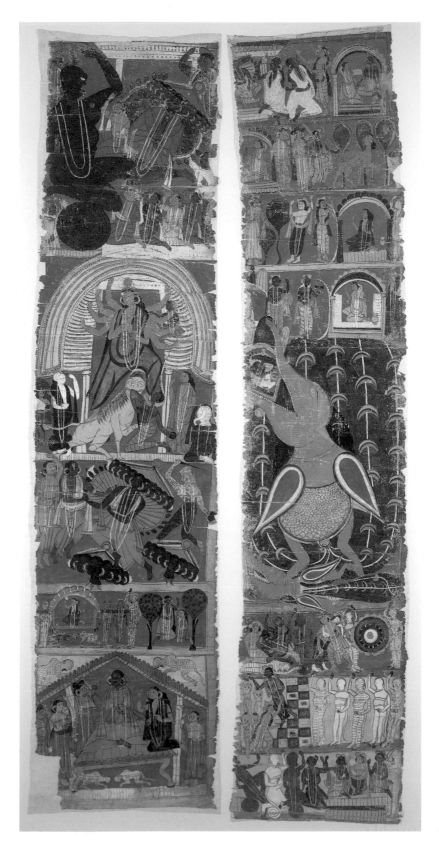

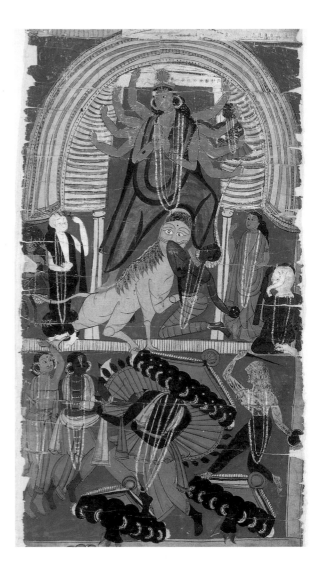

41, detail

Ravana, disguised as a holy man, approaches Sita, protected by a magic line or
circle. / 5. In his effort to rescue Sita, the bird Jatayu attempts to crush in his
beak Ravana's chariot containing the demon and Sita; below, Jatayu lies mor-
tally wounded by Ravana. / 6. From left to right: Rama slays Bali, the king of
the monkeys; monkeys stand on either side of a circular form (unidentified
episode). / 7. From right to left: Sugriva and four monkey allies hail Rama and
Lakshmana, who, with the monkey army, build the bridge to Lanka. / 8. Rama
and Lakshmana strike a deal with Sugriva and four monkey allies.

Identification of the episodes on the scroll fragment on the left follows.[53]
The second and third registers are illustrated in detail. 1. The monkey Angada,
Bali's son, sitting on his coiled tail, confronts Ravana. / 2. Before his battle
with Ravana, Rama fashions a clay festival image of the Great Goddess Durga,
the slayer of the buffalo demon, which he, Lakshmana, and Sita then worship.
/ 3. Rama with a special dart, Lakshmana, and a warrior battle Ravana, whose

ten heads, although severed twice, have magically regenerated. / 4. From left to right: Monkeys carry Sita out of Ashoka Grove; Rama is reunited with Sita. / 5. With Lakshmana at their side, Rama and Sita sit enthroned in a palace while three allies hail them and monkeys offer homage.

Several of these scenes illustrate episodes or details that are peculiar to Bengal and that are not found in the Sanskrit version of the *Ramayana*. In the first register of the scroll fragment on the left, the portrayal of the confrontation between Ravana and the monkey Angada, which provides comic relief and is a favorite of Bengali audiences, closely follows Krittivasa's Bengali text: "[Angada] looked so formidable with his mountainous body and eyes that glowed like stars and head about to touch the skies. . . . Angada has kicked open the doors and entered. With one leap he was in. Coiling his great tail, he made a seat for himself and sat on it, and looked around."[54] In the second register of the scroll fragment on the left (illustrated in detail), Rama's fashioning and worshiping a clay festival image of Durga before going to battle is portrayed as described in Krittivasa's Bengali version; there, as in other Bengali texts, it is recounted that Rama initiated the celebration of a festival of the warrior goddess in the autumn when he needed her help for victory (a festival of Durga had formerly been celebrated only in the spring.)[55] Rama is shown in the upper right actually shaping the arms of the clay figure under the semicircular framework traditionally made for such festival figures; the framework usually supports a painting divided into registers with narrative scenes and iconic images of the Great Goddess, although such a painting (known as a *chalachitra*) is not seen here, probably for reasons of scale. In the third register of the same fragment (also illustrated in detail), Ravana's regenerating heads are pictured as described in Krittivasa's account of the battle: "One by one, Rama shot his deadly weapons and beheaded Ravana's ten heads with their jewelled helmets. But ten more exactly the same sprang up from the shoulders and Ravana fought with redoubled vigor."[56] In the seventh register of the scroll fragment on the right, it is interesting to note that the artist shows both Rama and Lakshmana putting bricks in place while in Krittivasa's Bengali version, only Rama is mentioned as doing so.[57]

The two scroll fragments are richly colored in deep blue, red, flesh tones, black, and white. Particularly noteworthy is the visualization of Jatayu, the giant bird, attempting to rescue Sita: actually a vulture, he is portrayed as a peacock with his spread patterned tail filling, like a great temple cloth, the entire length and width of the background plane of an unusually long vertical panel.[58] All but one register of the scroll fragment on the left are also enlarged panels, indicating their importance as culminating episodes in the Bengali version of the story.

Reproduced (detail): scroll fragment on the left, reg. 2, Deva Prasad Ghosh, "An Illustrated *Rāmāyana* Manuscript of Tulsīdās and Paṭs from Bengal," *Journal of the Indian Society of Oriental Art* (Calcutta) 13 (1945): pl. 12; Deva Prasad Ghosh, *Mediaeval Indian Painting, Eastern School (13th Century to Modern Times Including Folk Art)* (Delhi: Sundeep Prakashan, 1982), pl. 93; Bishnu Dey and John Irwin, "The Folk Art of Bengal," *Mārg* (Bombay) 1, no. 4 (1944): 50.

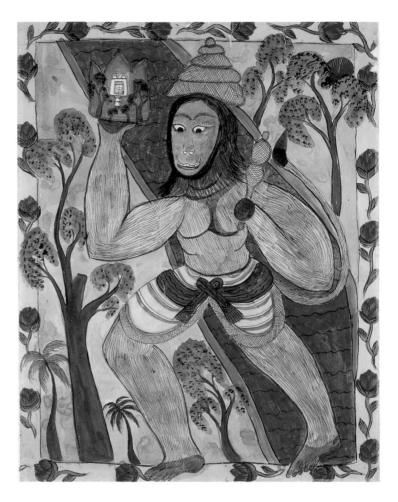

42

42. Iconic image of Hanuman, the monkey chief, carrying the mountain of medicinal herbs, for display at festivals and fairs
West Bengal, Midnapur district, village Nirvayapur
CA. 1985, by Gauri Chitrakar
Probably tempera on paper
28½" x 22⅛" (72.3 cm x 56.2 cm)
Private collection

This single-image painting depicts a famous episode in the *Ramayana* that demonstrates the ability of Hanuman, the heroic monkey chief, to overcome obstacles. When the hero-god Rama, his brother, Lakshmana, and scores of monkey and bear soldiers have apparently fallen in a great battle, Hanuman assumes gigantic scale, flies over the ocean, and hastens to the Himalayas to obtain four kinds of healing herbs that grow on a special mountain; unable to distinguish the herbs from other vegetation, he tears out the entire mountain and carries it back to the battlefield so that the medicinal herbs can revive the fallen.

The single-image work was created by Gauri Chitrakar, a woman who belongs to a family of the painter caste and has taken up scroll-painting, a task traditionally performed by men in Bengal. The artist has employed standard iconography in portraying the monkey chief in his enlarged form, transporting the mountain (which appears small by comparison) in one hand and wielding a mace in the other; she has given a new cast to the theme in imagining Hanuman looking down as trees and branches are pulled into the wake of his powerful movements. In addition, she has adapted the meandering zigzag form customarily used for representing rivers in Bengali scrolls for rendering her diagonally aligned ocean.

The single-image painting, created as a salable commodity in contrast to scrolls, which are kept by painter-performer caste families for use in storytelling, is intended for display and worship during festivals and fairs. The single-image painting is known as a *chauka* or *chaukash* (square) *pata*, though it is typically rectangular. The single image is bordered on all four sides by a narrow band embellished with a scrolling floral pattern similar to the ornamental designs edging the registers of scrolls; the painting is related in its iconic and vertical format to the enlarged beginning and end panels of scrolls from the Midnapur district. The relatively simple contours and the loose rather than painstaking execution of this painting demonstrate something of the evolution of the Bengali tradition from a more courtly to a more folkish style.

Garoda Scroll Paintings

Introduction

The Garoda scroll painting, traditionally produced in north Gujarat, is distinguished by its special format, which employs iconic panels for invoking deities, narrative panels that illustrate not one or two but several legends, and didactic panels that illustrate various punishments for sins and rewards for virtuous behavior.[59] Known as a *tipanu* (record) or *bhambhal* (noisy narrative), the Garoda scroll is displayed in conjunction with singing and oral recitation of verses and prose. The scroll is, moreover, regarded as a kind of mobile temple, as visually indicated by its opening panel, which characteristically features a triple-domed shrine or temple in which is ensconced a deity usually represented by a symbolic water jar with human eyes. The narrative (and didactic) tradition is called Garoda after its priest-performers, who are male members of the Garoda caste and who may also be the artists who paint the scrolls; the village audiences for Garoda presentations are mostly female members of the Bhangi, Dhed, Meghval, Vaghri, Nayak, and various other so-called low-caste Hindu artisan communities.

A Garoda scroll (no. 43) is vertical and typically contains nineteen panels. The first five registers present deities who are ritually invoked to witness the recitation and to bless the performer and audience; the deities include, besides the one represented in the opening panel, equestrian figures that are perhaps personifications of the sun and moon, Ganesha, Shiva, and Lakshmi. The next

eleven registers recount nine different stories, not from Sanskrit versions of the Indian epics but rather from Gujarati versions and from local oral tradition. The stories are represented, with only one exception, by a single register in which one or more episodes may actually be illustrated; it is the Garoda storyteller's challenge to keep his audience engaged in each story with only a key illustration of a single episode or perhaps two juxtaposed episodes. The final three registers present visualizations of the afterlife, including passage of deceased humans to the place of judgment presided over by Yama, the god of the dead, and the torments inflicted on sinners in various hells.

The subject matter and the sequence of images in the various sections of the Garoda scroll appear to be fairly standardized, though there are differences in modes of representation (and in the interpretation of the pictorial elements). Evident, too, in the published examples of such scrolls is a great variety of individual folkish styles. The scroll usually measures one hundred eighty-six inches by fourteen inches. The shape of the registers is horizontal or square, according to the subject matter, except for the fourteenth, which shows the full figure of the large-bodied warrior Bhima (also transliterated Bheema) and is a long vertical panel. The scrolls are generally made of sheets of inexpensive mill-made papers, which have been pasted end to end, but were formerly most likely made of cloth. In the past, water-based pigments were derived from local plants and minerals; more recently, commercially produced paints have been employed. In creating a scroll, the artist typically divides the picture space on unprimed paper into registers and draws rough contours of the customary iconography with pencil. The artist applies flat color to the outlined shapes and then defines and details his forms with brushed—most often, black—contour lines. The unpainted background is sometimes enlivened by a random pattern of red daubs or dots that probably represent flowers. Faces of figures, except for Lakshmi, Ravana, and Bhima, are represented in profile.

Garodas, known by many local names, such as Garuda, Garudi, Garo, and Garu, are considered fallen members of the Brahmin or priestly caste. Male Garodas serve as priests to the so-called low-caste communities of the region at their ceremonies of birth, marriage, and death. Many Garodas excel in the singing and leading of devotional songs, a form of worship, and may conduct all-night sessions in villages. Some members of the Garoda caste are storytellers who travel from village to village with their scrolls in a cloth bag; for their presentation, they are paid in wheat flour, grain, and rupees. A very limited number of Garoda narrators are also painters who prepare scrolls for their own use or supply scrolls to those who only narrate. Garodas may also be astrologers, who read manuals to determine auspicious dates and times for important events and make and illustrate horoscope scrolls in a style similar to their tradition of narrative picture scrolls; other Garodas practice palmistry. Today, fortune-telling, chiefly through astrology, is considered both a more lucrative and a higher-status task than narration and painting of legends.[60]

This narrative tradition that also morally educates by showing the consequences of personal conduct is reported to be facing extinction, with little production of new scrolls occurring today. Notice of this tradition was first published in 1980.

43. Garoda scroll painting illustrating nine stories in regional versions of the *Ramayana* and the *Mahabharata* and in local legends and also illustrating scenes from Death's kingdom, for use as a visual prop in storytelling performances
North Gujarat
Early 20th century
Ink, transparent and opaque water-based pigments, and metallic paint on paper
95" x 12" (241.3 cm x 30.5 cm)
The Denver Art Museum, Anonymous gift, 1985.656

This scroll, used by members of the Garoda caste of Gujarat in conjunction with oral recitation of stories, portrays standard imagery, with only a couple of exceptions, in illustrating episodes from a number of different legends and also illustrating scenes from Death's kingdom, after invoking deities.[61] The registers are identified as follows: / 1. A four-armed deity holding two scepters, within a temple, flanked by two male guards holding swords. 2. / Two equestrian figures, with the sun and moon, flanking a flowering plant. / 3. Ganesha enthroned, flanked by his consorts. / 4. Shiva, with his wife, Parvati, on his lap, seated on Nandi the bull, flanked by two female figures, on the left holding a scorpion, on the right holding snakes. / 5. Lakshmi enthroned, holding lotuses and rosaries in her four arms. / 6. Villagers harvesting a miraculous yield (legend of the local saint Dhana Bhagat of Dhola). / 7. Durga on her tiger and Bahuchara on a cock, killing the buffalo demon (local legend of the Goddess). / 8. Krishna quelling the serpent Kaliya, flanked by rearing female snakes (local legend of Krishna). / 9. Shravana fetching water from a cross-shaped pond and being struck by Dasharatha's arrow; Shravana's parents hanging in baskets from a tree (*Ramayana*). / 10. Rama and Lakshmana chasing the golden deer; Ravana, garbed as an ascetic, approaching Sita (*Ramayana*). / 11. Sita seated in Ashoka Grove; Hanuman carrying the mountain of medicinal herbs (*Ramayana*). / 12. The ten-headed demon king Ravana enthroned. / 13. King Harishchandra (also transliterated Harischandra) giving his daughter in marriage, losing his fortune, offering himself and his family for hire (local version of the legend of King Harishchandra). / 14. Bhima (also transliterated Bheema), shaking a tree to punish rivals who have cheated his brother in games of chance (*Mahabharata*) (illustrated). / 15. A devout couple, Sheth Sagalsa and his wife, sacrificing their son in a test of their religious vows (local legend of Chelaiyyo). / 16. The feet of Ramdev, or of his lame wife, flanked by his wife bringing offerings, and Ramdev as Vishnu in the form of a child, floating on a leaf (local legend of Ramdev Pir). / 17. A servant presenting the recently dead to Yama for judgment, a deceased man being carried in a palanquin to judgment. / 18. A deceased woman, holding onto the tail of a cow, crossing the river to the netherworld, followed by a horse and chariot. / 19. Sinners being punished in seven hells; Vishnu appearing to a woman playing a stringed instrument.

Unusual in this scroll is the anthropomorphic image of the deity in the first register. Also untypical is the depiction of Lakshmi who, in the fifth register, holds attributes in her four hands. The creator of this scroll has employed a rich red for most garments and a brownish orange for practically all skin color.

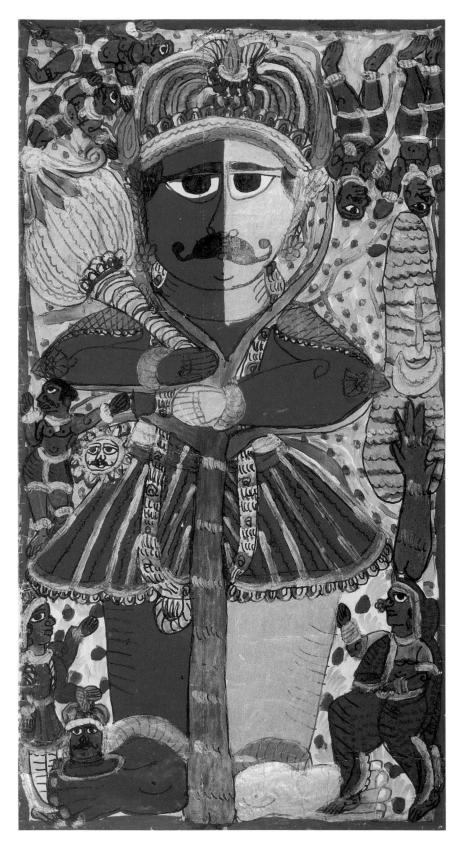

43, detail

Bhima in the fourteenth register (illustrated) is typically painted in two colors, here with red and "silver" (probably aluminum radiator paint[62]), the latter used to indicate his extraordinary strength; the same "silver" is used throughout the scroll as rhythmic embellishment, in some instances thickly delineating the exterior and interior contour lines of structures and garments and in other instances filling the entire shape of forms, such as crowns, bangles, swords, and rivers. A pattern of irregularly daubed red dots, placed close to tan leaflike shapes and probably representing flowers, animate the unpainted ground, which, because of acidity in the paper, has turned a tannish yellow.

Jadupatua Scroll and Ritual Paintings

Introduction

Originating in Eastern India and documented at least in the Santal Parganas district of Bihar and in the Midnapur and some other districts of West Bengal, the Jadupatua tradition appeals to Hindu, Muslim, and tribal viewers and comprises paintings that serve two different functions: particular kinds of narrative scrolls as well as ritual images. Relatively well-known among the latter type of Jadupatua painting is a portrait of a recently deceased tribal person that is completed in a ritual way, the ritual magically effecting the deceased's well-being in the afterlife. It is this kind of painting and function that gives the tradition its name (*jadu*, magic; *patua*, painter).

The magic ritual involves a symbolic restoration of eyesight (*chakshudana*) to the deceased person in his or her portrait representation (nos. 49–51). The ritual is enacted when the painter, upon hearing of the death of a tribal person, goes to the house of the deceased's family with stock images of men, women, and children. These pictures, representing individuals in profile, are complete except for the pupils of the eyes. Beside the figures, the painter might also have painted various objects such as a pot or an umbrella or even animals (e.g., a goat or a chicken) as desirable possessions in the netherworld. Upon arrival, the painter makes careful inquiries about the deceased that allows him to present the family with an appropriate image. Then, for a fee calculated in accord with the apparent means of the household, the Jadupatua supplies the missing pupil, assuring relatives that their loved one will no longer have to wander blindly. At the request of the family and for another fee, the painter might also bring the drawing to a sacred river and ritually submerge it, in place of the deceased's charred bones, if the family members cannot afford to leave their everyday tasks to travel and perform the funerary rite themselves.[63] Such paintings are made for Santals, a tribal group found in the Santal Parganas and other districts of southern Bihar and in some districts of neighboring West Bengal. They are also made for members of the Bhumij tribe in the Midnapur and Bankura districts of West Bengal. These portraits of the dead are most often called *chakshudana patas* (eye-bestowal or -restoration paintings) after the purpose of the ritual, but they may also be called *paralaukik patas* or *chitras* (paintings of the next world), especially in West Bengal: mortuary portraits made for display to bereaved

Bhumij tribal families of the Bankura district are in fact frequently quite elaborate compositions that place the deceased in royal pavilions and surround them with servants and all the accoutrements that signal a comfortable position in the afterlife.[64]

Far less well-known than *chakshudana patas*, but certainly created to function as part of a ritual, are Jadupatua images of a special kind of demon believed to cause the death of Santals (nos. 50–52). Upon the request of a family that has lost one of its members to this demon, the artist is said to display the demon's image while narrating how the relative died: the demon is reputed to enter the deceased's household without being noticed by possessing a domestic animal, such as a chicken or goat, which contaminates the deceased's drinking water with urine. Fearful of further deaths in the household, the family rids itself of the unclean water vessels and the possessed animal by presenting them to the Jadupatua.[65] The demon in such paintings is shown with the possessed animal and usually with some water containers as well. The demon may be shown with deceased tribe members (depicted in profile as they are in *chakshudana patas*—see nos. 50, detail, and 51) or may be shown without them (see no. 52); the two presentations of the demon invite speculation as to whether this type of Jaduapatua painting originated independently or as a special form of *chakshudana pata*.

Jadupatua narrative scrolls illustrate a number of subjects, with varied appeal to tribal, Hindu, and Muslim audiences. The subjects include the didactic theme of Death's kingdom, with death personified as an old ruler meting out various punishments for specific sins and rewards for virtuous acts (no. 45); the story of creation according to the Santals (no. 48); and the Santal Baha (flower) festival, which honors the Santals' godlike spirits called *bongas* (nos. 47–48). Other themes are the Santals' mass gatherings for group dancing; Santal legends (no. 46); the legend of the tigers' god, a subject appealing to Muslim, Hindu, and tribal audiences (no. 44); and Krishna's escapades with the milkmaids, a Hindu story with strong attraction for tribespeople. Jadupatua scrolls frequently illustrate more than one theme. Jadupatua scrolls are sometimes called Santal scrolls after their largest audience; the term is especially apt when they deal exclusively with Santal themes.

Jadupatua scrolls are not intended to be seen apart from a sung or chanted performance of the depicted stories. The Jadupatuas travel from village to village to instruct and entertain their varied rural audiences. A Jadupatua who travels to the village of a deceased tribal individual to perform *chakshudana* might afterwards distract the family and other members of the village from grieving by entertaining them with his performance of the stories illustrated by his scrolls.[66]

Mortuary pictures are executed in water-based earthen colors on thin, inexpensive paper (frequently scrap commercial paper); the paintings seldom exceed twelve inches in either direction. Jadupatua narrative scrolls too are typically narrow and also rarely exceed twelve inches in width, though their length varies according to the number of registers. Scrolls are constructed of inexpensive sheets of paper that have been glued or sewn together and attached at each end to bamboo poles as rollers. Sometimes the scroll is attached to a cloth support for better

preservation of the fragile paper. While the Jadupatuas formerly made their own water-based paint from vegetable matter or minerals, in the twentieth century they apparently came to rely instead on commercial paint products.[67]

Though one of the most idiomatically varied of India's popular traditions, Jadupatua painting is generally schematic, informed by emphatically linear descriptions of the human figure, animals, objects of domestic use, and landscape elements. There is little modeling of volumes and minimal description of space. Sparely and conceptually rendered against plain, unpainted backgrounds, the pictorial elements of the Jadupatua tradition form an extremely tensive shorthand style.

In Bihar, Jadupatua painters have practiced their art as a consequence of their birth into Hindu families of the Jadupatua caste. The painter-performers have traditionally been male. These Jadupatuas speak a mixed form of Bengali and Santali; while revered for their magical powers by members of the Santal tribe who are their principal audience, the Jadupatuas are nevertheless considered by Santals to be their social inferiors. In the 1940s, most Jadupatuas in Bihar earned additional money by farming and by piercing ears and noses for rings; in an effort to elevate their social status, some Jadupatuas in Bihar were reported to have changed their caste name to Chitrakar.[68] In other accounts, Sutradhars (architectural carpenters) are said to make but not ritually complete the eye-bestowal paintings used by the Bhumij tribe in Bankura district, West Bengal; and some Jadupatuas are said to be members of a distinct tribe, who are brass workers in addition to being painter-mendicants—this tribe is reputed to have resided, at least in the early 1950s, in the Santal Parganas district of Bihar, in Birbhum, Midnapur, and Bankura districts of West Bengal, and in the former Manbhum district[69] (now divided between Bihar and West Bengal).

The extent to which the tradition survives is unknown.[70] As part of the culture of Eastern India, whose art heritage was noticed and valued by artists and intellectuals early in this century, Jadupatua painting has been comparatively well documented, at least in the past, alongside other regional traditions, though it has not been the sole subject of a major study in English.

Representative Works: Jadupatua Scroll and Ritual Paintings, nos. 44–52

44. Two registers in a fragment of a scroll painting illustrating the legend of the tigers' god, observation of the Muslim festival of Muharram, and scenes of Santal life, for use as a visual prop in storytelling performances
Upper: The shrine of the tigers' god
Lower: The tigers' god
Bihar, Santal Parganas district, Dumka subdivision
CA. 1920
Transparent and opaque water-based pigments on paper
19⅞" x 12" (50.5 cm x 30.5 cm)
The British Library, Oriental and India Office Collections, Add Or 3411

This scroll fragment depicts in its lower register the tigers' god as a Muslim saint or *pir* (literally, elder; also religious leader, guide). The holy man is

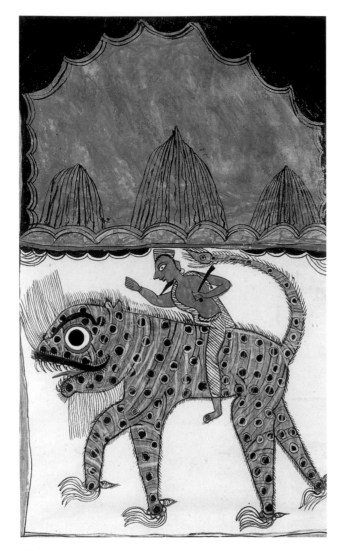

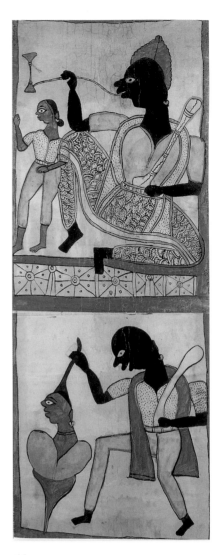

44

45

bearded and capped; bare-chested, he wears diagonally striped trousers and a scarf around his neck; holding a club in his left hand, he is mounted on a spotted, striped, and abundantly whiskered tiger, whose open mouth displays its tongue and deadly fangs. In the upper register under a black scalloped arch is probably the *pir's* shrine, a triple-domed structure set against an orange background. The two registers are the first section of a multiple-subject scroll that propitiates at its outset a holy man who can prevent tigers from attacking those who honor him.

Cults of tigers' gods are found throughout India, indicating the real danger that tigers posed to human life and livestock and the need to propitiate whatever beings could control them (see nos. 13, 39). In lower Bengal on the delta of the Ganges River, the cult of the tigers' god, Barekhan Ghazi, venerated by

both Hindus and Muslims, manifested itself in the creation of special scroll paintings (called *ghazi patas*) that depicted the deity's deeds and the punishments inflicted on those who refused to make offerings to him. In these scrolls, the tigers' god is shown as a bearded Muslim religious mendicant holding a rosary and a special staff and riding a tiger. The scroll painting practice associated with the cult of this tigers' god evidently spread north to the Santal Parganas district. There it was adapted to serve tigers' gods of that region who were known by other names—among them Satya Pir and Satya Narayan—and were venerated by Hindus, Muslims, and Santals. In the old Santal Parganas district (which included most of southern Bihar), scrolls of the tigers' gods came to be painted by the Jadupatua caste. It is a peculiarity of the Santal Parganas scrolls that the tiger mount is painted with spots as well as, or rather than, stripes. This transformation may indicate the fact that the Hindi word *bagh* and the Santali word *kul* may be used for either tiger or leopard, or it may reflect the fact that, with increasing deforestation of the area, the local tiger population had significantly diminished while some leopards remained. The "spotted tiger" occurs in other popular paintings of the area (see nos. 15, 39).[71] In this picture, the tiger's animated whiskers and very long claws may reflect the importance of these tiger parts to natives of Bihar who avidly sought them as charms.[72]

Reproduced: Mildred Archer, *Indian Popular Painting in the India Office Library* (London: Her Majesty's Stationery Office, 1977), frontispiece, col. pl. A; Pupul Jayakar, *The Earthen Drum: An Introduction to the Ritual Arts of Rural India* (New Delhi: National Museum, [1981]), p. 154, fig. 137.

45. Two registers in a fragment of a scroll painting illustrating scenes from Death's
 kingdom, for use as a visual prop in didactic storytelling performances
 Upper: The god of death enthroned and smoking a hookah, with a servant or a
 deceased person awaiting judgment
 Lower: A servant of the god of death holding a sinner by the hair in the jaws of
 fire (or holding up a sinner's head that has been severed from the body)
 Bihar, Santal Parganas district, Dumka subdivision
 CA. 1920
 Transparent and opaque water-based pigments on paper
 20¹¹⁄₁₆" x 7¹⁵⁄₁₆" (52.5 cm x 20.2 cm)
 The British Library, Oriental and India Office Collections, Add Or 3412

These two registers are the opening images of a scroll devoted entirely to the god of death and his kingdom. The upper register depicts the deity as a bald and black-skinned lord wearing a crown and elaborately patterned pants; he sits at ease and smokes a hookah (water pipe). His club or scepter of authority, which is tucked into his waistband, appears to be a large cracked leg bone. A small male figure, one of Death's servants (or perhaps a soul about to be judged), leans like a child against Death's knee. In the lower register, a bald and black-skinned male figure, undoubtedly a servant of the god of death, suspends the head of a sinner by the hair into a mouthlike shape, identified as fire[73] (or he may be holding up a sinner's head and, possibly, part of the upper torso that have been severed from the body). The first and second registers are separated

by a broad band with a decorative pattern that may also indicate the side plane of a platform or cushion on which the deity sits. This portion of a didactic scroll, created by a Hindu painter for Hindus, Muslims, and Santals, sparely but brilliantly visualizes the dreadful majesty of a personification of death.

Reproduced: [Mildred Archer], *Indian Paintings from Court, Town, and Village*, exh. cat. (London: Arts Council of Great Britain, 1970), [n.p.], no. 66; (upper reg. only) Mildred Archer, *Indian Popular Painting in the India Office Library* (London: Her Majesty's Stationery Office, 1977), pl. 17.

46. Two registers in a fragment of a Santal scroll painting illustrating Santal legends, the celebration of the Baha festival, the legend of the tigers' god, and scenes from Death's kingdom, for use as a visual prop in storytelling performances
 Upper: Indra Raja beseeching Sengel Bonga to behead his eighteen sons, whom he could no longer maintain
 Lower: The severed heads of Indra Raja's eighteen sons and their bloodshed, which became the eighteen streams to be crossed on the way to Jagannatha temple, Puri
 Bihar, Santal Parganas district, Dumka subdivision, Banskuli circle, village Bora
 CA. 1940, by Malindra Chitrakar
 Transparent and opaque water-based pigments on paper
 16¾" x 11" (42.5 cm x 28.0 cm)
 The British Library, Oriental and India Office Collections, Add Or 3493

This section of a multiple-subject scroll painting illustrates a Santal legend. The upper register depicts a red-skinned, four-headed, four-armed male deity seated on a very high platform or stool with a supplicant male kneeling before him; a male attendant with an upraised arm hailing these figures; and a small bird resting in front of the deity's throne. The lower register shows eighteen severed heads, neatly arranged in two rows, from which blood flows in narrow, parallel streamlets. The deity, represented in the mode of the four-headed Hindu god Brahma, is one of the major Santal *bongas* (spirits), namely, Sengel Bonga. The supplicant is Indra Raja, a legendary ruler of the Santals, who asks the deity to behead his eighteen sons because he cannot afford to maintain them. He asks the deity to transform their blood into waterways, and so their bloodshed becomes the eighteen streams that must be crossed in making a pilgrimage from Santal Parganas to Puri, site of the famous temple of the deity Lord Jagannatha (see discussion of Puri paintings in Chapter 2). According to the artist, the eighteen heads are also locally understood to be a representation of Sengel Bonga or Moreko Turuiko (the Five-Six), an alternate name.[74]

47. A Santal scroll painting illustrating the celebration of the Baha festival and scenes from Death's kingdom, for use as a visual prop in storytelling performances
 Bihar, Santal Parganas district
 First half of the 20th century
 Transparent and opaque water-based pigments on seamed paper
 183" x 12" (464.8 cm x 30.5 cm)
 Chester and Davida Herwitz Collection

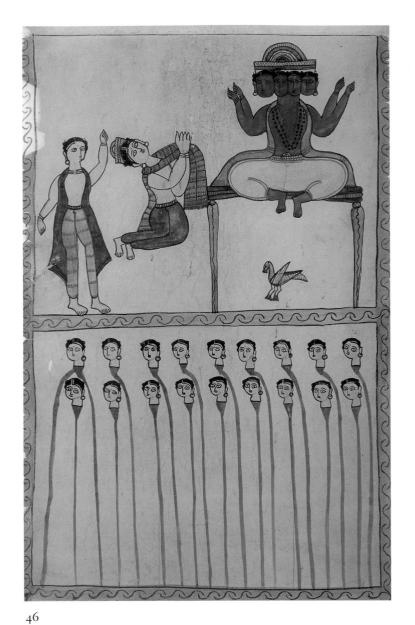

46

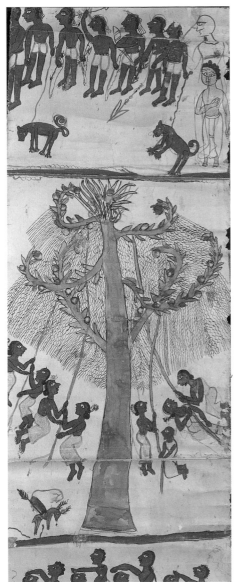

47, detail

This narrative scroll made for Santals fully illustrates the tribe's annual spring celebration of the Baha (flower) festival, which honors the Santal godlike spirits (*bongas*). The festival activities include worshiping the *bongas* in a sacred grove, sacrificing animals, dancing and swinging in seasonally flowering trees, making and drinking rice-beer, and preparing meat and other foods for a communal feast.[75] The scroll also contains registers with scenes from Death's kingdom. The scroll appears to be missing some initial registers, which typically present the three chief Santal *bongas* and the Santal story of creation.

Descriptions of the scenes on the registers follow (all figures are Santals un-

less otherwise noted).[76] Part of the sixth register and the entire seventh register are illustrated. 1. Two men (or a man and a boy) and a woman approaching the sacred grove to honor the *bongas*; a woman departing. / 2. A couple churning butter; a green-skinned man looking at a pot, probably of rice-beer, suspended from a tree. / 3. A group of boys walking or dancing in formation, accompanied by two adults. / 4. A couple approaching the sacred grove. / 5. Boys in formation, carrying bows and arrows; girls, with flowers in their hair, dancing; a man cutting(?) a woman's hair; all observed by a green-skinned man. / 6. Men, with dogs on leashes, hunting with bows and arrows, observed by a green-skinned man and a light-skinned man (partially illustrated). / 7. Women, with flowers in their hair, swinging from a blossoming tree (illustrated). / 8. Couples and a group of women dancing, accompanied by drummers, observed by a green-skinned man; men carrying a stag on a litter; men getting possessed by their spirit gods. / 9. Four men, two with guns, surrounding a horse and shooting into a tree. / 10. A man shooting an arrow at a bird in a tree, accompanied by a man and woman. / 11. Death's servants inflicting punishments on sinners, including the decapitation of a woman. / 12. Four virtuous men sitting at ease in Death's kingdom. / 13. A man, holding the tail of a bullock, crossing the river to the netherworld, met by Death's servant, who brandishes an axe. / 14. Men killing a lamb and a python, cooking food, drinking, and getting possessed. / (15–16. Two partial registers used in mending the end of the scroll.)

This scroll contains a particularly beautiful image of tribal women swinging in a blossoming tree in the seventh register (illustrated). Also remarkable is the recurrence of a green-skinned man in the second, fifth, sixth (partly illustrated), and eighth registers; this figure may be a representation of Krishna, a Hindu deity especially beloved by the Santals.

Reproduced (details): regs. 7, 12–14, Sabita Ranjan Sarkar, "Bengal," *Mārg* (Bombay) 43, no. 4 (June 1992): 46–47.

48. A Santal scroll painting depicting the three chief Santal *bongas* (spirits) and illustrating the Santal story of creation, the celebration of the Baha festival, and scenes from Death's kingdom, for use as a visual prop in storytelling performances
Bihar, Santal Parganas district
Mid-20th century
Transparent and opaque water-based pigments on seamed paper mounted on cloth
232" x 10¾" (589.3 cm x 27.3 cm)
Samuel P. Harn Museum of Art, University of Florida, Gift of Mr. and Mrs. Thomas J. Needham, PA.71.29

This multiple-subject scroll made for Santals by a Hindu painter illustrates four common subjects in the Jadupatua tradition: the Santal *bongas* (spirits), the Santal story of creation, the Baha (flower) festival as previously described (see no. 47), and scenes from Death's kingdom.[77]

Descriptions of the scenes on the registers follow (all figures are Santals unless otherwise noted). The first register is illustrated. 1. The three chief Santal *bongas* (spirits), Maran Buru, Jaher Era, and Sin Cando, enthroned (illustrated). / 2. The two-headed Santal creator god, Thakur Jiu, seated on a gooselike bird,

48, detail

presiding over creation of the world; a woman watching over a child. / 3–5. Two men and a woman and a group of males and a couple proceeding to and returning from the sacred grove. / 6. A couple churning butter; a man looking at a pot, probably of rice-beer, suspended from a tree; other men preparing food; a man cutting off the braid of a woman. / 7. Men with bows and arrows and women with flowers in their hair dancing in formation. / 8. Women with flowers in their hair attaching rope to a flowering tree in order to swing; a man aiming his bow and arrow at a horse./ 9. Couples dancing; a white-skinned man, who may be intoxicated, dressed in Western garb and standing pigeon-toed. / 10. Women dancing, accompanied by drummers. / 11. Men carrying a stag on a litter; a seated male elder surrounded by boys. / 12. A man, with a woman, aiming his bow and arrow at a bird in a tree. / 13. A man, holding the tail of a horse, approaching the river to cross it to the netherworld; two men (or a man and a woman) fighting with knives; two women on the other side of the river, with a horse, being met by Death's servant. / 14. Three women and a man ap-

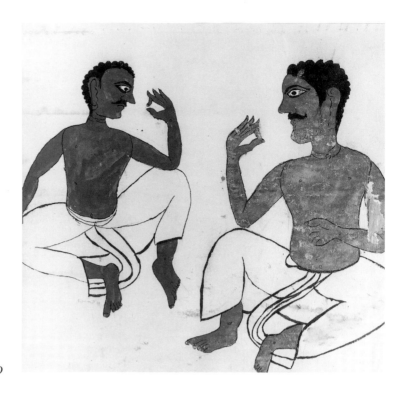

49

proaching or leaving the sacred grove. / 15. Death's servant holding up the head of a woman, severed from her body as punishment for sins. / 16. Four virtuous men, being rewarded with ease, sitting in Death's kingdom. / 17. Two men, one carrying a child, approaching what may be a watery entrance to the netherworld. / 18. A man being punished for sins by being stretched over a bed of fire by Death's servants. / 19. A male elder with a man and a woman observing the original Santal couple enclosed in a womblike shape; three men appearing to approach the river; on the other side of the river, a man using an axe to strike the head of a horned animal whose tail is being held by a man; other men and a woman engaged in festival activities: preparing food, bearing drink, dancing, and getting possessed by their spirit gods.

It is interesting to note that the representation of the three Santal *bongas* (illustrated) is modeled here, as is customary, on the iconography of the Jagannatha trio worshiped at Puri (compare especially no. 29).[78] Many scenes portrayed in this Jadupatua scroll are not only similar to those of the previous scroll (no. 47) but also follow one another in a similar sequence. The style of this scroll, however, is considerably sparer and perhaps more naive, as it exhibits much less sense of unified space in each of its registers. Nevertheless, its Hindu painter succeeds in emphatically communicating to his Santal viewers his awareness of the importance of these images in their tribal life.

Reproduced (detail): upper portion of reg. 13, University Gallery and Jacksonville Art Museum, *Jamini Roy and Bengali Folk Art: A Special Exhibition*

of Works in the Collection of Mr. and Mrs. Thomas J. Needham of Jacksonville, Florida, exh. cat. (Gainesville: University Gallery, University of Florida, 1971) no. 56.

49. Ritual eye-bestowal painting (*chakshudana pata*) depicting two deceased tribesmen
Bihar, Santal Parganas district
20th century
Transparent and opaque water-based pigments on paper
10" x 10½" (25.4 cm x 26.7 cm)
Mary C. Lanius

Two bare-chested tribesmen in plain white lower garments, the figure on the right slightly larger than the one on the left, sit on the ground, facing each other in profile. By ritually painting in their pupils at the request of their relatives, the Jadupatua has delivered the men from blindness in the afterlife. This mortuary portrait appears to go beyond the usual stock representation, delivering instead a real, if also stylized, likeness. The artist has carefully described his subjects' similar curly hair and handlebar moustaches and varying hairlines and noses.

50. Five ritual eye-bestowal paintings (*chakshudana patas*) depicting groups of deceased tribal persons, one depicting, in addition, a death-delivering demon (*pishacha*)
West Bengal, Midnapur district, or Bihar, Santal Parganas district
20th century
Transparent and opaque water-based pigments on sewn paper
Sizes, top to bottom, left to right, in present mount:
1. 8½" x 25⅝" (21.6 cm x 65.1 cm)
2. 7" x 14" (17.8 cm x 35.6 cm)
3. 9½" x 9½" (24.1 cm x 24.1 cm)
4. 7¼" x 6½" (18.4 cm x 16.5 cm)
5. 8¼" x 12⅞" (21.0 cm x 32.7 cm)
Samuel P. Harn Museum of Art, University of Florida, Gift of Mr. and Mrs. Thomas J. Needham, 1987.1.58

These five spare images of Santal tribal persons of various ages appear to be portrayals of the dead. (Only the third folio is illustrated here.)

1. A man and a woman surrounded by five children; beside them, a peacock or other bird, and what may be two pools of water or wells.

2. Five children of diminishing heights, the last almost in fetal position, another holding a goat on a leash; below them to the right, a diagrammatic representation of a pool with one fish at its edge.

3. A man and a woman on either side of a threatening demon who wears hanging decorations at his elbow, shoulder, hip, and knee joints; below the demon, two vessels and a chicken or other bird (illustrated).

4. A man; below him to the left what appears to be a pool or well; below him to the right, a cow tied to a stake.

5. A woman and two smaller male figures; between them, what appears to be a pool or well; below it, a peacock.

All five images appear to have been created by the same artist. Of special interest in the series is the third folio (illustrated), which depicts a demon with clawlike feet and hands, sticking out his blood-red tongue and reaching out to seize both the man on his left and the woman on his right; the demon hovers over a chicken and what may be a cup and another utensil. The demon is probably the *pishacha*, a malevolent spirit believed to be the disembodied soul of a liar, adulterer, or criminal, or one who has died insane;[79] this evil spirit is associated with the period immediately after death, since he preys on the recently deceased as a bloodthirsty monster and eater of raw flesh.[80] In Eastern India, the *pishacha* is moreover believed to actually cause the death of Santals. Accordingly, the Jadupatua is said to display a picture of the death-delivering demon upon request to the family of a dead person: the Jadupatua narrates how the *pishacha* had surreptitiously entered the house by possessing the family's chicken or other animal that subsequently contaminated a water vessel with its urine; he also narrates how the relative unknowingly drank the contaminated water and died. The Jadupatua is given both the vessel that held the water and the possessed animal by the bereaved family, anxious to rid the household of the demon's instruments of death. The third folio (and possibly the other paintings in this set, all of which show a domestic animal and a water vessel or a pond or well) may have been used by a Jadupatua in such a ritual.[81] The Jadupatua has also ritually supplied pupils to the eyes of the deceased so that they will not wander blindly in the netherworld; like the preceding entry (no. 49), these im-

50, detail

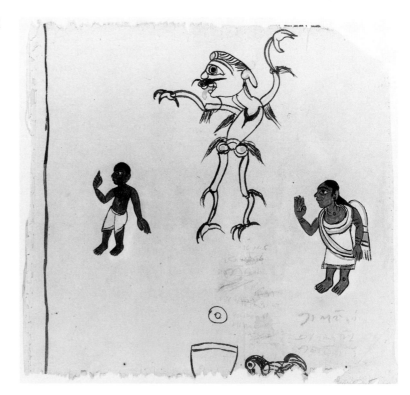

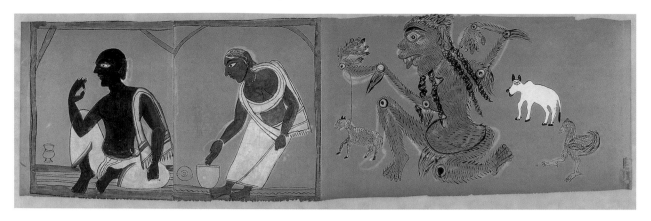

ages are also *chakshudana patas* (eye-bestowal paintings). It is not known whether the group presentations indicate the death of all represented or whether the dead are being shown with those they leave behind. (For other images of the demon who causes death, see nos. 51–52.)

51. Ritual eye-bestowal painting (*chakshudana pata*) depicting two deceased tribal persons and a death-delivering demon (*pishacha*)
 West Bengal, Midnapur district, or Bihar, Santal Parganas district
 20th century
 Transparent and opaque water-based pigments on seamed paper
 10¼" x 34¼" (26.0 cm x 87.0 cm)
 Nesta and Walter Spink

Like the third folio in the preceding entry (no. 50), this picture portrays deceased Santals and a demon. Here, on the left, the mortuary figures, a seated man and a standing woman, each equipped by the Jadupatua with eyesight and a vessel or two for the afterlife, are enclosed in minimally described pavilions; on the right, a hairy green demon with four long locks of hair flails his bone-thin arms and appears to run after the Santals, otherwise at ease in the afterworld, ready to snatch them. The demon, probably a *pishacha* (see no. 50), here displays articulated hands and feet and wears a very brief feathery lower garment and feathery decorations suspended from his elbows and shoulders and other decorations at his wrists and knee joints. The *pishacha* is surrounded here by a goat held on a leash, a white cow, and a chicken, animals that the demon is believed to possess in order to bring about the deaths of Santals. The Jadupatua is said to display a painting of a *pishacha* upon request to the deceased's family while recounting how the relative has died by drinking water contaminated by the urine of the possessed animal; the Jadupatua is given the possessed animal and the water vessel by the family, which is fearful of further deaths.[82] Such a painting enhances the artist's ritual role as deliverer. A painting with an image of the *pishacha* is also rhetorical and didactic insofar as it motivates the living to accumulate enough good deeds to qualify for heaven and release from death and rebirth by portraying the consequences of not doing so.[83]

52

52. A ritual image of a death-delivering female demon (*pishachi*) eating a raw organ
West Bengal, Midnapur district, or Bihar, Santal Parganas district
Early to mid-20th century
Transparent and opaque water-based pigments on paper
8⅛" x 4¼" (20.7 cm x 10.7 cm)
Courtesy of Arthur M. Sackler Museum, Harvard University Art Museums,
Loan from Private Collection, TL34483.1

A hairy black female demon, with a protruding, bill-like mouth, exposes a well-articulated set of teeth as well as her tongue as she appears to bite into an organ from which fresh blood flows. The gruesome, emaciated figure has pendulous, missile-shaped breasts, an angular extended abdomen, and spindly, hairy arms and legs. The female demon is probably the *pishachi*,[84] the feminine counterpart of the *pishacha* (see nos. 50–51). The *pishachi* stands in front of a small goat on a leash and two vessels, goods presumably belonging to the household of the deceased Santal (whose organ she devours) and used by the demon to deliver death. The painting was probably intended for display to a Santal tribal family that had recently lost one of its members to death; it was displayed in conjunction with a narration of how the *pishachi* caused the death of the relative by entering the family's household without notice by possession of its goat, which subsequently contaminated the water supply with urine. To assuage the family's fears of further deaths, the Jadupatua would then remove the vessels that held the unclean water and the possessed animal from the household.[85] Despite the artist's likely anticipation of material gains from the creation of this picture and its display (perhaps on many occasions), he has recorded his genuine horror at the female demon's unspeakable act.

"Paithan" or Chitrakathi Paintings

Introduction

"Paithan" or Chitrakathi painting is one of India's great popular narrative traditions, imparting to village peoples their heritage of sacred stories as found in local versions of the *Mahabharata* and the *Ramayana* and in other regional works. The painting tradition is based in the western portion of the Deccan Plateau, known as the Western Deccan. Scholars have conjectured that the tradition was once widespread throughout the Western Deccan, that is, in practice in Maharashtra, neighboring northern Karnataka, and even areas of Andhra Pradesh,[86] though only one village, Pinguli in southern Maharashtra near the Goa border, is known to have been a painting center.[87] The tradition and style are named after the village of Paithan (formerly Pratishthan), south of Aurangabad, in Maharashtra, where the first sets of paintings identified as a distinct folk idiom are reported to have been found (though not necessarily created).[88] The tradition has been more recently termed Chitrakathi after the caste of artist-performers called Chitrakathis (*chitra*, picture; *katha*, story), who traditionally paint the pictures and tell the stories.[89] Though somewhat misleading, the earlier name, "Paithan" (or "Paithan School"), remains more widely used.

Like almost all Indian popular narrative traditions, the "Paithan" tradition involves both painting and storytelling, image and performance. Episodes in a story are illustrated in a set of paintings, all the same size—approximately twelve by sixteen inches—and with each picture usually depicting only one episode. The pictures, gathered in a loose-leaf folio called a *pothi*, are displayed in sequence, one at a time, their display synchronized with recitation of the events in the narrative.

Scholars give two different accounts of the sequential presentation of a *pothi*. In the first, pairs of paintings in sequence are pasted back-to-back with a small bamboo stick between them for handling; recounting the narrative, the storyteller holds up each of the picture cards, displaying one side and then the other, until all episodes of the story are told.[90] In the second account, pictures are painted on the front and the back sides of a single sheet of paper,[91] or, again, pairs of paintings are pasted back-to-back in sequence; the whole set of pictures is leaned against a wooden board of similar size held in place against the storyteller's knee; pictures are then turned over by hand and subsequently put aside.[92] In both modes of presentation, two narrators (sometimes husband and wife)[93] or as many as three narrators (all men)[94] take turns reciting or singing the story, accompanied by musical instruments. The performance, though highly entertaining, is regarded as a form of worship; accordingly, Ganesha, the god of beginnings, and Sarasvati, the goddess of culture and speech, are ritually invoked and their images are displayed at the beginning of the narration (see no. 56 that depicts Sarasvati).

Favored stories (and the professional standards of the caste) are reflected in a report from the end of the nineteenth century in which it was noted that each painter-storyteller family was required to have the following sets of pictures with a prescribed number of images: forty of Rama, thirty-five of Babhruvahana (see nos. 55a, b), forty of Rama and Sita, forty of Harishchandra (also transliterated Harischandra), and forty of the Pandava brothers.[95] The penalty for not observing these rules of the caste was to pay a fine.[96]

The creations of the Chitrakathi caste are characterized by a visual language distinct from the many other traditions of Indian painting. The general features undoubtedly evolved to facilitate reading the pictures, which, though relatively small, had to carry over the extent of crowds that gathered to see and hear the episodes. The effectiveness rests primarily on the pictures' dramatic immediacy, that is, a close-up view of heroic action, and a unique emphasis on symmetrical composition that boldly sets forth the essentials of the action in easily graspable visual terms. Evident in "Paithan" compositions is an artistic intelligence that conceptually organizes and balances the pictorial elements, almost algebraically, on either side of the vertical center line of compositions that are with few exceptions horizontal. Sometimes the relationship between left and right is one of equivalence (see nos. 56–57); more often, it is one of opposition (see nos. 53–54, 55b). The dichotomized compositional format is eminently suited to grand tales of confrontation and combat. There are indeed many "Paithan" pictures where the arrows of the dueling warriors meet point-to-point with extreme neatness on the vertical center line of the composition. The center line may also be marked by the trunk of a tree (see no. 53), a flowering plant, or an architectural column (see no. 57).

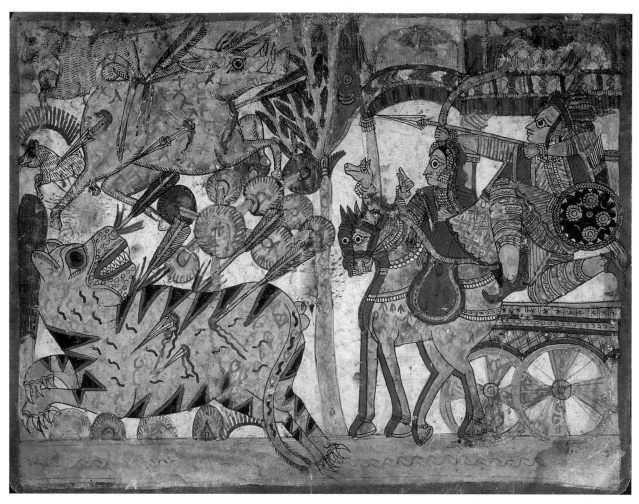

53

Pictorial legibility at a distance is also facilitated by the clearly outlined figures, drawn without foreshortening or modeling, that are characteristic of the "Paithan" or Chitrakathi style. Parts of the body are drawn from multiple points of view and are combined in a single image, that is, head and appendages are represented in profile, but torso and eye frontally. This strategy provides maximum exposure of each form. The eye—an enlarged orb whose pupil is represented by a solid black dot—is an especially noticeable and characteristic feature of "Paithan" painting that intensifies the figures' confrontational drama. (A closed eye, on the other hand, indicates death.)

The figures dominate their settings, whether architectural or landscape. Architecture is usually represented by only the front plane of a miniaturized pavilion-like structure; landscape elements are highly stylized and fantastic and include such diverse inventions as severely abstracted triangular trees and tulip-like trees with supple and playfully intertwined trunks.

Several substyles that employ these general stylistic features have also been distinguished in surviving examples of the tradition.[97] The pictures are painted

in an opaque water-based paint, occasionally thinned to render transparent effects. Both pigments prepared by the artists and commercially produced paints have apparently been used.[98] The paint is applied to an unprimed surface. The vast majority of surviving paintings are executed on imported, industrially made papers. Close examination of unfinished works indicates that the composition is begun with a light line sketch, followed by blocking in areas of flat color whose edges are then crisped with bold, dark contour lines. Each series has a unified color cast, some series favoring blues and greens, others reds and earth tones.

In the "Paithan" or Chitrakathi tradition the storytellers are also the painters of the pictures. The members of this caste are Marathi-speaking and worship Hindu deities; though illiterate, they possess, through oral tradition, extensive knowledge of their cultural heritage.

It is not known how long "Paithan" or Chitrakathi painting has been in practice; the possible dates of pictures can only be approximated through watermarks, the earliest of which is 1835.[99] In this tradition's one known painting center, the village of Pinguli, where performance of narratives with older pictures has continued, attempts have been made to collect existing pictures and to revive the painting practice.[100]

Representative Works: "Paithan" or Chitrakathi Paintings, nos. 53–57

53. Subhadra and Abhimanyu's journey through a forest full of wild animals, a folio
from a Chitrakathi series illustrating the story of Vatsala's choice of Abhimanyu
to be her husband (*Abhimanyu Vatsala Svayamvara*),[101] a local legend, probably
in a Marathi version of the *Mahabharata*,[102] for use as a visual prop in storytelling
performances
Western Deccan (Maharashtra and northern Karnataka)
CA. 1840
Transparent and opaque water-based pigments on paper
12" x 15⅜" (30.5 cm x 39.1 cm)
Philadelphia Museum of Art, Gift of the Friends of the Museum, 68-12-5

This picture, one of a series used in storytelling performances, depicts a mother and son in the midst of a journey whose dangers are both physical and psychological. The mother Subradra, wife of the Pandava prince Arjuna, has taken up the reins of his chariot to drive through a forest beset with wild beasts, while Abhimanyu, the son of Subhadra and Arjuna, fends off the attacks of the animals with a bow and arrows. The two are anxiously traveling to the young girl Vatsala's house in order to preserve Abhimanyu's engagement to Vatsala; her family has broken off the match because it has heard that the Pandavas have lost their kingdom in battle.

The artist presents the perilous passage almost playfully through a number of visual conceits that are characteristic of the "Paithan" style. Among these are many repeated and rhyming shapes, such as the twinned horses drawing the chariot and the analogous points of Abhimanyu's arrows and the tiger's daggerlike stripes. The artist, moreover, has typically divided the composition along its cen-

tral vertical line, here coinciding with a tree trunk, and pictorially separated the world of wild animals and untamed nature from the more static world of human beings. The warrior's domesticated horses, whose legs have been called wooden-toy-like by one scholar,[103] appear to balk at their approach to the boundary between these two worlds; only the warrior's arrows cross the line, finding their target in the bloodied bodies of tiger and boar—without diminishing their ferocious vitality. The artist's strategies underscore the artificiality of the image and assure the viewers that the representation is, after all, only a picture; on the other hand, such strategies, because they constitute and perfect artistic form, make the represented event all the more memorable.

Reproduced: Anna Libera Dallapiccola, *Die „Paithan"-Malerie: Studie zu ihrer stilistischen Entwicklung und Ikonographie* (Wiesbaden: Franz Steiner Verlag GMBH, 1980), p. 367, fig. D II 1; Stella Kramrisch, *Painted Delight: Indian Paintings from Philadelphia Collections*, exh. cat. (Philadelphia: Philadelphia Museum of Art, 1986), p. 147, fig. 134; and Eva Ray, "Documentation for Paiṭhān Paintings," *Artibus Asiae* (Ascona) 40, no. 4 (1978): 255, fig. 1.

54. A tiger about to be attacked by a warrior, a folio from a Chitrakathi series illustrating the story of the horse sacrifice (*Ashvamedha*)[104] in a Marathi version of the *Mahabharata*, for use as a visual prop in storytelling performances
Western Deccan (Maharashtra and northern Karnataka)
CA. 1840
Transparent and opaque water-based pigments on paper
12" x 16⅛" (30.5 cm x 41.0 cm)
Cynthia Hazen Polsky

54

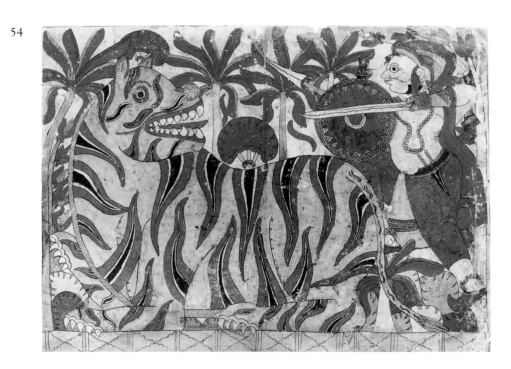

A warrior equipped with sword, shield, and lance climbs a rocky elevation to better stalk a tiger. The startled tiger, surprised from behind, turns his small but alert head over the magnificent bulk of his striped, low-slung body to eye his potential attacker and to fend him off with a hiss that displays powerful fangs. The tension of the sudden confrontation, conveyed through lines that cut across the upper portion of the painting, is nevertheless subtly undercut by a curious languor that permeates the picture's atmosphere. Fronds of palm trees and the tiger's stripes appear to undulate to similar waves of oppressive heat. The image used in storytelling performances asks, but does not answer, Which of these beings will become the other's prey?[105]

55. Two folios from a Chitrakathi series illustrating the story of Babhruvahana in a Marathi version of the *Mahabharata*, pasted back-to-back, for use as a visual prop in storytelling performances
 a. Vrishaketu shooting Babhruvahana into the air on a magical weapon, a half-circle of arrows (recto)
 b. Babhruvahana resuming his fight with Vrishaketu (verso)
 Western Deccan (Maharashtra and northern Karnataka)
 CA. 1850
 Transparent and opaque water-based pigments on paper
 11⅞" x 17³⁄₁₆" (30.2 cm x 43.7 cm)
 Los Angeles County Museum of Art, Museum Associates Purchase from the Nasli and Alice Heeramaneck Collection
 M.71.1.30a, b

Pasted back-to-back as they were actually used by the itinerant storytellers, these two pictures represent two consecutive moments in a duel between Babhruvahana and Vrishaketu, an ally of Arjuna. The paintings are from a "Paithan" series illustrating the story of Babhruvahana, who has angered his father Arjuna for failing to act like a warrior and is challenged to fight him.

 In the vertical image, Vrishaketu has shot Babhruvahana into the heavens on a magical weapon that encloses the victim in a half-wreath of arrows. Babhruvahana appears momentarily in the heavens, with the moon on his left and the sun on his right. He carries a quiver, a bow, and the several arrows he has just taken from Surya, the sun, to kill Arjuna and his brothers, having told Surya that he is Vrishaketu, his grandson. Below, Vrishaketu is poised to shoot another arrow from his bow. His gesture is mimicked by a crouching monkey with one raised paw with long claws. The verticality of the image is exceptional, a mode reserved in "Paithan" painting for those few narrative episodes in which a hero is shot into or placed in the heavens. In the reverse image, which is typically horizontal, Babhruvahana has descended to earth, still enclosed in his opponent's weapon, and the battle continues. These two pictures exhibit all the muscular tension of actual armed conflict viewed at close range.[106]

 Reproduced (55a): October House, *The Arts of India and Nepal: The Nasli and Alice Heeramaneck Collection*, exh. cat. (Boston: Museum of Fine Arts, 1966), p. 132, no. 189a recto.

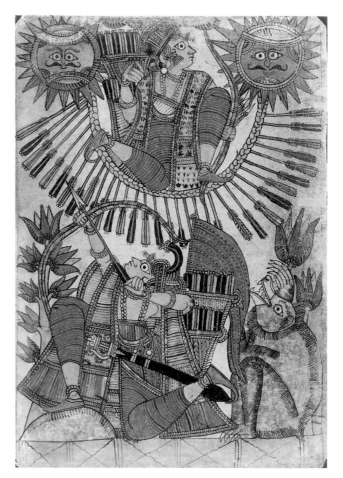

55a

55b

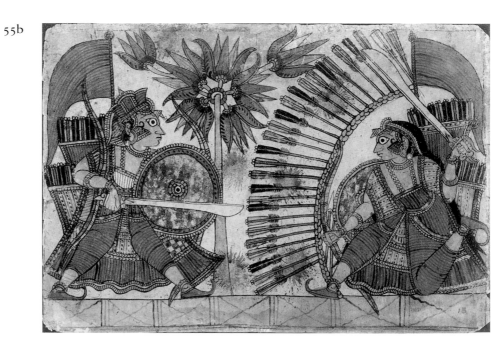

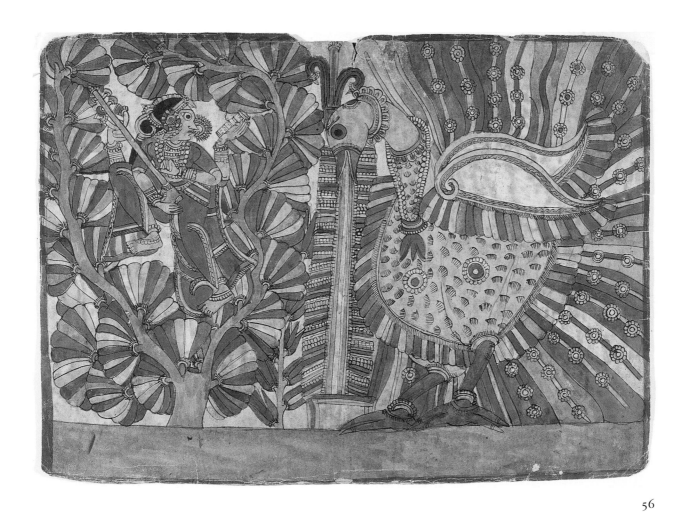

56. The goddess Sarasvati and her peacock, the second folio from a Chitrakathi se-
 ries, for use in ritual invocation of deities in storytelling performances
 Western Deccan (Maharashtra and northern Karnataka)
 CA. 1850–60
 Transparent and opaque water-based pigments on paper
 12⅛" x 16⁷⁄₁₆" (30.7 cm x 41.8 cm)
 Courtesy of Arthur M. Sackler Museum, Harvard University Art Museums,
 Loan from Private Collection, TL34483.2

In the Chitrakathi tradition, the painter-storytellers introduce their narratives
with pictures and invocations of Ganesha, the god of auspicious beginnings,
and Sarasvati, the goddess of speech, learning, wisdom, and the arts. This pic-
ture, which depicts Sarasvati with a peacock (instead of her usual mount, a
goose) and with some of her typical emblems such as a lute or *vina*, cymbal, and
book, is, then, probably the traditional second picture in a Chitrakathi series.

On the left, the goddess stands encircled by the garland-like boughs of a
flowering tree.[107] On the right, the peacock displays swirling, multicolored
plumage. In reality the peacock's cry is high-pitched and piercing; but here, per-
haps employed instead as a counterpoint to the artful speech inspired by Saravasti

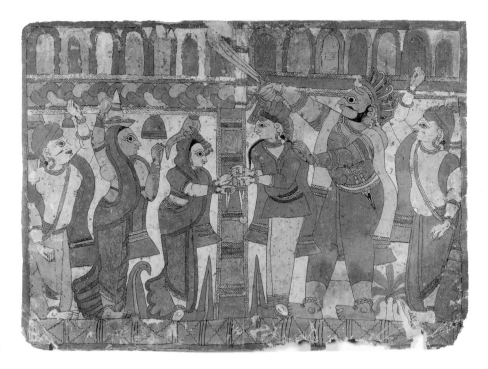

57

or as a device to draw viewers' attention to the physical organ of speech (which will be well exercised by the storyteller in the impending performance), a very long and elaborately feathered tongue emanates from the bird's open beak. The tongue's vertical line, strategically drawn down the middle of the page, clearly divides the composition into two equal parts. The central placement of the embellished tongue pictorially suggests the central importance of speech in the ongoing creation of Indian culture, through oral transmission of its epics.[108]

57. Marriage of Vrishaketu and the daughter of King Yavanatha (Yauvanashva), a folio from a Chitrakathi series illustrating the story of the horse sacrifice (*Ashvamedha*)[109] in a Marathi version of the *Mahabharata*, for use as a visual prop in storytelling performances
Western Deccan (Maharashtra and northern Karnataka)
CA. 1860
Transparent and opaque water-based pigments on paper
12¼" x 15½" (31.1 cm x 39.4 cm)
Los Angeles County Museum of Art, Gift of Paul F. Walter, M.74.123a

This scene from a marriage ceremony uniting Vrishaketu and a king's daughter takes place within a pavilion whose column is central in the composition, as is typical in "Paithan" paintings depicting marriage.[110] The bride and groom, facing each other, stand on either side of this column and perform a marriage ritual involving the use of betel nutcrackers, which here are shaped like daggers.[111] The giant figure of Meghavarna raises his sword to bless the couple; a woman, carrying a basket filled with auspicious offerings on top of her head,

and two Brahmin priests also extend their arms in blessing.[112] The participants in the marriage ceremony are rhythmically distributed across the shallow space of the pavilion interior; reaching from floor almost to ceiling, they function visually like caryatids. A variety of miniaturized and highly abstracted trees and vegetation at the ground line punctuate the interspaces between the architectural columns and the columnlike figures. The image was one of a series used in storytelling performances.

Reproduced: Anna Libera Dallapiccola, *Die „Paithan"-Malerei: Studie zu ihrer stilistischen Entwicklung und Ikonographie* (Wiesbaden: Franz Steiner Verlag GMBH, 1980), p. 227, fig. B III 4.

Par *Paintings*

Introduction

The large-scale horizontal paintings on cloth of the *par* tradition convey the epic lives of local hero-gods to village peoples in rural Rajasthan.[113] The paintings, which overflow with figures and pictorial incidents, are designed to provide a dramatic visual backdrop for storytelling; displayed in conjunction with a ritual all-night performance, they are customarily opened, that is, unrolled, only after sundown[114] and, perhaps as a consequence, are called *pars,* which in Rajasthani dialect means "folds."[115] At every performance, the numerous narrative episodes depicted on such paintings are illuminated, one at a time, with an oil lamp moved about by an assistant to the principal performer, who simultaneously points out clusters of characters in action and verbally recounts the hero's epic story in verse through singing and declaiming, to the accompaniment of musical instruments and dancing. Such multimedia performances, however, are more than entertaining narration because they also constitute liturgies that honor hero-gods, with the performers serving as cult priests and with the paintings employed as mobile shrines; accordingly, both performers and attendees make ritual offerings to the images of hero-gods at the center of the paintings before the narration begins.[116]

The principal subjects of the story cloths, as the paintings of the *par* tradition are sometimes called, are the lives of Pabu or Pabuji and Devnarayan (also called Devji), two legendary Rajasthani heroes who came to be regionally revered as incarnations of the god Vishnu. Each hero-god has a separate audience of devotees and is served by different castes of performer-priests called *bhopas.* The cattle-rescuing hero Pabuji is worshiped by seminomadic Rebari herders and is served by *bhopas* of the so-called low-caste Nayak community. The clan-avenging hero Devnarayan is worshiped primarily by the Gujar caste and is served primarily by *bhopas* from the same caste. Other subjects depicted on *pars* include the lives of another local hero-god, Ramdev (also portrayed in northern Gujarat's Garoda scroll painting tradition; see no. 43) and of Rama and Krishna (incarnations of Vishnu); these subjects appeal to yet other communities that are served by priest-performers of still other castes.

For each story-cloth subject, a distinctive iconography has evolved, though

superficially those featuring Pabuji and Devnarayan may appear quite similar. Common to all *pars* is a dense packing of the available picture area, with figures grouped in scenes very closely placed to one another. Also common is a relatively simple, flat construction of pictorial space, consisting of figures placed against a background plane. Figures are unmodeled. Major characters are arranged with an avoidance of overlapping; the effect of overlapped minor characters is that of a fanned deck of cards. There is no indication of a ground plane or sky, although there are numerous ground lines or registers on which some of the figures and architectural structures—most often, courts—stand. Buildings are represented by only their front planes. The figures are rhythmically distributed from top to bottom of the picture area, without the kind of change in size that makes forms recess in space; the scale of figures is relative to the social status of the characters they represent and the roles they play in the story.

Dominating the compositions of *pars* celebrating Pabuji (nos. 58, 60) and Devnarayan (no. 59) are large-scale images of the hero-gods, iconically enthroned and attended by court members in the middle of the paintings. Surrounding these central images are many groups of figures in scenes that represent one or more episodes of the story. The arrangement of imagery on the *pars* honoring Pabuji is determined, according to one scholar, not on the basis of sequence of events (as found, for example, in the comic-strip format) but rather on the basis of place, that is, representations of all episodes that occur in the same geographic place are found clustered in one area of the painting and nowhere else. Guided by the performers' lamp, the viewer follows the action of Pabuji's story as it unfolds in various places on the cloth. With the hero-god's court at the center, the courts of friends and family on either side, the courts with which marriage relations are contracted even farther out, and the courts of adversaries on the far left and right sides, the painting is not only a temple enshrining the deity but also a conceptual and symbolic map of the geographic territory in which the epic story plays out.[117] This arrangement of scenes (according to geography) and of courts (according to their friendly or adversarial relationship with the hero-god) does not apply as consistently, however, in the case of *pars* honoring Devnarayan.[118]

To accommodate the numerous episodes in these complex stories, the *pars* must be extremely wide: those telling Pabuji's story are generally fifteen to eighteen feet wide and four to five feet high, while those telling Devnarayan's story, a much longer epic, are usually twenty-five to thirty feet wide and four to five feet high. The stories of other hero-gods are illustrated on smaller cloths. The narrative incidents are painted on cotton cloth that has been initially stiffened with starch and then burnished with a special stone device. It is customary for the artist to make his own pigments, using locally available plants and minerals and mixing them with gum and water. He lays out the complicated composition with a sketch in a light yellow color. He then applies the traditional colors of red, which vividly predominates, and green, blue, yellow, orange, and brown, one at a time, blocking in shapes without modeling them. Finally, he outlines the forms and creates details like eyes and moustaches with a flowing, nuanced black line.[119]

Although *bhopas* occasionally paint their own *pars* (for an example, see no. 60), they usually commission a member of a special community of painters with

the surname Joshi.[120] These painters belong to an astrologer clan and the Chhipa caste, whose traditional work has been textile printing and dyeing. Members of this community of painters claim to be a subgroup of the Brahmin or priestly caste and have resided principally in Bhilwara, Shahpura, and Chittorgarh.

The Joshi artist follows prescribed rituals in beginning and finishing work on a new painting and also in initiating its use. For the painting to be considered completed, for example, the artist must ceremoniously paint in the pupil of the eye of the hero-god (an act that invokes the deity to dwell in the story cloth) and he must also ritually sign the *par* and write the name of the *bhopa* who commissioned it. Moreover, in the case of Devnarayan *pars*, if the patron has paid the artist's fee (instead of the *bhopa*), the patron's name is also written on the cloth. Because the deity is believed to reside in the *par*, there are also special rites for the disposal of an old painting that must be replaced: the painting is immersed in a sacred lake at Pushkar[121] or, alternately, in a well.[122] (It is only recently that *pars* have come to be seen by viewers beyond the audiences for which they were painted, some having found their way to dealers of antiquities.[123])

The age of the tradition is unknown, though literary evidence attests to its existence by the early nineteenth century.[124] The *par* tradition of painting on cloth is related to a mural tradition; there are wall paintings with similar iconography in the Shekhavati area of Rajasthan, one dating from at least 1750.[125] Murals similar to *pars* featuring Devnarayan are painted to this day in that hero-god's temples and shrines;[126] there are also some murals in which a terra-cotta relief of the deity, a special artifact produced in the Rajasthani town of Molela, is installed at the center of the painting.[127] The traditional use of *pars* in ritual performances continues to this day alongside the developments of the past thirty-some years, that is, commercial production of decorative paintings in the *par* style for a nonrural or foreign market, in smaller sizes and with many fewer episodes and nontraditional themes.[128] The two major epics celebrated in the *par* tradition, those of Pabuji and Devnarayan, have only recently been translated into English.

Representative Works: Par *Paintings, nos. 58–60*

58. Painted cloth of Pabuji (*Pabuji ki Par*), for use as a visual prop in storytelling
 performances
 Inscribed in Marwari: "Shri Ramaji / King "Great King" Shri Shri 108 [times]
 Shri / In the great rule of [ruler whose name is unclear] in the village of Shahpura / The hand of Ghuisulal [and] Durgalal painted [this] par / The par is signed for [bhopa whose name is unclear] of [village] / Maradhara(?) / It is signed for Rs. [rupees] 301 / [on] the 7th day bright fortnight of [the lunar month of] Vaisakha [April-May], 1975 [i.e., A.D. 1919]."[129]
 Rajasthan, Shahpura
 Probably mid-20th century, signed and dated(?) by Ghisu Joshi and [son] Durga Joshi
 Opaque water-based pigments on cotton cloth
 54" x 221" (137.2 cm x 561.3 cm)
 Joseph C. Miller, Jr.

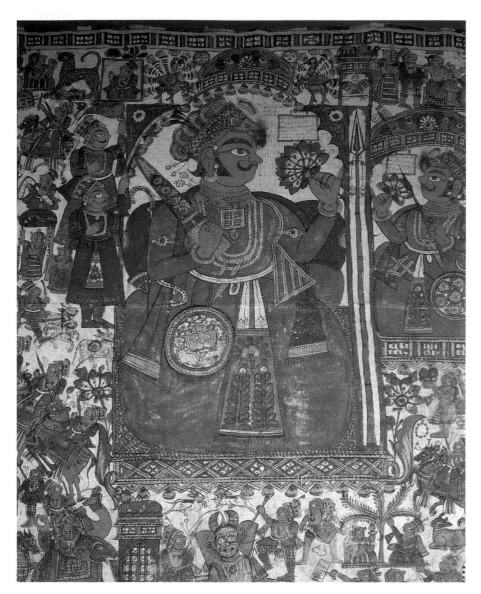

58, detail

The epic of Pabuji, preserved in oral tradition, tells the story of a local hero-god who must leave his own wedding to keep his promise to protect another's cattle; he is unfortunately killed before he can return and consummate his marriage. His story, which embodies ideals of personal conduct, especially in the face of conflicting commitments, entails numerous episodes that are illustrated on the painting, which was used in conjunction with ritual performances of the legend.

Pabuji is one of four children of Dhadal Rathor, but, unlike his siblings, he is an incarnate god with a nymph mother who disappears shortly after his birth, promising to return to him in the form of a mare. After his father's death,

Pabuji and his half brother Buro set up court in their village and fight the Khicis, who are encroaching on their territory; when Jindrav Khici's father is killed in the battle, Pabuji and Buro offer one of their sisters in marriage to Jindrav Khici, in an effort to ameliorate the situation. Jindrav Khici, however, remains hostile and is further angered when the lady Deval, an incarnation of the Goddess, gives Pabuji an exceptionally fine black mare that Khici had wanted for himself. Pabuji promises Deval that he will protect her cattle from the Khicis, in exchange for the mare (actually his mother). In one of the many exploits that follow, Pabuji kills the ten-headed demon king Ravana (a feat usually attributed to the hero-god Rama in the epic *Ramayana*) when he goes to Lanka to raid she-camels as a wedding gift for his niece, Buro's daughter. While Pabuji is returning to his home, a Rajasthani princess falls in love with him on first sight, and their marriage is later arranged; after many delays and an ominous journey to the court of the princess's family for the wedding, Pabuji must leave the marriage ceremonies before they are completed, as Deval has sent a message that Khici has stolen her cattle. One of Pabuji's warrior-companions kills all of Khici's men, but Pabuji spares the life of Khici so that his sister will not be widowed. Pabuji and his men restore the cattle to their rightful owner Deval, while Jindrav Khici returns to fight Pabuji with another army. He strikes down Pabuji, who is taken to heaven in a palanquin. All of Pabuji's men die in this battle; their widows immolate themselves on their husbands' funeral pyres. After some time, Pabuji's nephew (Buro's son), who has grown up ignorant of his family origins, is informed by Deval of his history; he eventually kills Jindrav Khici, avenging the deaths of Pabuji and the Rathors.[130]

Pabuji's court dominates the central area of the painting, with the hero portrayed as the painting's largest figure (illustrated). Enthroned in his court, Pabuji holds a sword and a lotus and faces his four courtiers, who are represented in smaller scale. Pabuji's black mare is depicted below his court on the right. To the left of Pabuji is a small court where his half brother Buro is enthroned. Approximately in the middle of the left side of the painting is the court of Umarkot, the home of Pabuji's bride. On the far ends of the composition are the territories of the enemies of Pabuji, Ravana's kingdom of Lanka on the far left, separated by a band of water, and Khici's court (and another court) on the far right. Interspersed between the courts are depictions of the narrative's many action-filled episodes, including the she-camel raid in the lower left corner, the fight between Pabuji and the ten-headed demon Ravana close to the edge of the left side, and the final battle in which the armies of Pabuji and of Khici face off in great arcs on the far right side. Also portrayed on the upper left edge are the gods and goddesses invoked at the beginning of the performance and in special songs employed in recounting episodes involving marriage.

Well executed by a Joshi painter, the *par* is typically colored in red, orange, brown, ochre, yellow, blue, green, and black. The worn condition of the *par* on its far right side indicates that the painting was unrolled, according to tradition, from the right for display in many ritual performances and that it characteristically experienced hard use.

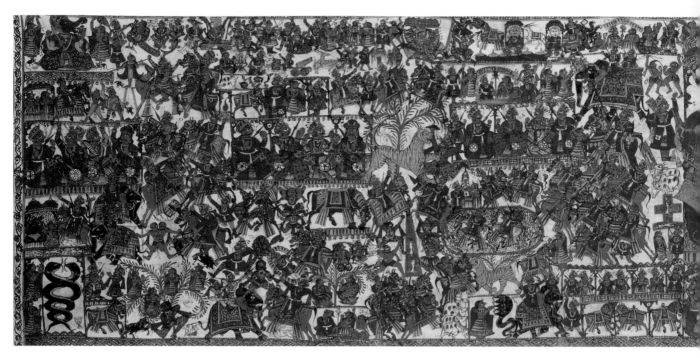

59. Painted cloth of Devnarayan (*Devnarayan ki Par*), for use as a visual prop in storytelling performances
Inscribed in Marwari: "In the period of the President Rajendra Prasad [first President of India after Independence, 1950–62] / In the city of Udaipur of the country India / The artist Ramgopal Joshi wrote: / Bhopal Kalu of village Manvas(?) Rupees 351_____? / Year [obliterated] / [Lunar month of] Chaitra [March-April], 13th day of the dark fortnight."[131] Inscribed in English: *R.G. Joshi*.
Rajasthan, Udaipur
Mid-20th century(?), signed and dated by Ramgopal Joshi
Opaque water-based pigments on cotton cloth
68" x 289" (172.7 cm x 734.1 cm)
Mingei International Museum, Gift of Millard and Mary Sheets, 1985.025-001

The story of Devnarayan, also called Devji, is illustrated on this painted cloth that was used as a visual prop in ritual performances of the legend. The epic is a complex oral narrative that recounts the life of a local hero-god and his Rajasthani family through four generations. The epic begins with the story of a clan patriarch called Bagh (tiger), who fathers twenty-four sons. Collectively known as Bagravats (sons of Bagh), they marry into the Gujar caste and squander their fortune and drink wine to excess. One son, Savai Bhoj, is drawn into a clandestine marriage with Jasvanti, an incarnation of the Goddess, who has promised the god Vishnu that she will carry out punishment of this clan for allowing their drink to

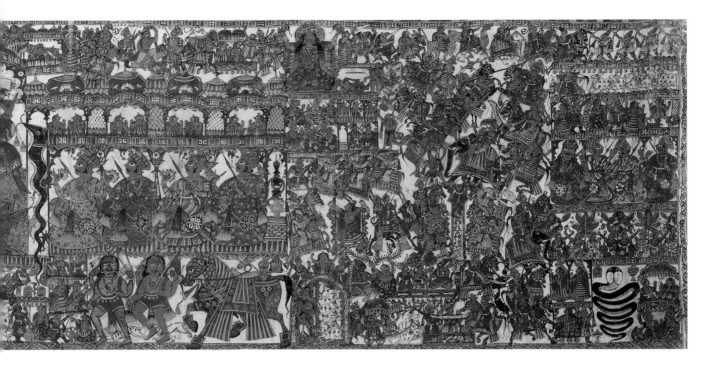

seep into the netherworld. Accordingly, she annihilates the brothers in their war with her legal husband, an old Rajput king. All of the brothers' widows except Bhoj's wife commit suicide by mounting their husbands' funeral pyres; Bhoj's wife retires to a remote area to perform penance. Vishnu, impressed by her devotion, incarnates himself as Devnarayan and is born of a lotus flower. When the incarnate god learns of his family origins, he avenges the honor of his clan by another war with the old king. The epic finally recounts how the generation that comes after Devnarayan initiates a tradition of the worship of the local hero-god among the Gujar caste.[132]

Devnarayan, the largest figure on the painting, is shown in profile, centrally enthroned in a pavilion, seated on the snake Sesha (also transliterated Shesha) and facing the rearing snake, Basag Naga. Clothed in a red robe and turban and with his moustache terminating in a well-groomed curlicue, he holds a sword in one hand and a small flower in the other. Facing Devnarayan in his court to the right are his four courtiers, depicted in smaller scale, each holding a spear, while three hold flowers similar to Devnarayan's and one smokes a hookah (water pipe). The court of Jasvanti's husband is to the upper left of the central figure of Devnarayan. As in *pars* celebrating Pabuji, the gods and goddesses invoked at the beginning of the performance and in special songs used for episodes involving marriage are portrayed along the border of the upper left edge.

Among the most striking images of the numerous episodes in this complex narrative are those related to the battle of the brothers with the old king, found

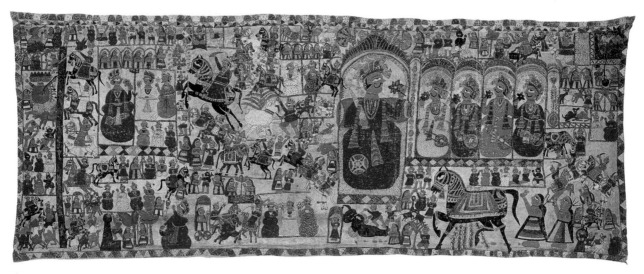

60

throughout the right side of the story cloth. Here, the wife of one of the brothers discovers the headless corpses of her slain sons; Jasvanti, straddling two cannons, comes to her old husband's assistance; and one of the brothers valiantly continues to fight even though beheaded by Jasvanti.

The crowded picture space, which ambitiously packs in the events in the lives of four generations, is narrowly bordered on all sides with variously patterned bands: a diagonal checkered pattern forms the bottom border, continuous half circles and squares create the top, and scrolling vegetation is employed on both left and right sides. This Devnarayan *par*, well executed in the traditional style, omits some scenes that are characteristic of the epic while including some related to the Pabuji story; the two rearing snakes in the left corner and the single rearing snake in the right corner appear to be unique to this *par*.[133] The *par* untypically contains a legend with the initials of the artist's given name and his full surname in English script along the top border of the left section of the painting.

60. Painted cloth of Pabuji (*Pabuji ki Par*), for use as a visual prop in storytelling performances
Rajasthan
Mid-20th century
Opaque water-based pigments on cotton cloth
64¼" x 165" (163.2 cm x 419.1 cm)
The Denver Art Museum, Anonymous gift, 1985.551

This *par* illustrates the oral epic of Pabuji, as related in the first entry in this section (no. 58), and has a very similar layout of the courts and territories of the principal characters interspersed with battles and other narrative scenes. The style of this Pabuji *par*, however, is considerably less sophisticated than the style of those produced and signed by Joshis, professional painters who are traditionally commissioned by *bhopas* (performer-priests) of different castes to execute these large-scale paintings of hero-gods worshiped by different communities. In addition to its folkish style, the *par* is not signed. Accordingly, it can be assumed that the

painter of this story cloth was probably a *bhopa* who used it in his ritual performances of the Pabuji legend.

Particularly striking in this *par* is the stylization of the figures in the courts, whose overlarge and circular lower bodies resemble the heavy, spherical bottoms of so many roly-poly toys. In spite of these curving forms, the composition is nevertheless charged with an overall angularity, quite unlike the fluidity that characterizes *pars* painted by Joshis. The figures, abstractly drawn without modeling, have few interior contour lines; there is a great emphasis on flat shapes, many of which are straight-sided—those painted yellow are stippled with multicolored dots like confetti. A narrow band with a pattern of randomly colored and stippled triangles surrounds the entire visual field.

72° 80° 88° 96°

32° 32°

AFGHANISTAN

Jammu
and
Kashmir

H
I
M
A
L
A
Y
A
S

CHINA

TIBET

Himachal
Pradesh

PAKISTAN

Punjab

Haryana

NEPAL

Sikkim

BHUTAN Arunachal Pradesh

Assam Nagaland

Delhi

Rajasthan

Nagar

Uttar
Pradesh

Ganges

Bihar

Ganges

BANGLADESH Manipur
Tripura Mizoram

24°

Nathadwara

Mewar Malwa

Gujarat Madhya Pradesh

West
Bengal
Calcutta

MYANMAR
(BURMA)

INDIA

Mumbai
(Bombay)

Maharashtra

Orissa

DECCAN PLATEAU

BAY OF BENGAL

16° 16°

Goa

Andhra
Pradesh

ARABIAN
SEA

Karnataka

Madras

Tamil
Nadu

Kerala

Key to symbols for sites of miniature painting

■ Mughal painting

□ Mughal-influenced painting in the Deccan

◆ Rajasthani painting

◇ Rajasthani-influenced painting in the Himalayan foothills

▶ Eastern Indian painting

▼ South Indian painting

▲ Company painting

8° 8°

SRI
LANKA

INDIAN OCEAN

72° 80° 88°

4

Paintings Informed by Sophisticated Traditions

Paintings Informed by the Jain Tradition

Introduction

The Jain painting tradition emerged to serve the Jain community, faithful to the tenets of Jainism, an ancient religion, like Buddhism, that originated in India as a reformation of an early form of Hinduism. The Jain faith proposes not a personal creator god for veneration but rather twenty-four human beings, known as *jinas* (conquerors), who liberated themselves from the bondage of the senses, individuality, and continuous death and rebirth. The released conquerors give the faith its name and are also called *tirthankaras* (ford- or passage-makers) because they assist others in crossing the river of existence to a nontemporal, transcendent state of indifference, serenity, and omniscience by illuminating the goal and by providing a model of living that involves discipline, asceticism, and the utmost respect for living beings. Only the last two exemplars of these Jain ideals, Parshvanatha of the eighth century B.C. and Mahavira of the sixth century B.C., are believed to have been historical persons. The latter is credited with a reorganization of the faith that provided the foundation for the form of Jainism in practice today. The faith apparently spread from Mahavira's birthplace in Bihar to Western and South India.

Some traces of very early Jain mural painting survive, most in South India. What is known today, however, as Jain painting is principally defined by illustrations of Jain texts painted in Western India (Gujarat and Rajasthan) in a distinctive linear style that portrays human figures with faces that have pointed noses and chins and are depicted from a three-quarter view except the far eye that is fully shown; the pictorial elements, often embellished with lavish applications

147

of gold, are set against background planes of red or blue. The evolution of the style is evident in Jain manuscript illustrations from the twelfth through the sixteenth centuries, initially executed on palm leaves and later on paper.[1] In the seventeenth and eighteenth centuries, Jain painting became less distinctive as more influences from Mughal and Rajasthani court painting were assimilated.

Despite its frequent use of costly gold in manuscript illustrations, the Jain painting tradition cannot be said to be a courtly one on the basis of its patronage, since it developed to serve a religious community whose lay members have been mostly merchants and professionals dwelling in towns or cities. One of the ways these lay members acquired religious merit was to commission scribes and artists to copy or create illustrated manuscripts, which were subsequently donated to communally supported libraries (*bhandaras*) attached to temples and monasteries. Jain monks and nuns studied, ritually displayed, and explicated these manuscripts to the lay faithful, especially during the rainy months, when the monks and nuns could not travel as mendicants as is their custom during the rest of the year. (See no. 64, for a view of a Jain ascetic, religious leader—though not a monk—reading a scripture.) Thousands of commissioned manuscripts of both Jain and non-Jain texts survive in the *bhandaras* of Rajasthan and Gujarat, where the largest portion of the Jain community has resided.

Jain manuscripts are narrative and didactic. Manuscripts of the *Kalpa Sutra* (Book of Ritual), Jainism's principal text, illustrate the same main events (conception, birth, renunciation, enlightenment, and liberation) in each of the lives of the *tirthankaras*. Other manuscripts illustrate legends and religious stories that demonstrate philosophical or ethical teachings special to Jainism. Yet other manuscripts, such as the *Sangrahani Sutra* (Book of Compilations), illustrate Jain cosmological stories and concepts (some in compelling visual forms), while the *Kshetrasamasa* (Compendium of Sacred Grounds) illustrates the sect's geographical concepts. Such manuscripts were often protected by wooden covers that were also painted with Jain subject matter.

Less well-known are Jain paintings on cloth (*patas*) or paper portraying a variety of different subjects; most are designed as objects of meditation or veneration for use in various rituals. Some paintings on cloth or paper display in enlarged scale the arresting visualizations of religious and cosmological concepts that occur in Jain manuscripts (no. 63), some influenced by Tantrism, a cult with esoteric doctrines and practices (no. 61). *Tirtha patas* depict Jain temples clustered in various mountain-top pilgrimage sites known as *tirthas*; kept in the *bhandaras*, these large-scale painted cloth hangings are ritually displayed and venerated by devotees who cannot, as ritually prescribed, travel in person to the pilgrimage sites during certain festival times.[2] Other *patas* present *yantras* of mantras (diagrams representing mystic sound) for the devotee to use in meditation, though this subject is also frequently found executed on paper in a range of sizes.[3] Iconic images of the *tirthankaras* painted on paper in various formats are venerated and displayed in home shrines[4] as meditative aids during daily prayers in praise of the Jain exemplars (nos. 62, 65). Finally, scrolls (usually constructed of paper) known as *vijnaptipatra*, are created as letters of invitation from a lay community to particular monks, requesting them to come and preach in the community's town or city during the next rainy season. Among

the popular motifs found on these scrolls (as well as on other artifacts) are eight auspicious signs (*ashtamangala*), such as the swastika and a full vase, and images of the fourteen dreams that each mother of a *tirthankara* experienced during her pregnancy.[5]

Before the second half of nineteenth century, all the paper employed in Jain paintings was undoubtedly handmade and the cloth supports were handspun. Paintings on cloth required priming with a paste of rice or wheat flour so that colors would not bleed; after the paste dried, it was burnished.[6] A sketch in pencil or charcoal was then drawn, and pigments, made by the artists from local minerals and vegetable matter, were applied with brushes made from animal hairs. The artists, commissioned by Jain laypeople to create *patas* and to illustrate manuscripts (whose texts were copied by scribes), were professional painters who were not exclusively involved in the production of Jain paintings; unlike the painter castes associated with specific traditions discussed in Chapters 2 and 3, the artists who worked for Jain patrons apparently worked also for Hindu and Buddhist patrons; the artists did not constitute a single caste but rather came from many different social and religious backgrounds, including Islam. The diversity of the artists who created Jain paintings is reflected in the range of sophistication, from highly refined to very folkish, that is evident in even a cursory survey of the several distinctive forms found in the tradition. The Jain works discussed here either are designed for the private devotional use of laypeople or manifest the folkish end of the continuum of Jain style.[7] Scholarly treatment of Jain paintings has focused on the sophisticated aspects of the tradition.

*Representative Works: Paintings Informed
by the Jain Tradition, nos. 61–65*

61. A devotee's image of Garuda with Indra, Varuna, Agni, and Vayu, perhaps for use as a visual aid to meditation on a concept of the human body with subtle centers or in rituals for treating poison
 Rajasthan or Gujarat
 17th century[8]
 Opaque water-based pigments on paper
 10" x 4½" (25.4 cm x 11.4 cm)
 Dr. Alvin O. Bellak, Philadelphia

This image of a composite being, part-man and part-bird, portrays Garuda, the vehicle of the god Vishnu and the great destroyer of serpents: the heroic subject of mythological stories, Garuda vanquishes snakes as he is their natural enemy.

In the painting, the full figure of Garuda, adorned with many snakes, is shown standing in an elongated oval formed by the length of a snake's body. Garuda's face is portrayed in three-quarter view and with the far eye fully shown in the manner typical of early Jain manuscript painting. Patterned bands representing wings extend from a collar around Garuda's neck over his shoulders to the wrists of his human hands. Four pairs of intertwining snakes, depicted along the vertical axis of his body, surround geometrical figures

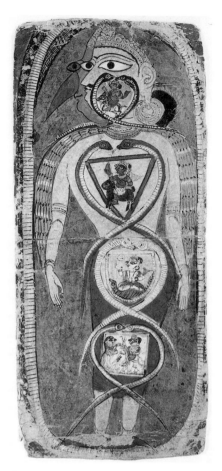

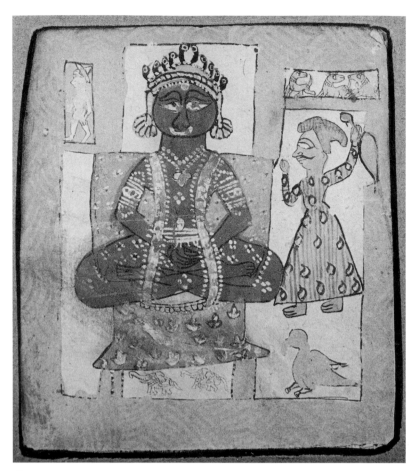

61

62

enshrining images of deities. The lowest pair frames a square containing Indra, golden-skinned, clothed in a green garment, holding a trident, seated on his elephant mount, and attended by a female figure. The second pair from the bottom frames a crescent containing Varuna, the god of oceans and waters, who is portrayed white-skinned, clothed in a red garment, and seated on a *makara* (a mythical water creature). The pair at Garuda's chest frames an inverted triangle containing Agni, the god of fire, who is depicted as ruddy-skinned, clothed in a white garment, holding fire in his hand, and riding a black ram. The pair at throat level frames an image of Vayu, the god of wind, who is shown green-skinned, wearing a red garment, and riding a white horse.

The inclusion of these deities is unusual in the portrayal of Garuda. The composition may constitute a visualization of a concept of the human body, which posits an immaterial network that channels energies within the physical body and that also has centers or points of contact (represented as lotus *chakras* or discuses or wheels) between itself and the physical components. This non-physical network or inner body, known as "the subtle body," is associated with

Tantrism, whose scripture-based cult beliefs and practices have influenced Jain-ism, Hinduism, and Buddhism.[9] In this interpretation of Garuda's image, the serpents may symbolize the channels of the body's ascending energies. Resem-bling Tantric representations of "the subtle body" with *chakras*, this painting of Garuda displays only four of the usual seven inner body centers but the same first three enclosing shapes of square, crescent, and inverted triangle; and it fea-tures different deities within the *chakras* but parallel symbolizations of the realms of earth, water, fire, and air. Like Tantric representations of "the subtle body," this painting may have been employed in religious instruction as a di-dactic chart and perhaps was also used as a visual aid to meditation.

The image of Garuda may have also served as a visual aid in certain rituals enacted to neutralize poison, especially from snakebite. Such rituals requiring Garuda's powers are described in the sacred writing *Agni Purana* (bk. 3, chap. 295 [ed. J. L. Shastri, 1986]); all the rituals are said to employ the repeated recitation of various mantras, principally, the name of Garuda. Of special inter-est in the interpretation of the painting seen here is the mention of a meditation to be performed in conjunction with the repetition of the mantras: a similar vi-sualization of the same gods of earth, water, fire, and air that are depicted along the center line of Garuda's body as well as Shiva, the god of formless ether. The visualization appears to be aided by the use of an occult diagram.[10] Such mental and possibly physical images portraying Garuda, as he is seen here, may have been used to facilitate the visualization of the deities, required for ritual efficacy in neutralizing poisons.

62. A devotee's image of the second Jain savior or "ford-maker" (*tirthankara*), Ajita-natha, for use in a domestic shrine
 Western Rajasthan
 Late 18th century
 Opaque water-based pigments on paper
 4¾" x 4¼" (12.1 cm x 10.8 cm)
 Lorna and Roy Craven

The second Jain savior or "ford-maker" (*tirthankara*), Ajitanatha, is portrayed as an ascetic, garlanded and crowned, seated on an orange lotus throne. Beneath him are two elephants, his special cognizance. Ajitanatha's earthen gray skin coloring deviates from the golden yellow that is customarily used for the second savior. Ajitanatha is attended by a fly-whisk bearer wearing an orange turban and a striped and patterned tan garment; beneath the attendant is a bird. In a small, narrow, vertical panel in the upper left is a male figure with a broad-brimmed hat who appears to be walking; the image may represent the ascetic himself or a mendicant Jain monk who traditionally wanders on foot during all but the rainy months (June through September); in a small horizontal panel in the upper right are three animals, perhaps lions. The figures are framed by a gray border with a subtle linear pattern suggesting water. The painting was undoubtedly one of a set of twenty-four depicting all of the twenty-four *tirthankaras*. Intended for private veneration in a home shrine, the full set of paintings was used as a visual aid to the recitation of the Jains' daily morning prayer in praise of the *jinas* (conquerors).

63. A Jain community's image of the cosmic man or the universe visualized as a hu-
man figure (*loka purusha*), for use in a communal library
Inscribed in Devanagari script
Rajasthan
19th century
Opaque water-based pigments on cloth
29¹¹/₁₆" x 19¼" (75.4 cm x 48.9 cm)
The David and Alfred Smart Museum of Art, The University of Chicago, Gift
of Mr. and Mrs. B. C. Holland, 1992.26

This striking image of a human figure with arms akimbo, incorporating a
grided and checkered hourglass shape and a column of picture panels, visualizes
the Jain concept of the universe and also charts a path to spiritual perfection.
The painting is unfinished, but most of the essential elements traditionally in-
cluded in the image are present in either finished or sketched form.

According to Jain cosmology, the universe has three parts, the upper world
of the gods (*deva loka*) or the heavens, the middle world of human beings (*ma-
dhya loka*) or earth, and the lower world of infernal beings (*naraka loka*) or
the hells; the parts of the universe are visualized as forming a colossal human
figure, almost invariably male, known as the cosmic man. In the painting at
the figure's "waist" is a circle that locates the middle world of earth, which, if
completed, would show a continent with a sacred mountain at its center, sur-
rounded by water. Below the circle are seven horizontal registers represent-
ing seven hells, with their inhabitants—sinners and punishing tormentors—
barely sketched in. Above the middle world, there are four panels showing the
abodes of the gods, who are represented ensconced in pavilions; they are fully
painted, while the background plane is unfinished. The hells and the heavens
are identified with inscriptions. Although numbers are not universally em-
ployed on images of the cosmic man, they appear here on the stepped grid that
forms the hourglass shape of the figure. Even numbers from 4 to 28, found
on the left side, are the square roots of the numbers from 16 to 784, found on
the right side.[11] The numbers on the left indicate the length (and width) of
the square unit of measure used in calculating the extent of the various sec-
tions of each world; the numbers on the right indicate the square measure or
area of each section. When the square measures or areas on the right are added,
the resulting number—which is immense—reveals the size of the universe and
the enormous distances through which a soul must travel in various transmi-
grations to arrive at spiritual perfection (*siddhi*) and finally rest within the cres-
cent usually found in the forehead of the human figure.[12] The cosmic man can
alternately be read as an image of the enormous potential in the human body
or person or as an image of the perfected human who has integrated the cos-
mos into his or her being.[13] With or without numbers, the cosmic man may
also be read as a compelling visual representation of the correspondence in
structure between the macrocosm and the microcosm.[14]

This image, which is like a game board in charting the universe as well as
the "distances" involved in spiritual development, may be related to the Jain
version of the Indian race game of Snakes and Ladders, whose goal is to reach
heaven, in which the game board is incorporated in a human figure (see no.

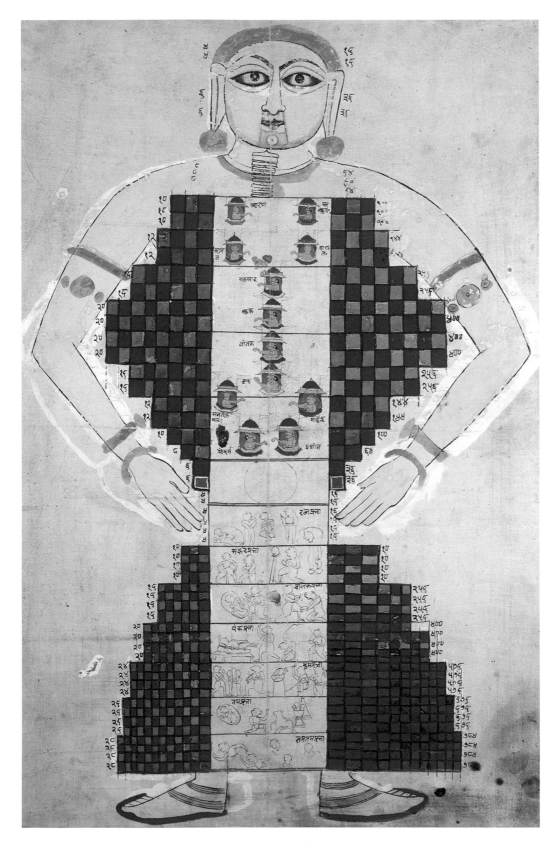

63

94).[15] Visualization of the universe as a human person displaying images of heaven, earth, and hell in vertical alignment may be based on the itinerant storyteller, displaying a vertical picture scroll with scenes of rewards and punishments, known in India from ancient times (for examples of the enduring practice of appending scenes of the afterlife to the final registers of narrative scrolls, see nos. 39, 43, 47–48; see no. 45, part of a full scroll on the subject).

The artist has completely painted the blue and red checkered pattern on the stepped grid of the hourglass form, and he has filled in the figure's hair and jewelry with ochre; the artist apparently changed his mind in drawing the figure in the picture space, since white paint covers over what seem to be initial contour lines. The feet of the cosmic man are typically splayed.

Usually kept in communal *bhandaras* (libraries attached to Jain temples and monasteries), images of the cosmic man are ritually displayed for contemplation and veneration by the faithful.[16]

Reproduced: *The Smart Museum of Art Bulletin* (Chicago) 3, 1990–1991, 1991–1992 (1992): 46.

64. A Jain ascetic venerating a ritual cross-stand (*thavani*), an illustration from an
 unidentified Jain manuscript
 Western India, probably Gujarat
 Second half of the 19th century
 Transparent and opaque water-based pigments on paper
 3¾" x 4⅝" (9.5 cm x 11.7 cm)
 Private collection

64

This male figure, clothed in diaphanous garments with the suggestion of reddish stripes composed of chevrons, is a *yati*, a member of a class of Jain clergy and the religious and social leader of a group of Jain laypeople.[17] Seated on a pillow on a low platform, the *yati* is venerating a ritual structure, known as a *thavani*, made of four narrow cylinders, probably of wood, bound midway or a bit closer to the top, on which a cache of scriptures has been installed in a tasseled cloth covering. The *yati* holds a leaf of scripture in one hand and perhaps a cloth, which covers his other hand. Nearby is a small broom for use in gently brushing away insects without harming or killing them, in exercise of *ahimsa* (noninjury), the most important principle of right conduct according to Jainism. The folkish image is from an unknown manuscript.

65. Twenty-four pages of a devotee's picture album depicting the twenty-four Jain
saviors or "ford-makers" (*tirthankaras*), for use in a domestic shrine
Inscribed in Devanagari script
Gujarat
CA. 1940–50
Transparent and opaque water-based pigments on paper
Each: 12¹⁄₁₆" x 8⁵⁄₁₆" (30.6 cm x 21.1 cm)
Private collection

This set of twenty-four pages from a disassembled devotional picture album portrays each of the twenty-four *tirthankaras* venerated by the Jain community. Each page presents a composite view of the exemplar in his shrine, utilizing three different vantage points. The upper section of each page depicts an eye-level exterior view of the temple's spires above the sanctum. The middle section of each page portrays the *tirthankara*, with an identifying emblem, enthroned in the temple sanctum under an arch and between two columns, flanked by two attendants. The lower section of each page presents the distinctively patterned floor plane of the temple interior, horizontal in reality but placed as a vertical plane within the picture, as if the spectator were viewing it from above. Above each *tirthankara* is an inscription bearing his name, all with the prefix *shri* (illustrious) and honorific suffixlike -*ji*, both common terms of respect, appended. The last *tirthankara*, Mahavira, has in addition the epithet *swami* (also transliterated *svami*) (self-realized) appended to his name.[18]

The presence of the red goose as the cognizance of the fifth *tirthankara* and the mace of the fifteenth identifies this set of images as one serving the Svetambara (literally, white-clad) branch of the Jain community, which emerged in opposition to the Digambara (literally, sky-clad, or naked) branch sometime in the first century in a theological dispute involving, among other things, proper modes of dress for monks. Accordingly, it may be observed that each *tirthankara* is lightly clad in a diaphanous robe embellished with golden dots. The iconographic differentiation of the *tirthankaras* adheres closely to published standards. The pages illustrated here show the seventh, eighth, ninth, and tenth *tirthankaras* with typical emblems, that is, golden-skinned Suparshvanatha with a swastika (no. 65a, left), white-skinned Chandraprabha with a crescent (no. 65a, right), white-skinned Suvidhinatha with a *makara* (a mythical water creature) (no. 65b, left), and golden-skinned Sitalanatha with an urn sur-

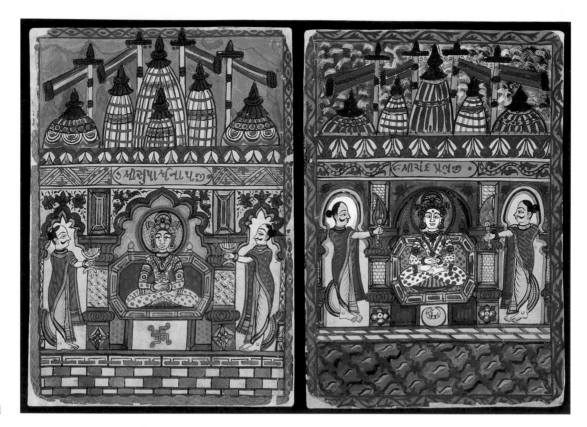

65a, detail

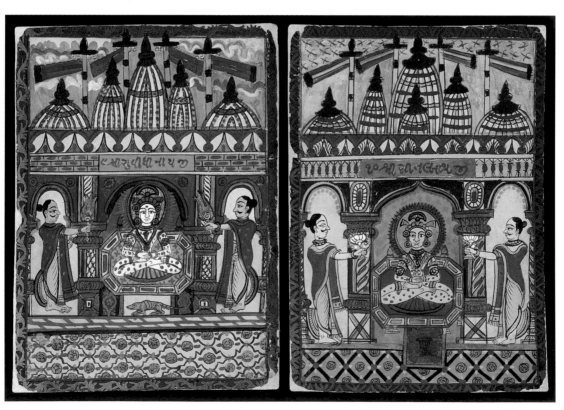

65b, detail

rounded by vegetation (no. 65b, right). Only Mallinatha, the nineteenth, is uncharacteristically painted green instead of yellow, while Padmaprabha and Naminatha, the sixth and twenty-first, normally distinguished by red and blue lotuses respectively, have the colors of their flowers reversed.

The pages of the book were originally pasted back-to-back so that two pages would be seen simultaneously. The artist, perhaps a Jain devotee, has taken great pains to provide enormous variety in a series of images that are essentially similar stereotypes. For example, the skies, partially hidden by the temple spires, are opaquely painted on some pages and transparently on others; some skies are hung with clouds, limned in a variety of ways, while other skies are enlivened by diversified droves of birds, including one that features a fish flying in the midst of a feathered flock. The decorative floor patterns of the temple interiors are freshly invented on every page with different floral and geometric motifs recalling popular European designs of the 1930s and 1940s; temple walls are successively painted a radiant green, ruby red, and cerulean.

The picture album was probably designed to be used as a visual aid to the recitation of the daily morning prayer in praise of Jain exemplars by a devotee in a household shrine.

Paintings Informed by the Nathadwara Tradition

Introduction

The Nathadwara painting tradition serves the Hindu sect that venerates Krishna, an incarnation of the god Vishnu, as a seven-year-old boy known as Shri Nathji (great lord; or lord, with the prefix *shri*, meaning "illustrious," and the honorific suffixlike *-ji* appended). The sect was founded by Vallabhacharya in the fifteenth century and since that time has been guided by the founder's descendants, known as *goswamis*. The sect originated as part of concurrent religious movements in India that emphasized personal devotion (*bhakti*) as the way to salvation. Eschewing asceticism, the sect espouses instead a doctrine of salvation by divine gift; it is consequently called *Pushti Marga* (the Path of Grace). Devotees gratefully and joyously celebrate their tender-aged lord in a daily and yearly cycle of elaborate rituals that involve painting, religious singing, music, and dance.[19] The painting tradition is named after the Rajasthani town of Nathadwara, the location of the sect's main shrine and a pilgrimage center since 1672.

Nathadwara artists create a variety of artifacts for a variety of patrons (in a variety of styles), from large painted cloths commissioned by the leaders of the sect for use in temple rituals to items made for sale to Nathadwara pilgrims and devotees of Shri Nathji for use in domestic shrines.[20] Unlike most pilgrimage traditions (including those discussed in Chapter 2), Nathadwara painting is chiefly but not exclusively characterized by a highly refined style, adapted from Rajasthani miniature traditions established under royal patronage; for this reason, some scholars consider Nathadwara painting a sophisticated tradition, while other scholars regard it as a form of popular painting.[21]

Only Nathadwara artifacts produced for popular consumption are presented here, including, of course, pilgrims' souvenir paintings, usually on paper, featuring iconic images of the child-god in festival costume (nos. 66–67). In these portraits, Shri Nathji is depicted as a short, black figure with an arm upraised, an abbreviated reference to his miraculously holding up Mount Govardhana to protect villagers from a deluge sent by the god Indra. The images are made in a variety of sizes, some as small as two inches by one inch. Another type of souvenir painting has as its subject the various sculptures installed at different shrines of the sect and worshiped as divine living presences. Executed in very small scale, sets of these images are bound in tiny books (no. 69).[22] Both kinds of souvenir paintings are intended to be carried home by pilgrims for private veneration or to be distributed to friends and family. The small devotional images are sometimes fitted into *toranas*, decorative cloth hangings suspended across the top of doors, in Gujarati homes. The images of Shri Nathji used in *toranas* are also found executed on reverse glass, probably produced by nonspecialist artisans (see discussion of paintings on reverse glass in Chapter 5).[23]

Also made for devotees are small paintings on cloth that replicate in reduced scale and in simpler compositions the painted cloth hangings or banners called *pichavais* (literally, displayed at the back), which are hung behind large sculptures of the deity installed in Nathadwara and at other shrines. The large hangings, undoubtedly the fullest expression of the tradition produced by only the most accomplished artists, portray a range of images governed by tradition, including episodes in the life of Krishna, festivals celebrated at Nathadwara, and symbolic forms such as lotuses. They are ritually displayed at liturgically appropriate times of the day and of the annual cycle of festivals and seasons.[24] While large *pichavais* up to eight or nine feet in both directions are commissioned by priests for ritual use in temples, small ones have been produced in the past, their scale an indication of having been designed for use by devotees in home shrines (no. 70).[25]

Among the popular forms of Nathadwara painting that are of interest but not represented here are idyllic landscapes produced as souvenir images, sometimes on glass, made between the late nineteenth century and the 1950s; such landscapes appear to borrow conventions from Western paintings (known through reproductions) and usually contain images of Krishna, his consort, and devotees engaged in activities that narrate episodes of his life.[26]

Handmade and machine-made papers are used for painting devotional pictures. The cotton cloth support of *pichavais* is traditionally prepared by applying wheat paste to stiffen the cloth before it is painted with water-based pigments. Painters either make their own pigments from minerals and plants or use commercially produced powders. Some artists today also employ commercially produced, ready-to-use poster paints. Recently, some artists have started using hardboard as the support for *pichavais* compositions executed in oil paints.[27]

Nathadwara painters belong to two Brahmin subcastes, the Adi Gaud and the Jangid, and inherit their vocation from birth. As many as two hundred painters continue to practice their traditional art even today,[28] usually assisted in various painting tasks by the members of their families.

It is not known when the Nathadwara tradition emerged as a distinct form

of painting. It is likely that it does not predate the late seventeenth century; few individual painters who worked within the tradition before the nineteenth century are known by name.[29] Scholarly study of the Nathadwara tradition has primarily focused on the large and artistically ambitious *pichavais* used in shrines of the sect, and, more recently, on depictions of priests performing worship rituals for various festivals. The latter, relatively small paintings executed in Rajasthani miniature styles, are commissioned by the priests as mementos and historical records of actual events.[30] Although produced in greater quantities and accordingly more widely distributed, pilgrims' souvenir paintings and small *pichavais* for use in domestic shrines have seldom been documented; scholarly attention to these popular devotional materials appears to be limited to a few general remarks.[31]

*Representative Works: Paintings Informed
by the Nathadwara Tradition, nos. 66–70*

66. Two souvenir paintings (*chabis* or *chavis*; or *chitrajis*) made for pilgrims to
 Nathadwara, for use in domestic shrines
 a. Shri Nathji in a saffron costume
 b. Shri Nathji in a dancing costume
 Rajasthan, Nathadwara
 a. Second half of the 19th century
 b. Mid-20th century
 Opaque water-based and metallic pigments on paper
 a. 5⅛" x 3⅜" (13.0 cm x 8.6 cm)
 b. 7⅝" x 5⅞" (19.4 cm x 14.9 cm)
 Private collection

These two paintings were undoubtedly images produced for pilgrims to the shrine of Krishna as Shri Nathji at Nathadwara. Each painting depicts a different mode of dressing the sculptural form of the boy-god installed there. The varied modes of lovingly dressing and adorning Shri Nathji are known as *shringaras* and are ritually prescribed for particular times of worship during the day or during the annual cycle of festivals and seasons celebrated at Nathadwara. This kind of small, iconic image is known to devotees as a *chabi* or *chavi* (portrait) or *chitraji* (painting).[32]

The work on the left shows Shri Nathji dressed in a saffron coat, trousers, and turban, with a red orange scarf around the upper part of the torso—an outfit employed for many birthday celebrations.[33] Shri Nathji's coat (*chakdar jama*), derived from a garment popular at the Islamic Mughal court of the sixteenth century,[34] is embellished here with silver borders and a red orange dot pattern and has a hem that falls in four points. Shri Nathji's close-fitting trousers (*suthana*) display red orange stripes. His turban is jeweled and bedecked with two small plumes. Shri Nathji is garlanded with stylized strands of pearls and flowers and holds a flute (*venu*) under his right arm. Shri Nathji stands against a white stele slightly toned with pink. His face is painted a deep blue with black modeling, and his feet are shown splayed.[35]

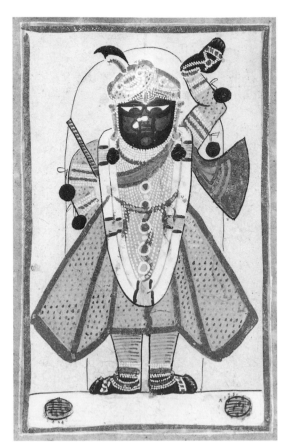

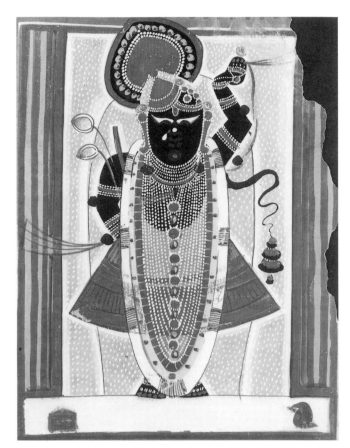

66a

66b

In the work on the right, Shri Nathji wears a dancing costume connected with other festivals,[36] a presentation that is a regularly employed, with some variations, in paintings made for sale to pilgrims in the town bazaar.[37] The dancing costume features a skirted garment (*kachhani*) tied around the waist and reaching to the knees, close-fitting trousers (*suthana*), and a large fanlike ornament (*morchandrika*) composed of peacock feathers and worn on the headdress. Shri Nathji, with his hair in a tasseled braid, holds a flute and two lotus buds with his right arm and a rose, a symbol of Mount Govardhana, in his raised left hand. Around his neck are stylized strands of pearls and a flower garland that reach to his feet. A long scarf (*uparna*) is wrapped around his upper torso, and its ends swing out on either side of his body. A box for pan (betel leaves, a mild stimulant chewed with betel nut and mineral lime) and a water jug wrapped in red cloth are set on the floor before him. In this instance, Shri Nathji's skirt is red and silver, and his scarf is a semitransparent red and yellow; he stands against a light grey stele patterned with small white dots and bounded on either side by a silver cloth hanging with red and orange stripes.

67. A pilgrim's souvenir painting (*chabi* or *chavi*; or *chitraji*) depicting Shri Nathji
in a dancing costume, for use in a domestic shrine
Rajasthan, Nathadwara
Late 19th century
Opaque water-based and metallic pigments on paper
13½" x 9" (34.3 cm x 22.9 cm)
Subhash Kapoor

Undoubtedly painted for a pilgrim to Nathadwara, this image of Shri Nathji in
a dancing costume is called a *chabi* or *chavi* (portrait) or a *chitraji* (painting) by
devotees.[38] Its iconography is almost identical to that of one of the pilgrim's
paintings (no. 66b) previously discussed. The dancing skirt in this example,
however, is divided into three bands instead of two, while Shri Nathji carries
three lotus buds instead of two. Here the child deity wears no scarf and stands
against a stele that is patterned with small white tear-shaped marks and bor-
dered on either side with a silver band. The delineation of form in this painting
is untypically bold, accomplished with broad, spontaneous, and stylizing brush
marks that are more characteristic of Kalighat paintings (see nos. 17–23). The
monochromatic color scheme of black, white, and silver on an unpainted tan
background—modern and minimal in feeling—is also unusual in Nathadwara
paintings.

67

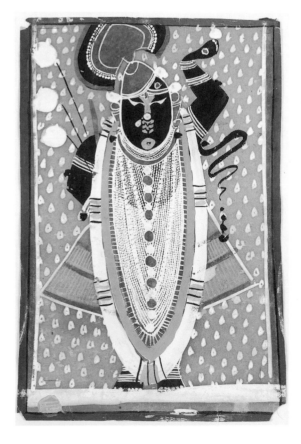

68. A devotee's icon depicting Shri Nathji in a dancing costume, for use in a domestic shrine
Rajasthan, Nathadwara
Mid-20th century
Opaque water-based and metallic pigments on paper
27⅛" x 22⅛" (68.9 cm x 56.2 cm)
Private collection

The relatively large size and fine execution of this painting of Shri Nathji may indicate that it was not created for sale to pilgrims but rather commissioned by a wealthy merchant devotee. As in the Nathadwara paintings (nos. 66b, 67) previously discussed, Shri Nathji is dressed in a dancing skirt, but here the bands are painted orange, deep blue, and red and are overlaid with delicate diagonal grids painted in gold. The deity's flaring scarf is orange. The three lotuses carried in his right hand show the flower in various states, that is, as a bud, a flower just opening, and in full bloom. These flowers and those in his garland are clearly represented and not stylized. Two jeweled cowherd sticks (*vetras*) lean against his right leg. His feet are shown foreshortened. He stands against a light blue plane with a allover pattern of swirling white flowers. Around that plane on either side and at the top is a design of leaves and lotuses against a black background.

68

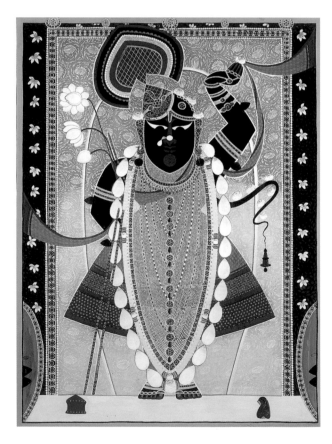

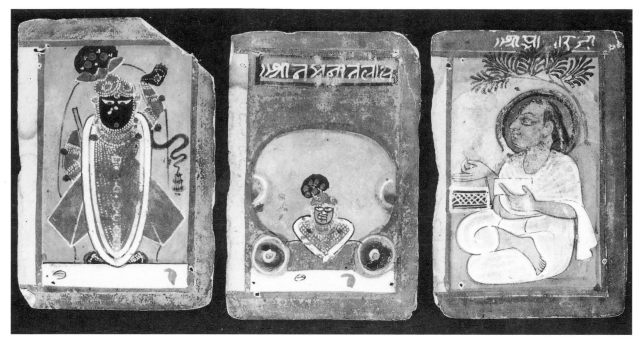

69. Nineteen pages from a Nathadwara pilgrim's souvenir devotional book (*gutka*),
 for use in a domestic shrine
 Inscribed in Devanagari script
 Rajasthan, Nathadwara
 Late 19th century
 Opaque water-based pigments on paper
 Each: approximately 2⁷/16" x 1¹¹/16" (6.2 cm x 4.3 cm)
 Private collection

Tiny bound books with devotional paintings similar to this set of nineteen images were formerly purchased in great quantities by Nathadwara pilgrims to distribute to friends and relatives upon the pilgrims' return home or to keep for personal veneration. Devotees are reported to venerate these books by ritually touching them before beginning their daily worship in home shrines, in the same way that it is customary in India for a person to touch the foot of an eminent ididual as way of acknowledging one's own subservice (see nos. 33, 79). These small souvenir books are called *gutkas* and usually feature twenty to twenty-two paintings. *Gutkas* continue to be made, though at the present time they may be mechanically printed rather than hand-painted.[39]

The majority of the images in these books are representations of the various large and small sculptural figures of Krishna that are venerated as living presences of the deity (*svarupas*), at Nathadwara and at other sect shrines, principally in Rajasthan and Gujarat. Other images feature the founder of the sect and his descendants (*goswamis*), who promulgated the religious movement and cared for the sacred figures. The number of images of revered historical priestly figures varies from a few to several; in this set of nineteen paintings, there are

three such images.[40] Both kinds of images may be inscribed with identifying names.

The first fourteen images are generally arranged in a standard sequence.[41] With the exception of the sixth image, which is apparently missing from this set of paintings, the images—many of which are inscribed, some with variant spellings[42]—are arranged and described in that traditional order. The first three folios are illustrated.

1. The temple icon of Krishna as a seven-year-old boy, known as Shri Nathji (ill., left).

2. The temple icon of Krishna as a crawling infant, known as Navanit-priyaji, inscribed *Shri Nabhanatala* (ill., center).

3. Vallabhacharya (1479–1531), founder of the Pushti Marga religious sect, who is also called Acharya, inscribed *A . . . araji* (possibly, *A*[ch]*ara*[ya]*ji*, that is, Vallabha) (ill., right).

4. Vitthalnathji, (1516–86), son of Vallabhacharya and head of the Pushti Marga sect, portrayed in yogic breathing posture.

5. The temple icon of Vishnu portrayed as four-armed, known as Mathureshji, inscribed *Shri Mutharesha*.

6. The temple icon of Krishna portrayed with arms resting at his waist and accompanied by a consort, known as Vitthalnathji (apparently missing from this set of paintings).

7. The temple icon of Vishnu portrayed as four-armed, known as Dvarkadhishji, inscribed *Shri Drivarakanathji*.

8. The temple icon of Krishna portrayed with four arms (two of which play a flute) and with a female attendant on either side, known as Gokulanathji, inscribed *Shri Gokalanathji*.

9. The temple icon of Krishna portrayed playing the flute, known as Gokulachandramaji, inscribed *Shri Gokulacharamaji*.

10. The temple icon of Krishna as a crawling child, known as Balakrish-naji, inscribed *Shri Balakasanaji*.

11. The temple icon of Krishna portrayed playing the flute and with a figure on either side, known as Madanamohanji, inscribed *Madanamohanaji*.

12. Balaramji, Krishna's brother, with his wife Revah in the bottom right (script effaced).

13. Two blue handprints.

14. Two blue footprints.

The remaining images are considered somewhat less important. Their sequence may vary from set to set; in other sets there may also be additional images. The images in this set are inscribed and identified as follows:

15. Damodarji Dauji II (1797–1826), a famous priest of the Pushti Marga sect, inscribed *Shri Dauji*.

16. The temple icon of Krishna portrayed playing the flute, known as Gopalalal, inscribed *Shri Gopalalala*.

17. The temple icon of Krishna portrayed with arms extended, known as Natvarlal, inscribed *Shri Natavaralala*.

18. The temple icon of Krishna as an infant known as Mukundarayji, inscribed *Shri Mukanarayaji*.

19. The temple icon of Krishna portrayed as four-armed, known as Kalya-narayaji, inscribed *Shri Kalanarayaji*.

20. The temple icon of Krishna portrayed playing the flute, known as Tribhangilalji, inscribed *Shri Tarabansilala*.

A similar palette of red orange, green, dark blue, silver, yellow, white, black, and flesh tones is employed in all the paintings in this set; a red border surrounds each image.

70. A devotee's *pichavai* (temple hanging) depicting blue lotuses, for use in a do-
 mestic shrine
 Rajasthan, Nathadwara
 Mid-20th century
 Opaque water-based pigments on cotton cloth
 47" x 70" (119.4 cm x 177.8 cm)
 Chester and Davida Herwitz Collection

This relatively small *pichavai* (temple hanging), depicting blue lotuses—bud-ding, opening, and in full bloom—on intertwining stems with capacious leaves that mimic the stages of flowering, was probably made to be hung behind a

sculptural image of Shri Nathji in a home shrine (or a small temple). Dominating the composition and centrally placed is an exceptionally large blossom with three expanding rings of petals, as is found in many *yantras* (visual aids to meditation) based on lotuses (compare no. 87). Likewise, the number and layout of the remaining flowers and leaves that ring the central lotus and border the edges of the painting seem to be as precisely determined by symbolic logic. The image is set out on a background of cool yellow. The multivalent lotus has traditionally symbolized the material universe emanating from its divine center. *Pichavais* depicting the flowering lotus plant that grows in water are traditionally employed during the summer, when even its image can bring a sense of cool refreshment.[43]

Paintings Informed by Court or Company Miniature Traditions

Introduction

India's many traditions of miniature painting and some related traditions of mural painting catered to a host of Muslim and Hindu rulers of ever-changing, successively expanding and diminishing empires, kingdoms, and territories on a vast subcontinent with many regions, separated from the rest of Asia by the Himalayas. The various miniature traditions developed, flourished, and declined in conjunction with the fluctuating political powers of the courts with which they were associated. The main miniature traditions include Mughal painting that developed under the patronage of Muslim rulers of the Mughal empire in North India and Mughal-influenced painting created for Muslim sultans in the Deccan, Rajasthani painting that developed under the patronage of Hindu rulers in Western and Central India and Rajasthani-influenced painting created for Hindu courts in the Himalayan foothills (sometimes called Pahari painting, Pahari meaning "hill"), as well as those painting forms that developed under the patronage of Hindu rulers and aristocratic landowners in Eastern and South India. The sophisticated miniature traditions consequently comprise myriad stylistic modes, ranging, for example, from the infinitely detailed and spatially complex forms of Mughal painting to the concisely abstracted and flattened forms of the Malwa idiom that came into being in the western portion of Central India (present-day Madhya Pradesh).

Miniature paintings were often narrative in function, depicting the deeds of Muslim and Hindu rulers and the legendary feats of mythological heroes and deities recounted in the *Ramayana* and the *Mahabharata* and in other Indian stories known through oral tradition but also recorded in written form. Portraiture, genre scenes, and the attentive recording of plants, animals, and birds were also favorite subjects for miniatures, especially in those created for the Muslim courts.

Miniatures were painted by professional artists, initially on palm leaves, strung together and protected by wooden covers, and later on paper sheets, which were either assembled as loose folios in albums or bound together in books. Miniature paintings were frequently accompanied by handwritten texts

copied, not by the court painters who were usually illiterate, but by scribes who could read and write. The painting tasks involved in producing a single painting in a series were, moreover, frequently divided among several artists, especially those working in ateliers attached to the Muslims courts.

When the British and other foreigners came to govern parts of India and patronage of artists by the weakened Indian courts consequently diminished, Indian miniature painters adapted their own stylistic conventions to serve the newly arrived rulers, who commissioned them to document indigenous plants, animals, and birds and also to depict new subject matter in new formats, such as encyclopedic series spotlighting Indian gods and festivals and the many varieties of caste work performed by the Indian population. This adapted form of miniature painting produced for nonnative patronage is usually called Company painting, after England's East India Company, whose economic interests in the subcontinent gradually grew into political power. Company paintings were produced in India wherever there were large populations of Europeans, and, accordingly, are characterized not by a single style but rather by many different regional miniature styles. Company paintings depicting landscapes or interiors, moreover, frequently exhibit curious hybridizations of Indian modes of spatial representation with European perspective, a feature also shared by some paintings of the same period made for Indian patrons (see nos. 34, 78).

While the vast majority of surviving miniature paintings manifest the special qualities characteristic of these diverse traditions, some miniatures, although clearly informed by sophisticated traditions, do not fully conform to customary standards. These paintings, executed with very modest materials and rendered in either a commonplace or a decidedly folkish way, were most likely produced for common people.

Among those rendered in routine and frequently uninspired ways are two types of miniatures that utilize the conventions of the Mughal painting tradition. One type, termed "Bazaar Mughal," was produced in great quantities and sold from shops as decorations and gifts to a broad range of Muslim peoples residing in large towns close to Mughal courts; this type of miniature often illustrates secular Hindu themes, such as visualizations of musical modes or idealizations of women lovers. Another type of miniature made for common people is termed "Popular Mughal" and is said to have been produced for a variety of patrons by Rajasthani artists who may have had some training in the painting workshops attached to Mughal courts.[44]

Decidedly folkish miniatures, on the other hand, employ some but not all the characteristic features of a miniature tradition in a less technically accomplished and refined manner than is customary; nevertheless, they evince extraordinary vitality and sometimes great aesthetic appeal. The artists and patrons of folkish miniatures informed by sophisticated traditions are not as clearly defined as those associated with "Bazaar" and "Popular" Mughal painting and may, in fact, involve different kinds of artists and patrons in different regions. Some folkishly rendered miniature paintings were undoubtedly produced by court painters for patrons other than rulers, and some were perhaps produced for the court artists' own enjoyment. According to some scholars, the practice of

Indian painters working exclusively for the courts began only after the estab-lishment of Mughal rule in the early sixteenth century; previously, and even af-terwards, artists working for the courts of India, especially the many small ones, often also painted for the merchants, bankers, and other professionals in their areas[45] and even perhaps for the so-called lower castes. Accordingly, it is not surprising that many folkish miniatures originated in Western or Central India and other areas formerly governed by Hindu rulers with small courts or by Hindu landlords. Other examples of folkishly rendered miniature painting may have been created by village artisans (*shilpins*) who had been trained to accom-plish a variety of artistic tasks rather than the specialized tasks of a popular painting tradition and, working directly for village patrons, attempted to emu-late court traditions. Yet other folkish miniatures may have been produced by professional painters associated with one or another of the popular narrative or iconic traditions, such as the Garoda scroll painters of north Gujarat (see discus-sion of Garoda scroll paintings in Chapter 3), an assumption supported by strong stylistic similarities.[46] Some examples of folkish miniature painting were undoubtedly produced by scribes who chose to illustrate some manu-scripts by themselves, sometimes painting in a lively but less professional man-ner than court painters; in other instances, the scribes may have hired folk painters, such as the scroll-painting Patuas of Bengal (see discussion of Bengali scroll paintings in Chapter 3), to supply illustrations for the texts that the scribes had been commissioned to copy.[47]

The folkish expressions of stylistically diverse miniature traditions do share some conventions, such as simplified shapes, absence of modeling, frontal or profile presentations of figures from eye-level viewpoints, and a flattened con-struction of pictorial space with few overlapping planes and no articulated floor planes. Although sometimes considered naive or folkish by scholars, especially when employed together with certain other features such as minimal interior description of forms, bold colors, and emphatically symmetrical compositions, these conventions are not inherently so.[48] For that reason, only examples of miniature paintings that are executed by folkish hands with less costly materi-als are called "folkish" here.

Executed with modest materials and media, the folkish miniatures that are presented here are informed by court traditions of Western, Central, Eastern, and South India, and one is perhaps informed by Company painting in South India. The works include the illustrated first page of a manuscript bearing an invocation of the elephant-headed god Ganesha (no. 71), manuscript pages and folios illustrating episodes in the lives of the hero-gods Rama (nos. 74, 76) and Krishna (no. 78), a manuscript page and a folio illustrating the victorious ex-ploits and the power of the Goddess (nos. 72, 75), and images of a bird (no. 73) and of a bear (no. 77), perhaps from series of similar subject matter. Only the manuscript page invoking Ganesha (no. 71) is inscribed (on reverse) with a date and the names of the patron and of the scribe who may be the artist. Selected primarily for their aesthetic appeal, these folkish examples can demonstrate only certain aspects of this special area of Indian miniature painting. To date, limited scholarly attention has been given to popular forms of miniature paint-ing, some of which are folkishly rendered.[49]

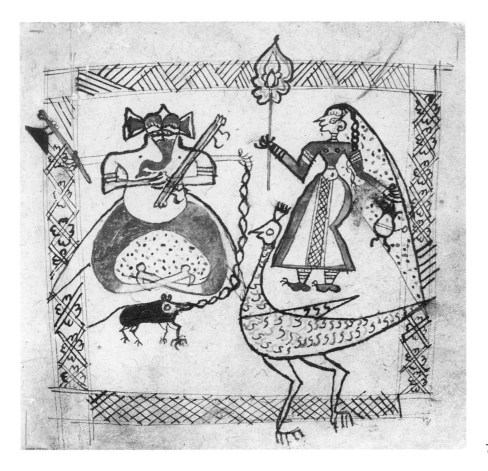

71

*Representative Works: Paintings Informed by Court or
Company Miniature Traditions, nos. 71–78*

71. First page of a manuscript, depicting Ganesha and Sarasvati
 Inscribed on reverse: "I pray to Lord Ganesh. The book is the work of Doom
 Chaju's grandson and the son of Gopala named Dayala and written by Khatri
 Kalu at the town of Nagar, whose ruler is Gopal Dasji; the ruler of Rantham-
 bhor is Jaggan Nathji, and the emperor of Lahore is Padshah Akbar; in the year
 V.S. 1646 (1589 A.D.) on Chaitra, Vade, 11th."[50]
 Rajasthan, Nagar
 Signed and dated (on reverse) 1589 by the scribe Khatri Kalu
 Transparent and opaque water-based pigments on paper
 6⅝" x 7¼" (16.8 cm x 18.4 cm)
 Courtesy of Arthur M. Sackler Museum, Harvard University Art Museums,
 Loan from Private Collection, TL20349.11

This lively image pairs Ganesha, the elephant-headed god of wisdom who both
makes and removes obstacles for human beings at the beginning of their tasks,
and Sarasvati, the goddess of speech, learning, and the arts. As the inscription

on the reverse indicates, the image was part of a book and appropriately invokes these deities, as customary, on what was probably its first page.[51] The image may have been created by Khatri Kalu, the scribe who has signed his name as the writer of the book, or the scribe may have commissioned a painter to illustrate the page.

Ganesha is seated on the left, his legs folded in yogic meditative posture. Four-armed, he holds a flag in his upper left arm and a rat or a mouse, his animal mount, on a braided leash in his upper right; Ganesha appears to be playing the *vina* (lute), more commonly associated with Sarasvati, with his lower arms. Wearing her hair in a single long braid under her head covering, Sarasvati stands to the right of Ganesha, and looks more like his attendant than a goddess; she holds a feather fan in one hand and perhaps a rosary, a typical attribute, in the other; she is placed on her mount, here a peacock rather than the more commonly shown goose. Suggesting the floor plane of a temple compound, a square formed by freely drawn decorative bands encloses the pair.

The decisively angular style of this work may be related to folk painting traditions, especially those of Rajasthan; the proximity and orientation of the two deities in this picture is, in fact, very similar to their representation in the upper left corner of story cloths of the *par* tradition (see nos. 58–60). The style of this work also has been linked with concurrent miniature painting for the courts in Western India, exemplified in a series illustrating the *Chaurapanchasika*, a Sanskrit love story.[52]

Reproduced: Stuart Cary Welch, *Indian Drawings and Painted Sketches, 16th through 19th Centuries*, exh. cat. (New York: Asia Society, 1976), p. 27, no. 1.

72. The Goddess battling Chanda and Munda, a page from a manuscript illustrating the *Devi Mahatmya* (The Hymn of Greatness of the Goddess)
Western India
CA. 1650–70[53]
Transparent and opaque water-based pigments on paper
4⅛" x 5½" (10.5 cm x 14.0 cm)
Dr. Alvin O. Bellak, Philadelphia

This image depicts in a very literal way a narrative episode that is recounted in the *Devi Mahatmya* (The Hymn of Greatness of the Goddess), a text celebrating the victories of the Goddess;[54] the painting was probably part of a folkish manuscript illustrating the full text.

Prior to the episode presented here, the warrior generals Chanda and Munda have described the great beauty of the Goddess to their leader, the demon Shumbha. When the Goddess declines the demon's marriage proposal due to her vow to marry only the man who succeeds in defeating her, a great battle ensues. In the depicted confrontation, the Goddess has manifested herself as ferocious Kali (the black one) in order to destroy the second army sent by Shumbha under his generals Chanda and Munda. The Goddess is portrayed as hook-nosed, bony, and blue-skinned, mounted on a snarling tiger and battling the warriors, who advance from the right, on mountainous terrain under a blood-red sky. In her various arms, the Goddess holds a sword, a club, a garland of human skulls, and an elephant dangled by his leg, while she bites into the

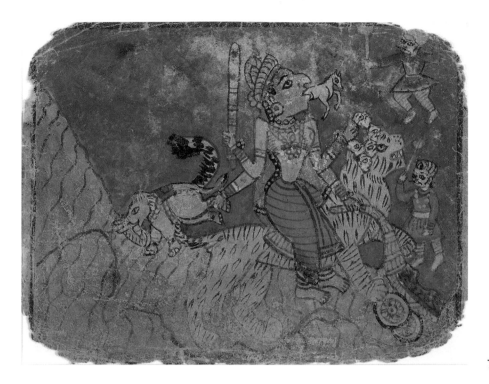

72

body of a horse, thrust halfway into her mouth; below the Goddess, an over-turned empty chariot lies at the tiger's feet. The Goddess is destroying her would-be suitor's army by flinging his elephants, warriors, horses, chariots, and drivers into her mouth and grinding them to bits. Subsequent to the episode presented here, the generals Chanda and Munda will also be defeated by the Goddess's sword; displaying their severed heads and roaring with the laughter of the victorious, the Goddess will be given a new name that contracts the names of her victims—Chamunda. The painting, though small in actual physical size and though containing apparently few pictorial elements, is immense in its imaginative scale.

73. A bird resting on a tree branch
 Rajasthan
 17th century
 Transparent water-based pigments on paper
 8¼" x 5⅞" (21.0 cm x 14.9 cm)
 Dr. Alvin O. Bellak, Philadelphia

Studies of plants, animals, and birds are rare in the court painting traditions of Rajasthan but are common in the Mughal tradition. This folkish Rajasthani image of a bird may borrow its subject, its palette, and its quasi-documentary intent from a Mughal model. Cool tints of jewel-like colors—amethyst and emerald green—have been deftly employed with a warm orange brown on a buff background to portray a bird quizzically looking upward as it rests on a

73

tree branch. The spontaneous—and even amusing—rendering of the image with loosely brushed color, however, totally departs from the characteristic precision and gravity of the Mughal studies.

74. Two pages from a manuscript illustrating the *Ramayana*
 a. Rama pursues the golden deer while Ravana approaches Sita
 b. Hanuman finds Sita in Ashoka Grove
 Rajasthan or Central India
 CA. 1725–50
 Transparent and opaque water-based pigments on paper
 a. 8" x 5⅝" (20.3 cm x 14.2 cm)
 b. 8¼" x 5⅝" (20.9 cm x 14.2 cm)
 Courtesy of Arthur M. Sackler Museum, Harvard University Art Museums,
 Loan from Private Collection, 233.1983, 232.1983

Portrayed on these two folkish pages are scenes from the *Ramayana*, the epic story of Rama, a hero-prince and incarnation of the god Vishnu, who recovers his wife, Sita, from abduction by the ten-headed demon Ravana. In the scene on the left, Rama with a bow and arrow pursues a golden deer (actually a disguised demon), while Ravana, disguised as a mendicant, approaches Sita to abduct her. Rama is accompanied by another archer (perhaps his brother, Lakshmana), or he—like the

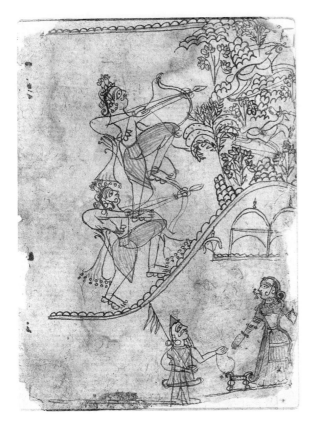

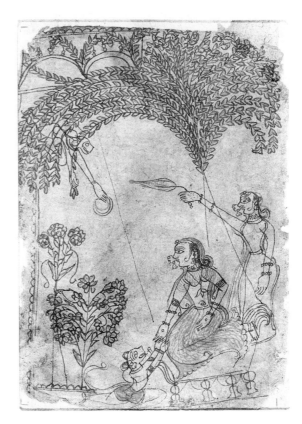

74a

74b

deer—may appear twice, pictorially suggesting the difficulty, described in Valmiki's Sanskrit version of the story (bk. 3, chap. 44), of apprehending the miragelike creature that keeps disappearing and reappearing at a distance in the depths of the forest. In the scene on the right, the monkey Hanuman discovers Sita on a swing in Ashoka Grove, attended by a female whisk-bearer. Hanuman is shown twice, first concealed in a tree, dangling the ring Rama has given him as a token of recognition for Sita, and then reunited with Sita, kneeling at her feet. The images, deftly executed in red and black line only, are lyrically spontaneous celebrations of both the legend and the art of drawing.

75. Kali seated in sexual union with Shiva as a corpse, an image for use as a visual
aid to meditation and worship, perhaps one of a series depicting manifestations
of the Goddess (*Mahavidyas*)
Rajasthan, Mewar
18th century
Transparent and opaque water-based pigments on paper
7" x 7" (17.8 cm x 17.8 cm)
Subhash Kapoor

This image visualizes an important religious concept in Indian culture involving notions of gender, that is, divinity, conceived as active, creative, female en-

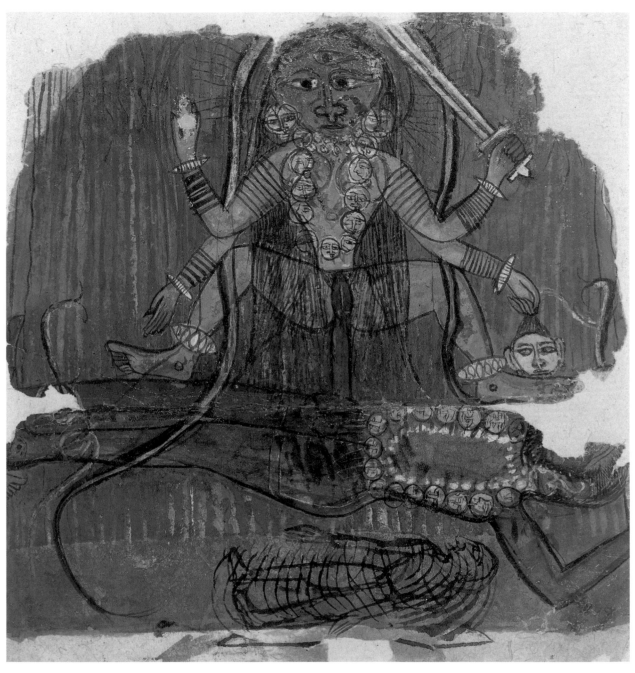

75

ergy (*shakti*), not only interacting with but also necessarily dominant over its male aspect, equated with quiescence and passivity. Celebrating female power as primary, the image illustrates the well-known dictum of goddess worship in India: Without *shakti*, the god Shiva is *shava* (corpse).

The Goddess appears as horrific Kali squatting in sexual union with a recumbent, corpselike Shiva. Kali, who personifies both creation and destruction,

appropriately displays emblems of both life and death—she wears a necklace of skulls and is four-armed, displaying a sword and a severed head in her arms on the right and symbolically removing fear and imparting bliss through her hand gestures (*mudras*) on the left. A long snake is draped over her head, like a scarf; long, wispy hair veils her naked torso. She is three-eyed, signifying her power to look into the past, present, and future, but here her glance is less furious than is typical and is even somewhat sad. She does not show her tongue or fangs, other typical signs of her destructive nature. Her divine consort, Shiva, lies beneath her, dependent on her vitality to rise from his state of death, destruction, trance, or sleep. The smaller male figure that lies beneath Shiva appears to be wrapped in cloth, as is customary before cremation, and may represent Shiva's condition in an even less manifest state, should he forget or be without Kali's dynamic support. By extension, both male figures represent the state of the universe—in desperate need of the Goddess's power in order to be elevated to the level of manifest existence.

The folkish hand that created this sketchy version of the image, a favorite of Kali's devotees, in no way diminishes its visual power. Variations of the theme show Kali standing or dancing on Shiva's prone body. The image is probably intended for use as a visual aid to meditation or worship. It may have been part of a series depicting ten distinct manifestations of the Great Goddess, many of which portray the deity as fearsome or terrible in appearance, just as Kali is shown here in especially dreadful form. Some of these manifestations are, however, esoteric dieties known only in the literature and practices of the Tantric cult, unlike Kali who is universally known and independently worshiped. Called the *Mahavidyas* (literally, higher knowledge), such images facilitate understanding of the terrifying aspects of divine power, which constitutes transcendent knowledge.[55]

76. Two folios from a series illustrating episodes of the *Ramayana*
 a. The monkey king Sugriva fighting with his brother, Bali
 b. Monkey soldiers building the bridge to Lanka
 Perhaps West Bengal or Bihar
 19th century
 Opaque water-based pigments on paper
 a. 6" x 8⅞" (15.3 cm x 22.5 cm)
 b. 7⅛" x 9¾" (18.1 cm x 24.7 cm)
 Courtesy of Arthur M. Sackler Museum, Harvard University Art Museums,
 Loan from Private Collection, 419.1983 A, B

Sugriva is an important ally of Rama in the *Ramayana*; a monkey king in exile, he is depicted in the upper image fighting his brother, Bali, who has deprived him of both his wife and his kingdom.[56] In the lower image, three monkeys, representative of the monkey army under Sugriva's leadership, build the bridge to Lanka[57] that will help Rama rescue Sita from abduction: a white monkey carries building blocks, balancing one on his head; an orange monkey holds a block and a bricklayer's trowel; a blue monkey appears to set a block into place. In both images, the monkey subjects are set against a medium blue background bordered by a narrow, unembellished band of indigo.

76a

76b

77

77. A performing bear
Tamil Nadu
CA. 1900
Transparent water-based pigments on paper
13" x 16�5⁄16" (33.0 cm x 41.4 cm)
The Art Institute of Chicago, Gift of Mrs. Carolyn Wicker, 1939.344

This painted sketch exemplifies the keen and sympathetic interest in animals that is evident throughout Indian art. The shaggy-haired, muzzled bear depicted here most likely performed for villagers gathered at fairs and crossroads, under the direction of an itinerant master who collected food, cloth, or rupees in exchange. Such pairs—mendicants and performing monkeys or bears—wander India even today. The artist seems to have incorporated into his picture much perceptual information, particularly catching the alertness and affection in the animal's gaze, rather than relying more typically on South Indian stereotypes of animal forms. The artist may have been influenced by examples of European art that were circulating in India at the time or by his observations of contemporary European artists who were painting "from life" in India. He may also have been influenced by Indian miniature painters who had previously worked for Indian rulers but were now commissioned by foreigners residing in India, particularly the British, to produce elegant visual records of indigenous plants and animals, among a host of other subjects. Such pictures made for foreigners are known as Company paintings after the East India Company of England. This delightful picture of a performing bear is, however, considerably less refined than published examples of such paintings.

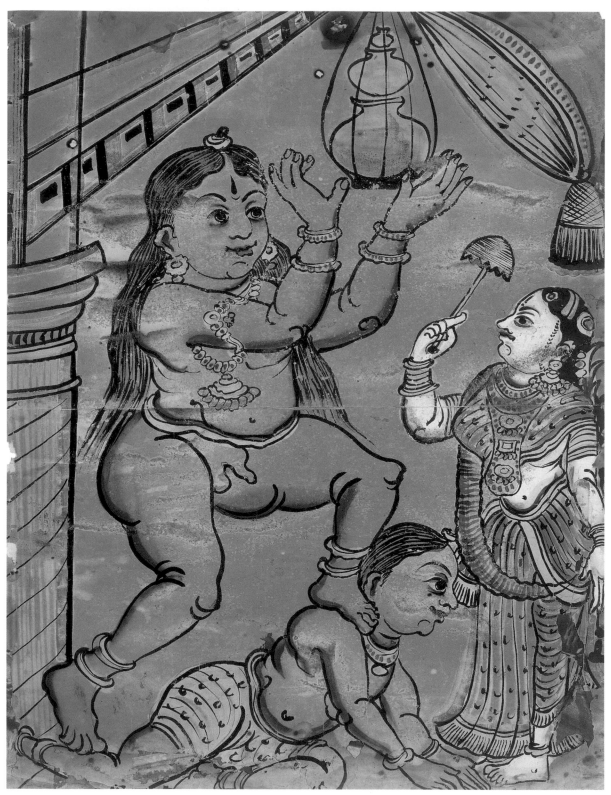

78

78. Krishna stealing curds, a folio from a series illustrating the legend of Krishna
 Tamil Nadu
 First half of the 20th century
 Transparent water-based pigments on paper
 15⁹⁄₁₆" x 12¼" (39.5 cm x 31.1 cm)
 Private collection

In this animated image from Tamil Nadu, a long-haired, unclothed boy Krishna (an incarnation of the god Vishnu) uses the body of a playmate as a kind of stepstool to reach up to steal curds from a set of pots suspended from the ceiling. Krishna's foster mother, Yashoda, viewing the mischief from the side, feigns a frown, shakes her index finger in mock disapproval, and threatens punishment with a miniature parasol that she holds in the same hand. In other painted versions of the narrative, Krishna steals butter. Krishna's well-loved prank sometimes occurs as Yashoda is seen disappearing through a doorway, presumably distracted from her butter churning to attend to a boiling pot inside. The story and its varations are part of the myth of Krishna, recounted in many sources but in greatest detail in the *Bhagavata Purana*, which includes many events in his childhood. The story reveals something of the endearing playfulness of Krishna the child-god.

The figures, loosely painted in a black contour line of varying width with minimal, stylized modeling, exhibit South Indian traits but in a folkish manner. The painting shows some influence of European painting in the hybrid representation of its interior space, specifically on the left, where a lintel is drawn on a curious diagonal, diminishing in size as it apparently recedes toward a vanishing point outside the picture; on the right side a draped arch, a typical convention in Tanjore pictures (see discussion of Tanjore and Mysore paintings in Chapter 2), provides a partial frame of the scene. (For an iconic presentation of Krishna as butter thief in the Tanjore style, see no. 35.)

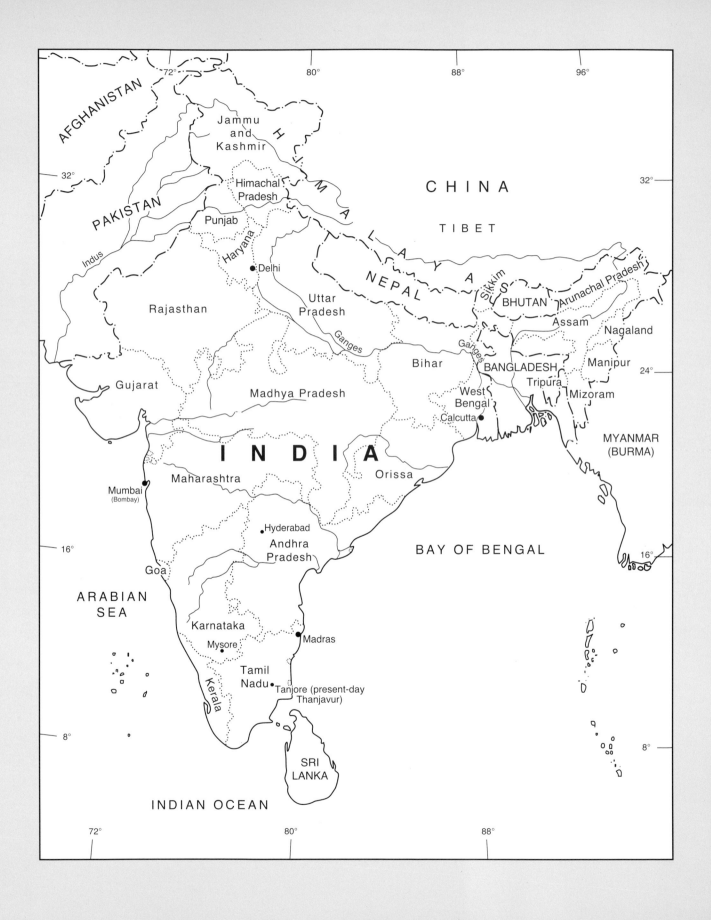

5

Paintings on Reverse Glass

Introduction

The majority of Indian reverse paintings on glass feature religious images created for devotees of the middle and lower classes,[1] but, unlike the pictures of other popular iconic traditions, glass paintings are not associated with a single place of pilgrimage or with any one region. Nor is their technique indigenous. The practice of reverse painting on glass probably originated in Europe and was introduced into India in the late eighteenth century through imported European examples and also by emigrant artisans from China who had learned the technique in Canton from European missionary priests. These Chinese artisans had previously practiced the craft in China, not for a Chinese market but for export to Europe as Chinese curiosities. When these artisans came to India, they found patrons for glass paintings in India's ruling families and produced mostly portraits of persons within the courts, including favorite mistresses and dancing girls. The European-Chinese technique spread rapidly to local Indian artisans, who adapted it to the growing demand of an emerging professional middle class for inexpensive images of the deities to be hung on the wall for private devotion.[2]

The artisans (*shilpins*) who took up the new technique were not bound to a painting tradition with a set iconography, as were the professional painters of Puri and many other places (for discussions of such traditions, see Chapters 2 and 3). The *shilpins* were rather trained to perform a range of art-related tasks, including wood carvings, festival decorations, and mural paintings, for their own and other communities. As nonspecialist producers working for a range of patrons that included villagers, the middle and professional classes in towns and cities, and even royalty, the *shilpins* developed glass painting in extraordinary variety.[3]

A particularly vigorous school of glass painting evolved in Tanjore (present-day Thanjavur) (nos. 79–80), deriving its subject matter, compositions, and opulent appearance from the special mode of painting in practice there (see discussion of Tanjore paintings in Chapter 2). But styles characteristic of other areas in South

India can also be distinguished. These styles developed in places in Tamil Nadu other than Tanjore, in Hyderabad and in other places in Andhra Pradesh, as well as in Karnataka (though not in Mysore), in Maharashtra, and in Kerala. Two other principal styles of glass painting can be distinguished. One originated in Western and North India, that is, the area comprising the present-day states of Gujarat (no. 81), Rajasthan, Uttar Pradesh, Jammu and Kashmir, and the Punjab region (defined by the valleys of the Indus River and its five tributaries) that includes parts of present-day Pakistan. Another style developed in Eastern India, an area comprising present-day Bangladesh and the Indian states of Bihar and West Bengal. There are also a number of styles within these three principal regional styles. The various styles are identified by their subject matter, treatment of details in clothing, and other elements such as body types and decorative patterning.[4] All over India, inexpensive religious icons on reverse glass were created in these regional styles for Hindu devotees to venerate in home shrines or to be hung on the walls of communal prayer halls where private religious services or devotional singing sessions were held.[5] In parts of India with large populations of Muslims, such as Hyderabad, Gujarat, and Uttar Pradesh, pictures displaying Muslim religious images (for example, the *burraq*, a mythical being with the head of a woman, the body of a horse, the tail of a peacock, and wings) or pictures inscribed with scriptural texts or prayers, sometimes constituting animal figures known as *tughras*, or purely decorative compositions of flowers and foliage were also produced for installation in homes or mosques. In the Punjab and in Rajasthan, portraits of Sikh gurus modeled on existing prototypes were produced for Sikh believers who resided principally in the Punjab.[6] Portraits of local Hindu and Muslim rulers and of middle-class individuals were also produced in the regional styles of numerous places. Finally, iconic and decorative images in various regional styles were sometimes created to be fitted into middle-class domestic shrines, door panels and window frames, European-style headboards, and other items.[7] Small glass paintings—especially sets depicting Krishna as Shri Nathji (see discussion of Nathadwara paintings in Chapter 4)—were produced for display as attached parts of textile doorway hangings (*toranas*), a traditional domestic ornamental furnishing in Gujarat and Rajasthan. A broad range of artistry and skill is evident in a survey of Indian glass paintings, from sophisticated and courtly to naive and folkish.[8] Despite their frequent lack of sophistication, an undeniable charm and appealing directness are manifest in many examples of this popular tradition.

In reverse painting on glass, the back side of a plane of glass is used as the support for the painting, but the completed image is viewed from the front through the transparent depth of the plane. The process involves not only a reversal of image from the back of the painting to the front but also a reversal of the normal painting process. When artists work directly on paper or canvas, they usually create large areas first and then refine those areas with smaller, more detailed forms. By contrast, when artists work in reverse on glass, they must delineate their forms with contour lines and also draw out the surface patterns and other details first, since these will be seen first from the front through the transparent plane. A pen or a brush may be used for this beginning stage. Next, if some illusion of volume is desired, a schematic modeling in a linear or minimal tonal manner may be laid in. At this stage, colored foil paper or mica, instead of paint, may be

inserted into parts of the depicted forms to further enrich the surface of the paint-ing with additional reflective materials. Alternately, metallic paint or mirroring medium may be applied in selected areas. Finally, opaque paint in various colors is brushed into the remaining large areas, with the artists' careful observation of the boundaries of shapes marked by contour lines. The process requires a high degree of initial clarity of intention and is most likely facilitated by the use of a line drawing to scale placed under the glass as a guide. A water-based paint is generally used, though examples of reverse paintings employing the European medium of oil paint also survive. Because of the fragile nature of the support, glass pictures tend to be small, seldom exceeding two feet in any direction. The glass pane is generally enclosed in a metal or wood frame for protection.

In most areas of India (except for Gujarat, where the production of glass paint-ings is reported to continue to this day),[9] the demand for painted icons, includ-ing those on glass, declined at the beginning of the twentieth century when less expensive chromolithographs became available. The revival of interest in col-lecting and preserving old glass paintings[10] has stimulated the contemporary pro-duction of new pictures, especially in Madras and Thanjavur, where a simultaneous revival of Tanjore painting appears to be taking place. Scholarly attention to this popular medium has been limited.

Representative Works: Paintings on Reverse Glass, nos. 79–81

79. A devotee's icon depicting the marriage of Rama and Sita, for use in a domestic shrine
 Tamil Nadu, Tanjore
 Late 19th or early 20th century
 Opaque water-based pigments and metallic foil on reverse glass in a metal frame
 18⅛" x 16⅛" (46.0 cm x 41.0 cm)
 Private collection

This reverse glass painting, produced for a devotee to use in a home shrine, depicts the marriage of Rama and Sita, as related in the epic *Ramayana*. Wearing the high crowns and elaborate jewelry of royalty, the couple is centrally enthroned within a draped pavilion. Rama extends his hands, heaped with an offering, to Sita; she cups her hands under his and, perhaps as a tender expression of her subservience, rests her foot upon his. Surrounding the couple in mirror symmetry, which com-positionally reinforces the picture's theme of union, are several pairs of figures. Two sages (*rishis*) and the king-fathers of the bride and groom stand with their arms raised over the couple on either side of the pavilion platform; two female attendants stand with their arms crossed on either side of the base of the pavilion; and two priests sit in front of the pavilion, tending the sacred fire which the cou-ple circumambulates as part of the marriage ceremony. All these paired figures and Rama are presented in profile; only Sita, whose face is shown in a three-quar-ter view as she turns to look directly at her viewers, appears to break the inten-sity of the communal witness of her marriage.[11]

A vivid reddish orange background plane strongly contrasts with the indigo blue, blue green, green, yellow, ochre, black, brown, and white that describe the

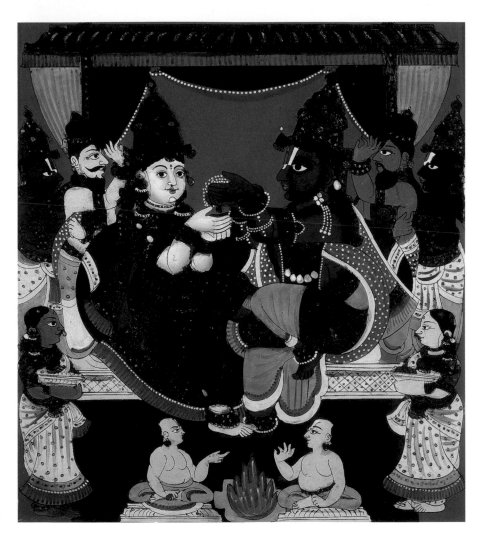

79

figures and other aspects of the scene. The painting is enhanced by extensive use
of gold foil in the representation of the pavilion and the crowns, jewelry, and
clothing of the figures, especially Sita's sari, which is entirely metallic and re-
flective. Employment of gold foil in this picture parallels the gilding techniques
and the insertion of reflective and eye-catching materials that are characteristic of
Tanjore paintings on cloth stretched over wood supports; moreover, the iconic
presentation of the marriage of Rama and Sita is undoubtedly modeled on South
Indian compositions of the same theme (see discussion of Tanjore and Mysore
paintings in Chapter 2). The iconic presentation of the marriage of Rama and
Sita here differs from presentations of the same theme in narrative painting tra-
ditions: compare, for example, a Bengali scroll in which the marriages of four
couples, that is, of Rama and his three brothers to four princesses—which oc-
curred, according to the *Ramayana*, on the same day—are depicted within the
same frame (see no. 40, reg. 3).

80. Idealized portrait of a courtesan with a sitar
 Tamil Nadu, Tanjore
 Opaque water-based pigments, metallic foil, and mica on reverse glass in a wooden frame
 Late 19th or early 20th century
 24" x 18" (61.0 cm x 45.7 cm)
 Alice Christensen and Stephen Grant

A seated courtesan, jeweled and attired in a short-sleeved black bodice and a deep red sari with broad gold bands, adjusts a string of her sitar. The courtesan is fair-skinned and wears a rose—the sign of her profession—in her tightly bound and probably oil-smoothed black hair. Her face is turned slightly from the frontal po-

80

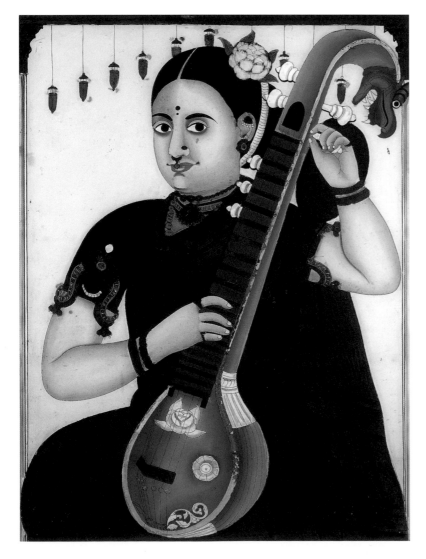

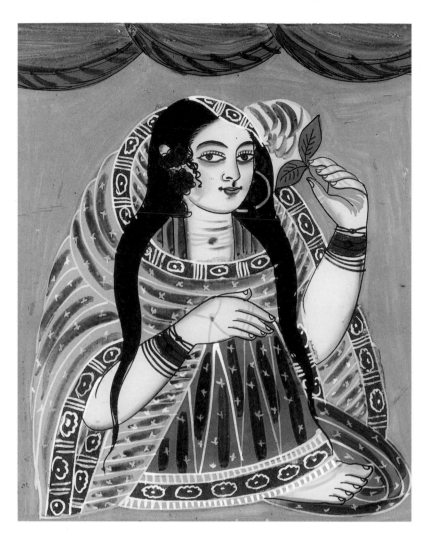

81

sition, but she looks straight out, directly encountering the gaze of her viewers. Tiny Victorian lamps, popular in British-ruled India at the time when this picture was painted, are hung behind the courtesan in an inverted V against a simple interior plane. The use of metallic foil and mica gives a special luster to the courtesan's sari and jewelry and to the hanging lamps and mimics—as in the preceding work (no. 79), though much less opulently—the gilded surfaces characteristic of the Tanjore tradition of painting on cloth stretched over wood (see discussion of Tanjore and Mysore paintings in Chapter 2). The courtesan's portrait, embodying South Indian ideals of beauty and well-being, is typical and not individualized; the courtesan is both remote and engaging.[12] According to scholars, rulers may have commissioned such images as portraits of favorite courtesans.[13] (Compare the idealized courtesan in no. 81; also see no. 17.)

Reproduced: Roy C. Craven, Jr., "Indian Reverse Painting on Glass," *Arts of Asia* (Hong Kong) 13, no. 1 (January-February 1983): 73, fig. 10.

81. Idealized portrait of a Muslim courtesan holding a rose
 Gujarat or Rajasthan
 Early 20th century
 Opaque water-based pigments and metallic foil on reverse glass
 11⁹⁄₁₆" x 9⅝" (29.4 cm x 24.4 cm)
 Private collection

Like the previous picture (no. 80), this reverse painting on glass features a courtesan, with the identifying attribute of a rose, looking directly at her viewers. The courtesan holds the rose to her head with a henna-decorated palm. The courtesan, who is probably a Muslim, is enveloped in a tentlike red orange outer garment (*chador*) that covers her head and body. One bare foot protrudes from the hem of her green skirt. Her voluminous garb is bordered with gold foil bands, which are further embellished with patterns painted in white. The courtesan, a beauty, is made up with black and red eyeliner and wears particularly ornate earrings terminating in bells. Her two black braids (or locks), shaped like serpents, dramatically fall almost to the ground. The courtesan sits in an interior space minimally described with a red bound drape against a cerulean background. Like the previous picture, this portrait may have been produced for a ruler, having as its subject a favorite mistress.[14] (Also see the idealized courtesan in no. 17.)

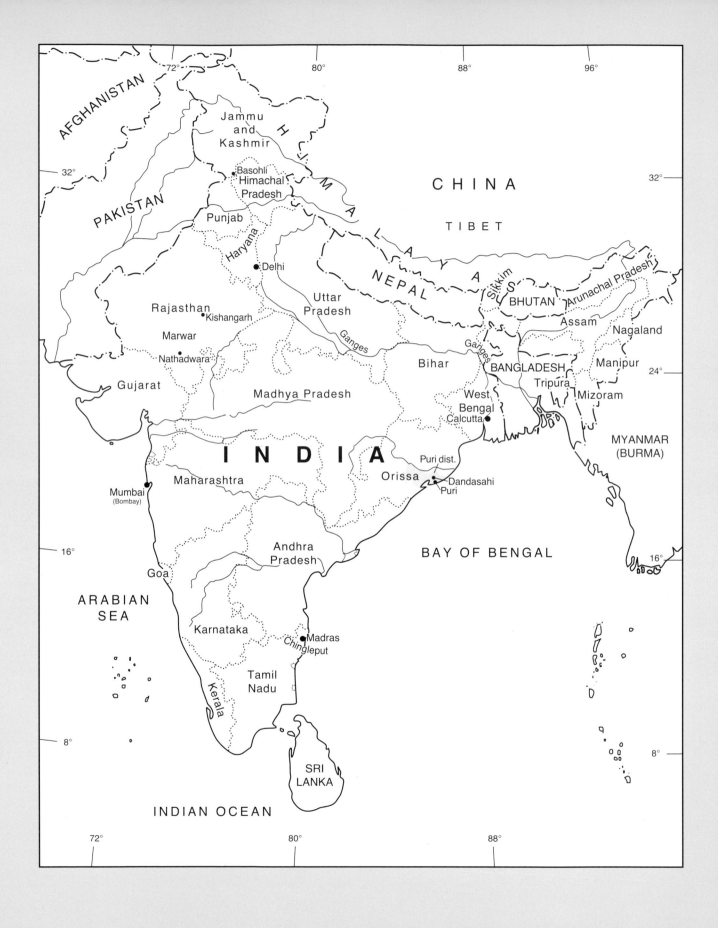

6

Paintings Serving Didactic, Divinatory, and Other Cultural Functions

Introduction

Besides the many popular painting traditions that have evolved to fulfill distinct ritual, iconic, and narrative ends in particular areas of India, several other types of popular paintings have sprung up and developed to serve yet other cultural functions. The special purposes of these forms may be didactic, divinatory, documentary, recreational, or ritual; however, these forms are not solely associated with a specific tradition and are not peculiar to a single locale or region. Rather, these types of popular paintings have been or are produced in many areas of India, having originated or having flowered in a variety of places, regional styles, and formats. If these forms have been in fact produced within a painting tradition, they generally do not define it, as they constitute subsidiary works. Created by and for a broad range of common people, these types of popular paintings include ritual images or genealogies wholly and partially composed with calligraphy, symbolic diagrams for meditation and worship, illustrations of punishments for sins, books of omens, horoscopes and calendars, game boards, playing cards, erotica, and various practical manuals. A brief survey of these types follows, illuminating something of their particular significances in Indian life and culture.

Images composed of inscriptions are found in abundance and variety throughout India. Inscriptions are, of course, inherently meaningful but may also be metaphorically employed to constitute the entire figure or parts of recognizable forms, such as the deities and their attributes, religious architecture, landscapes, and even the shapes of letters (see nos. 82–84). Inscriptions may also convey significance in a more abstract way through their repetition and distribution within the composition, through the use of variously colored inks, and through spacing between the units of text to create secondary geometric

forms that enrich the significance of the image. The nature of the texts employed in such paintings may be complete literary works, usually of a religious nature, or prayers and mantras (verbal utterances of varying length, which may or may not convey meaning in conventional language) repeated in meditation and also used to address or abstractly represent deities. For example, there are many images of Hanuman, Rama's devoted warrior ally, in which the name of Rama (repeated as a mantra) covers the monkey demigod's entire body or is significantly found on his tongue, necklace, and waistband (see no. 83). Names of historical persons may also be featured in an allover image, as, for example, in genealogies of the founding family of the Hindu sect fostering worship of Krishna as a seven-year-old boy (nos. 85–86). A related application of the practice of composing images from text is found in Islamic *tughras* in which the calligraphy of a prayer or other text is so arranged as to also form a representational image such as a lion, bird, or camel.[1] More abstract use of inscriptions is exemplified in a meditation diagram in which Sanskrit letters are placed in alphabetic sequence not only to form an eight-pointed geometric figure but also to visualize a concept of the universe in flux (no. 88). All these works, most of which are designed for use in a ritual context, reflect a number of factors peculiar to Indian culture. These include the value given to sound and therefore to repeated recitation of sacred texts in a culture where transmission has been overwhelmingly oral, the use of mantras in all kinds of rituals to effect changes in the individual and the world, and the elevation of sound as fragments of speech over visual imagery—because they are prior and more abstract in the Indian devolutionary cosmogonic order. These practices of using texts as part of images are found not only in popular expressions but also occasionally in sophisticated traditions as exemplified in the late-eighteenth-century Kishangarh work *Maharaja Savant Singh's tears irrigate the garden of his poetry* (Los Angeles County Museum of Art, W.89.51.2): here, water flowing from the enlarged eyes of the mystic-poet-king of Kishangarh is channeled into troughs that neatly border the rectangular plots in which his inscribed poetry flowers. The earliest occurrence of these practices of inscriptional art is unknown. Certain practices are related, at least in their metaphorical function, to the purely pictorial composite forms, in which, for example, the body of a horse bearing a deity is composed of the bodies of devotees (see no. 28). Other practices may have been inspired by the architectural display of inscriptions of sacred texts on Islamic structures. Yet other practices (including writing or carving of a text or the name of a deity, the latter repeatedly, on the interior walls of some Hindu temples) probably evolved with the spread of literacy to common people in the nineteenth century, a phenomenon that increased the perception of sound, word, and text as sacred realities.[2]

Symbolic diagrams called *yantras* (literally, tools) also recur throughout India in great variety. Sometimes employing mantras, sometimes abstracted forms of recognizable realities, sometimes purely geometric forms, these special images are created by devotees under the guidance of gurus and employed as a focusing device for meditation or as the physical entity (or shrine) into which a deity can be invoked to reside in private religious rituals. *Yantras* frequently embody conceptualizations of the universe as emanating from a divine

center (no. 88); they are also believed to be abstract representations of aspects of the Godhead, with a traditionally prescribed image associated with each of numerous deities and also usually associated with a corresponding mantra (no. 87). Just as there are thousands of deities in the various Indian conceptions of reality, so there are thousands of *yantras* representing them. The significance of these representations is, however, not widely known, as *yantras* and their meanings are revealed primarily by religious masters only to aspirants. The basic elements in every *yantra*, which are extremely rich in their metaphysical allusions, are 1) the central point or extensionless dot called the *bindu* and 2) its enclosure, whose boundaries may form a circle, a triangle, or other straight-sided polygon, but most often a square. Some religious masters consider *yantras* (as representations of divinity) to be inferior to mantras but superior to the more sensuously appealing anthropomorphic images, such as the hero-prince Rama or the Great Goddess Durga, the warrior. Besides being painted or drawn on paper and other two-dimensional surfaces, *yantras* may also be created in shallow relief on sheet metal or in full three-dimensional form in a variety of materials. While *yantras* are usually regarded as having a more elevated spiritual function than the ritual floor paintings executed in Hindu villages all over India from ancient times (see ill., p. 21), there are many visual similarities between them, similarities so strong as to perhaps suggest a relation of origin. But *yantras* may have also evolved from diagrammatic temple floor plans that symbolically enclose and protect a relatively small inner sanctum containing the icon of the tutelary deity.

Illustrations of punishments for specific sins or transgressions of ritual observances and rewards for virtue are also found in a wide variety of painting formats that didactically show individuals the afterlife consequences of their present behavior. Sometimes occurring within the context of narrative traditions, punishments and rewards in the afterlife may be the single subject of the traditional artifact (as exemplified in some Bengali and Jadupatua scrolls, such as no. 45). Or the theme may also be featured in a section of a larger work (as exemplified in Garoda and some Jadupatua scrolls, such as nos. 43, 47–48). The theme also apparently occurs outside specific narrative traditions as a popular independent production enumerating varieties of torments, sometimes in book form (nos. 89–90). The theme even crops up as part of the border imagery on a race game board whose spiritual goal is reaching heaven or deliverance from continuous rebirths.[3] The particularities of the punishments are based to a large extent on local oral tradition and are also found incorporated in writings called the *Puranas* as lists of the hells, torments, and subhuman rebirths that are the consequences of specific failings.[4] The number and names of the hells vary from writing to writing; the *Vishnu Purana* (bk. 2, chap. 6), for example, lists twenty-eight, among them describing the hell called *Krimibhaksha* where, for the sinners who hated their fathers or the members of the priestly caste or the gods, worms are food. These hells are not believed to be eternal places of punishment as in Western Christian cultures but are rather regarded as abodes through which souls must pass before being reborn as higher or lower beings. Certain religious groups, such as the Jains and the Swaminarayan sect, have their own traditions of picture albums graphically displaying punishments in various hells (for a Jain example,

see no. 90).[5] Pictures illustrating punishments for sins and rewards for good deeds are generically called *Yama patas* after Yama, the first human to die and thereafter the god of the dead who with his servants enforces the consequences prescribed for the varieties of good and bad behavior. The tradition of *Yama patas* is apparently ancient, as there is very early literary evidence of itinerant "picture-showmen," known as *Yama pattikas*, displaying images of the next world in which sinners are enduring punishments and the righteous are enjoying peace.[6] Pictures illustrating punishments and rewards in the afterlife continue to be produced even today, some in commercially printed form as single sheets or as pages bound in softcover booklets. The tradition, in all of its imaginative multiplicity, obviously plays an important role in the moral education of both young and old, encouraging the avoidance of sin and the mending of sinful ways.

Visual aids for divination are used in several contexts and occur in a variety of painting formats. Fortune-tellers ritually employ books of omens (*shakuna-malas*) whose folios enigmatically depict various fates (nos. 91–92). Astrologers inscribe and illustrate calendars that set auspicious timings for festivals and other events (no. 93), as well as creating horoscopes that give direction for an individual's life course. The popularity of these aids reflects deeply held Indian beliefs in fate (or karma) and in the necessity of harmonizing personal activity with planetary movements. Other works that give assistance in discernment or interpretation of omens include charts for reading the personality of the individual from the hand, the eye,[7] and the foot and illustrated treatises on the meaning of dreams.[8]

Painted game boards entertain and educate by laying out the stages or steps in spiritual development and a course of life whose goal is heaven (no. 94). Playing cards hone intellectual and social skills (no. 96); called *ganjifa* in India and neighboring Islamic regions, they survive in both court and popular styles. Some of the popular styles of playing cards are associated with popular traditions, such as that of Orissa, where production of cards is an ancillary task of the artists who paint Puri's sacred images. Three types of Indian packs, reflecting a complex history of cultural exchange between India and central Asia, Europe, and China, and within areas of India itself, can be distinguished. Mughal *ganjifa*, introduced into India during the early Mughal period, generally consist of ninety-six cards in eight suits, each with twelve cards. The Hinduized form of Mughal *ganjifa* generally consists of 120 cards in ten suits, each with twelve cards. The suits in these *ganjifa* represent the ten incarnations (*avataras*) of Vishnu, and the pack is called *dashavatara* after that fact. There are also Hindu packs with *Ramayana* and other themes, with differing numbers and kinds of suits. Finally, there are Indo-European packs that employ the Arabic numerals and the suits of playing cards introduced into India by Portuguese, French, and English traders.[9] Most playing cards used in India today are apparently printed in India, with European suits, except in Orissa, where playing with old-style cards can still be observed; painted cards with Indian suits, if they continue to be made in the many other areas where they formerly flourished, are produced for export or tourist markets.[10]

Finally, manuals with pictures portray the steps in successful completion of practical activities. Most significant among these are manuscripts on the art of

love, illustrating or derived from texts like the *Kama Sutra* that encyclopedically detail erotic positions and many other aspects of sexual experience. More than explication of erotic technique, these works are deeply connected with Indian aesthetics and religion and reflect a host of common concerns. Examples of painted erotica survive in both sophisticated and popular styles, consumers of the latter most likely having been members of the urban upper-middle class (no. 95). More mundane subjects of illustrated how-to manuals include the care and treatment of horses and of elephants, the digging of wells, and the making of clothes, turbans, and jewelry.[11]

Painted by hand to fulfill a range of purposes from the elevated to the pragmatic, these works have functioned, at least in the past, as essential elements in living daily life throughout India and, perhaps for that very reason (in addition to their often commonplace styles), have seldom been perceived as "art." Despite their important role in everyday matters and their ubiquity, few of these types of popular paintings (with the exception of playing cards) have been presented in exhibitions or have been the subject of scholarly studies. During the 1970s, meditation diagrams or *yantras,* which had previously been known only to their patrons and creators (religious masters and their students), enjoyed some exposure in the Western world in several exhibitions and studies of art related to the esoteric cult of Tantrism.

*Representative Works: Paintings Serving Didactic,
Divinatory, and Other Cultural Functions, nos. 82–96*

82. A devotee's image of the Great Goddess drawn with the text of the *Devi Mahatmya* (The Hymn of Greatness of the Goddess) or the *Durga Saptashati* (Seven Hundred Verses on Durga), for use as a visual aid to its recitation
 Inscribed in Sanskrit
 Rajasthan
 1853, signed and dated by the scribe Chiman Rama
 Ink and opaque water-based pigments on paper
 62¾" x 54¼" (159.4 cm x 137.8 cm)
 The Ravicz Collection

This magnificent painting of the Great Goddess is impressive not only because of its physical scale but also because of the sheer quantity of text incorporated in the image. Inscribed in various colored inks, text fills every square inch of the bodies of the Goddess and of Bhairava (a fierce aspect of the god Shiva), as well as being employed on all four edges of the picture. The Goddess, portrayed here as Durga, wields in her four major arms and forty-eight smaller arms a number of weapons, drums, snakes, skulls of victims, and other attributes of her terrifying power, as she also communicates various feelings, thoughts, and blessings through hand gestures (*mudras*). The Goddess wears a red head veil, a tight-fitting bodice, and a bluish green skirt, which appears striped because black, red, and white inks have been used for different sections of the text. The Goddess is adorned with an elaborate necklace, earrings, bangles, and ankle bracelets. She sits on her typical mount, a tiger. The sun and moon appear on either side of

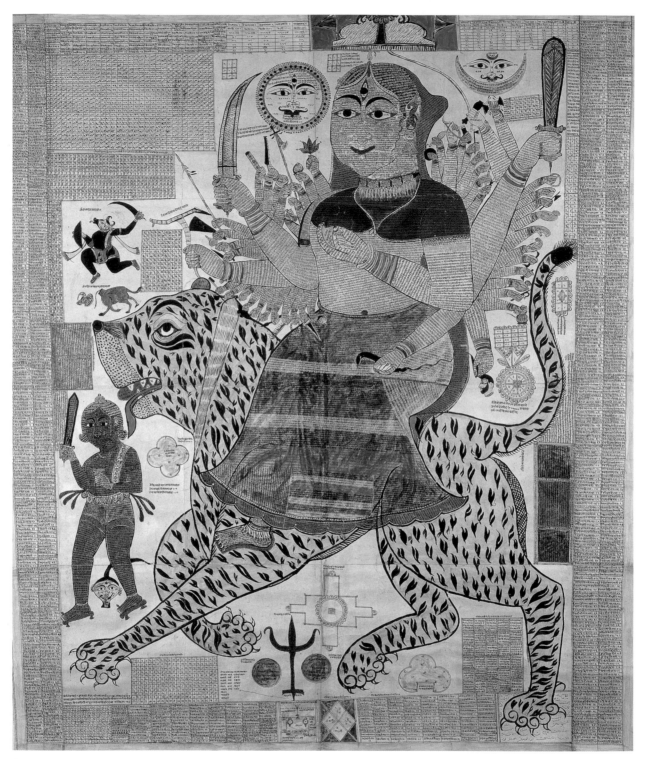

82

her face. On the left side of the painting is a much smaller figure of her husband, Shiva, as Bhairava, wearing wooden sandals and holding a cup and a sword. Above him, in even smaller scale, is Mahishasura, the chief demon vanquished by the Goddess; he is represented twice—as human warrior with a buffalo head and as a decapitated buffalo.

The principal text in the painting, found on the body of the Goddess and beginning at the uppermost point of her head, is the *Devi Mahatmya* (The Hymn of Greatness of the Goddess) or, as it is also called, the *Durga Saptashati* (Seven Hundred Verses on Durga).[12] Composed around the fifth or sixth century A.D., this text celebrates the creation of Durga from the combined energies of male deities and her victorious activities, undertaken on their behalf, to deliver the world from various evils. While the text came to be part of another scripture, the *Markandeya Purana*, it is also known independently as a popular devotional work that is privately read or recited and publicly chanted during the annual autumnal *Durga Puja* (worship of Durga). The inscription at the center bottom of the painting below the trident of Shiva makes clear the religious function and use of the painting by devotees: "The Procedure for Performing the Worship of the [*Durga*] *Saptashati*." Found elsewhere in the painting are other parts of the text as well as various mantras; ancillary works, including one known as the Goddess's "armor" (which the devotee typically recites before the *Devi Mahatmya*); and invocations to the sun and the moon. Also found throughout the painting are several astrological and calendrical computations pertaining to the worship of the Goddess. A psuedo-inscription in Persian below the left rear paw of the lion in the lower right corner of the painting appears to be without meaning; the reason for its insertion is unknown. The painting is signed and dated by the scribe below the extended left paw of the tiger in the lower left corner of the painting: *mītī jeṣṭa-śudī 2 budhavāsare saṃvat 1910 kā śāka 1775 kā līkhatamvale devabrāhmaṇakuśāla-gaṛ mai śrīavadhivihārijī kā miṃdar mai cīman rāma līvāliṃ vāl* [or *līkhalīṃvāl?*] *ki putraḥ aura bācai paḍai jyāku humārv āsirvāda vaṃcyā śānti astaḥ śubham* ("Date: on the day of the planet Budha on the second day of the bright fortnight of the month Jeṣṭa in the year 1910 of the saṃvat era and 1775 of the śāka era [that is, a Wednesday in May-June of the year A.D. 1853] the scribe Cīman Rāma in the temple of Śrī Avadhivihārijī, the place of welfare of gods and brahmans[?] wrote this. May his son, and whoever reads this or recites it aloud, have our blessings. May there be peace and prosperity").

Impressive in scale, the picture demonstrates in a grand way the central importance of the recitation of the *Devi Mahatmya* in the devotional life of *shaktas* (goddess worshipers). Also impressive in its level of artistry, the painting exemplifies a grand version of the popular devotional practice of composing images with sacred texts.

Reproduced: Gerald Larson, Pratapaditya Pal, and Rebecca P. Gowen, *In Her Image: The Great Goddess in Indian Asia and the Madonna in Christian Culture, exh. cat.* (Santa Barbara: UCSB Art Museum, University of California, 1980), p. 49; Ajit Mookerjee, *Kali, the Feminine Force* (New York: Destiny Books, 1988), p. 59.

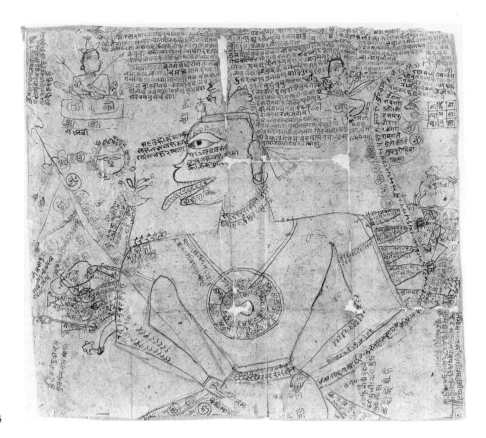

83

83. Fragment of a devotional image of Hanuman depicted with five heads and
twelve arms, drawn by a devotee with *yantras* (meditation diagrams), Rama's
name and other mantras, and other invocations, for use as a visual aid to medi-
tation
Inscribed mostly in Sanskrit
Rajasthan
19th century
Ink on paper
13⁹⁄₁₆" x 15³⁄₁₆" (34.4 cm x 38.5 cm)
Courtesy of Arthur M. Sackler Museum, Harvard University Art Museums,
Loan from Private Collection, 402.1983

This folkish drawing, undoubtedly created not by a professional artist but by a
devotee as a visual aid to meditation, depicts the monkey demigod Hanuman,
Rama's loyal, selfless, and courageous ally in the epic battle with the ten-headed
demon Ravana. As the drawing shows only Hanuman's head and upper torso, it
appears to be a fragment of an originally larger work, known as a *pataka*, which
typically presents a centrally placed, full figure of the monkey demigod.[13]
Hanuman is portrayed with five small heads emerging from his crown. These
are identified, from left to right, as monkey, boar, horse, man-lion, and eagle,
the middle three representing some of Vishnu's incarnations in previous ages

and the last representing Vishnu's mount Garuda. The portrayal of the monkey demigod with imagery associated with Vishnu makes clear that Hanuman—as an ally of Rama, who is an incarnation of Vishnu—exercises all of the superior powers derived from the same source.[14] In other treatments of the five-faced (*panchamukhi*) image of Hanuman that became popular in the eighteenth century, especially in Rajasthan, the heads may be larger and presented on either side of the monkey's face. Hanuman is shown typically sticking out his tongue and also displaying on his chest a pectoral or shield with a segmented rim. This form is very likely the *kavaca* (mystical "shield") that manuals of esotoric religious practices known as Tantric instruct devotees to figuratively construct with "strings" (or repetition) of mantras. Hanuman's two major arms are akimbo, each sprouting five small arms that hold various attributes. Ravana's severed heads, symbolizing the defeat of evil, hang from Hanuman's tail.

The work is heavily inscribed, probably by the same person who made the drawing; the inscriptions consist of numerous syllables that are the various "seed" formulae (*bija mantras*), which abstractly symbolize the deities in the element of sound and whose ritual use by devotees invokes their divine power and presence. Some of the syllables used here form phrases that are celebratory invocations, such as *anjani putraya namah* ("salutations to Anjani's son," that is, Hanuman). In some instances, placement of the inscriptions constitutes parts of Hanuman's image; for example, the name of Rama, the greatest of mantras, is repeatedly inscribed to form Hanuman's tongue, necklace, and waistband, while the word *namaha* (worship) encircles Hanuman's *kavaca*. The solid text found in the upper portion of the painting appears to consist of mantras and various instructions for meditation.[15] The red ink in which the work was drawn and inscribed is now considerably faded; much wear and tear along the creases of the folds that remain in the fragment may indicate how extensively this image of Hanuman was actually used in meditation and ritual practices.

84. A temple drawn entirely with Rama's name by a devotee to acquire religious
 merit and to use as a visual aid to meditation
 Inscribed in Devanagari script
 Eastern Bihar, near Bengal border
 19th century
 Ink on paper
 22⁵⁄₁₆" x 8¹⁵⁄₁₆" (56.7 cm x 22.6 cm)
 Courtesy of Arthur M. Sackler Museum, Harvard University Art Museums,
 Loan from Private Collection, 305.1983

This beautiful image of a Hindu temple is drawn entirely with the name of Rama, the hero of the epic *Ramayana* and an incarnation of Vishnu.[16] The calligraphy, neatly hung in swags and also arranged in parallel diagonal lines that form herringbone and squared-off bull's-eye patterns, constitutes the very structure of the temple, with a main spire (*shikhara*), outer pavilion (*mandapa*), and walled courtyard complete with flags. The drawing exemplifies a pictorial variant of the devotional practice of writing the name of Rama, the greatest mantra, an enormous number of times for religious merit. The practice of writing the mantra, which evolved with the spread of rudimentary literacy at the end of the nineteenth cen-

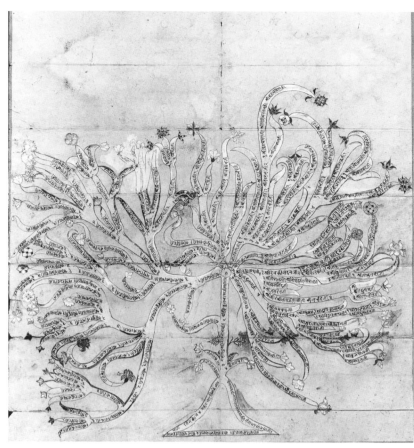

84

85

tury, extends the practice of verbal repetition of mantras as a focusing device in meditation. Even today, devotees fill ledger books with Rama's name, while elaborate pictures and designs made up of thousands of *Ramas*—like so many bricks in a structure—continue to be produced. Consisting of more than a visual conceit, these pictures embody a belief in the efficacy of words and reveal a theology of Vishnu as the supreme and omnipresent Pervader constituting all of the manifest world.

85. A genealogy (*vamsha vriksha*) of the religious leader Vallabhacharya and his descendants represented as a flowering tree with names inscribed on the trunk and branches
Inscribed in Devanagari script
Rajasthan
19th century
Opaque water-based pigments on paper
21½" x 19³⁄₁₆" (54.6 cm x 48.7 cm)
Courtesy of Arthur M. Sackler Museum, Harvard University Art Museums,
Loan from Private Collection, 34.1983

This image of a flowering tree with calligraphy in its branches represents the genealogy of Vallabhacharya (1479–1531),[17] the founder of the religious sect that worships Krishna as Shri Nathji, and his descendants (see discussion of Nathadwara paintings in Chapter 4). The genealogy begins with Vallabhacharya springing as trunk out of the triangular base of the tree with his three siblings, their order of birth—as is that of all descendants on this tree—meticulously enumerated. Of Vallabhacharya's two sons, Gopinathji (1512–1524) and Vitthalnathji (1516–1586), it is the latter that becomes the next section of the tree trunk. The tree then fans out into seven branches that represent Vitthalnathji's seven sons, again numbered and shown in the order of their birth from left to right: Girdharji (1541–1621), Govindarayji (1543–), Balakrishnaji (1546–), Gokulanathji (1552–), Raghunathji (1555–), Yadunathji (1559–), and Ghanshyamji (1572–). Each of these branches fans out again, representing the descendants of the seven sons and so on until several generations complete the crown of the tree. Some of the branches end without reaching the outer edge of the crown, apparently signifying the end of that part of the family with the last named individual. Most of the branches, both long and short, effloresce at their tips with tiny stylized blossoms that are distinctive in color and form.

This inscribed genealogical tree (known as a *vamsha vriksha*) is considerably more folkish in style than even the souvenir paintings of the Nathadwara tradition that evolved to serve the sect. The spare composition of this tree is in striking contrast to the pictorially illustrative treatment of the same theme in the sect's sophisticated temple hangings (*pichavais*), in which tiny, carefully rendered portraits of family members are enclosed in niches or in hosts of medallions, row upon row.[18]

86. Fragment of a genealogy (*vamsha vriskha*) of the religious leader Vallabhacharya and his descendants represented as a flowering tree with names inscribed on the trunk and branches
 Inscribed in Devanagari script
 Rajasthan
 19th century
 Ink and transparent water-based pigments on paper
 26" x 18⅜" (66.0 cm x 46.7 cm)
 The Ravicz Collection

Though visually conceived in a very different manner from the preceding work (no. 85), this image with calligraphy pulsating in crowded, narrow, swirling channels is also the genealogical tree (*vamsha vriskha*) of Vallabhacharya and his descendants.[19] This image is probably not complete, as the right edge of the painting appears to be torn and is without the border pattern of flowers and leaves found on all other sides. The trunk of the tree—which here is more abstract and geometrized—is found at the lower right corner of the painting but was originally probably in the center. The tree trunk grows out of a conjoined trapezoid and square, together perhaps suggesting a mountain. Within the band around the trapezoid is an inscription that indicates that this tree representing Vallabhacharya and all his descendants rests on a base of one hundred sacrifices carried out by Vallabhacharya's ancestors to ensure an incarnation of

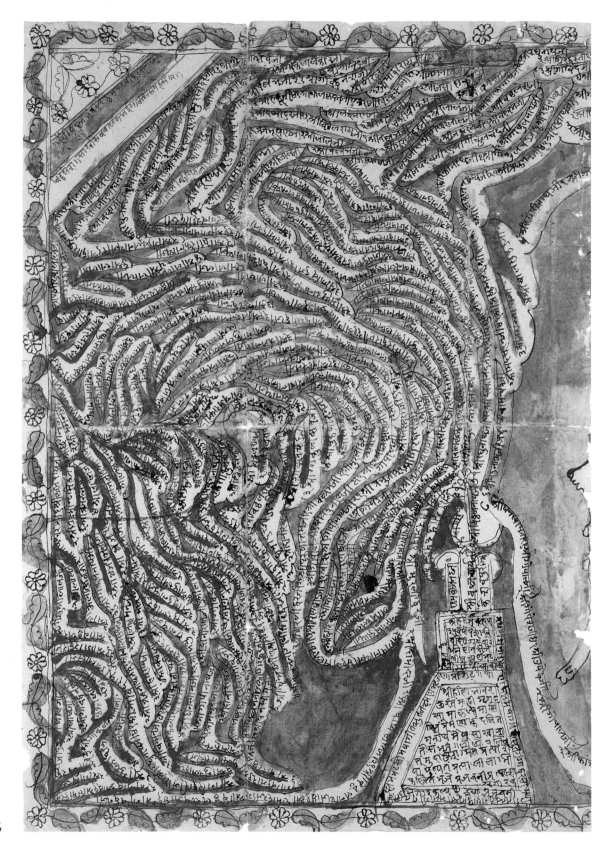

Vishnu in their own family, that incarnation being, of course, Vallabhacharya himself. Resting on the trapezoid is a square bearing Vallabhacharya's father's name. Vallabhacharya springs out of his father as the middle third of the tree trunk, siblings on either side. Sprouting from Vallabhacharya are his two sons Gopinathji and Vitthalnathji, the latter rising on the same vertical axis as his father to terminate in a small flower from which his seven sons branch out, again in the order of their births, from left to right, and enumerated. As the branching continues, several generations fill out the tree. The contour lines of the drawing and the inscriptions are executed in black ink; the background color is transparent red. The spontaneous, even ragged, mode of writing and applying color and the sprawling composition radically depart from the refined and sophisticated manner characteristic of the Nathadwara painting tradition that evolved to serve the followers of Vallabhacharya.

87. A devotee's meditation diagram *(yantra)* consisting of left-turning swastika su-
 perimposed upon a lotus
 Rajasthan
 CA. 1850
 Opaque water-based pigments on paper
 9½" x 9½" (24.1 cm x 24.1 cm)
 Courtesy of Arthur M. Sackler Museum, Harvard University Art Museums,
 Loan from Private Collection, 509.1983

This composition within a square depicts a left-turning swastika, with enclo-sures implying treasures *(niddhis)* at its tips, superimposed upon a pink sixteen-petaled lotus in full bloom. Above these radiating forms, whose centers coincide, are a pair of small hands or handprints and below them a pair of small footprints. A creeper with a number of tiny lotuses encircles the lotus and

87

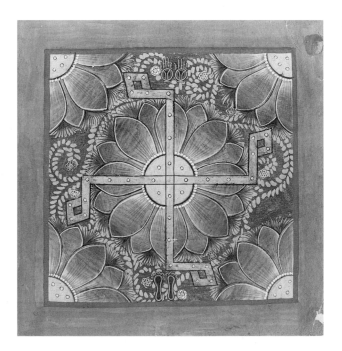

swastika and connects the images of the hands and feet. In each corner of the composition is a quarter segment of a lotus blossom whose center points coincide with the points that form the square framing the whole.

This beautiful image, employing the archetypes of swastika and lotus, is undoubtedly a *yantra*—an abstract representation of powers of the deity—used in meditation to harness the imagination and also worshiped, though the exact significance of the composition remains unknown. Each pictorial element is richly multivalent in the Indian language of signs and symbols. The lotus traditionally symbolizes manifest reality unfolding like so many petals from a divine center. The four-directional swastika is generally a sign of all-encompassing well-being and auspiciousness, while the left-turning swastika is associated with the feminine principle and the "left-handed" spiritual path of esoteric religious beliefs and practices of the cult of Tantrism.[20] Isolated pairs of footprints are typically identified as those of a deity and are consequently also auspicious, as they indicate the possibility of the deity's taking up residence in the shrine of the *yantra* when invoked by a devotee. Handprints signal blessings.

88. A devotee's meditation diagram (*yantra*) with eight angles visualizing the evolution and involution of the universe
Inscribed in Sanskrit: *aṣṭakoṇa yantra anulomānulomakhyām ekaviṁśīntra triśata tamavarśvasya kālacakram asya bhedaḥ* 576 ("An eight-cornered *yantra* called the Anulomanuloma, an alphabetical and reverse-ordered chronogram *yantra* 300 less 21 dark years . . . 576 segments.")[21]
Rajasthan
19th century(?)
Ink and transparent and opaque water-based pigments on paper
22" x 21" (55.9 cm x 53.3 cm)
Julia Emerson

This eight-angled, star-shaped diagram formed by the coincidence of two squares is an *ashtakona yantra* (meditation aid in the form of a figure with eight angles). It features the letters of the Sanskrit alphabet arranged in sixteen radial lines around the center of the figure. The letters are arranged clockwise, beginning on the rim of the figure to the right of the figure's uppermost point; the letters progressively encircle the center, descending to its point. As the alphabetical order of Sanskrit begins with sixteen pure vowels, vowels head each of the sixteen radial lines. The letters that follow are combinations of each of these vowels with the thirty-six consonants, Sanskrit being written in a syllabic script (that is, representing consonants only in combination with vowels). Each radial line thus contains one of the vowels and all its possible permutations by combination with all of the consonants. The movement toward the center is both spirally inward as well as radial as one progresses through the 576 sounds found in the *yantra*. That number of sounds is the product of sixteen vowels times thirty-six consonants. Placed at the center of the *yantra*, enclosed in a circle, is an irregular hexagon formed by the intersection of two triangles whose largest angles point horizontally to the left and the right. The diagram is enriched by a pattern of stripes, lined in red, that echo the contours of the eight-pointed figure and create an optical illusion of vibrating expansion and contraction.

The *yantra* abstractly visualizes a conception of the universe radiating from

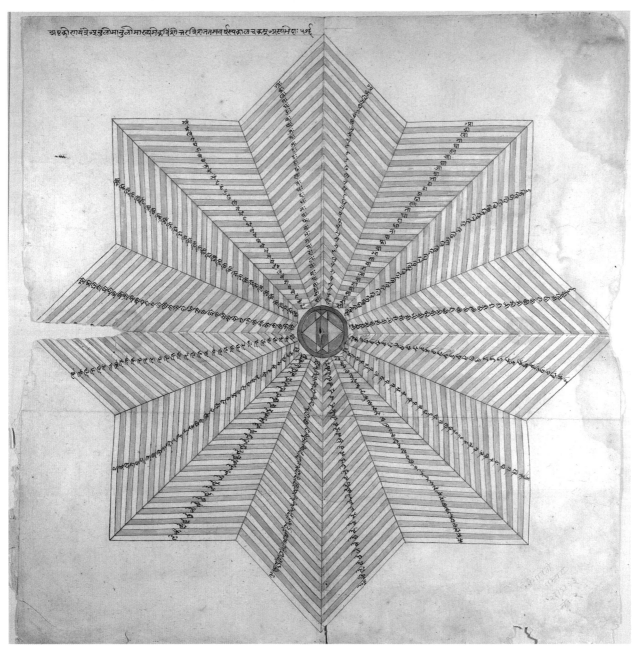

88

a Supreme Principle in a multitude of forms and then devolving back into its center. Particles of sound, the most abstract element, are differentiated and ordered to represent the variety of manifestations emanating from the Supreme Principle. The devotee typically vocalizes the sound fragments inscribed on the *yantra* as an aid to psychologically reaching a state of mental concentration in union with the Principle. Image, number, language—all play a role in this conceptually complex but concisely and elegantly rendered abstraction.[22]

89. Eight pages from a picture album depicting the punishments for sins in various
hells, for use as a didactic visual aid
Inscribed with Devanagari numerals
Rajasthan, Marwar
CA. 1820
Pencil and opaque water-based pigments on paper
Various sizes, each approximately 8" x 6½" (20.3 cm x 16.5 cm)
Permanent Collection of the Craft and Folk Art Museum, Gift of Catherine
and Ralph Benkaim, 1984.18.10–17

These eight pages from a book of punishments detail the torments awaiting the
perpetrators of various crimes and sins. Some pages include depictions of the
servants of Yama, the god of death, supervising or inflicting torment, mostly by
beating; others show the sinners being ravaged by the attacks of various ani-
mals. Each page is inscribed with a different numeral but there are gaps in the
sequence,[23] indicating that the pages are culled from a much larger set. The im-
ages are described in the order of the inscribed numerals.

1. A standing, animal-headed figure holding three figures in chains, a
bearded and moustached naked man crouching on all fours and two armless and
prone naked women, with serpents' heads emerging from the back of their
necks, numbered "13."

2. A standing naked woman in chains, two tigers biting her breasts, num-
bered "19."

3. A bearded and moustached naked man in chains, impaled on a vertical
spit bound by the tail of a serpent who also bites at his face, being beaten by two
figures, one animal-headed, the other a moustached human, numbered "20."

4. A standing naked woman in chains with leaf-shaped swords piercing
her body, numbered "21" (illustrated).

5. Two naked figures in chains, one a bearded and moustached man being
attacked by scorpions and snakes, the other animal-headed, being held in chains
by an animal-headed figure, numbered "25."

6. A naked woman and man being consumed by snakes, numbered "28."

7. A ceremonially dressed human figure, holding two fans, standing on
a bearded and moustached naked man in chains kneeling on all fours, num-
bered "31."

8. A bearded and moustached male figure in chains being attacked by a
tiger and four serpents and held and beaten by an elephant-headed figure, num-
bered "37."

The fourth page (numbered "21"; illustrated) apparently shows the special
torments of the hell known as the Sword-Leaf Forest (*Asipatravana*). This hell is
mentioned in the *Vishnu Purana* (bk. 2, chap. 6) as the place of punishment for
persons who wantonly cut down trees; in the *Markandeya Purana* (cans. 12, 14),
the hell is said to be experienced by those persons who do harm to their friends
and its afflictions are more fully described: driven by the blazing fires and
scorching sun in this hell's outer regions, sinners seek relief in a centrally lo-
cated shady forest filled with glistening leaves; upon their entrance, a wind
blows, and all the leaves—which are actually swords—fall upon them. The an-
imal-headed figure at the top of the fifth page (numbered "25") may depict the

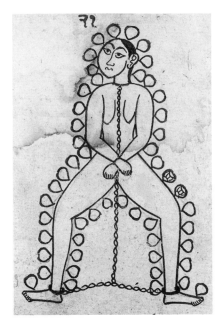
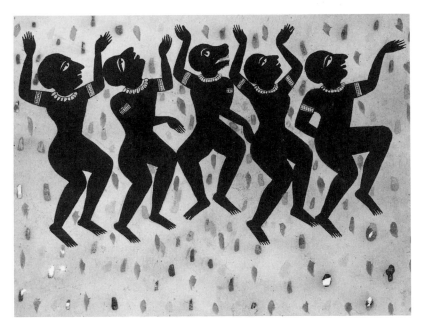

<div align="center">89, detail</div>

rebirth of a sinner in a subhuman state as punishment for a particular transgression, as described in lists of sins and consequent rebirths included in some writings, an example of which is found in the *Markandeya Purana* (can. 15). These powerful images were didactically employed in the moral education of the living to persuade them to avoid future wrongdoing or to mend their current sinful ways.

The images are essentially contour drawings fluidly brushed in black; some of the figures on all but one of the pages are minimally colored with single brush marks of red, green, pink, yellow-orange, or lavender. Traces of preliminary sketching in pencil remain.

90. A page from a Jain picture album depicting the punishments for various sins in various hells, for use as a didactic visual aid
Gujarat or Rajasthan
Late 19th century
Transparent and opaque water-based pigments on paper
4⅞" x 6½" (12.4 cm x 16.5 cm)
Dr. Alvin O. Bellak, Philadelphia

This stark but elegant image, probably a page from a Jain picture album depicting the punishments for various sins in different hells, shows five male figures, one with an animal head, in anguish, uneasily raising their arms, some lifting their legs, all looking upward with open mouths. The animal-headed figure may represent a soul's rebirth in a subhuman state as punishment for transgressions in a previous life. The distressed figures, who can find no comfort

91

either in the place or in the company of their fellow wrongdoers, are painted as silhouettes in solid black, relieved by white depicting their necklaces, armbands, eyeballs, and eyebrows. The cream background is delicately flecked with an irregular allover pattern of red, green, and yellow marks and narrowly bordered with red. The book to which this page once belonged was undoubtedly kept in a Jain library (*bhandara*) funded by the lay community and maintained by monks for the education and enlightenment of the faithful.

91. Nine folios from a fortune-teller's book of omens (*shakunamala*), for use as a visual aid in fortune-telling rituals
 1. Water buffalo in a shelter
 2. Four women in a pond
 3. Plant form
 4. Three animals
 5. Physician or astrologer taking a man's pulse
 6. Shiva shrine and standing male devotee
 7. Nine pots
 8. Turtle
 9. Woman standing, holding a bowl
 Himalayan foothills, perhaps Jammu and Kashmir, Basohli
 CA. 1730–50
 Transparent and opaque water-based pigments on paper
 Each: approximately 3¾" x 3½" (9.4 cm x 8.9 cm)
 Courtesy of Arthur M. Sackler Museum, Harvard University Art Museums,
 Loan from Private Collection, 19.1983.A–I

These small folios from a book of omens encode various fates revealed in the rituals of fortune-telling. Each originally had a small thread attached at its top center, as is evident from the worn top edges of most of the folios. The person whose fortune was being told apparently pulled a string attached to a folio that was then interpreted by the fortune-teller.[24] Drawn without ground planes and without even ground lines on all but two cards, these emblematic yet animate

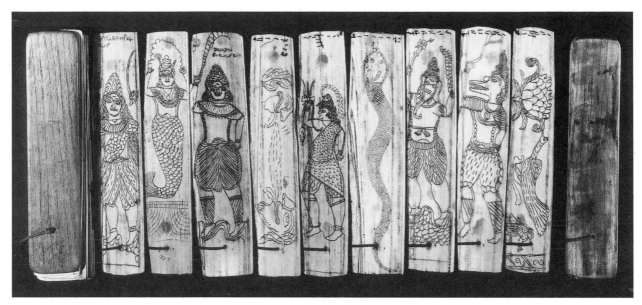

images are the master creation of a folk artist. The folios are subtly colored in pale orange reds, greens, ochre, and black.

92. A pulse (*nadi*) manuscript or a pulse astrologer's (Nadi Josiyar's) book of omens,
for use as a visual aid in spiritual direction and fortune-telling rituals
Inscribed in Tamil
Tamil Nadu (or Sri Lanka)
20th century
Transparent water-based pigments and colored inks on engraved palm leaves,
sewn with thread and bound with leather between two wooden covers
Each palm leaf: approximately 9¼" x 2" (23.5 cm x 5.1 cm); book depth: 2"
Permanent Collection of the Craft and Folk Art Museum, Gift of Frank and
Edith Wylie, 1984.19.30

This intriguing artifact, a palm leaf manuscript from Tamil Nadu (or possibly Sri Lanka), is designed for use in the spiritual direction of the pious and also in augering the future. Known as a *nadi* (literally, pulse) manuscript, such a book is said to be written for lucky individuals or for the members of a specific caste, instructing them to perform certain acts for their spiritual betterment, for example, visiting particular temples or attending festivals in honor of certain deities or accomplishing special remedial measures (perhaps to undo past sins and failings). The leaves of the *nadi* manuscript are read by the Valluvars in the area surrounding Madras in Tamil Nadu (formerly known as the Chingleput district) and by other fortune-telling castes in a few different places.[25] According to another source, such a manuscript is said to be employed in the rituals of fortune-telling: pulse astrologers called Nadi Josiyars augur the future by taking the client's pulse (*nadi*) and, after asking the client to drop a thread upon the closed book of palm leaves, by interpreting the omen or picture on which the thread lands.[26] This method of determining images for in-

terpretation may also possibly be employed in giving spiritual direction. (In South India, the word "pulse" signifies more than heart contractions and blood flow; it also suggests physical nerve fibers and the channels and currents of energy that flow through the bodies of individuals.)

This pulse manuscript has thirty-eight images folkishly rendered, possibly by a number of different hands, and nine leaves inscribed in Tamil by possibly three different hands.[27] Only nine are illustrated here. The images, some of which recur, illustrate a variety of subjects. Some are clearly male and female deities with typical emblems; only one leaf appears to show a single attribute of a deity. Hanuman, Shiva(?), Bhairava (a fierce form of Shiva)(?), Murugan (as Karttikeya is known in Tamil Nadu), and Ganesha appear a varying number of times, in some instances with their names inscribed. Three goddesses, Parashakti, Ankalishvari, and Parameshvari, appear with inscriptions of their names; two other crowned female figures—one with a five-pronged trident and axe, the other with fangs, a trident, and sword—are portrayed without identifying inscriptions; of the depicted goddesses, at least Ankalishvari can be identified as a popular Kali-type goddess known in South India by her Tamil name, Ankalaparamecuvari. Other images on the leaves include mermaids, men with apelike jaws, demoniac beings swallowing or impaling humans, hairy-bodied males with head hairs on end (a devotional phenomenon), and the heads of believers. Additional leaves depict snakes, scorpions, birds, insects, a lotus, and a temple. Perhaps most significant in the interpretation of the function of the manuscript is the image of a male fortune-teller holding an hourglass drum, which is inscribed: *kuṭukuṭuppaikkārarai-k-kaṇṭa pōtu kōriya kāriyam jeyamākum / tarmam ceytāl celvam————?* ("When one sees the fortune-teller, one's demand [or wishes] will be triumphant. If [you] give [him] alms, [you will become] rich ————?————?")

The linear images are engraved into the surface of the palm leaves; cerise red and black inks have been rubbed into the grooves to make the images visible. Although the creators of these images are most likely not professional artists, they draw, nevertheless, with energy and extraordinary conviction. A deep pink pigment has been applied to only the lower garment of Hanuman, on only one leaf; almost all the leaves bear deep pink dots, marks of ritual veneration, at the top or at the bottom or in both places.

93. Fragment of an astrologer's calendar (*panchanga*), for use in determining dates
 for festivals and auspicious timings for other events
 Inscribed in Devanagari script
 Southwest Rajasthan
 Late 19th or early 20th century(?)
 Ink and transparent and opaque water-based pigments on cotton cloth
 54½" x 9½" (138.4 cm x 24.1 cm)
 Lorna and Roy Craven

This fragment of a calendar was once part of a long vertical scroll used by astrologers to determine dates for festivals as well as auspicious timings for other events. The scroll fragment consists of part of the opening pictorial section that contains some of the numerical diagrams that fill the major portion of the

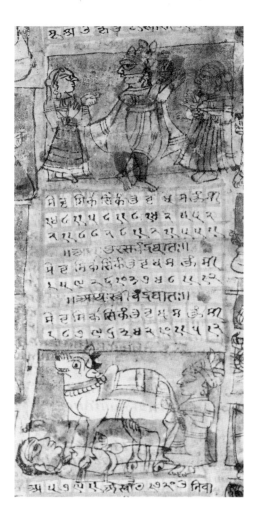

93, detail

scroll. The calendar is known as a *panchanga* (five limbs) after the five divisions
of time in the astronomical year traditionally observed in India.[28]

The calendar fragment appears to be missing the first register, which tradi-
tionally has an inscribed prayer flanked by two horses with riders and is followed
by a couple of horizontal bands with animals in procession. The calendar frag-
ment starts with the next traditional image, that of Ganesha, the elephant-headed
god invoked at the beginning of tasks, who is depicted with two female atten-
dants under a narrow band with three arches, each containing a lotus. On the left
are a number of incarnations of Vishnu (fish, turtle, boar, lion-headed man), fol-
lowed by four seated males who are also incarnations (the dwarf, Parashurama,
Rama and Krishna, Buddha) and the horse Kalki. On the right is a double column;
the inner column displays twelve images from the zodiac (ram, bull, seated man
representing Gemini, cock representing Cancer, lion, female representing Virgo,
scale, scorpion, bow, fish representing Capricorn, water jar, and a pair of fish); the
outer column displays images of nine planets represented as seated male figures,

seven of which govern days of the week. At intervals between the numerical diagrams in the central section of the calendar fragment are two more images, Krishna playing the flute and accompanied by two female cowherds and a man holding the tail of a cow that stands on a prone male figure (illustrated).

The figures in this opening segment of the calendar are drawn in a lively folkish manner; color is spontaneously applied with transparent effect; the principal background color is red, with the borders of the picture areas in yellow orange; the figures are painted in blue, green, and tan.

94. Shri Rama Knowledge Game Board (or game board for obtaining knowledge of
 Shri Rama)
 Rajasthan
 Inscribed in Devanagari script
 Late 18th or early 19th century
 Ink and transparent water-based pigments on paper
 12¹¹⁄₁₆" x 12⅝" (32.2 cm x 32.0 cm)
 Courtesy of Arthur M. Sackler Museum, Harvard University Art Museums,
 Loan from Private Collection, 35.1983

This work, with seventy-two inscribed[29] and numbered squares plus an inscribed lunette within an architectural design at the top center, is the traditional Indian "knowledge game board" (known in Hindi as *gyan chaupad*), for playing the "game of knowledge" (*gyan baji*). The board lays out a field for a race game with a spiritual goal—reaching the abode of the supreme deity Vishnu in the top center lunette, inscribed "Vishnu's paradise" (*Vaikuntha*). To arrive at this destination is to achieve, in a symbolic way, final liberation from the cycle of continuous rebirths or individuations that unperfected souls must endure.

The race begins in the lower left square, inscribed "the birth square of Shri Rama Knowledge Game Board" or *Shri Ramaji Jnana Chaupad janam* (with the Sanskrit term for knowledge, *jnana*, in place of *gyan*), indicating belief in Rama, an avatar of Vishnu, as supreme deity. At the throw of a die (or dice) or cowries,[30] a player moves through the squares, which represent lower to higher states of spiritual development identified with cosmic locations, according to Indian mythology; these include the sacred rivers Sarasvati, 47, Yamuna, 48, and Ganga, 49, as well as conceptual places, associated with primal elements such as the "realm of the wind" (*vay[u]*), 57, and the "realm of water" (*jala loka*), 53; with individual spiritual qualities; and with the abodes of various gods. The squares are numbered from left to right in the bottom row and then from right to left in the second from bottom and so on, until the last square at the top left, with the unnumbered lunette at the top center as the final goal. In the course of moving along this path, there is the possibility of a quick ascent by landing in a square that contains the base of a stylized ladder leading up to a higher numbered square and a higher state of being. Reversal of progress can also occur by landing in a square with the head of a snake, which drops the player down to a lower numbered square and a lower state of development. On this board, some of the eleven ascents include moving from the state of mercy (*daya*), 17, to the abode of Brahma, the creator god (*Brahma loka*), 69; from discernment (*viveka*), 46, to the realm of bliss (*ananda loka*), 66; and, most desir-

94

able of all, from spiritual devotion (*bhakti*), 54, directly to Vishnu's heaven (*Vaikuntha*). The ten descents include the hazards of falling from rebirth in a subhuman state (*kutsanga*, literally, "dog-associate" or "dog-born"), 24, to intoxication [or conceit(?)] (*mada*), 7, and from a state of ego[tism] (*ahamkara*), 55, to illusion (*maya*), 2.

This board, honoring Vishnu through his avatar Rama, is a Hindu version of the game. There are also Jain and Muslim versions, the Jain boards often being enclosed within the torso of a human figure or within a fully elaborated architectural structure. The number of vices and virtues, regions of the universe, and abodes of the gods one must pass through on the way to final liberation may be variously represented by 81, 84, 100, 124, 342, or 360 squares.[31] Modern English game boards called Snakes and Ladders borrow the pictorial motifs of the *gyan chaupad* but dispense with inscriptions evincing a spiritual goal. Evolved in Victorian England from Indian examples in repatriated colonial families, the secular game boards were reintroduced into India, where they have virtually replaced (except in the Jain community) the traditional version detailing the many steps—and risks—in the quest for religious development.[32] Both secular and traditional game boards are known today by the generic term Snakes and Ladders.

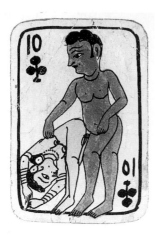

95

95. The ten of clubs with erotic figures
Orissa, Puri district
Second half of the 20th century
Opaque water-based pigments and lacquer on cotton cloth
3⅜" x 2⅛" (8.6 cm x 5.4 cm)
Dr. Alvin O. Bellak, Philadelphia

On a ten of clubs playing card, a standing man is depicted in intercourse with a woman who is also standing but bent over, her clasped hands around her head and touching the ground. The card is undoubtedly part of a set that consists of four suits (spade, heart, diamond, and club) borrowed from the French tradition but illustrating various erotic postures in the manner of the popular encyclopedic manuals of erotica produced all over India. It is not clear whether this hybrid creation was designed to appeal to the native wealthy urban classes or to tourists.[33]

The man's body is painted green, the woman's light orange; both figures are outlined in black. The numerals, suit sign, and a narrow band around the entire border are also black. All these forms are presented against a bright yellow background.

96. A set of playing cards with ten suits representing the ten incarnations of Vishnu (*dashavatara ganjifa*)
Orissa, Puri district, village Dandasahi
CA. 1985, by Arjuna Maharana
Opaque water-based pigments and lacquer on cotton cloth
Diameter of each card: 3" (7.6 cm)
Private collection

This complete set of 120 circular playing cards is ten-suited, the various suits depicting the ten incarnations or avatars of Vishnu as understood in Orissa.[34] Such sets are called *dashavatara ganjifa*; the suits or incarnations and their typical background colors and suit signs are as follows:

INCARNATION	BACKGROUND COLOR	SIGN
Fish (Matsya)	black	fish
Tortoise (Kurma)	yellow orange	tortoise
Boar (Varaha)	green	conch shell
Man-lion (Narasimha)	white	wheel
Dwarf (Vamana)	blue	water jug
Parashurama	light red	axe
Rama	yellow	arrow
Balarama	ochre	club
Jagannatha	brown	lotus
Horse-man (Kalki)	red	sword

Each suit has as its highest cards two court cards, the king (*raja*) card with the avatar on a chariot and the minister (*mantris*) card with the avatar against a plain background. The rest of the cards in each suit are counters, with the suit

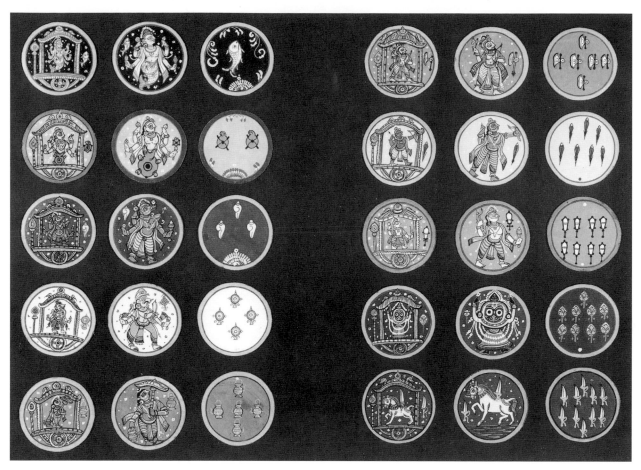

96, detail

sign depicted as many times as the value of the card. Illustrated here are the two court cards and a different counter card of each of the ten suits.

There are also expanded *dashavatara* sets with twelve and sixteen suits or incarnations. The avatars of Vishnu are a popular theme in many other forms of Puri painting. The circular shape of the cards is indigenous. Sets of such playing cards are typically stored in hand-painted boxes, also made by the traditional painters of Puri.

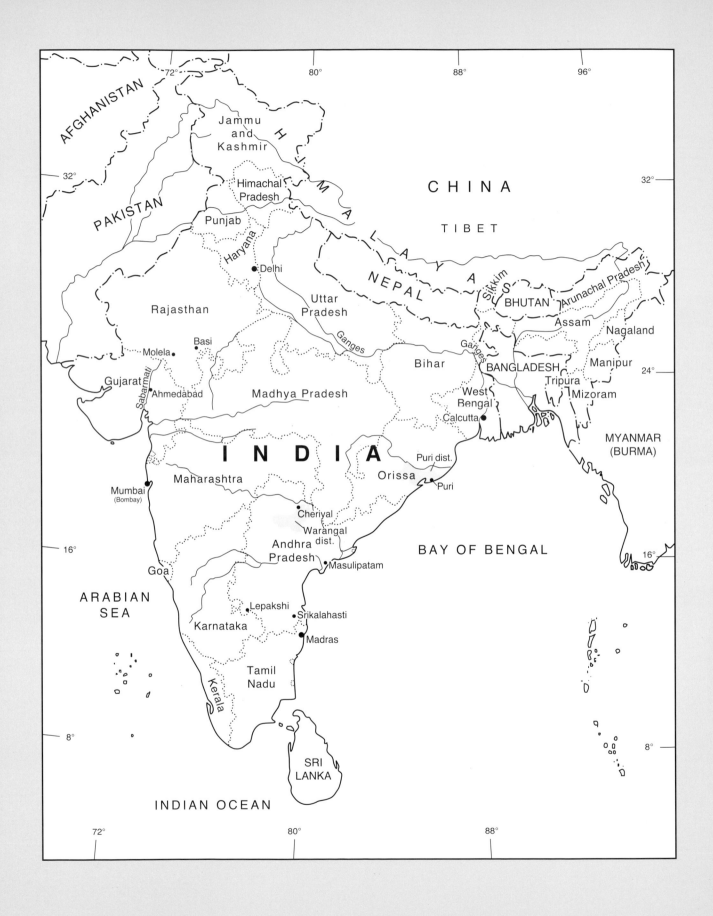

7

*Painting Employed with Other Media in
Popular Traditional Artifacts*

Painted and Printed Temple Cloths of the Mother Goddess

Introduction

In many regions of India, various types of imaged temple cloths, executed with different materials and techniques, have originated to serve narrative, iconic, or ritual ends for diverse groups of believers. One such tradition is found in Gujarat, where temple cloths painted and printed with mordants that combine with dyes to fix their colors are a component in goddess worship by the so-called lower castes.[1] The cloths, which were formerly made in villages in the areas surrounding Ahmedabad but now probably are produced only in the city proper,[2] honor the Great Goddess under the aspect of Mother Goddess (Mata) in one or more of several manifestations peculiar to Gujarat, such as Ambika on a tiger, Bahuchara on a cock, Meladi on a billy goat, Khodiar on a crocodile, and Vihat on a water buffalo.[3]

The temple cloths are square or rectangular, the latter called *matano chandarvo* (canopy of the goddess) or *matani dhoti* (garment of the goddess).[4] The rectangular cloths are used to form the walls and the square cloths to form the ceilings of tentlike temple structures that are erected to enclose the small outdoor shrines of Mata when a ritual sacrifice is to be offered. In the course of this ritual, the cloths are also placed on the floor, together with offerings before the shrine of Mata; in addition, they are worn as ceremonial garments by the priest, who goes into a trance with the help of wine as part of the ritual and, speaking as the goddess, answers devotees' questions. The playing of musical instruments and singing are part of the ritual activities. At the climax of the ritual, an animal is sacrificed and its warm blood drunk. The sacrificed animal is then

cooked and eaten by participants in the ceremony. This ritual honoring Mata attracts the so-called lower castes of Hindu society, including street cleaners, leather workers, agricultural workers, and the Vaghris, members of the artisan caste who create the temple cloths.[5]

Rectangular cloths generally feature a prominent, centrally placed iconic image of one of the several manifestations of Mata in Gujarat. Alternately, more than one manifestation may be employed, although the tradition's emphasis on centrality and symmetry is carefully maintained. The central figures, enshrined in a pavilion or a bower, are usually large and are again being drawn by hand, after a period when the contours of all the figures on the temple cloths had only been printed. Around the central form(s), on either side, are horizontal registers, sometimes demarcated with lines. These registers are filled with rows of small hand-printed figures; some, portraying devotees, are repeated throughout the registers, while others are singular images representing mythological characters or deities. On the left side of most temple cloths in the middle registers, a priest leading a buffalo to sacrifice is depicted close to the central image of the manifestation of Mata. The image represents the actual sacrifice propitiating Mata (in which the cloth is used in various ways), while the overall composition with its rows of devotees suggests a grand religious procession to that ritual event. The pictorial area of the composition is typically framed by geometric and floral bands. Rectangular cloths are large; the smallest size is about four feet by six feet.[6] Square cloths feature a central medallion enclosing a manifestation of the Mother Goddess, ringed by rows of small printed figures, some repeated and some appearing only once.

Creating the cloths is a complicated process involving many steps, materials, techniques, and groups of artisans. The cloth is prepared by washing and repeated soakings in several different solutions; each soaking is followed by either boiling or rinsing the cloth and then drying it. The cloth is painted and printed with mordants to fix the colors of dyes by combining with them. Different mordants are used to achieve black and a deep red, the principal colors employed in this tradition. The contour lines of larger figures are painted with a twig charged with a mordant that will make black. Small repeat figures are printed with carved wooden blocks charged with a mordant that will also make black. Flat areas inside and outside the contours are selectively painted with a mordant that will make red. After mordants are applied, the cloth is dyed and again washed to rid it of excess dyes, and then it is dried and bleached in the sun.

Many of the steps in this process take place on the banks of the Sabarmati River in Ahmedabad, close to the street where the professional artisans of this tradition, the Vaghris (also transliterated Vagharis), now live. So-called low-caste Hindus, the Vaghris are reported to formerly have been nomadic or to have lived in villages near the city.[7] While Vaghris paint and block-print the figures on the temple cloths, other social groups are also traditionally involved in their creation: Muslims do the dyeing, and another group of artisans carves the wooden blocks used by the Vaghris in printing.

As in many traditions that serve religious ends, the cloths used in goddess worship are considered sacred and are discarded when they become worn. Consequently, few examples survive from the nineteenth century. While temple

cloths honoring Mata are now being sold as commercial items for decoration of businesses and upper- and middle-class homes, the cloths continue to be used in devotional ceremonies by the original communities for which they were created.

Other traditions of mordant-painted textiles, sometimes also mordant-printed, developed in South India, where they are known as *kalamkari* (after *kalam*, a special pen used to apply the mordants, and *kari*, work).[8] In the past, *kalamkari* centers such as those in Srikalahasti and Masulipatam sprang up around great temples; there artisans produced narrative and iconic religious cloths, stylistically related to temple murals of the region, to be used as canopies and hangings on temple walls and carts during festivals. Because the patrons of these painted and printed temple cloths were mostly powerful temple officials and rulers gifting temples, they are not considered here. Also excluded from discussion here are fabrics for clothing and domestic articles, which were produced at *kalamkari* centers for Indian markets and for export to Europe and other parts of Asia;[9] after a period of decline, such items are again being produced with government support.

Representative Work: A Painted and Printed Temple Cloth of the Mother Goddess, no. 97

97. Temple cloth of Mata (the Mother Goddess) as Vihat (the twenty-armed), for use in goddess worship
 Gujarat, Ahmedabad
 CA. 1989, by Dilip Vaghi Chitara
 Mordants, painted and printed, and dyes on cotton cloth
 69¼" x 138½" (175.9 cm x 351.8 cm)
 Private collection

The central image on this temple cloth is the twenty-armed goddess Vihat or Visota or Vishat slaying the buffalo demon.[10] The theme and iconography are related to the Indian myth of the Great Goddess Durga slaying the buffalo demon. The goddess Vihat is one of the several manifestations of the Mother Goddess (Mata) worshiped by the so-called lower castes in Gujarat. Vihat typically sits on a water buffalo and is usually portrayed with many arms; her depiction with twenty arms, as seen here, is actually rare. Vihat figures in the creation myth of the Vaghris, the caste that creates temple cloths for goddess worship.[11]

The demon, traditionally represented as a male warrior emerging from a buffalo body, is seen twice here, charging both to the left and to the right. The goddess is portrayed straddling the backs of both figures of the buffalo demon; her face in profile is depicted on both the left and the right sides of her head.[12] The doubling of the buffalo demon and the doubling of the goddess's face in profile function pictorially to manifest their extraordinary powers.[13] Two severed heads of the slain buffalo demon lie below its two festooned bodies. Displaying armbands, bracelets, and necklaces, two moustached warriors whose torsos are emerging from the buffalo demon's two bodies are depicted turning around to face Vihat and brandish swords. The goddess is crowned and tat-

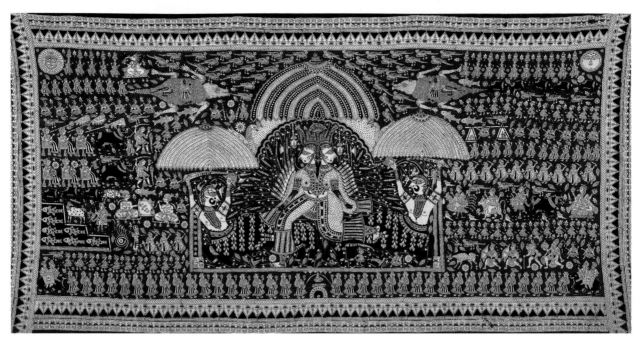

97

tooed; she wears elaborate necklaces, bracelets, and earrings. Her clothing is patterned with stripes and also dots, perhaps relating to the dots that are put on her shrine, which is regarded as her body, at the time of a ritual sacrifice.[14] In her ancillary arms, she holds a veritable arsenal of weapons, mostly small axes and swords, which, together with other weapons, project all around her like a fountain, and whose capacity to fatally injure is especially intended for the buffalo demon. Vihat and the demon are enclosed in a pavilion crowned by a triple dome. Many birds fill the space around the dome above the goddess. Two large crocodiles in mirror symmetry, accompanied by some fish, navigate the space over the umbrella-like domes above the heads of the demon. As the crocodile is associated with another manifestation of the Mother Goddess known as Khodiar, the artist's employment of the image suggests the additional strengths of an infinitely powerful divine being.

In the upper corners of the temple cloth are the traditional images of sun and moon; in the lower corners the artist has placed an elephant with a ruler and a driver in a howdah. On both the left and the right of Vihat and the two figures of the buffalo demon are ten horizontal rows of small figures, some filled with repeated images of village women carrying milk pots on their heads, churning butter, or bearing flowers or swords, some with repeated images of male warriors and wild boars. Interspersed on the left are singular images related to the actual ritual sacrifice in which this cloth is employed and which it also depicts. There are, for example, in the fourth and fifth rows several musicians playing horns, cymbals, and a drum; adjacent are two representations of the water buffalo to be sacrificed and the officiating priest wielding a sword and holding up a blood bowl. The left side also contains images of gods such as Krishna, playing his flute, and the elephant-headed Ganesha, as well as imagery

218

associated with local myths, such as a pond with seven fishes. On the right in the seventh row are additional manifestations of the Mother Goddess, that is, Bahuchara on a cock (also portrayed in the Garoda scroll painting tradition, as described in no. 43), Ambika on her tiger, Meladi on a billy goat, and another scene of a sacrificial animal being presented to the Goddess, four-armed and seated. Also on the right are images of the mythic heroes Rama and Lakshmana pursuing the golden deer, followed by Sita and Hanuman, and Shravana, a minor mythic character, carrying his blind parents suspended in triangular enclosures from a yoke across his shoulders.[15] The composition is framed by a broad double band with geometric and floral motifs and colored in a rich earth red, black, and white.

The contours of the large figures of the goddess Vihat and the buffalo demon and their enclosing structure are mordant-painted by hand; the contours of the rest of the images are mordant-printed with designs carved on wooden blocks. The cloth was hand-painted and block-printed by Dilip Vaghi Chitara, a member of an artisan family engaged for many generations in the making of temple cloths; he was at the time only seventeen years old.

Painted Leather Shadow Puppets of Andhra Pradesh

Introduction

Closely related in function to popular narrative painting traditions, India's puppet play traditions provide entertainment and religious and moral instruction to village peoples in performances involving storytelling, singing, and sometimes instrumental music and dance. Puppetry, at least in South India, also fulfills certain ritual functions. The performance of certain plays may be specially commissioned by temple officials or by families for their auspiciousness, that is, to honor or assuage deities at the time of their festivals, to cure disease, to disperse drought, or to ensure a good harvest.[16] As diverse as forms of popular narrative painting, India's wealth of puppet types, which includes string, rod, hand, and shadow figures, has similarly evolved over centuries in various places and circumstances.

Perhaps the most ancient of these forms, shadow puppets are favored in this presentation because their two-dimensionality brings them closer to painting in their actual construction than string, glove, rod, and other types of puppets. Of the four or five shadow traditions that spread over southern India, only two—those of Karnataka and Andhra Pradesh—typically employ color on their figures that is visible in performance; the two traditions are, moreover, stylistically related and are known for the scale of their figures, which exceeds that of other traditions. The puppets of Andhra Pradesh are distinguished from those of Karnataka by their more complex color, larger size, and greater number of articulated joints.

The puppeteers of the Andhra tradition, which is regionally called *tolu bommalata* (dance of leather puppets),[17] typically travel on foot from village to village with their puppets, seeking the sponsorship of community leaders and the

*Painting
Employed with
Other Media in
Popular
Traditional
Artifacts*

wealthy for performances, which occur at night. The puppeteers erect an outdoor stage and bamboo poles on which they hang a wide rectangular screen of semi-transparent cloth, usually employing white saris. They project a light onto the screen from behind and hold and manipulate their puppets behind the screen in front of this light source, causing colored shadows to be cast on the reverse of the cloth—the audience on the other side of the screen never sees the puppets themselves. It is traditional for the puppeteers to invoke Ganesha, the god of beginnings, and Sarasvati, the goddess of culture and speech, with a projection of their images and to make them dance before moving them away from the screen. Likewise, according to custom, they lavishly praise their audience and the donors of the performance and vulgarly chastise those who have not contributed. Only then does the drama commence and, with comical sequences interpolated, continue through the night. A night's performance may consist of a full story, a part of a story, or excerpts from different stories; on the following nights, performance of the same story may resume, or other stories may be introduced.

The stories are favorite episodes in local versions of the *Ramayana* and the *Mahabharata*. There are no written texts as such for the plays performed as shadow puppet theater. Rather, the texts are orally transmitted in puppeteer families from one generation to another and continue to evolve since some improvisation is a feature of every performance. The texts are complex, comprising dialogue, poetry, prose, and song lyrics gathered from a host of oral, literary, and musical traditions that embrace a wide range of courtly and popular styles including, for example, classical ragas (ancient traditional Indian melodic patterns) and songs from current Indian films. The plays' textual components are delivered in Telegu, the language of the audience; the puppeteers, whose native tongue is Marathi, must learn the Telegu texts by heart or create them on the spot.[18]

In Andhra Pradesh a performing troupe usually consists of eight people: two men and two women who sing and manipulate the puppets, two to three instrumentalists, and one to two others who hand the puppets to the performers and participate in the choric repetition of lyrics in a higher pitch. Members of a troupe are usually a family: a husband, his wife or wives, children, and other relatives.

Each troupe makes its own puppets and keeps them in repair. Creating a new puppet requires skills different from those of performance and involves several steps, the first being preparation of the parchment. In the past the puppeteers used the skins of different animals for different kinds of characters, but today they employ only goatskin. For a large shadow puppet, three skins are required, which the puppeteers must render uniformly thin and translucent by a laborious process of cleaning, soaking, scraping, and stretching. The outlines of the parts of an old puppet (or puppet model) are traced onto the parchment, or, alternately, the contours of a new design may be freely drawn with pencil or charcoal and then scratched onto the parchment. The parts are cut out with a scissors. The parchment is perforated in certain areas to represent jewelry and the patterning and banding of fine garments. In the past, Andhra puppeteers used dyes made from natural materials to color their puppets, but today they are more likely to employ synthetic ones. Special colors are associated with certain characters; for example, the hero-gods Rama and Krishna, avatars of Vishnu, are always colored

blue, while the ten-headed demon Ravana is typically painted red (no. 99). The many joints that characterize most Andhra puppets are created by punching holes at appropriate points along the edges of adjacent puppet parts and passing string through the holes and tying it. Bamboo rods are then attached to these moveable parts of the puppets so that the puppeteers can easily and less visibly manipulate them in performances (see no. 99).

In Andhra Pradesh, it is customary for each troupe to have about one hundred figures. Some of the characters, like Hanuman, who can magically enlarge or shrink his body, may require several puppets in several different sizes in accordance with the demands of different stories. The sizes of puppets vary from district to district and correspond to the nature of the characters being represented, some of whom, like the ten-headed demon Ravana and Bhima (also transliterated Bheema), the mammoth Pandava prince, are traditionally given extra-large scale (see nos. 98–99); standard heights for puppets from various Andhra districts or locales range from forty-six to seventy-eight inches.[19] The heads, hands, and feet of most figures are presented in profile, while torsos are shown frontally. The outer shapes of the puppets emphatically define the varying natures of the characters they represent. There is an overall muscularity to these shapes and a decided thickness of physique. Garments, jewelry, and hair are typically embellished with rich and intricate patterns. On the basis of common details of costume in South Indian paintings of the Vijayanagara period (fourteenth through sixteenth centuries) and also on other evidence, scholars deduce that prototypes of present-day South Indian shadow figures probably originated about five hundred years ago. The style of Andhra shadow figures, except for their strong colors, has been related to sixteenth-century South Indian mural painting, exemplified in the Virabhadra temple at Lepakshi in Andhra Pradesh. A strong stylistic similarity to the narrative folk tradition of "Paithan" or Chitrakathi painting of nearby Maharashtra (see nos. 53–57) is also evident in Andhra puppets and perhaps even more so in those of Karnataka, which frequently feature several figures in a scene with landscape elements paralleling "Paithan" forms. The case for the influence of "Paithan" painting on Andhra's puppet tradition is undoubtedly strengthened by the fact that Andhra shadow players are Marathi-speaking and are reputed to have come from the same area of present-day Maharashtra as the Marathi-speaking creators of "Paithan" paintings.[20]

The Marathi-speaking puppeteers apparently migrated from Maharashtra to Andhra Pradesh in the late eighteenth century; they probably represent a second wave of puppet theater in Andhra, since literary texts point to an earlier shadow tradition. Formerly without a fixed residence, most but not all of the puppeteers have settled today, and many have taken up other occupations in addition to performing. Some puppeteers now exchange plastic and stainless steel utensils for clothes, which they mend and sell to the poor. Others have become involved in agriculture and the breeding of cattle and goats.[21]

Competition with modern forms of entertainment has reduced the demand for puppet performances. In the recent past, there have been scholarly efforts to document—and governmental efforts to preserve and renew—the pictorial, theatrical, and musical arts and skills employed in the shadow traditions of Andhra Pradesh and other South Indian regions.

*Painting
Employed with
Other Media in
Popular
Traditional
Artifacts*

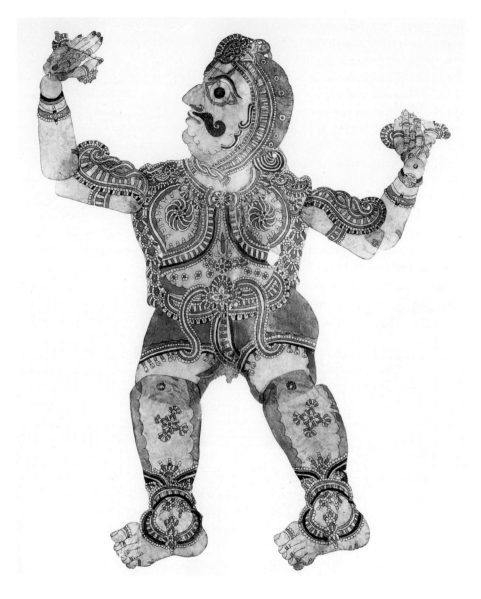

98

*Representative Works: Painted Leather Shadow Puppets of
Andhra Pradesh, nos. 98–99*

98. Shadow puppet representing Bhima, for use in performances of puppet plays
 narrating stories from the *Mahabharata*
 Andhra Pradesh
 Early 20th century
 Water-based pigments on leather
 56" x 22" (142.2 cm x 55.9 cm)
 The Denver Art Museum, Anonymous gift, 1985.661

Bhima (also transliterated Bheema), a character in the epic *Mahabharata*, the
second of the five Pandava princes and their main military leader, is renowned

for his great appetite, size, and strength: accordingly, his puppet image is traditionally given extra-large scale,[22] and he is typically portrayed, as seen here, as a powerful wrestler in wrestler's shorts. Barefooted, he displays many toe rings as well as finger rings and bracelets; he wears leg and upper arm protectors and ankle supporters and a perforated vest. A scarf covers his ears and is tied under his chin. While his moustache terminates in a meticulously groomed curlicue, the underside of his jaw is stubbled. His large, staring black pupil in a circular eye is a typical feature in both Andhra puppets and "Paithan" or Chitrakathi paintings.

Bhima plays a prominent role in *Mahabharata* stories favored by the puppeteers, one of which is the slaying of Kichaka (also transliterated Keechaka), a minister of Virata, the king with whom the Pandavas under disguised identities sought refuge and work during their time of exile. Bhima, hired as the king's cook, slays Kichaka, reducing him to a ball of tissue, because the minister has unwittingly desired Draupadi, the joint wife of the five Pandavas. *Mahabharata* stories with Bhima are also popular with storytellers associated with certain narrative painting traditions (for examples, see Andhra paintings nos. 36–37, in which Bhima or a Bhima-like character is featured).

99. Shadow puppet representing the ten-headed demon Ravana, for use in performances of puppet plays narrating stories from the *Ramayana*
Andhra Pradesh
Late 19th to early 20th century: head, torso, and extremities of varying ages
Water-based pigments on leather
68" x 36", width of arms fully extended: 70" (172.7 cm x 91.4 cm, 177.8 cm)
Joyce and Kenneth Robbins

Ravana, the ten-headed demon king of Lanka who abducts the wife of the hero Rama and is his principal opponent in the epic *Ramayana*, is another character who, like Bhima in the preceding entry, is traditionally represented in extra-large scale in his puppet image.[23] Ravana's primary head is presented frontally, a mode reserved for only a few puppet characters, mostly demons. Ravana has large, staring eyes, curling fangs, and a grimacing mouth framed by an elegantly trimmed beard and moustache; his smaller additional heads, which manifest his demonic power radiating in all directions, are arrayed in profile on either side of his primary head. Lavish jeweled pendants cover not only his bare chest but the entire length of his thick torso. He wears a red lower garment. Floral and geometric patterns embellish his boots. Ravana's body is customarily painted red but here is only partially so, indicating that this puppet image has been mended with parts from other puppets, as is customary in the puppeteers' maintenance of their collections. This puppet appears to be missing two auxiliary heads, a sign of the hard use that popular forms like puppets endure. The puppet has been conserved with the bamboo sticks that are employed to manipulate it in performance still attached.

Reproduced: Kenneth S. Robbins, "Indo-Asian Shadow Figures," *Arts of Asia* (Hong Kong), September-October, 1983, pp. 65, 75; Milo C. Beach, *The Art of India and Pakistan,* exh. cat. (Durham, N.C.: Duke University Museum of Art, 1985), p. 18.

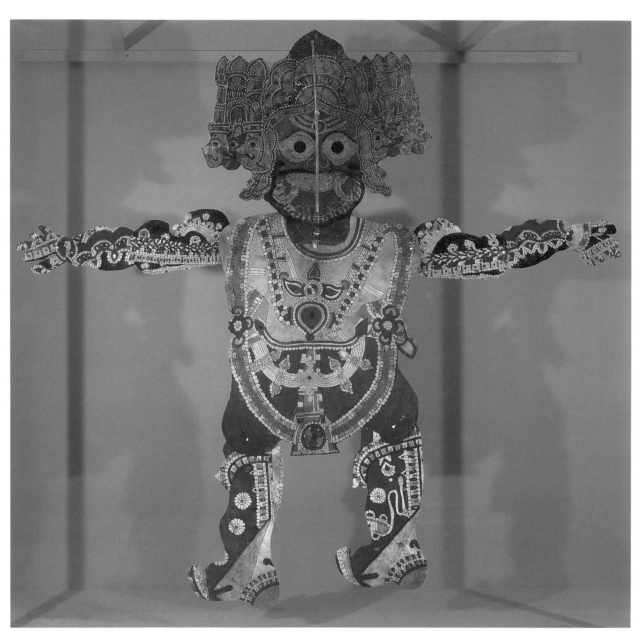

99

Introduction

In India, painting has traditionally been employed in the creation of numerous three-dimensional forms. The staggering variety of types that may be polychromed includes figures of deities that are worshiped, votive figures—both animal and human—that are used as ritual offerings to the gods, portable shrines or shrines that are permanently installed inside the home or in an outdoor site, portable shrines with folding panels that are used as visual props in the narration of stories, dolls and toys that are ritually displayed or used in children's play, masks that are used in story performances, manuscript covers and boxes that are used for storing manuscripts or playing cards. Also painted are dowry boxes, wedding and memorial pillars, ritual artifacts, utensils, and furniture. In addition, architectural elements, such as doors, shutters, window frames, posts, pillars, and buttresses, are frequently ornamented with color and sometimes with patterns and pictorial imagery.

Traditional materials for the construction of these painted three-dimensional forms include local varieties of wood and clay (the latter sometimes mixed with dung and other components), papier-mâché, *sholapith* or pith (a reed that is cut easily into planes and glued), ivory, bone, and stone. Traditional polychroming media include water-based pigments, used on wood, papier-mâché, pith, ivory, bone, and stone and sometimes varnished or lacquered; slips (mixtures of colored clay, water, and other materials) or water-based or resin-based pigments, which are applied to dried or fired clay; and resin-based pigments, which are applied to wood. The numerous techniques employed in using these support materials and media, as well as the various painting styles, which evince a broad range of characteristics from sophisticated to folkish and primitive, are often unique to particular social groups in different regions or villages or sections of towns and cities in India.[24]

While in some instances the role of painting is undoubtedly to adorn or decorate utilitarian objects, in other instances painting a three-dimensional form is far more significant and may even be raised to the level of ritual. For example, the practice of painting in the eyes of a sculptural form of a deity endows it with "life" in a way similar to practices in two-dimensional painting traditions.[25] The painting of certain three-dimensional forms contributes, furthermore, to the fulfillment of their distinctive cultural functions, which can parallel the ritual, iconic, narrative, and other purposes of popular two-dimensional painting traditions. Accordingly, rich and intense color, carefully applied to a sculpted deity to represent lavish garments and jewelry, raises the "status" of the deity in the eyes of the devotee and makes the icon all the more attractive to the devotee.

Some polychromed three-dimensional forms are, in fact, associated with certain popular iconic and narrative painting traditions and may constitute a major or auxiliary part of their producers' caste work. Puri artists, for example, who traditionally create images of the Jagannatha trinity used in temple rituals as well as souvenir paintings for pilgrims to Puri, are also charged with the

*Painting
Employed with
Other Media in
Popular
Traditional
Artifacts*

yearly repainting of the great temple carts employed in their cult's annual car festival (see discussion of Puri paintings in Chapter 2); these artists also create and paint many kinds of subsidiary three-dimensional artifacts, such as toys, masks, boxes for playing cards, replicas of the sculptural images of the deities installed in the temples of their sect, and miniature and domestic shrines (see no. 100), for sale during fairs and festivals. The painters of Cheriyal, Warangal district, Andhra Pradesh, who are commissioned by storytellers of many castes to produce scrolls illustrating various legends (see discussion of Andhra or Telangana scroll paintings in Chapter 3), prepare and paint special three-dimensional figures representing deities, human characters, and animals for use in storytelling performances (see no. 101).

On the other hand, some traditions of polychroming three-dimensional forms apparently exist without relation to forms of two-dimensional painting and are followed by woodworkers, potters, or other artisan castes. For example, the woodworkers of Basi, Rajasthan, create portable shrines, called *kavads*, with folding panels that illustrate episodes in the legend of the enshrined deity,[26] while the potters of Molela, Rajasthan, create shrinelike painted ceramic relief plaques with images of various gods, local hero-gods, and ancestor figures—both artisan communities working independently of a two-dimensional painting tradition.[27] Similarly, the potters of West Bengal create earthen covers (*saras*) painted with images of the goddess Lakshmi or other deities for special ritual use by Hindu women during the annual autumn harvest festival.[28] Yet another artisan caste in West Bengal constructs large ephemeral sculptural images of the Great Goddess Durga with clay, dung, and straw—which they also paint and lavishly clothe—for worship by urban and village communities during the annual Durga festival.

Selected for presentation here are two painted three-dimensional artifacts that have been produced within two-dimensional painting traditions; while these artifacts are usually regarded as secondary works, their purposes are in fact closely related to the iconic or narrative purposes of their traditions' principal forms. The extent of scholarly attention paid to India's abundant supply of such artifacts varies according to artifact. Some practices of painting three-dimensional forms, such as those connected with terra-cotta production of *saras* and dolls and toys in Bengal, are relatively well documented, while other practices are barely known.

Representative Works: Painted Three-Dimensional Artifacts from Selected Traditions, nos. 100–101

100. A devotee's portable folding shrine, for use in a domestic setting
Orissa, Puri district(?)
Early 20th century
Opaque water-based pigments on carved wood
15¾" x 8¼" x 13⅜" (40.0 cm x 21.0 cm x 34.0 cm)
The Ravicz Collection

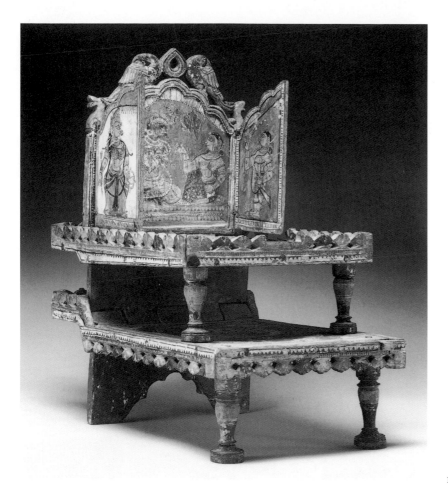

100

This beautiful ritual artifact from Orissa is a portable folding shrine for use in a domestic setting. A devotee would typically invoke the deity to descend into the carved and painted wooden form, make his or her offerings, and then dismiss the divine presence. Composed of two parallel horizontal planes with turned legs at the front and a vertical back plane that extends to the floor and has folding wings, the shrine can be collapsed so that it occupies less space, facilitating its transport or storage when not in use. The shrine features both an anthropomorphic image of divinity in Krishna, an avatar of Vishnu, as well as a more subtle representation of divine power in a lotus design that appears three times on the shrine and typically symbolizes the visible world emanating from its divine center and Supreme Pervader, that is, Vishnu.

Krishna is portrayed in the upper section of the vertical plane, to which folding pictorial wings are attached. Customarily represented as dark-skinned, garlanded, and playing his flute, Krishna sits with a consort, probably Radha, on a lotus seat in a deep red pavilion-like interior; a green parrot, the mount

*Painting
Employed with
Other Media in
Popular
Traditional
Artifacts*

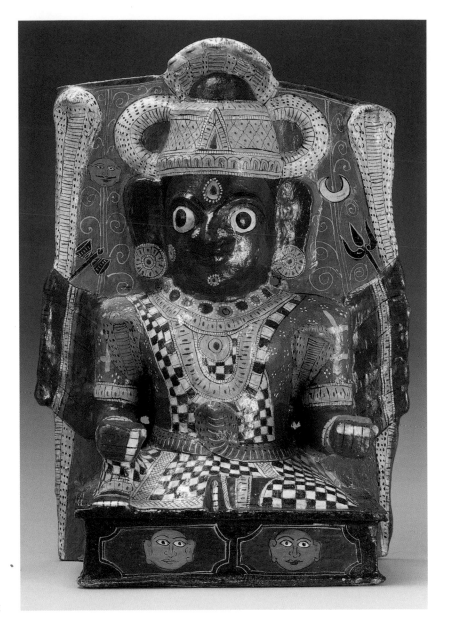

101

of Kama (the god of love), observes the couple from an architectural niche. Above this pictorial presentation along its scalloped and arched top edge are two large carved green parrots flanking a carved *yoni* (a stylized image of female genitals). Depicted on the inside of the folding wings are a female devotee holding a lotus and a shell, attributes associated with Vishnu or Kama, on the left and a female attendant holding a fly whisk on the right. The outer sides of these wings, which can be closed to conceal the image of Krishna, portray two buxom crowned females—light- and ruddy-skinned—holding bows and arrows, attributes associated with Kama.

Displaying three concentric rings of petals (the inner and middle with

228

eight petals and the outer with sixteen), stylized lotuses are carved in shallow relief and painted in red, yellow, and green on both of the shrine's horizontal planes and also on the reverse side of its vertical plane. In the last instance, the lotus design is bordered with shells, appertaining to Vishnu and symbolically associated with the seaside pilgrimage center of Puri, where the cult of the Jagannatha trinity evolved from a synthesis of tribal and Hindu deities and its principal deity Jagannatha is regarded as an incarnation of Vishnu (see no. 26). The shell motif on this Orissan shrine may visually reinforce the popular identification of Puri's deity Jagannatha with Krishna, the embodiment of divine attractiveness.

Reproduced: Mingei International Museum of World Folk Art, *India: Village, Tribal, Ritual Arts* (La Jolla, California: Mingei International Museum of World Folk Art, 1981), pp. 36–37.

101. Doll representing the folk goddess Ganga Bhavani, for ritual display and worship in storytelling performances
Andhra Pradesh, Warangal district, village Cheriyal
CA. 1989, by D[analakota] Chandraiah
Opaque water-based pigments, tempera, and lacquer on wood, sawdust, and other materials
19" x 14" x 6½" (48.3 cm x 35.6 cm x 16.5 cm)
Private collection

This painted three-dimensional representation of the folk goddess Ganga Bhavani is one of a set of approximately fifty dolls used in ritual display and storytelling in rural areas of Andhra Pradesh. The goddess is not a character in the story but is ritually installed to preside over the narration of the local legend of Karihavala Raju, the king of Warangal Fort; she is also worshiped with a goat sacrifice after the story is concluded. The audience for this presentation is a caste of goatherds known as Dhangars (or Yadavs); the narrators—from another caste—are known as Mandhahechis (or Mandhets); the artists who make the dolls at the request of the narrators are members of the Nakash community of scroll painters in Warangal district.[29]

The goddess, whose abundant powers are symbolized by her twelve arms, is seated on a low chair, throne, or platform, the lower half of her body dissolving into the seat plane, while her back is attached to the structure's rear vertical plane. Her three-dimensional arms reach forward, one with a shallow indentation for holding a small lamp, the other ready to receive offerings from the audience. The goddess's ten additional arms, which are in slight relief, fan out and collectively clutch, as scepters of authority, rearing white serpents with expanded hoods, together with a small hourglass drum on the left and a small trident on the right. Other snakes found on her person protect her—or may signal her comprehension of their energies: the expanded hood of a five-headed white snake hovers, in strong relief, over the goddess's crowned head, while a blue snake coils around her waist and the heads of ochre snakes emerge from her armpits. Clothed in a blue bodice and a black-and-white checkered sari, the goddess is adorned with large earrings, necklaces, nose jewels, a nose ring, wrist and ankle bracelets, and a religious marking on her forehead. The goddess's skin

*Painting
Employed with
Other Media in
Popular
Traditional
Artifacts*

color is ruddy, and she has mammoth protruding eyes, similar to the enlarged orbs characteristic of "Paithan" or Chitrakathi paintings of nearby Maharashtra (see nos. 53–57) and of the shadow puppets of Andhra Pradesh (see nos. 98–99). Personifications of the sun and moon gods, here placed against single stalks of vegetation, appear on either side of the goddess's head; in the horizontal panel at her feet are the heads of two males.

The reverse side of the vertical panel to which the goddess's back is attached is painted, but without relief. The configuration of painted images suggests the goat sacrifice concluding the folk ritual; from top to bottom, the following images appear: the head of a male with wide-open eyes, winglike ears, fangs, and an extended tongue, flanked by two green parrots; a four-armed female figure holding a knife, trident, and drum, attended by a crowned, winged male figure on the left and a monkey (perhaps Hanuman) on the right; and a man carrying a goat, flanked by two female figures.

Notes

Scholarly Interest in India's Popular Painting: A Short Overview

1. George C. M. Birdwood, *The Industrial Arts of India*, South Kensington Museum Art Handbooks, vol. 2 (London: R. Clay, Sons, and Taylor, 1880), p. 62. See Bibliography for additional references mentioned in this overview.

2. T. N. Mukharji, *Art-Manufactures of India {Specially Compiled for the Glasgow International Exhibition}* (Calcutta: Superintendent of Government Printing, 1888), pp. 14–15, 20, 22, 25, 31.

3. Ananda K. Coomaraswamy, *A History of Indian and Indonesian Art* (London: E. Goldston, 1927), p. 42.

4. Mildred Archer and W. G. Archer, "Santhal Painting," *Axis* (London), no. 7 (August 1936): 27–28.

5. Barbara Rossi, letter to author, 1993.

An Introduction to India's Popular Paintings

1. Mildred Archer, *Indian Popular Painting in the India Office Library* (London: Her Majesty's Stationery Office, 1977), p. 1.

2. See Ludo Rocher, "The Artist in Sanskrit Literature," in *Making Things in South Asia: The Role of the Artist and Craftsman*, ed. Michael W. Meister, Proceedings of the South Asia Seminar 4, 1985–86 (Philadelphia: Department of South Asia Regional Studies, 1988), pp. 19–20. Succession by adoption is another mode of transmission of a traditional art. Stella Kramrisch, "Traditions of the Indian Craftsman," in *Traditional India: Structure and Change*, ed. Milton Singer (Austin: University of Texas Press, 1959), p. 19.

3. For this fact and additional information on literary evidence of the antiquity of certain popular painting traditions, see Ananda K. Coomaraswamy, "Picture Showmen," *Indian Historical Quarterly* (Calcutta) 5 (1929): 182–87. Also see Jyotindra Jain, "The Painted Scrolls of the Garoda Picture-Showmen of Gujarat," *Quarterly Journal* (National Centre for Performing Arts, Bombay) 9, no. 3 (September 1980): 3–4.

4. Stuart Cary Welch, conversation with author, Cambridge, Massachusetts, 1992.

5. It is beyond the scope of this introduction to determine whether paintings produced for audiences other than those they originally served remain true examples of their respective traditions; items produced for trade are not always but sometimes subject to commercialization—and commercialization inevitably alters the content and form of work, subtly or blatantly. Commer-

cialized or altered products are sometimes disparagingly called "tourist art." On the other hand, new avenues created by the Indian government for the presentation of the work of folk and tribal artists in India have stimulated development of new expressions that may actually constitute entirely new art forms. See Jyotindra Jain, "Ganga Devi: Tradition and Expression in Madhubani painting," *Third Text* (London), no. 6 (spring 1989): 43–50, for a discussion of an artist who made significant innovations in the subject matter and form of her government-revived village painting tradition by introducing autobiographical material into her work. It may also be noted that India has a long history of producing at least textiles for foreign markets in addition to production for its own markets; see Mattiebelle Gittinger, *Master Dyers to the World: Technique and Trade in Early Indian Dyed Cotton Textiles* (Washington, D.C.: Textile Museum, 1982) for the example of one such textile tradition.

6. See Philip S. Rawson's remarks on the role of ornamentation in Indian culture, in *Indian Painting* (New York: Universe Books, [1961]), p. 12; a brief quotation of Rawson's remarks by the scholar Jaya Appasamy is cited in my discussion of Tanjore and Mysore paintings, Chapter 2, note 45.

7. To this general rule, there appear to be at least some exceptions. For example, the popular mural painting tradition that thrived mostly in the nineteenth century in the Sikar, Jhunjhunu, and Churu districts of Rajasthan is primarily decorative in function. In this area, known as Shekhavati after the patriarch of one of its ruling families, permanent murals on both exterior and interior walls of the mansions, temples, and memorial structures of a merchant community mix religious images with those of history and everyday life. The Shekhavati murals appear to have been painted to make known the taste and social position of their wealthy but nonroyal patrons. (I am indebted to Deokinnandan Sharma and Bhavanishankar Sharma for introducing me to this mural tradition and for showing me examples in several towns in the Sikar district in 1986.) There are also some merchant towns in Gujarat, such as Vaso, where houses are decoratively painted with permanent murals. (I am indebted to Shridhar Andhare for introducing me to the mural tradition in 1989.) There are also some tribal traditions of wall painting that appear to be decorative in function; see, for example, Mildred Archer and W. G. Archer, "Santhal Painting," *Axis* (London), no. 7 (August 1936): 27–28. It may be further noted that works produced for consumers beyond the original audience may become decorative as artists respond to the new consumers' tastes and decline to invest the real but intangible quality of belief in the symbols of their traditions, that is, potent symbols can become merely design motifs. The same absence of conviction may equally mark the work of an artist within the tradition's accustomed sphere of activity, if his understanding or attention to his task, for whatever reasons, is deficient.

8. Gurusday Dutt noted, for example, that one of the many patterns of the lotus in Bengali domestic ritual painting is an exact replica of a lotus design discovered at Mohenjo-Daro, an archaeological site of the Indus culture, CA. 2300–1750, B.C. "Indus Civilization Forms and Motifs in Bengali Culture," *Modern Review* (Calcutta) 66, no. 5 (November 1939): 584. Also see Stella Kramrisch, "The Ritual Arts of India," in *Aditi, The Living Arts of India* (Washington, D.C.: Smithsonian Institution Press, 1985), p. 248, for comments on evidence of antiquity of abstract forms in ritual floor painting.

9. I am indebted to Bhavanishankar Sharma and Deokinandan Sharma for introducing me to Hindu traditions of ritual painting in several villages of Tonk and Sawai Madopur districts of Rajasthan in 1986.

10. For more information, see Verrier Elwin, "Saora Pictographs," *Mārg* (Bombay) 2, no. 3 [1948]: 35–44.

11. I am grateful to Gulam Mohammed Sheikh for introducing me to Pithora (also called Pithoro) painting and for arranging my viewing of completed paintings in villages of Jambughoda district, Gujarat, in 1986.

12. For a beautiful explanation of the role of the image in Indian religious life, see Diana L. Eck, *Darśan: Seeing the Divine Image in India*, 2nd rev. and enl. ed. (Chambersburg, Pennsylvania: Anima Books, 1985).

13. Literally, "Rama's Way"; an epic poem recounting the life story and adventures of the princely hero Rama, an incarnation of the Hindu god Vishnu. The story existed in oral tradition before being cast in a Sanskrit version by the legendary poet Valmiki sometime between 200 B.C.

and A.D. 200. Rural audiences continue to know the story in its many local versions through the exhibition of pictures in conjunction with narrative performance and through other folk rituals.

14. Literally, "great Bharata"; the story of the legendary battle between the Pandavas and the Kauravas, rival branches of the family of Bharata, for a kingdom. A much longer epic poem than the *Ramayana*, the *Mahabharata* is probably a collective work and more a compilation than straight narrative: interspersed throughout the episodes are peripheral stories, legends, fables, moral and theological dissertations, and the great philosophical discourse on the nature of duty, known as the *Bhagavadgita*, delivered by the god Krishna to the Pandava warrior Arjuna, who was reluctant to take up the fight. Like the *Ramayana*, the *Mahabharata* existed in oral tradition before being rendered in Sanskrit; it continues to be known in rural areas through many local versions.

15. See Stella Kramrisch, *Unknown India: Ritual Art in Tribe and Village* (Philadelphia: Philadephia Museum of Art, 1968), p. 70, for her comments on similarity of composition in scrolls and the sculptural friezes of the Bharat railing of the second century B.C. Also see Ajit Ghose, "Old Bengal Paintings," *Rupam* (Calcutta), nos. 27–28 (1926): 100, for a comment on the similarity between scrolls and mural paintings. The large-scale painted and printed temple cloths of South India appear to incorporate scroll registers in their numerous narrative panels on either side of centrally placed iconic figures. The scroll registers of popular narrative painting also are incorporated in some court traditions of miniature painting, such as Malwa.

16. Pertinent to this presentation but beyond its scope are a number of other visual forms related to traditions and types of popular painting. Certainly connected with India's popular iconic traditions by common function are the commercially printed images of the deities, most in a Western illusionistic style; available since the end of the nineteenth century, they are offered for sale today in every Indian bazaar, their popularity having eclipsed or threatening the use of hand-painted icons. Also of interest in a discussion of urban popular painting are contemporary shop-keepers' signs (a hybrid of Indian and Western modes of imaging), as well as the large-scale, photo-based, painted advertisements of film scenes and film stars used to attract the Indian public to movie theaters. Interesting manifestations of popular painting in three-dimensional media include the formerly prevalent practice of polychroming stone statuary and architecture, the continuing practice of painting all manner of terra-cotta forms, and new traditions of decoratively painting commercial vehicles like trucks and rickshaws. Finally in the area of body decoration, of both humans and animals, there are ritual traditions utilizing paint, henna, powders and pastes, and tattoos on the human body as well as various practices of painting domestic animals and cutting decorative patterns into their coats.

Chapter 1

1. Jogendra Saksena, *Mandana: A Folk Art of Rajasthan*, ed. Mrinal Kanti Pal (New Delhi: Crafts Museum, 1985), p. 1.

2. Sudhansu Kumar Ray, "Artisan Castes of West Bengal and Their Craft," in *The Tribes and Castes of West Bengal*, by A. Mitra, Census 1951, West Bengal Land and Land Revenue Department (Alipore, West Bengal: Superintendent, Government Printing, West Bengal Government Press, West Bengal, 1953), pp. 305–6; Sudhansu Kumar Ray, *The Ritual Art of the Bratas of Bengal* (Calcutta: Firma K. L. Mukhopadhyay, 1961), p. 42. For further comments on the latter derivation, see Upendra Thakur, *Madhubani Painting* (New Delhi: Abhinav Publications, [1981]), pp. 37–38.

3. Nathu Ram Upreti, *Folk Art of Kumaon*, ed. Ruth Reeves, Census of India 1961, vol. 1, Monograph Series, part 7-A (Monograph 5) (New Delhi: Office of the Registrar General, India, Ministry of Home Affairs, 1969), p. 5.

4. Ibid., p. 11. Other alternative supports for ritual painting in Kumaon include low wooden seats, the inside plane of a winnowing tray, the outer plane of the pot in which the seed of the sacred *tulsi* (basil) plant grows, and the stone floor around a mortar. Ibid., p. 5.

5. Mildred Archer, *Indian Popular Painting in the India Office Library* (London: Her Majesty's Stationery Office, 1977), pp. 87–88.

6. Identification of the iconography is based on Upreti, *Folk Art of Kumaon* (1969), pp. 5–9,

11, 15–17, and esp. pls. 22, 46. This painting (no. 1) had previously been identified as originating in Rajasthan: J. LeRoy Davidson, *Art of the Indian Subcontinent from Los Angeles Collections* (Los Angeles: University of California, 1968), p. 116, no. 194; Gerald James Larson, Pratapaditya Pal, Rebecca P. Gowen, *In Her Image: The Great Goddess in Indian Asia and the Madonna in Christian Culture* (Santa Barbara: UCSB Art Museum, University of California, Santa Barbara, 1980), p. 58, no. 23. For similar pictures, see Jyotindra Jain and Aarti Aggarwala, *National Handicrafts and Handlooms Museum* (Ahmedabad: Mapin Publishing, 1989), p. 116; Pupul Jayakar, *The Earthen Drum: An Introduction to the Ritual Arts of Rural India* (New Delhi: National Museum, [1981]), pp. 112–13, fig. 94; Home of Folk Art (Gurgaon), *A Catalogue of Indian Folk and Tribal Art in the Collection of Home of Folk Art, Museum of Folk, Tribal, and Neglected Art* (Gurgaon: Home of Folk Art, 1990), p. 20, acc. no. 364/89. Jayakar identifies the goddess as Gauri and the painting's place of origin as Madhubani (Bihar); Home of Folk Art (Gurgaon) identifies the goddess as Hoi and the painting's place of origin as Madhubani (Bihar).

7. Upreti, *Folk Art of Kumaon* (1969), p. 8, pl. 22.

8. Ibid., p. 16.

9. I am indebted to Michael Rabe for the transliteration and translation of the five inscriptions on this work, which are set forth in this paragraph. Michael Rabe, conversation with author, Chicago, 1995.

10. Ibid., p. 17.

11. See Jogendra Saksena, *Art of Rajasthan: Henna and Floor Decorations* (Delhi: Sundeep Prakashan, 1979), pp. 52, 111–13, 133, 155–56.

12. Patterns are distinguished by the number of dots used to make the grids; see Upreti, *Folk Art of Kumaon* (1969), p. 10, pls. 24–35; for application of wall patterns to borders of ritual figural paintings, see ibid., pls. 39–41. These geometric patterns are also related to dot-based ritual floor painting compositions that are especially prevalent during Diwali and are said to replicate cut stone screen (*jali*) designs employed in Indian architecture to allow light and air to penetrate thick wall planes; the linear grids of *jali* designs in both ritual painting and architectural practice are formed with points or dots called *tapakis*; in many instances, *jali* designs in ritual floor painting are very similar to the wall patterns of Kumaon; however, *jali* designs in floor painting are not filled in with color and so remain linear. For discussion of *jali* designs in the ritual painting of Rajasthan, especially employed for Diwali, with references to similar practices in Uttar Pradesh, see Saksena, *Art of Rajasthan, Henna and Floor Decorations*, pp. 8, 111, 142–45, 189, and also pls. 35, 52 (6-b), 69–71.

13. For information on dot-based grids in ritual floor painting called *jali* designs, see the second part of note 12; for animal designs created with dots (*tapakis*) from Uttar Pradesh, see Saksena, *Mandana: A Folk Art of Rajasthan*, p. 39, pl. 90.

14. Identification based on M. Archer, *Indian Popular Painting*, p. 174. Regarding the pencil inscription on the work, M. Archer notes that the design was collected by Horace Arthur Rose (1867–1933), a member of the Indian Civil Service, who worked in the Punjab region from 1888–1917. The design was used for illustration of an article on Punjab folklore by Rose. The lithograph for the plate was made by W. Griggs and Sons. Ibid. The goddesses may be standing on the backs of camels (not peacocks, as identified by M. Archer).

15. Ibid., p. 174. See note 14 for an explanation of the inscription on the work.

16. Ibid., p. 171.

17. Mithila includes the modern-day districts of Champaran, Muzaffarpur, Darbhanga, Madhubani, Vaishali, Samastipur, and Saharsa, as well as parts of adjacent districts. For information on the geography, history, and culture of Mithila, see Thakur, *Madhubani Painting*, pp. 11–24.

18. For discussion of the derivation of *aripana*, see ibid., pp. 37–38.

19. For more information on floor painting in Mithila, see ibid., pp. 33–50, pls. 1–9.

20. M. Archer, *Indian Popular Painting*, pp. 85–87, pls. 43–48.

21. For detailed information, see Thakur, *Madhubani Painting*, p. 61.

22. Ibid., pp. 59–61.

23. For discussion of materials, see M. Archer, *Indian Popular Painting*, p. 87; Thakur, *Madhubani Painting*, pp. 63–67.

24. M. Archer, *Indian Popular Painting*, pp. 87–88. See Thakur, *Madhubani Painting*, pp. 66–67, for educational use of these works on paper.

25. For particulars of this history, see M. Archer, *Indian Popular Painting*, pp. 89–91. Also see Mary C. Lanius, "Mithilā Painting," in *Making Things in South Asia: The Role of Artist and Craftsman,* ed. Michael W. Meister, Proceedings of the South Asia Seminar 4, 1985–86, (Philadelphia: University of Pennsylvania, Department of South Asia Regional Studies, 1988), pp. 135–37.

26. See, for example, the autobiographical painting titled *The Cycle of Life* by Ganga Devi in Jyotindra Jain and Arati Aggarwala, *National Handicrafts and Handlooms Museum*, pp. 114–15. For other examples of personal subject matter in the traditional idiom by the same artist, see Jyotindra Jain, "Ganga Devi: Tradition and Expression in Madhubani Painting," *Third Text* (London), no. 6 (spring 1989): 48–49.

27. M. Archer, *Indian Popular Painting*, p. 93.

28. Ibid., pp. 88–89.

29. For inscriptions, see ibid., p. 94.

30. Identification of figures is based on M. Archer, *Indian Popular Painting*, p. 94. The unidentified composite figures may perhaps be categorized as *kinnaras* (literally, what kind of man is this?), mythical semidivine beings whose varied forms include human heads and horse bodies and vice versa and human heads and bird bodies; I am indebted to Michael Rabe for this suggestion. Michael Rabe, conversation with author, Chicago, 1994.

31. Identification of figures follows M. Archer, *Indian Popular Painting*, pp. 85–86.

32. Thakur, *Madhubani Painting*, p. 60. For similar aide-mémoire, see Stella Kramrisch, *Unknown India: Ritual Art in Tribe and Village* (Philadelphia: Philadelphia Museum of Art, 1968), pl. 44 (detail), and M. Archer, *Indian Popular Painting*, pl. 35.

33. Thakur, *Madhubani Painting*, p. 40.

34. For this introduction to Warli painting in Thane district, Maharashtra, I relied on Yashodhara Dalmia, *The Painted World of the Warlis: Art and Ritual of the Warli Tribes of Maharashtra* [Loka Kala Series] (New Delhi: Lalit Kala Akademi, [1988]), esp. pp. 145–207, for information on the marriage painting. For discussion of the ritual wall paintings of the Warlis in Gujarat districts adjoining Maharashtra, see D. H. Koppar, *Tribal Art of Dangs*, ed. V. L. Devkar (Baroda: Department of Museums, 1971), pp.106–24.

35. For detailed socioeconomic information about the Warlis in Thane district, Maharashtra, see Dalmia, *Painted World of the Warlis*, pp. 13–21.

36. [Jivya Soma Mashe, Balu Mashe, and Lakshmi Lal], *The Warlis: Tribal Paintings and Legends*, ed. Lakshmi Lal (Bombay: Chemould Publications and Arts, [1982]), pp. 62–63.

37. Identification is based on the explication of the marriage painting, including its variant form in Ganjad village, in Dalmia, *Painted World of the Warlis*, pp. 145–207; also see figures on pp. 60, 99, 120, and 214.

38. Information on the tiger god festival and Warli icons of the tiger god is based on Dalmia, *Painted World of the Warlis*, pp. 69–75, 209–12, respectively. For related practices involving the tiger followed by Warlis and other tribes in the Dangs district of Gujarat adjoining Maharashtra, see Koppar, *Tribal Art of Dangs*, pp. 75–87. For an illustration of a Warli wall painting of the tiger in Dangs district, see ibid., p. 82.

39. I am indebted to Fred Smith and Philip Lutgendorf for reading the signature. Fred Smith, letter to author, 1994; Philip Lutgendorf, conversation with author, Chicago, 1994.

40. See [Mashe, Mashe, and Lal], *Warlis: Tribal Paintings and Legends*, p. 30.

41. I relied entirely on M. Archer, *Indian Popular Painting*, pp. 67–74, for information on the Mali tradition.

42. Mildred Archer has documented W. G. Archer's collection of Mali paintings, which was gathered while he worked as a British Civil Service officer in Purnea during 1938–39 and which is now part of the Oriental and India Office Collections of the British Library. Ibid., pp. 73, 75–84.

43. Ibid., pp. 22–23, 75. M. Archer also notes that the village of Madhubani in Purnea district (from which this and the Mali painting in the following entry, no. 16, were collected) is distinct from the town of Madhubani, formerly in Darbhanga district and presently in Madhubani district, which is today an important center of production of Mithila or Madhubhani paintings on paper.

44. Ibid., pp. 75–76, pl. 27. Also see note 43 for information on Madhubhani in Purnea district, the painting's place of origin.

Chapter 2

1. Mildred Archer, *Indian Popular Painting in the India Office Library* (London: Her Majesty's Stationery Office, 1977), p. 141.

2. S. C. Belnos, *Twenty-Four Plates Illustrative of Hindoo and European Manners in Bengal*, pl. 14, cited in W. G. Archer, *Kalighat Paintings* (London: Her Majesty's Stationery Office, 1971), pp. 2–3, fig. 91.

3. "Like other centers of Hindu pilgrimage, Kalighat possessed a large prostitutes' quarter and Kali herself was regarded as their special patron." M. Archer, *Indian Popular Painting*, p. 142.

4. Hana Knížková, *The Drawings of the Kālīghāṭ Style: Secular Themes* (Prague: National Museum, 1975), pp. 65–66.

5. For a more detailed account, see W. G. Archer, *Kalighat Paintings*, pp. 11–15.

6. Ibid., pp. 3–7.

7. Knížková, *Drawings of the Kālīghāṭ Style*, pp. 8–9, 148.

8. M. Archer, *Indian Popular Painting*, pp. 142, 160; W. G. Archer, *Kalighat Paintings*, pp. 9–10.

9. Nikhil Sarkar, "Calcutta Woodcuts: Aspects of a Popular Art," in *Woodcut Prints of Nineteenth Century Calcutta*, ed. Ashit Paul (Calcutta: Seagull Books, 1983), p. 44.

10. Knížková, *Drawings of the Kālīghāṭ Style*, pp. 19–22, 152.

11. N. Sarkar, "Calcutta Woodcuts," pp. 11–15.

12. Jaya Appasamy, "Early Calcutta Wood Engraving," *Visva Bharati Quarterly* (Santiniketan) 39, nos. 3–4 (1973–74): 260–61; N. Sarkar, "Calcutta Woodcuts," pp. 17–23, 30–32.

13. There are several antique metal (lead-alloy) blocks in the collections of the Victoria Memorial and of private individuals. Trustees of the Victoria Memorial, Introduction to *Chitpur Relief Prints*, 2 folios (Calcutta: Trustees of the Victoria Memorial, 1985). Also see Pranabranjan Ray, "Printmaking by Woodblock up to 1901: A Social and Technological History," in *Woodcut Prints of Nineteenth Century Calcutta*, ed. Ashit Paul (Calcutta: Seagull Books, 1983), pp. 102–4; and N. Sarkar, "Calcutta Woodcuts," p. 44.

14. N. Sarkar, "Calcutta Woodcuts," pp. 18–20, 32, 37–42.

15. Appasamy, "Early Calcutta Wood Engraving," p. 262.

16. N. Sarkar, "Calcutta Woodcuts," p. 44.

17. W. G. Archer, *Kalighat Paintings*, pp. 15, 30–33; for W. G. Archer's full analysis of stylistic changes in Kalighat painting through four periods (1800–50, 1850–70, 1870–85, and 1885–1930), see ibid., pp. 1–16.

18. For other idealized portraits of courtesans executed in the Kalighat style, see M. Archer, *Indian Popular Painting*, ills. 77, 85, 86. For an example in a woodcut display print from Calcutta, see ibid. ill. 91.

19. I am grateful to Samuel Sundanandha for transliterating and translating the inscription; he suggests that the letters on the lower line may be the initials of a Tamil devotee or the owner of the painting, while the number on the upper line may be an inventory code (telephone conversations with author, letter to author, 1995). The legibility of the inscription requires its placement at the top of the composition with the prawn on the left and the fish on the right; to my knowledge, only one previously published example of this composition is similarly oriented: W. G. Archer, *Bazaar Paintings of Calcutta* (London: Her Majesty's Stationery Office, 1953), p. 50, fig. 22. At least two other previously published examples show the fish on the left and the prawn on the right; see M. Archer, *Indian Popular Painting*, ill. 81; and Knížková, *Drawings of the Kālīghāṭ Style*, pl. 33; for a horizontally oriented example, see Stuart Cary Welch, *A Flower from Every Meadow* (New York: Asia Society, 1973), p. 21, no. 4.

20. Mildred Archer and W. G. Archer, *Indian Painting for the British, 1770–1880* (London: Oxford University Press, 1955), p. 94. Also see Mildred Archer, *Natural History Drawings in the India Office Library* (London: Her Majesty's Stationery Office, 1962).

21. Knížková, *Drawings of the Kālīghāṭ Style*, pp. 91–92.

22. W. G. Archer, *Kalighat Drawings from the Basant Kumar Birla Collection (Formerly Ajit Ghose Collection)*, Birla Series of Indian Art (Bombay: Marg Publications, 1962), p. 9.

23. For another example from this series, see Pratapaditya Pal, "Kali, Calcutta, and Kalighat

Pictures," *Calcutta: Changing Visions, Lasting Images through 300 Years* (Bombay: Marg Publications, 1990), p. 123, fig. 17.

24. Robert Skelton and Mark Francis, eds., *Arts of Bengal: The Heritage of Bangladesh and Eastern India* (London: Whitechapel Art Gallery, 1979), p. 52.

25. N. Sarkar, "Calcutta Woodcuts," pl. 22 and pp. 36–37.

26. University Gallery and Jacksonville Museum, *Jamini Roy and Bengali Folk Art: A Special Exhibition of Works in the Collection of Mr. and Mrs. Thomas J. Needham of Jacksonville, Florida* ([Gainesville]: University Gallery, University of Florida, 1971), [n.p.], no. 53.

27. Anncharlott Eschmann, Hermann Kulke, Gaya Charan Tripathi, "The Formation of the Jagannatha Triad," in *The Cult of Jagannath and the Regional Tradition of Orissa*, ed. Anncharlott Eschmann, Hermann Kulke, and Gaya Charan Tripathi (New Delhi, Manohar, 1978), pp. 169–96.

28. Kay Talwar and Kalyan Krishna, *Indian Pigment Paintings on Cloth*, Historic Textiles of India at the Calico Museum, vol. 3 (Ahmedabad: Calico Museum of Textiles, 1979), p. 106.

29. Cited in Jagannath Prasad Das, *Puri Paintings: The Chitrakāra and His Work* (New Delhi: Arnold-Heinemann, 1982), pp. 48–49.

30. Ibid., p. 50. Also see Bijoy Chandra Mohanty, *Patachitras of Orissa*, Study of Contemporary Textile Crafts of India [Series], ed. Alfred Buhler (Ahmedabad: Calico Museum of Textiles, 1980), pp. 6–7.

31. Description of the *anasara pati* is based on J. P. Das, *Puri Paintings*, pp. 36–39. For a more detailed description of other painting tasks in relation to temple rituals, see ibid., pp. 40–47.

32. For a detailed discussion of pilgrim paintings, see J. P. Das, *Puri Paintings*, pp. 61–76.

33. For a map of painting centers and information on painter populations, see B. C. Mohanty, *Patachitras*, pp. 2, 7.

34. For a detailed account of the revival of Puri painting, see J. P. Das, *Puri Paintings*, pp. 81–89. Also see B. Mohanty, *Pata-Paintings of Orissa* (New Delhi: Publications Division, Ministry of Education, 1984), pp. 13–14.

35. Balarama is Krishna's brother; Bhuvaneshvari is the tutelary goddess of Orissa; and Narayana is a name of Vishnu.

36. For a mythological explanation of the unfinished quality of the temple icons, see J. P. Das, *Puri Paintings*, pp. 27–28.

37. Ibid., pp. 37–39; also see figs. 3–6. Also see Eberhard Fischer, Sitakant Mahapatra, and Dinanath Pathy, *Orissa: Kunst und Kultur in Nordost-Indien* (Zurich: Rietberg Museum, 1980), p. 221, figs. 488–91.

38. Talwar and Krishna, *Indian Pigment Paintings on Cloth*, p. 110; the composition is also called "conch shell-navel" (*shankha nabhi*) by J. P. Das, *Puri Paintings*, p. 120, fig. 30.

39. J. P. Das, *Puri Paintings*, p. 130.

40. For a detailed analysis of the iconography of similar paintings, see Talwar and Krishna, *Indian Pigment Paintings on Cloth*, pp. 110–12 and pl. 109, and B. C. Mohanty, *Patachitras*, pp. 8–9, pls. 13–13a.

41. I am grateful to Shyam Sundar Pattanaik for identification of the subject, origin, and date of this work (conversation with author, Bhubaneswar, 1986).

42. The iconography of Jagannatha as Madhava here differs from previously published examples of the theme. Compare: J. P. Das, *Puri Paintings*, p. 70, figs. 12–14; Fischer, Mahapatra, and Pathy, *Orissa: Kunst und Kultur*, p. 227, figs. 508, 510.

43. For a description of a similar picture conflating the two themes, see Stella Kramrisch, *Unknown India: Ritual Art in Tribe and Village* (Philadelphia: Philadelphia Museum of Art, 1968), p. 108, no. 310. For examples of the theme of *Kanchi-Kaveri* depicted without composite horses, see J. P. Das, *Puri Paintings*, p. 148, fig. 31; B. C. Mohanty, *Patachitras*, original painting, tipped-in between p. 22 and pl. 1.

44. J. P. Das, *Puri Paintings*, p. 62.

45. Information on the ceremonial limbs is from J. P. Das, *Puri Paintings*, pp. 44, 118, 171.

46. "The sacred icons['] . . . highly decorated character was an expression of devotion." Jaya Appasamy, *Thanvajur Painting of the Maratha Period* (New Delhi: Abhinav Publications, 1980), p.

34. Appasamy reinforces her statement by partially quoting Philip S. Rawson's comments on ornament in Indian painting (and culture) in Philip S. Rawson, *Indian Painting* (New York: Universe Books, [1961]), p. 12, which are here more briefly quoted: "One can say that underlying Indian art was always the intention to *adorn.* . . . This attitude towards ornament reflects an instinct deeply rooted in the Indian character. Indians have a great capacity for reverence, and this instinct demands that they express their feelings in acts. Time and again we shall meet this expression of respect through ornamental painting."

47. Appasamy, *Thanvajur Painting*, pp. 27–29.

48. Ibid., pp. 88, 91–93. Also see S. R. Rao and B. V. K. Sastry, *Traditional Paintings of Karnataka* (Bangalore: Karnataka Chitrakala Parishath, 1980), p. 37.

49. Appasamy, *Thanvajur Painting*, pp. 22–23, 29, 33–34.

50. For a more detailed description of the Tanjore technique, see ibid., pp. 38–40.

51. Rao and Sastry, *Traditional Paintings of Karnataka*, p. 28.

52. Ibid., pp. 23–24; Appasamy, *Thanvajur Painting*, pp. 24–25.

53. Identification of this work is based on Roy C. Craven, Jr., "Indian Reverse Painting on Glass," *Arts of Asia* (Hong Kong) 13, no. 1 (January-February 1983): 68, no. 1.

54. For similar works, see Rao and Sastry, *Traditional Paintings of Karnataka*, col. pl. 34 and pl. 2.

55. I am indebted to several persons for assistance in identifying the subject of this painting: primarily Michael Rabe and, through him, Indira Peterson, Vasudha Narayanan, and especially Patricia Mumme. Michael Rabe, letter (citing telephone conversations with Indira Peterson and Vasudha Narayanan and a letter from Patricia Mumme, 1993) to author, 1993; letter to author, 1994, and telephone conversations, 1993–94; Vasudha Narayanan, telephone conversations with author, 1994.

56. Information on the restored state of the original painting at Shri Ranganatha Temple is from Vasudha Narayanan, telephone conversation with author, 1994.

Chapter 3

1. For this introduction, I have primarily relied on Jagdish Mittal, "Scrolls: Narrative Painting," *India Magazine* (Bombay) 7, no. 5 (April 1987): 72–80, and Jagdish Mittal, conversation with author, Hyderabad, 1989, except as noted.

2. A compilation of epic, mythological narratives, the majority of which was composed before the end of the sixth century and probably by the end of the fifth century.

3. For registers of a scroll illustrating legends from the *Markandeya Purana*, see Kay Talwar and Kalyan Krishna, *Indian Pigment Paintings on Cloth*, Historic Textiles of India at the Calico Museum, vol. 3 (Ahmedabad: Calico Museum, 1979), col. pl. 12, pls. 113A, B. For registers of another example, see Mittal, "Scrolls: Narrative Painting," pp. 73–77. For a third example and information on the Padmasali community and their legendary ancestor whose story is told on such scrolls, see Jagdish Mittal, in *India: Art and Culture, 1300–1900*, by Stuart Cary Welch (New York: Metropolitan Museum of Art and Holt, Rinehart and Winston, 1985), pp. 20–21, 50–52.

4. V. V. S. Suryanaranya for the Assistant Director, Handicrafts Marketing and Service Extension Centre, Ministry of Textiles, Office of the Development Commissioner (Handicrafts), Government of India, Warangal, Andhra Pradesh, letter to author, 1989. Different transliterations of the names of some of these groups of storytellers and audiences and different accounts of what stories are favored by such groups are found in "Precious Patt Paintings of Telengana, Andhra Pradesh," by K. Rajaiah, trans. K. Y. Giri, in *Traditional Paintings: Old and New, An Exhibition of Existing Schools of Traditional Paintings in India* (New Delhi: Lalit Kala Akademi, 1989), [n.p.]. According to Rajaiah, stories of the origin of local castes, rather than local versions of the great Indian epics, appear to predominate in the narratives illustrated by Andhra scrolls.

5. Mittal, "Scrolls: Narrative Painting," p. 77.

6. Information on tribal performers was provided by D[analakota] Chandraiah, Andhra scroll painter, interview by author, assisted by Sandra Maheshwari and Saroj Dhruvu, village Cheriyal, Warangal district, Andhra Pradesh, 1989.

7. Mittal, "Scrolls: Narrative Painting," p. 77.

8. Ibid.

9. Ibid., pp. 73, 77, 79.

10. "[T]here was no line demarcating the painting done at the Deccani Hindu courts and at the village level." Ibid., p. 77; Mittal, conversation, 1989.

11. Information on materials and account of story dictation provided by D[analakota] Chandraiah, interview, 1989. For information on materials and on painters' rituals, also see Mittal, "Scrolls: Narrative Painting," pp. 79–80.

12. Mittal, "Scrolls: Narrative Painting," pp. 73, 79, 77; Mittal, conversation, 1989.

13. I am indebted to Jagdish Mittal for the dating of this piece. Jagdish Mittal, conversation with author, Chicago, 1995.

14. I am indebted to Marion Covey for identification of the story and description of scenes on the registers. Marion Covey, telephone conversations with author, 1992–94, conversation with author, Chicago, 1993, and letter to author, 1994.

15. J. A. B. van Buitenen, trans. and ed., *Mahābhārata*, vol. 3 (Chicago and London: University of Chicago Press, 1978), p. 60.

16. Mittal, "Scrolls: Narrative Paintings," pp. 77, 79.

17. I am indebted to Jagdish Mittal for identification of the artist and dating of this piece (conversation, 1995).

18. I am indebted to Marion Covey for identification of the story and description of scenes on the registers. See note 14.

19. Prabhat Kumar Das, "Face to Face with the Patuas," *Folklore* (Calcutta) 13, no. 10 (1972): 387–401.

20. See T. Richard Blurton, "Continuity and Change in the Tradition of Bengali Paṭa-Painting," in *Shastric Traditions in Indian Arts*, ed. Anna Libera Dallapiccola et al. (Stuttgart: Steiner Verlag Wiesbaden GMBH, 1989), vol. 2, figs. 167–71.

21. Shyamsundar Chitrakar, Dukhushyam Chitrakar, and Gurupada Chitrakar, Bengali scroll painters, interview by author, assisted by Sabita Ranjan Sarkar, village Naya, Midnapur district, West Bengal, 1986.

22. For an example of Hooghly painting, see Stella Kramrisch, *Unknown India: Ritual Art in Tribe and Village* (Philadelphia: Philadelphia Museum of Art, 1968), pl. 33, no. 367b.

23. For discussion of stylistic varieties and changes, see Deva Prasad Ghosh, "An Illustrated *Rāmāyana* Manuscript of Tulsīdās and Paṭs from Bengal," *Journal of the Indian Society of Oriental Art* (Calcutta) 13 (1945): 135–38; Blurton, "Continuity and Change in Bengali Paṭa-Painting," vol. 1, pp. 425–51, vol. 2, figs. 152–71; and David McCutchion, "Recent Developments in Patua Style and Presentation," in *Patua Art, Development of the Scroll Paintings of Bengal Commemorating the Bicentenary of the French Revolution*, by Alliance Française of Calcutta and Crafts Council of West Bengal (Calcutta: Alliance Française, [1991]), pp. 16–22.

24. George Michell, "Related Arts," in *Brick Temples of Bengal: From the Archives of David McCutchion*, ed. George Michell (Princeton: Princeton University Press, 1983), pp. 177, 182–83. Also see Sudhansu Kumar Ray's comments on similarity in the compositional arrangement of the relief plaques of Bengali temples and the registers of the scroll paintings of South India. Sudhansu Kumar Ray, "The Artisan Castes of West Bengal and Their Craft," in *The Tribes and Castes of West Bengal*, by A. Mitra, Census 1951, West Bengal, Land and Land Revenue Department (Alipore, West Bengal: Superintendent, Government Printing, West Bengal Government Press, 1953), p. 326.

25. See Binoy Battacharjee, *Cultural Oscillation: A Study of Patua Culture* (Calcutta: Naya Prakash, 1980) for information on the culture and mixed religious practices of Patuas in the Birbhum district of West Bengal. Also see Binoy Bhattacherjee, "The Patuas—A Study of Islamization," *Folklore* (Calcutta) 13, no. 10 (October 1972): 361–68.

26. Akshaykumar Kayal, "Illustrated Manuscripts (*Puthi*) and Cover-Designs (*Paataas*) in Bengal," *Folklore* (Calcutta) 13, no. 9 (September 1972): 353, 357. Also see *Folk Arts and Crafts of Bengal: The Collected Papers*, by Gurusday Dutt, ed. Samik Bandyopadhyay (Calcutta: Seagull Books, 1990), p. 84, where Dutt states that painted book covers were made by Patuas for the members of the scholarly class and that those of certain subjects displayed "a refined and sophisticated technique comparable to that of the advanced Rajput schools of painting."

27. Description of the derivation and function of the *chalachitra* is based on Deva Prasad Ghosh, *Mediaeval Indian Painting, Eastern School (13th Century A.D. to Modern Times Including Folk Art)* (Delhi: Sundeep Prakashan, 1982), p. 89; Dutt in *Collected Works*, p. 101, also discusses a mural form, transliterated as *chalchitra*, which is enclosed in a semicircular border (*chal*) on the inner walls of village houses and depicts the goddess Lakshmi in the center.

28. Dutt attributes forms of painting that are stylistically related to Bengali scroll painting to a number of artisan classes other than the Patuas, that is, the *chauka* or *chaukash pata* to the Sutradhars (architectural carpenters) and the *chal(a)chitra* to the Acharyas (artists of the priestly caste) and the Kumbhakars (potters). Appendix to *The Collected Papers*, pp. 91–92. For exhaustive descriptions of kinds of paintings produced by artisan castes and tribes, also see S. K. Ray, "Artisan Castes of West Bengal," pp. 299–321, 337–40.

29. Kramrisch, *Unknown India*, pp. 112–13, no. 366.

30. D. P. Ghosh, *Mediaeval Indian Painting*, p. 147, pl. 60.

31. Robert Skelton and Mark Francis, eds., *Art of Bengal: The Heritage of Bangladesh and Eastern India* (London: Whitechapel Art Gallery, 1979), front and back cover, p. 42, no. 53.

32. Blurton, "Continuity and Change in Bengali Paṭa-Painting," vol. 1, p. 429; T. Richard Blurton, "Scroll-Paintings in the British Museum from Murshidabad District," in *Patua Art: Development of the Scroll Paintings of Bengal Commemorating the Bicentenary of the French Revolution*, by Alliance Française of Calcutta and Crafts Council of West Bengal (Calcutta: Alliance Française, [1991]), p. 34.

33. See Kramrisch, *Unknown India*, pp. 112–13, and Skelton and Francis, eds., *Art of Bengal: Heritage*, p. 42, for different identifications of the scenes on the registers.

34. See Blurton, "Continuity and Change in Bengali Paṭa-Painting," vol. 1, pp. 443–48, for detailed description of the scenes on the fifty-seven registers.

35. For a detailed discussion of various types of tigers' gods and control of tigers by humans with special powers, see the following articles by Sarat Chandra Mitra: "Indian Folk-Beliefs about the Tiger," *Journal of the Anthropological Society of Bombay* (Bombay) 3, no. 1 (1892): 45–60; "On Some Additional Folk-Beliefs about the Tiger," *Journal of the Anthropological Society of Bombay* (Bombay) 3, no. 3 (1894): 158–63; "On the Indian Folk-Beliefs about the Tiger, Part III," *Journal of the Anthropological Society of Bombay* (Bombay) 4, no. 2 (1896): 80–89. Also see Asutosh Bhattacharayya, "Tiger in the Folklore of Bengal," *Folklore* (Calcutta) 6, no. 2 (February 1965): 84, in which the author reports that migrant woodcutters in the Sundarbans would not enter the forested areas until fakirs had made offerings to various gods and godlings, including *ghazis* venerated as deities, in order to chase away tigers.

36. Gurusaday Dutt, "The Tigers' God in Bengal Art," *Modern Review* (Calcutta) 52 (December 1932): 520–29; Gurusaday Dutt, "Indus Civilisation Forms and Motifs in Bengali Culture," *Modern Review* (Calcutta) 66, no. 5 (November 1939): 583–86; Mildred Archer, *Indian Popular Painting in the India Office Library* (London: Her Majesty's Stationery Office, 1977), pp. 22–23. According to Dutt, "Tigers' God in Bengal Art," pp. 522–23, the cult of Barekhan Ghazi was in decline at the time of his writing; *ghazi patas* were formerly produced in Bengal not by Patuas, the caste of professional scroll painters, but by Ganakas or Acharyas (artists of the priestly caste), who also formerly made scrolls illustrating the legends of Krishna and Rama but now produced clay festival images of Hindu deities; the Hindu Acharyas had created *ghazi patas* for professional Muslim beggars (Bedeys, also transliterated Bedes, of the fakir class) who were still, however, displaying them at fairs and festivals while singing doggerel verses outlining the deeds of the *ghazi*. For more information on the *asha danda*, the *ghazi's* special staff, see Gurusaday Dutt, "Indus Civilisation Forms and Motifs in Bengali Culture—II," *Modern Review* (Calcutta) 67, no. 2 (February 1940): 200–204; and Kramrisch, *Unknown India*, pl. 48, no. 325; p. 109.

37. Bhattacherjee, "Patuas—A Study of Islamization," p. 364.

38. Shiv Kumar Sharma, *The Indian Painted Scroll* (Varanasi: Kala Prakashan for Shiv Kumar Sharma, 1993), p. 109.

39. See Blurton, citing conversation with Asim Roy concerning Muslim settlements and the *ghazi*, "Scroll-Paintings in the British Museum from Murshidabad District," p. 33.

40. Bholanath Bhattacharaya, *Krishna in the Traditional Painting of Bengal* (Calcutta: Kamal Banerjee, 1972), p. 25.

41. Blurton, "Continuity and Change in Bengali Paṭa-Painting," vol. 1, p. 432.

42. For an example of some verses chanted in conjunction with the display of a scroll honoring the tigers' god Zinda Ghazi, see Dutt, "Tigers' God in Bengal Art," pp. 524–26; Dutt notes that not all the verses are strictly pertinent to the episodes on the registers of the scroll. For two accounts of the story of Ghazi, the tigers' god—called "Bada-khān Ghāzi" (that is, Barekhan Ghazi) or "Ghāzi-sāheb"—in two separate folk ballads, see Asim Roy, *The Islamic Syncretistic Tradition in Bengal* (Princeton: Princeton University Press, 1983), pp. 235–41, citing Abd al-Karim, *Kālu-Ghāzi-Champāvati* (Calcutta: Ghausiya Library, n.d.), and Zain al-Din, "Bada-khān Ghāzir Gān," ed. K. Datta, *Bhāratiya Lok-yān* (Calcutta University), vol. 3, nos. 1–2 (1963); according to Roy, although the ballads have many significant differences, they similarly focus on Ghazi and his companion Kalu and on Ghazi's victorious battle with a Hindu king for the hand of his Brahmin daughter in marriage. For accounts of the tigers' god in other literary sources, see Asutosh Bhattacharyya, "The Tiger-Cult and Its Literature in Lower Bengal," *Man in India* (Ranchi) 27, no. 1 (March 1947): 44–56.

43. Compare the iconography of this tigers' god with a different tigers' god, holding a staff, featured in a more recent scroll (CA. 1920) by a Jadupatua (magic painter) in neighboring Bihar (no. 44). Also see a tiger god, venerated by the Warli tribe in Maharashtra, represented not in human form but as a tiger (no. 13).

44. According to Asim Roy, the Muslim saint or *pir* Ghazi—like some other *pirs*—has power not only over tigers but also crocodiles; in his attempt to win the hand of a Brahmin princess, Ghazi must battle the Hindu tiger-god (Dakshin Ray) invoked by the princess's father; Ghazi defeats the crocodiles given to Dakshin Ray by the river goddess Ganga. *Islamic Syncretistic Tradition in Bengal*, pp. 231, 239.

45. Pradyot Kumar Maity, "Manik Pir Worship at Tamralipta," *Folklore* (Calcutta) 11, no. 5 (May 1970): 174–75.

46. For an account of Manik Pir's milking a barren cow, see ibid., p. 170.

47. For punishments inflicted on those who fail to give offerings, particularly of milk, to the tigers' god, see Dutt, "Tigers' God in Bengal Art," pp. 522, 525.

48. Dutt, "Tigers' God in Bengal Art," pp. 522, 526. Also see Blurton's discussion of these registers, "Continuity and Change in Bengali Paṭa-Painting," vol. 1, pp. 432–33, 448.

49. Blurton, "Continuity and Change in Bengali Paṭa-Painting," vol. 1, p. 429.

50. Ibid., vol. 1, pp. 433, 435; also see pp. 433–37 for a thorough analysis of stylistic conventions in this scroll.

51. I am indebted to Marion Covey for identification of the scenes on the registers. Marion Covey, telephone conversations with author, 1992–93; conversation with author, Chicago, 1993; letter to author, 1993.

52. [Krittibasa's] *Rāmāyana*, trans. Shudha Mazumdar (Bombay: Orient Longman, 1974). I am indebted to Marion Covey for this reference and for the identifications of the episodes that follow. Marion Covey, telephone conversations with author, 1992–94; conversations with author, letters to author, 1994.

53. The fragment on the left (64-169-4), containing an apparently iconic image of the Great Goddess in its second register, had previously been identified as belonging to a scroll depicting divine energy as female (*shakti pata*); D. P. Ghosh, "Illustrated *Rāmāyana* Manuscript of Tulsīdās," pp. 136–37, pl. 12. The fragment had also been similarly identified by other scholars who had, however, termed the theme the feats of Durga, the slayer of buffalo demon (*Durga Mahishamardini pata*); Bishnu Dey and John Irwin, "The Folk Art of Bengal," *Mārg* (Bombay) 1, no. 4 (1944): 50.

54. [Krittibasa's] *Rāmāyana*, p. 257.

55. Ibid., pp. 411–15.

56. Ibid., p. 409.

57. Ibid., p. 229.

58. Compare the representation of Jatayu in another Bengali scroll illustrating the *Ramayana*, in *Indian Painting*, by Philip S. Rawson (Paris: Pierre Tisné; New York: Universe Books, [n.d.]), p. 152.

59. For this introduction, I relied on Jyotindra Jain, "Painted Panels and Scrolls from West-

ern Indian Villages: Their Mythology and Rituals" in *The Cultural Heritage of the Indian Village,* ed. Brian Durran and T. Richard Blurton, British Museum Occasional Paper No. 47 (London: British Museum, 1991), pp. 119–34 as well as Jyotindra Jain, "The Painted Scrolls of the Garoda Picture-Showmen of Gujarat," *Quarterly Journal* (National Centre for Performing Arts, Bombay) 9, no. 3 (September 1980): 3–23; rev. and enl. version as "Survival of the 'Yamapattika' Tradition in Gujarat," in *Dimensions of Indian Art, Pupul Jayakar Seventy*, ed. Lokesh Chandra and Jyotindra Jain (Delhi: Agam Prakashan, 1986), vol. 1, pp. 173–86, vol. 2, pp. 58–67.

60. J. Jain, "Painted Panels and Scrolls from Western Indian Villages," p. 121. Similar subject matter in certain registers of the Garoda scroll and of the astrologer's calendar is also evident, as the second and third registers of both kinds of scrolls respectively display almost identical compositions of equestrian figures and of Ganesha; for examples of astrologers' calendars, see Talwar and Krishna, *Indian Pigment Paintings on Cloth*, pls. 107 A, B. J. Jain also finds a similar style and concept in the depiction of punishments in final registers of the Garoda scrolls and the eighteenth- and nineteenth-century picture albums that illustrate punishments for sins and were used by members of the Jain communities in Gujarat and Rajasthan and by members of the Swaminarayan sect; he speculates that Garodas may have produced this additional form of painting for these communities. J. Jain also speculates that Garodas may have illustrated late narrative manuscripts that are folkish expressions of miniature traditions of the region on the basis of similar pigmentation, stylistic devices, body types, and costumes. "Painted Scrolls of the Garoda Picture-Showmen," pp. 21–22, ills. 18, 19.

61. Identification based on J. Jain, "Painted Panels and Scrolls from Western Indian Villages," pp. 119–34; J. Jain, "Painted Scrolls of the Garoda Picture-Showmen," pp. 3–23; J. Jain, "Survival of the 'Yamapattika' Tradition in Gujarat," vol. 1, pp. 173–87, vol. 2, pp. 58–67.

62. According to Robert A. McCarroll, the conservator who prepared the scroll for exhibition (conversation with author, Denver, Colorado, 1991).

63. Verrier Elwin, "The Comic Strips of Rural India— I: The Krishna-Lila," and "The Comic Strips of Rural India—III: The Punishments of Hell," *Illustrated Weekly of India* (Bombay) 73, 15 June 1952, p. 10, and 29 June 1952, p. 29; M. Archer, *Indian Popular Painting*, p. 17.

64. S. K. Ray, "Artisan Castes of West Bengal," p. 304.

65. Ibid. Also see pl. 2a, no. 2, bet. p. 350 and p. 351, a *pishacha* image collected by S. K. Ray in Binpur, Midnapur [also reproduced in Philip Rawson, *Erotic Art of the East: The Sexual Theme in Oriental Painting and Sculpture* (New York: G. P. Putnam's Sons, 1968), fig. 125]. While D. P. Ghosh mainly quotes, among other scholars, S. K. Ray (*The Ritual Art of the Bratas of Bengal* [Calcutta: Firma K. L. Mukhopadhyay, 1963], p. 54) concerning *pishachas* as the cause of death of Santals, he states only that the demons "purposely desecrate the domestic utensils as an omen of death in the family," *Mediaeval Indian Painting, Eastern School*, pp. 93, 95. Ghosh says that *chaksuhudana patas* can include images of the *pishacha* but does not discuss the ritual function of such paintings. Ibid., p. 95.

66. M. Archer, *Indian Popular Painting*, pp. 16–17.

67. Ibid., p. 25.

68. Ibid., p. 16.

69. S. K. Ray, "Artisan Castes of West Bengal," pp. 301–2. For other scholars' identification of the Jadupatuas in certain areas as tribal persons, see D. P. Ghosh, *Mediaeval Indian Painting, Eastern School*, pp. 47, 113; Suhrid Kumar Bhowmik, "A Note on the Patuas of Bengal," *Folklore* (Calcutta) 10, no. 7 (July 1971): 253.

70. D. N. Saraf reports that folk paintings produced in Santal Parganas by a community known as *"chitrakars"* have been "introduced into the market," that is, circulated to nonvillage patrons. The *"chitrakars"* are identified as painters of traditional scrolls that depict narratives with moral lessons and also as performers who narrate those stories for Santal audiences. D. N. Saraf, *Indian Crafts: Development and Potential* (New Delhi: Vikas Publishing House, 1982), p. 46.

71. Dutt, "Tigers' God in Bengal Art," pp. 520–29; M. Archer, *Indian Popular Painting*, pp. 22–23, 35.

72. S. C. Mitra, "On the Indian Folk-Beliefs about the Tiger," p. 87.

73. M. Archer, *Indian Popular Painting*, p. 35. Archer identifies the sinner suspended in fire as a woman; she had previously identified the figure as a man being punished for "his refusal to give

fire to his neighbors during his lifetime." [Mildred Archer], *Indian Paintings from Court, Town, and Village* (London: Arts Council of Great Britain, 1970), [p. 40], no. 66.

74. Identification based on M. Archer, *Indian Popular Painting*, p. 53.

75. Ibid., pp. 19–21.

76. Identification of festival registers, ibid., pp. 19–21.

77. Identification of registers illustrating Santal deities and creation story, ibid., pp. 17–19; identification of festival registers, ibid., pp. 19–21.

78. For a detailed description of the deities, see ibid., p. 20.

79. William Crooke, *An Introduction to the Popular Religion and Folklore of Northern India* (Allahabad: Government Press, 1894), p. 153.

80. Alain Danielou, *The Myths and Gods of India* (Rochester, Vt.: Inner Traditions International, 1985), pp. 143, 302, 310. First published as *Hindu Polytheism* (New York: Bollingen Foundation, 1964).

81. See note 65.

82. See note 65.

83. Sudhansu Kumar Ray, *The Ritual Art of the Bratas of Bengal* (Calcutta: Firma K. L. Mukhopadhyay, 1963), pp. 54, 63.

84. Monier Monier-Williams, *A Sanskrit-English Dictionary* (1899; reprint ed., Oxford: Oxford University Press, 1979), p. 628.

85. See note 65. For a related picture of a death-delivering demon (without deceased tribal persons) from Dhalbhumgarh, [Singhbhum district], Bihar, in the collection of the Asutosh Museum, see S. K. Ray, *Ritual Art of the Bratas*, pl. 23, fig. c; also reproduced, Ajit Mookerjee, *Modern Art In India* (Calcutta, New Delhi: Oxford Book and Stationery Co., 1956), fig. 58. This painting of the *pishacha* may have been collected by S. K. Ray. In "Artisan Castes of West Bengal" Ray reports that he had collected two paintings related to the *pishacha*, one from Dhalbhumgarh, Bihar (which was in the collection of the Asutosh Museum), the other from Binpur, Midnapur district (in his own collection); only the latter was illustrated. For a related picture of a *pishachi* with similar pendant breasts who is, however, viewed frontally and shown with bloody organs in both hands and, presumably, a deceased tribal person in her stomach, see University Gallery and Jacksonville Art Museum, *Jamini Roy and Bengali Folk Art: A Special Exhibition of Works in the Collection of Mr. and Mrs. Thomas J. Needham of Jacksonville*, Florida ([Gainesville]: University Gallery, University of Florida, 1987), no. 61 (reproduced with different identification).

86. Jutta Jain-Neubauer, "Citrakathi Paintings of Maharashtra," in *Treasures of Everyday Art, Raja Dinkar Kelkar Museum* (Bombay: Marg Publications, [1978]), p. 110.

87. Valentina Stache-Rosen, "Shadow Players and Picture Showmen," *Quarterly Journal of the Mythic Society* (Bangalore) 66, nos. 3–4 (July-December 1975): 49–51.

88. For information on the collection of the first pictures noted as "Paithan" paintings, see P. J. Chinmulgund, "Paithan Paintings," in *Times of India Annual* (Bombay), 1962, p. 68; Stache-Rosen, "Shadow Players and Picture Showmen," p. 51; Eva Ray, "Documentation for Paiṭhān Paintings," *Artibus Asiae* (Ascona), 40, no. 4 (1978): 240. E. Ray notes that "there is no reason to believe that all, or even any, of these paintings [collected from Paithan for the Raja Dinkar Kelkar Museum in Pune] were painted in Paithan. . . ."

89. Jain-Neubauer, "Citrakathi Paintings," pp. 109–10; and Shridhar Andhare, "*Citrakathī* Tradition of Painting," in *Ajaya-Sri: Recent Studies in Indology, Prof. Ajay Mitra Shasti Felicitation Volume*, vol. 2, ed. Devendra Handa (Delhi: Sundeep Prakashan, 1989), p. 527.

90. Jain-Neubauer, "Citrakathi Paintings," p. 110; Jyotindra Jain and Aarti Aggrawala, *National Handicrafts and Handlooms Museum* (Ahmedabad: Mapin Publishing, 1989), p. 106.

91. Valentina Stache-Rosen, "*Schattenspiele und Bildervorführungen, zwei Formen der religiösen Unterhaltung in Indien*" (1976), p. 143, quoted by Anna Libera Dallapiccola, *Die „Paithan"-Malerei* (Wiesbaden: Franz Steiner Verlag GMBH, 1980), p. 19.

92. Stache-Rosen, "Shadow Players and Picture Showmen," p. 50 and pl. 6. Also see Andhare, "*Citrakathī* Tradition of Painting," fig. 172.

93. In the Pune district, according to the *Gazetteer of the Bombay Presidency, Ahmadnagar* (Bombay, 1884), p. 178, quoted by Dallapiccola, *Die „Paithan"-Malerei*, p. 19.

94. Andhare, "*Citrakathī* Tradition of Painting," p. 530 and fig. 172.

95. Rama is an incarnation of Vishnu, who as a warrior performs many heroic deeds to recover his kingdom; Sita is his wife who is abducted by a demon king and then rescued by Rama; Babhruvahana is a son of Arjuna who kills him and then is enabled to restore him; Harishchandra is a virtuous king who suffers many misfortunes; the five Pandava brothers are warriors who battle their princely cousins to recover their kingdom.

96. In the Pune district, according to the *Gazetteer of the Bombay Presidency*, vol. 18, pt. 1 (Bombay, 1885), p. 448, cited by Stache-Rosen, "Shadow Players and Picture Showmen," p. 48.

97. For an exhaustive treatment of stylistic variations, see Dallapiccola, *Die „Paithan"-Malerei*.

98. Ibid., p. 46.

99. E. Ray, "Documentation for Paiṭhān Paintings," p. 247.

100. Stache-Rosen, "Shadow Players and Picture Showmen," p. 49; and Andhare, "*Citrakathī* Tradition of Painting," pp. 532–33.

101. *Svayamvara* is a premarriage ceremony in which a girl of noble birth can choose her own husband.

102. See E. Ray, "Documentation for Paiṭhān Paintings," pp. 250–51, for the story. The characters are found in the Sanskrit version of the *Mahabharata*, but the story is not.

103. Stella Kramrisch, *Painted Delight: Indian Paintings from Philadelphia Collections* (Philadelphia: Philadelphia Museum of Art, 1986), p. 189.

104. For an account of this story illustrated with a set of sixty-eight "Paithan" paintings, see Jain-Neubauer, "Citrakathi Paintings," pp. 112–22.

105. The image may illustrate the incident in the story of the horse sacrifice in which a tiger tries to attack the black horse Shyamakarna being protected by Arjuna; the tiger is ultimately killed by Arjuna's warriors. See ibid., p. 115.

106. For similar pictures (recto), see: Chinmulgund, "Paithan Paintings," p. 72, fig. 13; Dallapiccola, *Die „Paithan"-Malerei*, fig. A I 3; p. 187, fig. B I 2; and p. 241, fig. B III 17; Jain-Neubauer, "Citrakathi Paintings," p. 118, fig. 48; and Stache-Rosen, "Shadow Players and Picture Showmen," pl. 4. For a similar picture (verso), see Dallapiccola, *Die „Paithan"-Malerei*, p. 189, fig. B I 3.

107. To my knowledge, previously published "Paithan" images of Sarasvati show the goddess enshrined in a pavilion; for examples, see Chinmulgund, "Paithan Paintings," p. 76, fig. 2; Dallapiccola, *Die „Paithan"-Malerei*, p. 153, fig. A III 2, and p. 245, fig. C I 2; Jain-Neubauer, "Citrakathi Paintings," p. 112, fig. 2; and Kramrisch, *Painted Delight*, p. 148, fig. 135.

108. Writing about a similar picture, Dallapiccola states that the halved composition of the goddess and her peacock can be interpreted as a visual expression of their equivalence as interchangeable manifestations of divinity: the overlarge bird can be said to be the goddess's "alter-ego." *Die „Paithan"-Malerei*, p. 244.

109. See note 104.

110. Dallapiccola, *Die „Paithan"-Malerei*, p. 354.

111. I am indebted to Stella Kramrisch for identification of the betel nutcrackers. Stella Kramrisch, letter to author, 1992. In India and Southeast Asia, betel or areca nuts, the fruit of the areca palm, are cut up and chewed with or without other ingredients, which may include lime, cloves, cardamom, and other spices. The leaves of a pepper plant that are also called betel are used to wrap the additional ingredients. Consumption has a mildly intoxicating effect. Ritual use is especially important in marriage ceremonies. For a description of associated customs in Maharashtra and a mention of "nutcrackers cum daggers," see Jyotindra Jain, "The Culture of *Tambula*: Betel Boxes, Lime Containers, and Nutcrackers," in *Treasures of Everyday Art. Raja Dinkar Kelkar Museum* (Bombay: Marg Publications [1978]), pp. 84–92.

112. Identification based on Dallapiccola, *Die „Paithan"-Malerei*, p. 227.

113. I am indebted to Joseph C. Miller, Jr., for discussions of the *par* tradition and for his critical reading of early versions of this introduction to *par* painting and explications of selected works. Joseph C. Miller, Jr., telephone conversations with author and letters to author, 1992–94.

114. John D. Smith, *The Epic of Pābūjī: A Study, Transcription and Translation* (Cambridge: Cambridge University Press, 1991), p. 8.

115. O. P. Joshi, *Painted Folklore and Folklore Painters of India (A Study with Reference to Rajasthan)* (Delhi: Concept Publishing Co., 1976), p. 15. Many different transliterations of the Indian word

for the painted cloth of this tradition—*pad*, *phad*, *phada, par, parh*, and *furh*, some marked with a diacritic—appear in the literature. Joseph C. Miller, Jr. (see note 113) prefers the term *par*.

116. O. P. Joshi, *Painted Folklore and Folklore Painters*, pp. 5–9, 14–17. The performance of the epic may also take place without a painting; see Talwar and Krishna, *Indian Pigment Paintings on Cloth*, p. 99; also see Smith, *Epic of Pābūjī*, p. 17; and Komal Kothari, "The Shrine: An Expression of Social Needs," trans. Uma Amand, in *Gods of the Byways: Wayside Shrines of Rajasthan, Madhya Pradesh, and Gujarat* [by Komal Kothari et al.] (Oxford: Museum of Modern Art, 1982), p. 22.

117. Smith, *Epic of Pābūjī*, pp. 8, 54–66.

118. Miller, letter, 1993.

119. Durgesh Kumar Joshi and Rajendra Kumar Joshi, *par* painters, interview by author, Shahpura, Bhilwara district, Rajasthan, 1989.

120. Smith, *Epic of Pābūjī*, p. 6. Paintings by *bhopas* may be less accomplished than those by artists of the Joshi community.

121. For discussion of rituals involved in painting and disposing of *pars*, see O. P. Joshi, *Painted Folklore and Folklore Painters*, pp. 19, 21–22, 35.

122. Smith, *Epic of Pābūjī*, p. 67.

123. Ibid.; also see O. P. Joshi, *Painted Folklore and Folklore Painters*, pp. 19, 35, where Joshi notes that the sale of an old *par*, the former residence of the deity, is a sacrilege but that the sale is sometimes economically necessary for the *bhopa* in order to pay for a new one since prices have increased with the development of commercial paintings in the *par* style for a nonrural market.

124. Smith cites Lieutenant-Colonel James Todd's observation in 1829 of the picture-performance tradition featuring the exploits of Pabu in *Annuals and Antiquities of Rajast'han* (London, 1829–32). *Epic of Pābūjī*, p. 5

125. The memorial dome (*chatri*) of Sardul Singh of Parasrampura. Ibid., pp. 67–69, pl. 9.

126. For an illustration of a Devnarayan shrine with a mural, see Kothari, "The Shrine: An Expression of Social Needs," plate on p. 4.

127. Jain and Aggarwala, *National Handicrafts and Handlooms Museum*, p. 112.

128. For changes in the *par* tradition due to commercialization, see O. P. Joshi, *Painted Folklore and Folklore Painters*, pp. 18–20. For examples of commercial *pars*, see ibid., col. pls. 1 (opp. p. 17), 5 (opp. p. 104); pls. 1–4 (between pp. 24–25). Another consequence of commercialization is production of *pars* by painters who are not Joshis or *bhopas*. According to Renaldo Maduro, while Nathadwara painters claim to have always done some authentic *par* painting on the side, some Nathadwara painters at the time of his writing were in fact producing, though not exclusively, "'suitcase-size' versions of the *Parh* for Western tourist consumption." *Artistic Creativity in a Brahmin Painter Community*, Research Monograph Series, no. 14 (Berkeley: Center for South and Southeast Asia Studies, University of California, 1976), pp. 68–69.

129. I am indebted to Joseph C. Miller, Jr., for the transliteration and translation of the inscription. Miller notes that the date in the cartouche, 1919—despite being clearly written—cannot be correct, since the father-and-son team, Ghisu and Durga, the artists named in the inscription, were not painting together at that time. Miller, letter to author, 1994.

130. Summary of the Pabuji legend is based on Smith, *Epic of Pābūjī*, pp. 9–12.

131. I am indebted to Joseph C. Miller, Jr., for transliteration and translation of the inscription. Miller identifies Ramgopal as the son, born in the 1970s, of the famous *par* painter Shrilal Joshi of Bhilwara. However, this identification of Ramgopal Joshi, which depends on the son of a painter of Bhilwara identifying himself as belonging to Udaipur, throws the dating in the inscription, 1950–62, into question. There is also, of course, the possibility that there is a painter named Ramgopal in Udaipur who is not the son of Shrilal. Miller, telephone conversations with author, 1992, and letter to author, 1993.

132. See O. P. Joshi, *Painted Folklore and Folklore Painters*, pp. 39–69, for a detailed account of the narrative and iconography. A translation of the oral epic into English has recently been completed; see Joseph C. Miller, Jr., *The Twenty-Four Brothers and Lord Devnarayan: The Story and Performance of a Folk Epic of Rajasthan, India*, Ph.D. dissertation, University of Pennsylvania, Philadelphia, 1994.

133. Miller, letter to author, 1993. According to Miller (telephone conversations with author, 1992, 1993), some paintings display imagery of both epics so that they can be used for storytelling with different communities.

Chapter 4

1. Moti Chandra, *Jain Miniature Paintings from Western India* (Ahmedabad: Sarabhai Manilal Nawab, 1949), pp. 22–28.

2. For examples of paintings of Jain pilgrimage sites, see Kay Talwar and Kalyan Krishna, *Indian Pigment Paintings on Cloth*, Historic Textiles of India at the Calico Museum, vol. 3 (Ahmedabad: Calico Museum of Textiles, 1979), pp. 82–90, figs. 86–90, col. pls. 9–10. Also see Phyllis Granoff, "Jain Pilgrimage: In Memory and Celebration of the Jinas," in *The Peaceful Liberators: Jain Art from India*, by Pratapaditya Pal et al. (New York and Los Angeles: Thames and Hudson and Los Angeles County Museum of Art, 1994), pp. 62–75, 252–54.

3. For examples of *yantras* of mantras, see Talwar and Krishna, *Indian Pigment Paintings on Cloth*, pp. 95–96, figs. 96–97.

4. For more information on Jain domestic shrines, some of which are elaborately carved and painted, see Roy C. Craven, Jr., "A Svetambara Jain Shrine," *Pharos* (St. Petersburg, Fla.) 16, no. 2 (1979): 16–23. Also see Pal, *Peaceful Liberators: Jain Art from India*, pp. 18–19, 24, 108–9, 112–13.

5. For examples of *vijnaptipatra*, see Umakant P. Shah, ed., *Treasures of Jaina Bhandaras* (Ahmedabad: L. D. Institute of Indology, 1978), figs. 141, 143, 145–48, 150–52. Also see Shridhar Andhare, "Jain Monumental Painting," in *The Peaceful Liberators: Jain Art from India* by Pratapaditya Pal et al. (London and Los Angeles: Thames and Hudson and Los Angeles County Museum of Art, 1994), pp. 84–86, 251.

6. Moti Chandra, *Jain Miniature Paintings*, p. 70.

7. For rarely published examples of folkish illustrations of Jain texts, see Musée des Arts Décoratifs de la Ville de Lausanne, *Citrakaras: L'Imagerie populaire de l'Inde/Citrakaras: Indian Popular Images* ([Lausanne]: Musée des Arts Décoratifs de la Ville de Lausanne, [n.d.], pp. 18–47.

8. I am indebted to Jagdish Mittal for this dating. Jagdish Mittal, conversation with author, Chicago, 1995.

9. Ajit Mookerjee and Madhu Khanna, *The Tantric Way: Art, Science, Ritual* (London: Thames and Hudson, 1977), pp. 66–69.

10. See Shantilal Nagar, *Garuda—the Celestial Bird* (New Delhi: Book India, 1992), pp. 110–11, for a discussion of this passage from the *Agni Purana* as a text conveying an aspect of Garuda, that is, Garuda as the destroyer of all kinds of poisons; while Nagar discusses the ritual meditation mentioned in the text as being aided by the use of an occult diagram, he does not provide an illustration.

11. I am indebted to Woodman Taylor for identifying the numerals on this work. Woodman Taylor, conversations with author, Chicago, and letter to author, 1994.

12. Collette Caillat and Ravi Kumar, *The Jain Cosmology*, trans. R. Norman (Basel, Paris, and New Delhi: Ravi Kumar, 1981; spec. ed., New York: Navin Kumar, 1981), pp. 54–55, fig. 10.

13. Mookerjee and Khanna, *Tantric Way*, p. 71.

14. Andhare, "Jain Monumental Painting," p. 83.

15. The similar formats employed in Jain game boards of Snakes and Ladders and in the cosmic man are also noted by Talwar and Krishna, *Indian Pigment Paintings on Cloth*, p. 84.

16. Ibid.

17. I am indebted to Manu Doshi for identification of the imagery in this work. Manu Doshi, telephone conversations with author, 1994. For more information on the *thavani* (also called *sthapana*), see Jyotintra Jain and Eberhard Fischer, *Objects of Meditation and the Pantheon*, vol. 2, *Jaina Iconography* (Leiden: Brill, 1978) pp. 10–11, 35; pl. 16.

18. I am grateful to Michael Rabe for reading the inscriptions on the paintings. Michael Rabe, conversation with author, Chicago, 1994.

19. I am indebted to Amit Ambalal for introducing me to Nathadwara painting and the *Pushti Marga* sect, for showing me many Nathadwara pictures in his collection, and for providing me with an introduction to Chiranjeevelal Sharma, a Nathadwara painter, and, through him, to other Nathadwara painters. Amit Ambalal, conversations with author, Ahmedabad, 1986.

20. For a survey of Nathadwara forms and styles, see O. P. Joshi, *Painted Folklore and Folklore*

Painters of India (A Study with Reference to Rajasthan) (Delhi: Concept Publishing Co., 1976), pp. 93–96; and Renaldo Maduro, *Artistic Creativity in a Brahmin Painter Community*, Research Monograph Series, no. 14 (Berkeley: Center for South and Southeast Asia Studies, University of California, 1976), pp. 58–70.

21. O. P. Joshi, for example, treats Nathadwara painting, defined principally by *pichavais* (painted cloth banners made for use in worship rituals), as a folk tradition—with many qualifications. *Painted Folklore and Folklore Painters of India*, pp. 72–97. Jyotindra Jain and Aarti Aggarwala include a large *pichavai* in the chapter "Painted Myths: Traditions of Indian Folk Painting" in their book, *National Handicrafts and Handlooms Museum* (Ahmedabad: Mapin Publishing, 1989), p. 118. Other scholars do not discuss Nathadwara painting as a folk tradition, primarily because of the sophisticated style of *pichavais*. I am grateful to Robert Skelton for his insight regarding this matter (letter to author, 1991).

22. I am indebted to Amit Ambalal for providing me with information on these small books of devotional images produced for Nathadwara pilgrims. Amit Ambalal, conversations with author, Ahmedabad, 1989, and letters to author, 1993–94.

23. Larger paintings on glass depicting Nathadwara imagery also survive. Whether they were produced by Nathadwara artists is unknown. Nathadwara paintings on glass are noted by Moreshwar G. Dikshit in *History of Indian Glass* (Bombay: University of Bombay, 1969), p. 127. For an example of a Nathadwara subject on reverse glass, see Jaya Appasamy, *Indian Paintings on Glass* (New Delhi: Indian Council for Cultural Relations, 1980), fig. 53.

24. For a comprehensive treatment of *pichavais*, see Robert Skelton, *Rājāsthānī Temple Hangings of the Kṛishṇa Cult from the Collection of Karl Mann, New York* (New York: American Federation of Arts, 1973).

25. For mention of small *pichavais* as pilgrims' souvenirs or their use in home shrines, see Moti Chandra, *The Technique of Mughal Painting* (Lucknow: U. P. Historical Society, Provincial Museum, 1949), p. 11; R. N. Mehta, "A Set of Decorative Textiles of *Pushṭimārgīya* Vaishṇavas in the Baroda Museum" and "An Annakūṭa Picchavāi," *Bulletin of the Baroda State Museum and Picture Gallery* (Baroda) 14 (1962): 20, and 20 (1968): 34; Jasleen Dhamija, "The *Pechwais* of Nathadwara," *Times of India Annual* (Bombay), 1965, p. 75; Saryu Doshi, "Dazzling to the Eye: Pichavais from the Deccan," in *Homage to Kalamkari* (Bombay: Marg Publications, [1978]), p. 68; and Talwar and Krishna, *Indian Pigment Paintings on Cloth*, pp. 13, 73.

26. For examples, see Amit Ambalal, *Krishna as Shrinathji: Rajasthani Paintings from Nathdvara* (Ahmedabad: Mapin Publishing, 1987), pp. 81 (bottom image), 82, 151.

27. Chiranjeevelal Sharma, conversation with author, Nathadwara, Rajasthan, and letter to author, 1986. For more information on materials and techniques of Nathadwara painting, see Talwar and Krishna, *Indian Pigment Paintings on Cloth*, pp. 73–77, and Ambalal, *Krishna as Shrinathji*, pp. 92–94.

28. Ambalal, *Krishna as Shrinathji*, p. 92.

29. For comments on the history of Nathadwara painting and on individual painters, see Skelton, *Rājāsthānī Temple Hangings of the Kṛishṇa Cult*, pp. 26–29; Talwar and Krishna, *Indian Pigment Paintings on Cloth*, p. 74; and Ambalal, *Krishna as Shrinathji*, pp. 85–92.

30. For a comprehensive treatment of this theme, see Ambalal, *Krishna as Shrinathji*.

31. For remarks on pilgrims' souvenir paintings of Shri Nathji in festival costume, see O. C. Gangoly, "A Group of Vallabhāchārya or Nāthdwāra Paintings and Their Relatives," *Bulletin of the Baroda State Museum and Picture Gallery* (Baroda) 1, pt. 2, February-July 1944 (1945): 31; G. N. Sharma, "Nathdwārā Paintings from the 17th to 20th Century A.D.," in *Indian History Congress, Proceedings of the 21st Session, 1958, Trivandrum*, ed. G. M. Morares et al. (Bombay: G. M. Morares for the Indian History Congress, 1959), pp. 558–59; Jasleen Dhamija, "Pechwais of Nathdwārā," p. 75; O. P. Joshi, *Painted Folklore and Folklore Painters*, pp. 93–94; R. Maduro, *Artistic Creativity in a Brahmin Painter Community*, pp. 67–68, 70–71; Ambalal, *Krishna as Shrinathji*, p. 79; Gulam Mohammed Sheikh, Preface to *Krishna as Shrinathji*, by Amit Ambalal, (Ahmedabad: Mapin Publishing, 1987), p. 7. For mention of *pichavais* for use in home shrines, see note 25.

32. I am indebted to Amit Ambalal for awareness of this term. Amit Ambalal, letter to author, 1994.

33. See Skelton, *Rājasthānī Temple Hangings*, p. 85, no. 2; p. 86, no. 3; p. 90, no. 12; p. 91, no. 13; and p. 95, no. 21; and Ambalal, *Krishna as Shrinathji*, pp. 28–29, 46.

34. Skelton, *Rājasthānī Temple Hangings*, p. 100.

35. Both features that can be helpful in dating the piece; for more information see Ambalal, *Krishna as Shrinathji*, pp. 83–84.

36. See Skelton, *Rājasthānī Temple Hangings*, p. 91, no. 14; p. 93, no. 17; p. 94, no. 19; and p. 96, no. 24.

37. Ambalal, letter, 1994.

38. See note 32.

39. I am indebted to Amit Ambalal for information on the custom of *gutkas*: the name of these books, the number and sequence of images, and their devotional use. See note 22.

40. Ambalal, letter, 1993.

41. Ibid.

42. I am indebted to Woodman Taylor for the transliteration and translation of the inscriptions on this set of paintings and for his help in identifying the images. Woodman Taylor, telephone conversations and conversations with author, Chicago, 1992–94, letter to author, 1992.

43. Talwar and Krishna, *Indian Pigment Paintings on Cloth*, p. 53.

44. Linda York Leach, *Indian Miniature Paintings and Drawings*, Cleveland Museum Catalogue of Oriental Art, pt. 1 (Cleveland: Cleveland Museum of Art in cooperation with Indiana University Press, 1986), pp. 106–7.

45. [Jagdish Mittal], *Indian Folk Paintings, 15th to 19th Century, from the Collection of Jagdish and Kamla Mittal Museum of Indian Art, Hyderabad* (New Delhi: Art CMC Gallery, 1990), p. 2. Also see Stuart Cary Welch's essay in this book.

46. Jyotindra Jain suggests, on the basis of "great similarity in drawing, pigmentation, narrative devices, divisions of spaces, rendering of costumes and facial and bodily features" in Garoda scroll painting of north Gujarat and the folkish miniatures originating in the same area, that Garoda scroll painters may have also produced miniatures illustrating legends and folktales. "The Painted Scrolls of the Garoda Picture-Showmen of Gujarat," *Quarterly Journal* (National Centre for Performing Arts, Bombay) 9, no. 3 (1980): 22.

47. Arkshaykumar Kayal, "Illustrated Manuscript (*Puthi*) and Cover-Designs (*Paataas*) in Bengal, *Folklore* (Calcutta) 13, no. 11 (September 1972): 353, 355.

48. Many of the spatial and figural conventions encountered in Indian folkish miniatures appear in the painting traditions of other cultures (such as Egypt) that can hardly be described as folkish. Many of the conventions seen in Indian folkish miniatures are, of course, derived not only from the courtly miniature traditions but also, through them, from the great pan-Indian style that was in practice throughout the subcontinent before the evolution of Mughal painting. Mughal painting, which originated under the patronage of Muslim rulers in North India in the late sixteenth century, synthesized the indigenous Indian conventions with the conventions of Persian and European painting. In some critical evaluations of this turn of events, the hybrid form became the defining standard of painterly sophistication, while the indigenous stylistic conventions that continued to be employed more or less independently in painting for some Hindu courts were by comparison unappreciated and even denigrated. While it is true that miniatures created for Hindu rulers employ indigenous conventions more than Mughal miniatures and are sometimes folkish in nature, whereas miniatures created for Muslim rulers employ synthesized conventions and are rarely folkishly rendered, that fact appears to be a matter of history and not an inevitability.

49. Scholarly attention to folkish miniatures has occurred principally in the context of exhibitions. Stuart Cary Welch has regularly included folkish expressions of miniature traditions; for some examples, see Stuart Cary Welch, *A Flower from Every Meadow: Indian Paintings from American Collections* (New York: Asia Society, 1973), nos. 5, 15, 25, 34. For further examples, also see [Jagdish Mittal], *Indian Folk Paintings*, pp. 5–6, 10–12, 16–25, 28. Also see Musée des Arts Décoratifs de la Ville de Lausanne, *Citrakaras*, pp. 68–77; Leach, as cited in note 44.

50. Stuart Cary Welch, *Indian Drawings and Painted Sketches, 16th through 19th Centuries* (New York: Asia Society, 1976), p. 27.

51. For another example of a first page of a manuscript honoring Ganesha and Sarasvati, see Stella Kramrisch, *Painted Delight: Indian Paintings from Philadelphia Collections* (Philadelphia:

Philadelphia Museum of Art, 1986), pp. 46, 164, fig. 39. For an example and descriptions of the practice of ritually invoking deities at the onset of narrative folk performances, see no. 56 and introductions to Garoda scroll paintings and "Paithan" or Chitrakathi paintings in Chapter 3, and introduction to painted shadow puppets of Andhra Pradesh in Chapter 7. Also see nos. 58–59.

52. Welch, *Indian Drawings and Painted Sketches,* p. 27. Also see Leela Shiveshwarkar, *The Pictures of the Chaurapañchāśikā: A Sanskrit Love Lyric* (New Delhi: National Museum, 1967).

53. I am indebted to Jagdish Mittal for this dating (conversation, 1995).

54. The depicted episode of the *Devi Mahatmya* that came to be contained in another text, the *Markandeya Purana,* is recounted in canto 87.

55. David Kinsley, *Hindu Goddesses: Visions of the Divine Feminine in the Hindu Religious Tradition* (Berkeley: University of California Press, 1986) pp. 161–65. For more information on the *Mahavidyas,* also see Philip [S.] Rawson, *The Art of Tantra* (Greenwich, Ct.: New York Graphic Society, 1973), pp. 130–34; Mookerjee and Khanna, *Tantric Way,* pp. 190–91.

56. See Philip S. Rawson, *Indian Painting* (Paris: Pierre Tisné; New York: Universe Books, [n.d.]), p. 152, for an almost identical representation of fighting monkeys; the image occurs within a Bengali scroll register depicting several episodes. The register containing the image is reproduced in *Arts of India: 1550–1900,* ed. John Guy and Deborah Swallow (London: Victoria and Albert Museum), p. 39, fig. 23.

57. I am indebted to T. Richard Blurton for assistance in the identification of this image. T. Richard Blurton, letter to author, 1993.

Chapter 5

1. Jaya Appasamy, *Tanjavur Painting of the Maratha Period* (New Jersey: Humanities Press, 1980), p. 70.

2. Jaya Appasamy, *Indian Paintings on Glass* (New Delhi: Indian Council for Cultural Relations, 1980), pp. 1–4.

3. Ibid., p. 9.

4. This brief description summarizes Appasamy's detailed survey of regional styles of glass painting, with illustrations, *Indian Paintings on Glass,* pp. 12–19, 25–36, figs. 1–86.

5. Appasamy, *Tanjavur Painting,* p. 70.

6. Appasamy, *Indian Paintings on Glass,* pp. 15, 17–18; for an example of a *burraq,* see fig. 5; for an example of a *tughra* in the form of a camel with a howdah, see fig. 60; for other examples of Muslim subject matter, see figs. 56–57, 61; for an example of a Sikh guru, see fig. 65.

7. For examples of a shrine and a window fitted with glass paintings, see ibid., figs. 37 and 80; fig. 39 shows a *torana,* though it is difficult to discern from the reproduction if the glass paintings depict Shri Nathji.

8. Appasamy comments that glass painting "never achieved the status of high art mainly because the medium was not practised by superior artists." Ibid., p. 20.

9. Ibid., p. 16.

10. Appasamy notes that while old glass paintings are rare in Indian museum collections (some exceptions being those produced for the court of Mysore that are now in the collection of the Jagmohan Palace Museum as well as those in the collection of Palace Museum of Kutch in Bhuj, Gujarat), many private individuals, both Indian and non-Indian, have been active in this century in collecting this formerly popular art. Ibid., pp. ix, 3, 20. Appasamy herself (1918–84) had a collection that was posthumously shown in the exhibition "Indian Paintings on Glass" at Manjusha Gallery, Rasaja Foundation, New Delhi, 1986.

11. For a similar picture on reverse glass, see Ministère de la Culture, Direction des Musées de France, *Dieux de l'Inde du Sud dans l'imaginarie populaire* ([Paris]: Sitecmo, Vauban Dieppe, 1982), p. 69, fig. 103.

12. For a similar picture on reverse glass, see Heinz Mode and Subodh Chandra, *Indian Folk Art,* trans. Peter and Betty Ross (Bombay: D. B. Taraporevala Sons and Co., 1985), fig. 383.

13. Appasamy states that idealized portraits of courtesans are in some instances based on real persons and in other instances simply represent an ideal type. Concerning the mistress of a ruler of

Maharashtra, she writes: "This lovely lady probably became the model for an ideal type which was painted frequently. Her oval face . . . was copied as the standard type of beauty in mistresses." *Indian Paintings on Glass*, pp. 15, 18.

14. See note 13.

Chapter 6

1. For a folkish example of a *tughra*, see Jaya Appaswamy, *Indian Paintings on Glass* (New Delhi: Indian Council for Cultural Relations, 1980), no. 60.

2. I am indebted to Philip Lutgendorf for awareness of the impact of literacy on devotional practices in India and for awareness of inscriptions on the interior walls of Hindu temples through his essay, "Banking on the Name," in which he describes the practice of writing short liturgical texts on temple walls for the benefit of literate devotees; and he also discusses the recent trend of inscribing entire temple interiors with long texts, citing as one example the Tulsi Manas Manir in Banaras, which has the text of the *Rāmcaritmānas* carved on its marble walls. Philip Lutgendorf, letter to author, 1993. The essay was subsequently published under the same title in *Journal of Vaisṇava Studies* (Brooklyn, N.Y.) 2, no. 2 (spring 1994): 147–62.

3. For examples, see Kay Talwar and Kalyan Krishna, *Indian Pigment Paintings on Cloth*, Historic Textiles of India in the Calico Museum, vol. 3 (Ahmedabad: Calico Museum of Textiles, 1979), pl. 102, no. 117, and p. 98; Andrew Topsfield, "The Indian Game of Snakes and Ladders," *Artibus Asiae* (Ascona) 46, no. 3 (1985): fig. 9.

4. Jyotindra Jain states that the *Vishnu Purana* is the basic source for images of punishments in the Garoda tradition. "Survival of 'Yamapattika' Tradition in Gujarat," in *Dimensions of Indian Art, Pupul Jayakar Seventy*, ed. Lokesh Chandra and Jyotindra Jain (Delhi: Agam Kala Prakashan, 1986), vol. 1, p. 182.

5. I am grateful to Amit Ambalal for drawing my attention to the Swaminarayan sect's tradition of picture albums illustrating punishments. Amit Ambalal, conversation with author, Ahmedabad, 1986.

6. See Ananda K. Coomaraswamy, "Picture Showmen," *Indian Historical Quarterly* (Calcutta) 5 (1929): 184–87.

7. For an example of a chart for reading the eye, see *Citrakaras: L'Imagerie populaire de l'Inde/Citrakaras: Indian Popular Images* (Lausanne: Musée des Arts Décoratifs de la Ville de Lausanne, 1981), pp. 34–35.

8. For examples of images used in the interpretation of dreams, see ibid., pp. 58–62. For a description of manuscripts used in interpreting dreams, also see K. C. Aryan and Subhashini Aryan, *Rural Art of the Western Himalaya* (New Dehli: Rekha Prakashan, 1985), p. 42.

9. These remarks summarize Rudolf von Leyden, *Ganjifa, The Playing Cards of India: A General Survey, with a Catalogue of the Victoria and Albert Museum Collection* (London: Victoria and Albert Museum, 1982), pp. 11–38.

10. Ibid., pp. 4, 28, 37.

11. Annalisa Colombara, Introduction to *Citrakaras l'Inde Chitrakaras: L'Imagerie populaire de Indian Popular Images*, trans. Catherine Debaca, ([Lausanne]: Musée des Arts Décoratifs de la Ville de Lausanne, 1981), p. 13.

12. I am indebted to Sheldon Pollock for identifying the texts in the painting and the date and the name of its scribe, for transliterating and translating all inscriptions presented in this entry, and for recommending the following bibliographic reference in which a complete translation of the text may be found: Thomas B. Coburn, *Encountering the Goddess: A Translation of the Devī-Māhātmya and a Study of its Interpretation* (Albany: State University of New York Press, 1991). Sheldon Pollock, conversations with author, Chicago, and letter to author, 1993. The *Devi Mahatmya* may also be found incorporated in the *Markandeya Purana* as cantos 81–93.

13. See K. C. Aryan and Subhashini Aryan, *Hanumān in Art and Mythology* (Delhi: Rekha Prakashan, [n.d.]), pp. 24, 33, and figs. 50–65.

14. Ibid., pp. 49–50.

15. I am indebted to several persons who assisted in the identification of various aspects of

this work. Woodman Taylor identified, among other things, inscriptions of the mantra Rama and their placement, which forms Hanuman's tongue and necklace (telephone conversations and conversations with author, Chicago, 1992–93). Philip Lutgendorf transliterated and translated other inscriptions included in this entry, discussed the devotional context of the work, and brought to my attention Hanuman's *kavaca* (letter to Stephen Prokopoff, 1993; letter to author, 1993). Fred Smith commented on the scribe, the placement of the mantra Rama, and the nature of the text located in the upper portion of the image (letter to author, 1994).

16. I am indebted to Woodman Taylor (telephone conversations and conversations with author, Chicago, 1992–93) and Philip Lutgendorf (letter to Stephen Prokopoff, 1993; letter to author, 1993) for identification of the text in this work. I am indebted to Philip Lutgendorf for insights on the devotional context in which this picture was made through his essay "Banking on the Name," subsequently published under the same title (see note 2).

17. I am indebted to Woodman Taylor for transliterating and translating the text on this piece, for help in identifying it as the genealogical tree of Vallabhacharya, and for informing me of its name, *vamsha vriksha*. Woodman Taylor, telephone conversations and conversations with author, Chicago, 1992–94. All dates for Vallabhacharya and members of his family are from the genealogy in Amit Ambalal, *Krishna as Shrinathji: Rajasthani Paintings from Nathdvara* (Ahmedabad: Mapin Publishing, 1987), p. 167.

18. See Robert Skelton, *Rājāsthānī Temple Hangings of the Kṛishṇa Cult* (New York: American Federation of Arts, 1973), pp. 58–63, pls. 14–16.

19. I am indebted to Michael Rabe for transliterating and translating the text of this work, which permitted its identification as the genealogical tree of Vallabhacharya's family (telephone conversations with author, 1992–94; letters to author, 1993–94). I am indebted to Woodman Taylor for discussions of this work in relation to the preceding work, no. 85, and for identifying it as a *vamsha vriksha* (telephone conversations and conversations with author, Chicago, 1992–94).

20. Madhu Khanna, *Yantra: The Tantric Symbol of Cosmic Unity* (London: Thames and Hudson, 1979), p. 33.

21. I am indebted to Michael Rabe for transliteration and translation of the inscription as well as for identification of the text (letters) in the *yantra*. Rabe notes that in this *yantra* the final consonant-vowel combination found in the ring closest to the center features the consonant conjunct *ksh* to complete the required number of thirty-six permutations. Michael Rabe, telephone conversations with author, 1992–93; letters to author, 1993–94.

22. For a similar *yantra* brought to my attention by Julia Emerson (letter to author, 1993), see Khanna, *Yantra*, p. 8.

23. I thank Fred Smith for identification of the numerals. Fred Smith, letter to author, 1994.

24. Stuart Cary Welch, *Indian Drawings and Painted Sketches, 16th through 19th Centuries* (New York: Asia Society, 1976), p. 28; for other folios from the same set, see ibid., p. 28, fig. 2, as well as [Jagdish Mittal], *Indian Folk Paintings, 15th to 19th Century from the Collection of Jagdish and Kamla Mittal Museum of Indian Art, Hyderabad* (New Delhi: CMC Art Gallery, 1990), no. 27. For examples from another book of omens, also see K. C. Aryan and Subhashini Aryan, *Rural Art of the Western Himalaya*, pp. 88–89, nos. 74–79.

25. Somalay (S. M. L. Lakshmanan Chettiar), *Folklore of Tamil Nadu* (New Delhi: National Book Trust, 1980), pp. 72–73.

26. This identification of the manuscript, made from photographs, was proposed by Kurikari, a woman from a Tamil Nadu village. I am indebted to Deborah Thiagarajan for securing this identification for me. Deborah Thiagarajan, letter to author, 1993.

27. Several individuals assisted with the identification of the images and inscriptions on this work; I am indebted to Michael Rabe and, through him, to Patricia Mumme (letter to Michael Rabe, 1993), also to Alf Hiltebeitel, who identified the goddess Ankalaparamecuvari (letter to author, 1993), and especially to David Buck, who provided several transliterations and translations of inscriptions, identified the fortune-teller, and commented on the number of hands inscribing the leaves (letters to author, 1993–94).

28. Information on *panchangas* and identification of iconography is based on Talwar and Krishna, *Indian Pigment Paintings on Cloth*, pp. 103–105, pls. 107A, B.

29. I am indebted to Michael Rabe for transliteration and translation of inscriptions throughout the work and for his help in dating the piece. Michael Rabe, telephone conversations with author, 1992–93, letters to author, 1993–94.

30. Topsfield, "The Indian Game of Snakes and Ladders," p. 203.

31. See ibid., pp. 203–11, figs. 1–11. Also see Talwar and Krishna, *Indian Pigment Paintings on Cloth*, p. 98, figs. 101–2.

32. Topsfield, "The Indian Game of Snakes and Ladders," pp. 203, 213–14, figs. 12–14. See Deepak Shimkhada, "A Preliminary Study of the Game of Karma in India, Nepal, and Tibet," *Artibus Asiae* (Ascona) 44, no. 4 (1983): fig. 7, for a contemporary Indian example.

33. Philip S. Rawson, *The Erotic Art of the East: The Sexual Theme in Oriental Painting and Sculpture* (New York: G. P. Putnam's Sons, 1968), p. 187 and fig. 127; Rudolf von Leyden, *Ganjifa, The Playing Cards of India*, p. 107.

34. Jagannatha, a form of the deity Krishna worshiped with his siblings at Puri temple, substitutes for Buddha, while Balarama or Balabhadra, Krishna's half-brother, substitutes for Krishna.

Chapter 7

1. I am indebted to Haku Shah for discussion of this tradition and for introducing me to the traditional artists Vaghi Lakshman Chitara and Dilip Vaghi Chitara. Haku Shah, conversations with author, Ahmedabad, 1986 and 1989.

2. In 1968, besides Ahmedabad, only one other active production center, Pitha Kotada on the penisula of Kathiawar (part of Gujarat), was noted; Dholka and Aghar, closer to Ahmedabad, were noted as former centers of production. [Joan Erikson], *Mata ni Pachedi: A Book on the Temple Cloth of the Mother Goddess* (Ahmedabad: National Institute of Design, 1968), map of Gujarat, n.p. According to John Irwin and Margaret Hall, writing in 1971, the Vaghris (*vagharis*), the artisan community that has made temple cloths for generations, were working only in Ahmedabad, after having been formerly settled in villages in areas surrounding the city. John Irwin and Margaret Hall, *Indian Painted and Printed Fabrics*, Historic Textiles of India at the Calico Museum, vol. 1 (Ahmedabad: Calico Museum of Textiles, 1971), p. 69.

3. For a comprehensive treatment of manifestations of the Mother Goddess in Gujarat, see Eberhard Fischer, Jyotindra Jain, and Haku Shah, *Tempeltücher für die Muttergöttinnen in Indien: Zeremonien, Herstellung, und Ikonographie gemalter und gedruckter Stoffbilder aus Gujarat* (Zurich: Rietberg Museum, 1982), pp. 59–92.

4. Eberhard Fischer, Jyotindra Jain, and Haku Shah, "*Mātāno Candarvo*: Textile Pieces for Goddess Worship in Gujarat," in *Homage to Kalamkari* (Bombay: Marg Publications, [n.d.]), p. 73. John Irwin and Margaret Hall call the square cloths *chandarvo* and the rectangular cloths *pachedi*. Irwin and Hall, *Indian Painted and Printed Fabrics*, p. 69.

5. Fischer, Jain, and Shah, "*Mātāno Candarvo*," p. 74.

6. Blenda Femenias, "Temple Cloths of Srikalahasti and Ahmedabad," in *Two Faces of South Asian Art: Textiles and Paintings*, by Blenda Femenias, Cynthia Cunningham Cort, and Joan A. Raducha (Madison: Elvehjem Museum of Art, University of Wisconsin-Madison, 1984), p. 11.

7. Fischer, Jain, and Shah, "*Mātāno Candarvo*," p. 7; Irwin and Hall, *Indian Painted and Printed Fabrics*, p. 69.

8. I am indebted to Lotika Varadarajan in New Delhi and J. K. Reddiyya in Hyderabad for discussion of the South Indian *kalamkari* traditions (conversations with author, 1989). I interviewed the *kalamkari* artists Mallipeddu Kailasam and R. Sundara Raju in Hyderabad and R. Emberumal (Naidu) in Sickinaikenpet, Tiruppanandal, Thanjavur district, Tamil Nadu, in 1989.

9. For a study of India's *kalamkari* production for its own and foreign markets, see Mattiebelle Gittinger, *Master Dyers to the World: Technique and Trade in Early Indian Dyed Cotton Textiles* (Washington, D.C.: Textile Museum, 1982).

10. The twenty-armed goddess is called Vihat by Fischer, Jain, and Shah, *Tempeltücher für die Muttergöttinnen in Indien*, pp. 79–80, figs. 156–57; Visota by [Erikson], *Mata ni Pachedi*, p. 48;

and Vishat by the artist, Dilip Vaghi Chitara (Dilip Vaghi Chitara, interview by author, Ahmedabad, 1989).

11. For more information, see Fischer, Jain, and Shah, *Tempeltücher für die Muttergöttinnen in Indien,* pp. 79–80.

12. For an image of a similarly doubled demon being slain by the goddess Vihat, who displays, however, only a single profile, see ibid., p. 189, fig. 386.

13. According to the artist, Dilip Vaghi Chitara, the two faces of the Goddess are necessary to catch the doubled demon (interview, 1989).

14. Fischer, Jain, and Shah, *"Mātāno Cardarvo,"* p. 74. Also see Fischer, Jain, and Shah, *Tempeltücher für die Muttergöttinnen in Indien,* fig. 258.

15. Identification of these images is based on Fischer, Jain, and Shah, *Tempeltücher für die Muttergöttinnen in Indien,* pp. 56–117.

16. Mel Helstein, "India," in *Asian Puppets: Wall of the World,* ed. various contributors (Los Angeles: UCLA Museum of Cultural History, University of California, 1976), pp. 19–20, 22.

17. For information on this tradition, I relied principally on M. Nagabhushana Sarma, *Tolu Bommalata: The Shadow Puppet Theatre of Andhra Pradesh* (New Delhi: Sangeet Natak Akademi, 1985).

18. For more information on the complex nature of the texts, see ibid., pp. 37–40.

19. Ibid., p. 42; for more information on the varying sizes of puppets and the varying number of movable joints according to locale, see Valentina Stache-Rosen, "On the Shadow Theatre in India," in *German Scholars on India,* ed. Cultural Department of the Embassy of the Federal Republic of Germany, New Delhi (Bombay: Nachketa Publications), vol. 2, p. 281; and Niels Roed Sorensen, "Shadow Theatre in Andhra Pradesh," *Sangeet Natak* (New Delhi) 33 (August 1974): 15–16.

20. For more information on stylistic influences, see Stache-Rosen, "On the Shadow Theatre in India," pp. 283–85.

21. For more information on the Andhra puppeteer population, see Nagabhushana Sarma, *Tolu Bommalata,* pp. 17–20, 46–48, 50, 57–58.

22. Nagabhushana Sarma, *Tolu Bommalata,* p. 42. For an illustration of Bhima's size relative to his brother princes, see ibid., p. 25; for an illustration of the same puppet in performance fighting Kichaka, see ibid., lower left, p. 53.

23. Ibid., p. 42.

24. For an overview of painted three-dimensional forms in various materials, media, and styles, see Jyotindra Jain and Aarti Aggarwala, *National Handicrafts and Handlooms Museum, New Delhi* (Ahmedabad: Mapin Publishing, 1989), pp. 80–81, 89–99, 122, 173–208.

25. Ibid., p. 90. Also see p. 185.

26. For a Company painting of a mendicant's wife carrying on her head a portable shrine with painted panels, see Mildred Archer, *Company Paintings: Indian Paintings of the British Period* (London and Ahmedabad: Victoria and Albert Museum in association with Mapin Publishing, 1992), p. 60, no. 26 (ptg. 10). For a photograph of a similar subject, see *Aditi: The Living Arts of India* (Washington, D.C.: Smithsonian Institution Press, 1985), p. 155, top left. A large *kavad* in the collection of the Denver Art Museum (acc. no. 1985.550), a choice example from the early twentieth century, measuring 31" (H.) x 18" (W., closed) x 10¾" (D.), portrays the legend of Krishna on its many panels and, according to its inscription, was used by a mendicant to collect donations to support a charitable cow shelter (*gaushala*) (I am indebted to Philip Lutgendorf for translation of the inscription; conversation with author, Chicago, 1994); this portable shrine with narrative folding panels had been requested by the author for loan for the exhibition that this publication documents; the work was, unfortunately, judged too fragile to travel. Miniature shrines, produced for pilgrims, children, and tourists, some with narrative panels, are more common.

27. For illustrations of the range of iconic forms produced at Molela, see Haku Shau, *Form and Many Forms of Mother Clay: Contemporary Indian Pottery and Terracotta* (New Delhi: National Crafts Museum, 1985), pp. 131–33.

28. For information on *saras,* see Gurusaday Dutt, "The Painted Sarās of Rural Bengal," *Journal of the Indian Society of Oriental Art* (Calcutta) 2, no. 1 (June 1934): 28–29.

29. Information about this work was provided by its artist, D[analakota] Chandraiah, a member of the Nakash caste of scroll painters (interview by author, assisted by Sandra Maheshwari and Saroj Dhruvu, Cheriyal, Warangal district, Andhra Pradesh, 1989). For a similar figure identified as "Yellamma-Gangamma," see *Aditi* (New Delhi: Handicrafts and Handlooms Exports Corporation of India, 1982), fig. 35. Compare other figures from a similar set: Jain and Aggarwala, *National Handicrafts and Handlooms Museum*, p. 201; Ajit Mookerjee, *Crafts Museum* (New Delhi: Crafts Museum, 1971), p. 22, fig. 11, and p. 23, fig. 12; the alternate caste name for the narrators of the legend of Karihavala Raju is from Jain and Aggarwala, National Handicrafts and Handlooms Museum, p. 201. Also compare an enshrined, ten-armed goddess figure, wearing a checkered sari, holding a trident, and identified as "Peddamma" in an Andhra painting with scroll registers; Lalit Kala Akademi, *Traditional Paintings: Old and New, An Exhibition of Existing Schools of Traditional Painting in India* (New Delhi: Lalit Kala Akademi, 1989), cover. Also compare a sculptural image identified as a serpent goddess (papier-mâché, Nirmal, Andhra Pradesh); D. N. Saraf, *Indian Crafts: Development and Potential* (New Delhi: Vikas Publishing House, 1982), p. 29.

Select Bibliography

The study of Indian popular paintings involves a vast body of literature written from many perspectives. In an attempt to assist the reader interested in pursuing aspects of this complex subject, the books and articles presented here are accompanied by annotations that indicate that the listed works contain references to—or illustrations of—one or more forms of Indian popular painting. The bibliography, though lengthy and ambitious in its attempt to sort out a large number of studies, is not exhaustive. The bibliography is limited to studies accessible to the author and, with a few exceptions, to studies in the English language. Studies of some forms of popular painting, such as figurative murals that are decorative in function and folkish in style or that are folkish manifestations of sophisticated traditions, are included in the bibliography, though such paintings are beyond the scope of this book. Though cited in the notes to the text, anthropological or sociological studies are not included here, unless they contain references to forms of popular painting.

A key to the annotations follows.

And	Andhra or Telangana scroll paintings
Ben	Bengali scroll and single-image paintings
BWc	Battala woodcuts
Gar	Garoda scroll paintings
Gla	Glass, paintings on reverse
Jad	Jadupatua scroll and ritual paintings
Jai	Jain tradition, paintings informed by the
Klg	Kalighat paintings
Mad	Mithila or Madhubani paintings
Mal	Mali paintings
Min	Miniature traditions, paintings informed by
Mur	Mural paintings
Nth	Nathadwara tradition, paintings informed by the
Pai	"Paithan" or Chitrakathi paintings

Par	*Par* paintings
PPC	Painted and printed (temple) cloths
Prn	Printed images, other than Battala woodcuts, including those mechanically produced
PSPu	Painted shadow puppets, especially those of Andhra Pradesh
Pur	Puri paintings
Rit	Ritual floor and wall painting traditions (Hindu)
TaM	Tanjore and Mysore paintings
Tri	Tribal ritual and decorative painting traditions
War	Warli paintings
2DP	Two-dimensional painted works serving didactic, divinatory, and other cultural functions
3DP	Three-dimensional painted artifacts

Abraham, T. M. *Handicrafts in India*. New Delhi: Graphics Columbia, 1964. [PPC, 3DP]

Agarawala, Ram Avatar. *Marwar Murals*. Delhi: Agam Prakashan, 1977. [Mur]

Allen, Marguerite. "The Jagannath Car Festival." *Mārg* (Bombay) 8, no. 4 (September 1955): 66–69, 81. [Pur, 2DP, 3DP]

Alliance Française of Calcutta and Crafts Council of West Bengal. *Patua Art: Development of the Scroll Paintings of Bengal Commemorating the Bicentenary of the French Revolution*. Calcutta: Alliance Française, [1991]. [Ben]

All India Handicrafts Board. *Indian Kalamkari*. New Delhi: All India Handicrafts Board, Government of India, Ministry of Industry, [n.d.]. [PPC]

Ambalal, Amit. *Krishna as Shrinathji: Rajasthani Paintings from Nathdvara*. Ahmedabad: Mapin Publishing, 1987. First published, New York: Mapin International, 1987. [Mur, Nth, Prn]

Ammandale, N. "Plant and Animal Designs in the Mural Decorations of an Uriya Village." *Memoirs of the Asiatic Society of Bengal* (Calcutta) 8, no. 4 (1929): 241–48, pls. 1–4. [Rit]

Anand, Mulk Raj. *Album of Indian Paintings*. New Delhi: National Book Trust, 1973. [Klg, Pur]

———. "The Hand and the Heart: Notes on the Creative Process in the Folk Imagination." *Mārg* (Bombay) 12, no. 4 (September 1969): 4–10.

———. *Madhubani Painting*. New Delhi: Publications Division, Ministry of Information and Education, Government of India, 1984. [Mad]

Andhare, Shridhar. "*Citrakathī* Tradition of Painting." In *Ajaya-Sri: Recent Studies in Indology. Prof. Ajay Mitra Shasti Felicitation Volume*, edited by Devendra Handa, vol. 2, 527–33, figs. 172–80. Delhi: Sundeep Prakashan, 1989. [And, Gar, Jad, Pai, Par, PSPu, Pur]

———. "Jain Monumental Painting." In *The Peaceful Liberators: Jain Art from India*, by Pratapaditya Pal et al., 77–86. New York and London: Thames and Hudson; Los Angeles: Los Angeles County Museum of Art, 1994. [Jai, 2DP]

———. "Painted Banners on Cloth: *Vividha-Tirtha-Paṭa* of Ahmedabad." In *Homage to Kalamkari*, 40–44. Bombay: Marg Publications, [1978]. Also published, *Mārg* (Bombay) 31, no. 4 (September 1978): 40–44. [Jai]

Appasamy, Jaya. "Early Calcutta Lithographs." *Lalit Kalā Contemporary* (New Delhi), no. 31 [n.d.]: 13–16ff. Reprinted in *The Critical Vision: Selected Writings*, by Jaya Appasamy (New Delhi: Lalit Kala Akademi, 1985), 74–80. [Prn]

———. "Early Calcutta Wood Engravings." *Visva Bharati Quarterly* (Santiniketan) 39, nos. 3–4 (1973–74): 260–67. [BWc]

———. "The Folk Inspiration in Modern Indian Painting." In *Indian Aesthetics and Art Activities: Proceedings of a Seminar*, vol. 2, 111–19. Simla: Indian Institute of Advanced Studies, 1968. Reprinted in *The Critical Vision: Selected Writings*, by Jaya Appasamy (New Delhi: Lalit Kala Akademi, 1985), 5–15; *Roopa-Lekhā* (New Delhi) 59 (April 1987): 39–45; *Sixty Years of Writing on Art and Crafts in India (from Roopa-Lekhā, 1928–1988)*, ed. Ram Dhamija (New Delhi: Sterling Publishers, 1988), 161–65. [Klg, 3DP]

———. "Folk Painting on Glass." *Lalit Kalā Contemporary* (New Delhi), no. 9 [September 1968]: 39–41ff. [Gla, TaM]

———. *Indian Paintings on Glass*. New Delhi: Indian Council for Cultural Relations, 1980. [Gla, Klg, Mur, TaM, 3DP]

———. "Painting on Glass in Southern India." *Oriental Art* (London), n.s., 21, no. 2 (summer 1975): 153–57. [Gla, TaM]

———. *Tanjavur Painting of the Maratha Period*. New Delhi: Abhinav Publications, 1980; New Jersey: Humanities Press, 1980. [Gla, Min, Prn, TaM, 2DP, 3DP]

Archana [Shastri, Archana]. *The Language of Symbols: A Project on South Indian Ritual Decorations of a Semi-Permanent Nature*. Edited by Gita Narayanan. Madras: Crafts Council of India, [1989?]. [Rit]

Archer, Mildred. *Company Paintings: Indian Paintings of the British Period*. Victoria and Albert Museum: Indian Art Series. Middletown, New Jersey: Grantha Corporation, 1992; London and Ahmedabad: Victoria and Albert Museum in association with Mapin Publishing, 1992. [Gla, Pur, TaM, 3DP]

———. "Domestic Arts of Mithila: Notes on Painting." *Mārg* (Bombay) 20, no. 1 (December 1966): 47–51. [Mad]

———. *Indian Popular Painting in the India Office Library*. London: Her Majesty's Stationery Office, 1977. [Ben, BWc, Klg, Jad, Mad, Mal, Pur, Rit]

[Archer, Mildred]. *Indian Miniatures and Folk Paintings from the Collection of Mildred and W. G. Archer*. Exh. cat. London: Arts Council of Great Britain, 1967. [Jad, Klg, Pur]

[———]. *Indian Paintings from Court, Town, and Village*. Exh. cat. London: Arts Council of Great Britain, 1970. [Jad, Klg, Mad, Pur]

Archer, Mildred, and W. G. Archer. *Indian Painting for the British, 1770–1880*. Oxford: Oxford University Press, 1955. [Gla, TaM]

———. "Santhal Painting." *Axis* (London), no. 7 (August 1936): 27–28. [Tri]

Archer, W. G. *Bazaar Paintings of Calcutta: The Style of Kalighat*. London: Her Majesty's Stationery Office for Victoria and Albert Museum, 1953. [Ben, BWc, Klg]

———. "Diwali Painting." *Man in India* (Ranchi) 24 (1944): 82–84. [Rit]

———. *The Hill of Flutes: Life, Love, and Poetry in Tribal India, A Portrait of the Santals*. [Pittsburgh]: University of Pittsburgh Press, 1974. First published, [London]: George Allen and Unwin, 1974. [Jad]

———. *India and Modern Art*. New York: Macmillan, 1959. First published, London: George Allen and Unwin, 1959. [Ben, Klg, Mad]

———. *Kalighat Drawings from the Basant Kumar Birla Collection (Formerly Ajit Ghose Collection)*. Birla Series of Indian Art. Bombay: Marg Publications, 1962. [Klg]

———. "Kalighat Painting." *Mārg* (Bombay) 5, no. 4 (1952): [n.p.]. [Klg]

———. *Kalighat Paintings*. London: Her Majesty's Stationery Office for Victoria and Albert Museum, 1971. [Ben, BWc, Klg]

———. "Maithil Painting." *Mārg* (Bombay) 3, no. 3 (1949): 24–33. [Mad]

Arts Council of Great Britain. *In the Image of Man: The Indian Perception of the Universe through 2000 Years of Painting and Sculpture*. Exh. cat., Festival of India in Britain, Hayward Gallery, London. London: Arts Council of Great Britain in association with George Wiedenfeld and Nicolson, 1982; New York: Alpine Fine Arts Collection, 1982. [Jai, Min, Nth, 2DP]

———. *The Living Arts of India: Craftsmen at Work*. Exh. cat., Festival of India in Britain. London: Arts Council of Great Britain, 1982. [Mur, Nth, PPC, 3DP]

Aryan, B. N. "The Art of Ganjifa: Traditional Indian Card Game." *Arts of Asia* (Hong Kong) 19, no. 2 (March-April 1989): 175–79. [2DP]

Aryan, K. C. *Unknown Pahari Wall Paintings in North India*. New Delhi: Rekha Prakashan, 1990. [Mur]

Aryan, K. C., and Subhashini Aryan. *Hanumān in Art and Mythology*. Delhi: Rekhas Prakashan, 1975. [Gla, Jai, Klg, Mad, Min, Mur, Pai, PSPu, 2DP, 3DP]

———. *Rural Art of the Western Himalayas*. New Delhi: Rekha Prakashan, 1985. [Min, Mur, Rit, 2DP, 3DP]

Ashmolean Museum. *Paintings of Jagannātha: An Exhibition of Puri Paintings from the Collection of Mildred and W. G. Archer.* Exh. cat. Oxford: Department of Eastern Art, Ashmolean Museum, 1967. Mimeographed. [Pur]

Auden, Sheila. "Dolls and Toys." *Art in Industry* (Calcutta) 2, no. 2 (March 1951): 1–6. [3DP]

Awasthi, Suresh. "Indian Puppet Theatre: Its Revival and Reconstruction." In *Puppet Theatre around the World*, edited by Som Benegal et al., 29–34. New Delhi: Bharatiya Natya Sangh, 1960. [PSPu]

———. "Puppet Theatre of India." *Arts of Asia* (Hong Kong) 5, no. 5 (September-October 1975): 46–54. [PSPu]

Banks, Colin. "Murals at Nath Dwara: A Unique View of Indian Temple Painting." *Connoisseur* (London) 206, no. 829 (March 1981): 202–4. [Mur, Nth, Prn]

Barbin, Christina. "Les femmes peintres du Mithila." *Message d'Extrême Orient* (Brussels) 4, nos. 15–16 (1974–75): 1121–28. Mimeographed. [Mad]

Basu, Ashish. *Handicrafts of W. Bengal—A Retrospect.* Calcutta: Ashish Basu, 1990. [Ben, Klg, 2DP, 3DP]

Beach, Milo C. *The Art of India and Pakistan.* Exh. cat. Durham, N.C.: Duke University Institute of the Arts, 1985. [Min, Nth, Pai, PSPu]

Behera, Karuna Sagar, ed. *Folk Art and Crafts.* Vol. 3, *Folk Culture.* Cuttack (Orissa): Institute of Oriental and Orissan Culture, [1983?]. [Ben, Mad, Rit, Tri, 2DP, 3DP]

Bell, R. C. "Snakes and Ladders." In *Board and Table Games from Many Civilizations*, vol. 2, 10–11. London: Oxford University Press, 1969. [2DP]

Benegal, Som, et al., eds. *Puppet Theatre around the World.* New Delhi: Bharatiya Natya Sangh, 1960. First published, *Natya* (New Delhi): [n.d.]. [PSPu]

Bhatt, Jyoti. "Mandana: Wall and Floor Decorations." *India Magazine* (Bombay) 12, no. 7 (June 1992): 70–79. [Rit]

———. "Sanja: A Traditional Art Form." *India Magazine* (Bombay) 11, no. 12 (November 1991): 20–31. [Rit]

Bhattacharjee, Binoy. *Cultural Oscillation: A Study of Patua Culture.* Calcutta: Naya Prakash, 1980. [Ben]

Bhattacharya, Binoy. "Les Pats et les Patuas du Bengale." In *Patua Art: Development of the Scroll Paintings of Bengal Commemorating the Bicentenary of the French Revolution*, by Alliance Française of Calcutta and the Crafts Council of West Bengal, 26–29. Calcutta: Alliance Française, [1991]. [Ben, Jad]

Bhattacharya, Bholanath. "Folk Arts and Crafts of Bengal: An Appreciation." *Folklore* (Calcutta) 23, no. 6 (June 1982): 133–35.

———. "Folk Arts and Crafts of Bengal: An Appreciation—II." *Folklore* (Calcutta) 23, no. 7 (July 1982): 152–54.

———. *Krishna in the Traditional Painting of Bengal.* Calcutta: Kamal Banerjee, 1972. [Ben, BWc, Jad, Klg, Mad, Min, Nth, PSPu, Pur, Rit, Tri, 2DP, 3DP]

———. "Occupational Mobility and Kalighat Patuas: A Sample Survey." *Folklore* (Calcutta) 13, no. 10 (October 1972): 369–76. Reprinted as "The Evolution of the Kalighat Style and the Occupational Mobility of the Patuas." In *The Patas and Patuas of Bengal*, ed. Sankar Sen Gupta (Calcutta: Indian Publications, 1973), 77–84. [Ben, Klg, Prn, 2DP, 3DP]

———. "The Role and Place of Folk Arts in Urban Culture, with Special Reference to West Bengal." *Folklore* (Calcutta) 23, no. 8 (August 1982): 172–73, 178.

Bhattacharya, Devashis. "Three Incidental Interviews about 'Pata'." *Folklore* (Calcutta) 13, no. 10 (October 1972): 377–81. [Ben, Klg, Rit, 3DP]

Bhattacherjee, Binoy. "The Patuas—A Study on Islamization." *Folklore* (Calcutta) 13, no. 10 (October 1972): 361–68. Reprinted under the name Binoy Bhattacharya in *The Patas and the Patuas of Bengal*, ed. Sankar Sen Gupta (Calcutta: Indian Publications, 1973), 95–100. [Ben]

Bhavnani, Enakshi. *Decorative Designs and Craftsmanship of India.* Bombay: D. B. Taraporevala Sons and Co., 1968. [PPC, Rit, 3DP]

———. *Folk and Tribal Designs of India.* Bombay: D. B. Taraporevala Sons and Co., 1974. [Mad, Pur, Rit, Tri, 3DP]

Bhowmik, Suhrid Kumar. "A Note on the Patuas of Bengal." *Folklore* (Calcutta) 10, no. 7 (July 1971): 251–57. [Ben, Jad, Klg]

———. "Sahibpat." In *Patua Art: Development of the Scroll Paintings of Bengal Commemorating the Bicentenary of the French Revolution*, by Alliance Française of Calcutta and the Crafts Council of West Bengal, 12–13. Calcutta: Alliance Française, [1991]. [Ben]

Birdwood, George C. M. *The Industrial Arts of India*. 2 vols. South Kensington Museum Art Handbooks. London: R. Clay, Sons, and Taylor, 1880. [Rit]

Blurton, T. Richard. "Continuity and Change in the Tradition of Bengali Paṭa-Painting." In *Shastric Traditions in Indian Arts*, edited by Anna Libera Dallapiccola in collaboration with Christine Walter-Mendy and Stephanie Zingel-Avé Lallemant, vol. 1, 425–51; vol. 2, pls. 151–71. Stuttgart: Steiner Verlag Wiesbaden GMBH, 1989. [Ben]

———. *Hindu Art*. Cambridge, Mass.: Harvard University Press, 1993. [Ben, Gla, Mad, PPC, Pur, Rit, TaM, 2DP]

———. "Scroll-Paintings in the British Museum from Murshidabad District." In *Patua Art: Development of the Scroll Paintings of Bengal Commemorating the Bicentenary of the French Revolution*, by Alliance Française of Calcutta and the Crafts Council of West Bengal, 32–37. Calcutta: Alliance Française, [1991]. [Ben]

———. "Tradition and Modernism: Contemporary Indian Religious Prints." *South Asia Research* (London) 8, no. 1 (May 1988): 47–69, figs. 1–9. [Prn]

Bonnerjea, Biren. "Note on Geometrical Ritual Designs in India." *Man* (London) 33 (October 1933): 163–64. [Rit]

Bose, P. N. "Three Specimens of Santal Drawing." *Man in India* (Ranchi) 5 (1925): 235–36. [Tri]

Brown, Carolyn Henning. "Folk Art and the Art Books: Who Speaks for the Traditional Artists?" Review of *The Art of Mithila: Ceremonial Paintings from an Ancient Kingdom*, by Yves Vequaud. *Modern Asian Studies* (London) 16, no. 3 (1982): 519–22. [Mad]

———."The Women Painters of Mithila." In *Festival of India in the United States 1985–1986*, [by various contributors], 155–61. New York: Harry N. Abrams, 1985. [Mad]

Bulletin—National Museum, New Delhi (New Delhi) 1 (1966). [PPC, 3DP]

Bussabarger, Robert F., and Betty Dashew Robins. *The Everyday Art of India*. New York: Dover Publications, 1968. [Par, PPC, Pur, Rit, 2DP, 3DP]

———. "Folk Images of Sanhji Devī." *Artibus Asiae* (Ascona) 36, no. 4 (1974): 295–306. [Rit]

Caillat, Collette, and Ravi Kumar. *The Jain Cosmology*. Translated by R. Norman. Basel, Paris, New Dehli: Ravi Kumar, 1981; special edition, New York: Navin Kumar, 1981. [Jai]

Calico Museum of Textiles. *Jaina Textiles, Manuscripts, Sculpture, Ceremonial Objects, and Woodwork*. Gallery notes. Ahmedabad: Calico Museum of Textiles, [n.d.]. [Jai, 2DP, 3DP]

California State College, Fullerton. *India: Arts of the People—Tribal/Village/Town*. Exh. cat. Fullerton: California State College, 1970. [Ben, Nth, Par, PPC, PSPu, 2DP, 3DP]

Cameron, Nigel. "Gods, Girls, and Some Pukka Sahibs: Brilliant Art of the Folk-Painters of Calcutta Bazaars." *Orientations* (Hong Kong) 3, no. 1 (January 1972): 48–60. [Klg]

Carey, Frances, ed. *Collecting the 20th Century*. Exh. publ. London: British Museum Press, 1991. [Ben, Pur]

Center for Puppetry Arts (Atlanta, Georgia). *Puppetry of India: An Exhibition of Figures Celebrating India's Culture*. Exh. cat. Atlanta, Ga.: Center for Puppetry Arts, 1986. [PSPu, 3DP]

Chakrabarti, Jayanta. "Kalighat Painting." *Bulletin of the Victoria Memorial* (Calcutta) 6–7 (1972–73): 57–63. [Ben, Klg]

[Chakrabarti, Jayanta]. *Kalighat Painting in the Collection of Nandan Museum*. Santiniketan: Nandan, Kala Bhavana, 1986. [Klg]

Chakraborty, Ashis Kumar. "Ramayana in the Scroll Paintings of Bengal." In *Patua Art: Development of the Scroll Paintings of Bengal Commemorating the Bicentenary of the French Revolution*, by Alliance Française of Calcutta and the Crafts Council of West Bengal, 9–10. Calcutta: Alliance Française, [1991]. [Ben]

Chakraborty, Sunil. "Laksmir Pat: A Study on Painted Earthen Lid Bearing the Image of Laksmi." In *Folk Art and Craft*, edited by Karuna Sagar Behera, vol. 3, *Folk Culture*, 133–40. Cuttack (Orissa): Institute of Oriental and Orissan Culture, [1983?]. [3DP]

Chand, Ramesh. "The Painted Terra-Cotta Wall Plaques of Molela Village." In *Folk Arts of India:*

Metal, Ceramics, Jewelry, Textiles, and Wood, by Ruth Reeves, edited by Alexandra K. Schmeckebier, 57–62. Syracuse, N.Y.: School of Art, Syracuse University, 1967. [3DP]

Chandra, Moti. *Jain Miniature Paintings from Western India.* Ahmedabad: Sarabhai Manilal Nawab, 1949. [Jai, 2DP]

[Chandra, Pramod, Jane Werner Watson, et al.]. *Indian Miniature Painting: The Collection of Earnest C. and Jane Werner Watson.* Exh. cat. Madison: Elvehjem Art Center, University of Wisconsin, Madison, 1971. [Min, Nth, Pur, TaM]

Chandra, Sarat. "The Art and Craft of Patta Painting." *Arts of Asia* (Hong Kong) 21, no. 4 (July-August 1991): 139–45. [Pur, 3DP]

Chatterjee, Ashoke. "Challenges of Transition: Design and Craft in India." In *Making Things in South Asia: The Role of Artist and Craftsman,* edited by Michael W. Meister, Proceedings of the South Asia Seminar 4, 1985–86, 3–9. Philadelphia: Department of South Asia Regional Studies, University of Pennsylvania, 1988.

Chatterji, Tapan Mohan. *Alpona: Ritual Decoration in Bengal.* With notes by Tarak Chandra Das. Reprinted, Calcutta: Orient Longmans, 1965. First published, Bombay: Orient Longmans, 1948. [Rit]

Chattopadhyay, Kamaladevi. "Art and Craft of Rajasthan." *Pushpanjali* (Bombay), no. 4 (1980): 46–51. [Mur, 3DP]

———. "Attributes of Folk Art." *Eastern Anthropologist* (Lucknow) 24, no. 2 (May-August 1971): 125–32.

———. "The Ecology of Folk Art." *Indian Horizons* (New Delhi) 26, no. 2 (1977): 5–10.

———. *The Glory of Indian Handicrafts.* New Delhi: Indian Book Co., 1976. [Ben, Nth, Par, PPC, PSPu, Pur, Rit, 3DP]

———. *Handicrafts of India.* 2nd rev. ed. New Delhi: Indian Council for Cultural Relations, 1985. First published, New Delhi: Indian Council for Cultural Relations, 1975. [Gla, Mad, Mur, Nth, PPC, PSPu, Pur, Rit, TaM, 2DP, 3DP]

———. "Handicrafts of Tamilnadu." *Indian Horizons* (New Delhi) 37, nos. 3–4 (1988): 1–5. [PPC, 3DP]

———. "Heady Magic of Handicrafts." In *Times of India Annual* (Bombay), 1977, 71–76. [Nth, Par, PPC, Pur]

———. *Indian Handicrafts.* New Delhi: Indian Council for Cultural Relations, 1963. [PPC, 3DP]

———. *India's Craft Tradition.* New Delhi: Publications Division, Ministry of Information and Broadcasting, Government of India, 1980.

———. "The Media of Puppetry." *Indian Horizons* (New Delhi) 35, nos. 1–2 (1986): 1–4. [PSPu]

Chattopadhyay, K. P. "Art of Tribal Folk." *Journal of the Assam Research Society* (Gauhati) 13 (1959): 34–36. [Rit, Tri, 3DP]

Chaudhuri, Sankho. "Tribal Art in India—A Way of Life." *Visva Bharati Quarterly* (Santiniketan) 46, nos. 1–4 (May 1980-April 1981): 193–207. [Jad, Tri, War, 3DP]

Chavan, Kamal. "Mural Tradition." *Mārg* (Bombay) 34, no. 2 [1982?] (special issue: The Art of Chhatrapatis and Peshwas): 73–84. [Mur]

Chavda, Jagdish J. "The Narrative Paintings of India's Jitwarpuri Women." *Woman's Art Journal* (Knoxville, Tennessee) 11, no. 1 (spring-summer 1990): 26–28. [Mad]

Chinmulgund, P. J. "Paithan Paintings." In *Times of India Annual* (Bombay), 1962, 67–72. [Pai]

Chitrakar, Ishat. "*Chanson d'un Sahibpat interprétée par Ishat Chitrakar de Muradpur.*" Collected by David McCutchion and Suhrid Kumar Bhowmick, 1970. In *Patua Art: Development of the Scroll Paintings of Bengal Commemorating the Bicentenary of the French Revolution,* by Alliance Française of Calcutta and Crafts Council of West Bengal, 15. Calcutta: Alliance Française, [1991]. [Ben]

Chopra, P. N., ed. *Tribal Arts and Crafts of India.* Our Cultural Fabric [Series]. New Delhi: Ministry of Education and Culture, Government of India, 1982. [Tri, War, 3DP]

Codrington, K. de B. "The Minor Arts of India." In *Indian Art,* edited by Richard Winstedt, 151–92. London: Faber and Faber, 1947. [Rit, 3DP]

Colombara, Annalisa. Introduction to *Citrakaras: L'Imagerie populaire de l'Inde/Citrakaras: Indian Popular Images,* translated by Catherine Debaca, 12–15. [Lausanne]: Musée des Arts Décoratifs de la Ville de Lausanne, 1981. [Jai, Min, Par, Rit, 2DP, 3DP]

Contractor, Meher. *The Shadow Puppets of India*. Darpana Monograph Series, vol. 2. Ahmedabad: Darpana Academy of the Performing Arts, 1984. [PSPu]

———. "Various Types of Traditional Puppets of India." *Mārg* (Bombay) 11, no. 3 (June 1968): 6–43. [PSPu, 3DP]

Coomaraswamy, Ananda K. "A Bengali Painting." *Bulletin of the Museum of Fine Arts* (Boston) 30, no. 178 (April 1932): 49. [Ben]

———. *The Indian Craftsman*. London: Probsthain and Co., 1909.

———. "The Nature of Folklore and Popular Art." *Quarterly Journal of the Mythic Society* (Bangalore), n.s., 27, nos. 1–2 (July-October 1936): 1–12. Reprinted in *Indian Art and Letters* (London) 11 (1937): 76–84; *Why Exhibit Works of Art?*, by Ananda K. Coomaraswamy (London: Luzac and Co., 1943) (which was reprinted as *Christian and Oriental Philosophy of Art* [New York: Dover Publications, 1956]), 130–43.

———. "Picture Showmen." *Indian Historical Quarterly* (Calcutta) 5 (1929): 182–87.

———. "'Spiritual Paternity' and the 'Puppet Complex': A Study in Anthropological Methodology." *Psychiatry* (New York) 8, no. 3 (August 1945): 287–97.

Cooper, Ilay. "The Painted Walls of Churu, Jhunjhunu, and Sikar Districts of Rajasthan." *South Asian Studies* (London) 2 (1986): 21–35. [Mur]

———. *Rajasthan: The Guide to Painted Towns of Shekhawati and Churu {with Street Maps}*. Churu: Arvind Sharma, [1991]. [Mur]

Cort, John E. "Following the Jina, Worshiping the Jina: An Essay on Jain Rituals." In *The Peaceful Liberators: Jain Art from India*, by Pratapaditya Pal et al., 39–54. New York and London: Thames and Hudson; Los Angeles: Los Angeles County Museum of Art, 1994. [Jai]

Craven, Jr., Roy C. "Indian Reverse Painting on Glass." *Arts of Asia* (Hong Kong) 13, no. 1 (January-February 1983): 67–75. [Gla]

———. "A Svetambara Jain Shrine." *Pharos* (St. Petersburg, Fla.) 16, no. 2 (1979): 16–23. [Jai, 3DP]

Czuma, Stanislaw, and W. G. Archer. *Indian Art from the George P. Bickford Collection*. Exh. cat. Cleveland: Cleveland Museum of Art, 1975. [Klg, Pai]

Dahmen-Dallapiccola, Anna Libera. "Kalighat Paintings in the J. u. E. von Portheim-Stiftung, Heidelberg." *RACAR, Review d'Art Canadienne, Canadian Art Review* (Quebec) 2, no. 2 (1975): 25–36. [Klg]

Dallapiccola, Anna Libera. *Die „Paithan"-Malerei: Studie zu ihrer stilistischen Entwicklung und Ikonographie*. Wiesbaden: Franz Steiner Verlag GMBH, 1980. [Ben, Jad, Klg, Mad, Pai, PSPu]

———. *Princesses et courtisanes à travers les miniatures indiennes*. Translated by d'Enrico Iasacco. Exh. cat. Paris: Galerie Marco Polo, 1975. [Klg]

Dallapiccola, Anna Libera, ed. *Krishna, the Divine Lover: Myth and Legend through Indian Art*. Bombay: B. I. Publications, 1982. [Mad, Nth, Pai, PPC, Pur, TaM]

Dalmia, Jashodhara. *The Painted World of the Warlis: Art and Ritual of the Warli Tribes of Maharashtra*. [Loka Kala Series]. New Delhi: Lalit Kala Akademi, 1988. [War]

———. "The Warli Chawk: A World View." *India International Centre Quarterly* (New Delhi) 11, no. 4 (December 1984): 78–89. [War]

[Dammert, Udo, and Gernot Prunner]. *Hinterglasmalerei aus Europa und Asien*. Edited by Leonore Stege, Interversa, *Referat Kunst und Kultur*. Cat., two exhs. Hamburg: Interversa, [1981?]. [Gla]

Das, A. K. "North-East India." *Mārg* (Bombay) 43, no. 4 (June 1992): 23–44. [Tri, 3DP]

Das, Asok, and Amit Ambalal. "Painting." In *Arts and Crafts of Rajasthan*, edited by Aman Nath and Francis Wacziarg, 158–75. New York: Mapin International, 1987. First published, London: Thames and Hudson, 1987. [Nth, Par]

Das, Jagannath Prasad. "Patachitra of Orissa." In *Homage to Kalamkari*, 76–77. Bombay: Marg Publications, 1978. Also published, *Mārg* (Bombay) 31, no. 4 (September 1978): 64–65. [Pur]

———. "Patachitras: The Jagannath Icons of Puri." *India Magazine* (Bombay) 2, no. 3 (February 1982): 44–47, 49, 51. [Mur, Pur, 2DP]

———. *Puri Paintings: The Chitrakāra and His Work*. New Delhi: Arnold-Heinemann, 1982; Atlantic Highlands, N.J.: Humanities Press, 1982. [Mur, Pur, Rit, 2DP, 3DP]

Das, Prabhat Kumar. "Face to Face with the Patuas." *Folklore* (Calcutta) 13, no. 10 (October 1972): 387–401. Reprinted in *The Patas and the Patuas of Bengal*, ed. Sankar Sen Gupta (Calcutta: Indian Publications, 1973), 107–21. [Ben]

Das, Sudhir Ranjan. "Ālpanā of the Kumārī-Vratas of Bengal." *Journal of the Indian Society of Oriental Art* (Calcutta) 11 (1943): 126–32. [Rit]

Das Adhikary, Swapan. "A Bibliographical Note on the Pat Painting of Bengal." In *The Patas and the Patuas of Bengal*, edited by Sankar Sen Gupta, 127–40. Calcutta: Indian Publications, 1973. Reprinted in *Folklore* (Calcutta) 14, no. 4 (April 1973): 136–49. [Ben, Jad, Klg, Rit, 2DP, 3DP]

Dasgupta, Kalyan Kumar. *Wood Carvings of Eastern India*. Calcutta: Firma KLM, 1990. [3DP]

Das Gupta, Tapan Kumar. *"Indische Schattenspielfiguren mit Affendarstellungen im Hamburgischen Museum für Völkerkunde."* *Mitteilungen aus dem Museum für Völkerkunde Hamburg* (Hamburg), n. s., 7 (1977): 53–100. [PSPu]

Dash, M. P. "A Note on the Illustrated Manuscripts and Pat Paintings of Orissa." *Orissa Historical Research Journal* (Bhubaneswar) 13, no. 3 (1965): 41–45. [Ben, Klg, Pur, 2DP, 3DP]

Datta, Birendranath. *Folk Toys of Assam*. Guwahati, Assam: Directorate of Cultural Affairs, Government of Assam, 1986. [3DP]

———. "Work on Pith: A Rich Folk Art of Assam." In *Folk Art and Craft*, edited by Karuna Sagar Behera, vol. 3, *Folk Culture*, 97–106. Cuttack (Orissa): Institute of Oriental and Orissan Culture, [1983?]. [3DP]

Datta, Santo. "Kalighat *Pats* and Ukiyo-e Prints: Reflections of Changing Societies." *Indian Horizons* (New Delhi) 31, no. 3 (1982): 5–26. [Klg]

Davidson, J. LeRoy. *Art of the Indian Subcontinent from Los Angeles Collections*. Exh. cat. Los Angeles: UCLA Art Council, UCLA Art Galleries, and Ward Ritchie Press, 1968. [Ben, Jai, Nth, Pai, Rit]

———. Foreword to *India: Arts of the People—Tribal/Village/Town,* [n.p.]. Fullerton: California State College, 1970.

Del Bontà, Robert J. "Calendar Prints and Indian Tradition." In *Shastric Traditions in the Indian Arts*, edited by Anna Libera Dallapiccola in collaboration with Christine Walter-Mendy and Stephanie Zingel-Avé Lallemant, vol. 1, 453–55; vol. 2, figs. 172–79. Stuttgart: Steiner Verlag Wiesbaden, 1989. [Prn]

Desai, Manu. "Writing with Lines of Colour: The Craft of *Rangoli*." *India Magazine* (Bombay) 5, no. 12 (November 1985): 56–63. [Rit]

Dev, Chittaranjan. "An Outline of the Folk-Art of Bengal." *Indian Folk-Lore* (Calcutta) 2, no. 3 (July-September 1959): 196–205. [Ben, Rit, 3DP]

Dey, Bishnu, and John Irwin. "The Folk Art of Bengal." *Mārg* (Bombay) 1, no. 4 [1947]: 45–54. [Ben, Min, Rit, 3DP]

Dey, Mukul. "Drawings and Paintings of Kalighat." *Advance* (Calcutta) (1932): 14–16. [Klg]

Dhamija, Jasleen. *Indian Folk Arts and Crafts*. India—the Land and People [Series]. Delhi: National Book Trust, India, 1977. [Mad, Nth, Par, PPC, Rit, Tri, 3DP]

———. "The *Pechwais* of Nathdwara." In *Times of India Annual* (Bombay) 1965, 73–80. [Nth]

Dhamija, Jasleen, ed. *Crafts of Gujarat*. Living Traditions of India Series. New York: Mapin International, 1985. [PPC, Tri, 3DP]

Dikshit, Moreshwar G. "Painting on Glass." In *History of Indian Glass*, 126–27, pl. D. Bombay: University of Bombay, 1969. [Gla, Nth, 3DP]

Dongerkery, Kamala S. *A Journey through Toyland*. Bombay: Popular Book Depot, 1954. [PSPu, 3DP]

Doshi, Saryu. "Dazzling to the Eye: *Pichhavais* from the Deccan." In *Homage to Kalamkari*, 66–72. Bombay: Marg Publications, [1978]. Also published, *Mārg* (Bombay) 31, no. 4 (September 1978): 55–59. [Nth, PPC]

———. "The Iconic and the Narrative in Jain Painting." *Mārg* (Bombay) 36, no. 3 [1986?]: 22–90. [Jai]

———. *Masterpieces of Jain Painting*. Bombay: Marg Publications, 1985. [Jai]

———. "Miniature Painting." *Mārg* (Bombay) 36, no. 4 (1986): 49–64. [Jai, Min, Mur, Pai, Rit, War]

Durai, H. Gnana. "Preliminary Note on Geometrical Diagrams (Kolam) from the Madras Presidency." *Man* (London) 29 (May 1929): 77. [Rit]

Dutt, Gurusaday. "The Art of Bengal." *Modern Review* (Calcutta) 51, no. 5 (May 1932): 519–29. [Ben, Klg, Mur, Rit, 3DP]

———. "Basic Dolls and Toys of Bengal." *Journal of Arts and Crafts* (Calcutta) 2, no. 2 (April 1939): 1–4, figs. 1–9. [3DP]

———. "Dolls and Figure Toys of Bengal." *Journal of Arts and Crafts* (Calcutta) 1, no. 1 (July 1938): 1–3, figs. 1–6. [3DP]

———. *Folk Arts and Crafts of Bengal: The Collected Papers.* Edited by Samik Bandyopadhyay. Calcutta: Seagull Books, 1990. [Ben, Jad, Klg, Mur, Rit, 2DP, 3DP]

———. "The Indigenous Painters of Bengal." *Journal of the Indian Society of Oriental Art* (Calcutta) 1, no. 1 (June 1933): 18–25. [Ben, Klg, Rit, 3DP]

———. "Indigenous Paintings of Bengal." *Roopa-Lekhā* (New Delhi) 3, ser. 12 (1932): 1–11ff. [Ben, Jad, Rit]

———. "Indus Civilisation Forms and Motifs in Bengali Culture." *Modern Review* (Calcutta) 66, no. 5 (November 1939): 583–86. [Ben, Jad, Rit, 3DP]

———. "Indus Civilisation Forms and Motifs in Bengali Culture—II." *Modern Review* (Calcutta) 67, no. 2 (February 1940): 201–4. [Ben, Jad, 3DP]

———. "The Living Traditions of the Folk Arts in Bengal." *Art and Letters: India, Pakistan, Ceylon* (London) 10, no. 1 (1936): 22–34. [Ben, Jad, Rit, 3DP]

———. "The Painted Sarās of Rural Bengal." *Journal of the Indian Society of Oriental Art* (Calcutta) 2, no. 1 (June 1934): 28–29. [3DP]

———. "References to Yama-Pata in Ancient Literature (Its Traditional Survivals in Bengal)." *Journal of Arts and Crafts* (Calcutta) 3, no. 1 (July 1939): 2–3, fig. 1. [Ben]

———. "The Tigers' God in Bengal Art." *Modern Review* (Calcutta) 52, no. 5 (November 1932): 520–29. [Ben, Jad, Rit]

Eastman, Alvan C. *Catalog of the Heeramaneck Collection of Early Indian Sculptures, Paintings, Bronzes, and Textiles.* Exh. cat. New York: Heeramaneck Galleries, 1934. [Jai, Nth, 3DP]

Elwin, Verrier. *The Art of the North-East Frontier of India.* Shillong: North-East Frontier Agency, 1959. [Tri, 3DP]

———. "The Comic Strips of Rural India—I: The Krishna-Lila." *Illustrated Weekly of India* (Bombay) 73, 15 June 1952, 9–11. [Jad]

———. "The Comic Strips of Rural India—II: The Santal Legends." *Illustrated Weekly of India* (Bombay) 73, 22 June 1952, 36–37. [Jad]

———. "The Comic Strips of Rural India—III: The Punishments of Hell." *Illustrated Weekly of India.* (Bombay) 73, 29 June 1952, 29. [Jad]

———. "Folk Paintings of India." Foreword to *Folk Paintings of India,* 2–4. New Delhi: International Cultural Centre, 1961.

———. "Saora Pictographs." *Mārg* (Bombay) 2, no. 3 [1948]: 35–44. [Tri]

———. "Some Saora Drawings." Also titled, "The Art of the Ikon." Photographs by Verrier Elwin; text based on Verrier Elwin, *The Religion of an Indian Tribe* ([Bombay]: Oxford University Press, [1955]). *Mārg* (Bombay) 8, no. 4 (September 1955): 64–65. [Tri]

———. *The Tribal Art of Middle India: A Personal Record.* London: Oxford University Press, 1951. [Tri, 3DP]

[Erikson, Joan]. *Mata ni Pachedi: A Book on the Temple Cloth of the Mother Goddess.* Ahmedabad: National Institute of Design, [1968]. [PPC]

Eschmann, Anncharlott, Hermann Kulke, and Gaya Charan Tripathy, eds. *The Cult of Jagannath and the Regional Tradition of Orissa.* New Delhi: Manohar, 1978. [Pur, 3DP]

Fabri, Ratna Mathur. "Murals on the Mud Walls of Rural India." *Lalit Kalā Contemporary* (New Delhi), no. 14 [1972?]: 38–40ff. [Rit]

Falk, Toby, and Mildred Archer. *Indian Miniatures in the India Office Library.* London: Sotheby Parke Bernet, and Delhi and Karachi: Oxford University Press, 1981. First published, London: Philip Wilson Publishers for Sotheby Parke Bernet Publications, 1981. [2DP]

Femenias, Blenda. "Temple Cloths of Srikalahasti and Ahmedabad." In *Two Faces of South Asian Art: Textiles and Paintings,* by Blenda Femenias, Cynthia Cunningham Court, and Joan A.

Raducha, 5–13. Madison: Elvehjem Museum of Art, University of Wisconsin-Madison, 1984. [PPC]

Femenias, Blenda, Cynthia Cunningham Cort, and Joan A. Raducha. *Two Faces of South Asian Art: Textiles and Paintings*. Exh. cat. Madison: Elvehjem Museum of Art, University of Wisconsin-Madison, 1984. [Jai, Nth, Min, PPC, Pur, TaM]

Fischer, Eberhard. "Das Tempeltuch der Muttergöttin aus Gujarat." *Archiv für Völkerkunde* (Vienna), no. 26 (1972): 15–27. [PPC]

Fischer, Eberhard, and Jyotindra Jain. *Art and Rituals: 2500 Years of Jainism in India*. New Delhi: Sterling Publishers, 1977. [Jai]

Fischer, Eberhard, Jyotindra Jain, and Haku Shah. "*Mātāno Candarvo*: Textile Pieces for Goddess Worship in Gujarat." Translated by Jutta Jain-Neubauer. In *Homage to Kalamkari*, 73–75. Bombay: Marg Publications, [1978]. Also published, *Mārg* (Bombay) 31, no. 4 (September 1978): 61–63. [PPC]

————. *Tempeltücher für die Muttergöttinen in Indien: Zeremonien, Herstellung, und Ikonographie gemalter und gedruckter Stoffbilder aus Gujarat*. Exh. cat. Zurich: Rietberg Museum, 1982. [PPC]

Fischer, Eberhard, Sitakant Mahapatra, and Dinanath Pathy. *Orissa: Kunst und Kultur in Nordost-Indien*. Zurich: Rietberg Museum, 1980. [Gla, Min, Mur, PPC, Pur, Rit, Tri, 2DP, 3DP]

Fischer, Eberhard, and Haku Shah. *Kunsttraditionen in Nordindien: Stammeskunst, Volkskunst, klassische Kunst*. Exh. cat. Zurich: Rietberg Museum, 1972. [Jai, Mur, 2DP, 3DP]

Fischer, Klaus. *Erotik und Askese in Kult und Kunst der Inder*. Koln: DuMont Buchverlag, 1979. [Klg, Min, Pai, Pur, 2DP]

Fisher, Nora, ed. *Mud, Mirror, and Thread: Folk Traditions of Rural India*. Exh. publ. Middletown, N.J.: Grantha Corporation in association with Museum of New Mexico Press, 1993; Ahmedabad: Mapin Publishing, 1993. [Gar, Par, PPC, Rit, 3DP]

Forance, Kathleen D. "Women's Festive Folk Paintings of Uttar Pradesh." *Indian Cultures* (Jabalpur) 36, no. 2 (1981): 5–21. [Rit]

Fuchs, Stephen. "The Bhils: People of the Bow." In *Gods of the Byways: Wayside Shrines of Rajasthan, Madhya Pradesh, and Gujarat*, [by Komal Kothari et al.], 33–47. Oxford: Museum of Modern Art, 1982. [Tri]

Fundació Joan Miró, Centre d'Estudis d'Art Contemporani. *Art Tàntric*. Exh. cat. Barcelona: Fundació Joan Miró, Centre d'Estudis d'Art Contemporani, 1975. [2DP]

Galerie Bargera. *Tantra Kunst—Jaina Kosmologie, 15.–19. Jahrhunderts*. Exh. cat. Koln: Galerie Bargera, 1977. [Jai]

Galleria d'Arte del Naviglio. *Tantra Art*. Exh. cat. Milan: Galleria del Naviglio, 1973. [2DP]

Gandhy, Khorshed. "Warli Painting." *India Magazine* (Bombay) 1, no. 6 (July 1981): 66–68. [War]

Gangoly, O. C. "A Group of Vallabhāchārya or Nāthdwāra Paintings and Their Relatives." *Bulletin of the Baroda State Museum and Picture Gallery* (Baroda) 1, pt. 2, February-July 1944 (1945): 31–40. [Nth]

————. "Summary Survey of Orissan Painting." *Mārg* (Bombay) 8, no. 4 (September 1955): 47–56. [Pur]

Ganguli, Kalyankumar. *Designs in Traditional Arts of Bengal*. Calcutta: Directorate of Industries, Government of West Bengal, 1963. [Ben, Jad, Klg, Min, Rit, 2DP, 3DP]

[Ganguli, Kalyankumar, et al.] *Asutosh Museum of Indian Art: An Introduction*. Calcutta: University of Calcutta, [1969?]. [Ben, Klg, Min, Pur, 2DP, 3DP]

Ganguli, Rabindranath. "Jogen Patua Who Settled at Howrah from Midnapur." *Folklore* (Calcutta) 13, no. 10 (October 1972): 382–86. Reprinted as "Jogen Patua—An Intimate Exposition," in *The Patas and the Patuas of Bengal*, ed. Sankar Sen Gupta (Calcutta: Indian Publications, 1973), 122–26. [Ben, 3DP]

Ghose, Ajit. "Old Bengal Paintings." *Rupam* (Calcutta), nos. 27–28 (July-October 1926): 98–104. [Ben, Klg, Rit, 2DP, 3DP]

————. "Old Bengal Paintings: Pat Drawings." *Indian Arts and Letters* (London) 2, no. 2 (1926): 41–53. [Ben, Klg, Rit, 2DP, 3DP]

Ghosh, Benoy. "Some Traditional Folk Arts of Bengal and Social Change." *Art in Industry* (Calcutta) 8, no. 3 (1967): 25–33. [Ben, 2DP, 3DP]

———. *Traditional Arts and Crafts of West Bengal: A Sociological Survey*. Calcutta: Papyrus, 1981. [Ben, Jad, Klg, 3DP]

Ghose, D. C. "Some Aspects of Bengal Folk Art." *Lalit Kalā Contemporary* (New Delhi) 29 [April 1980]: 38–39. [Klg]

Ghosh, Deva Prasad. "Eastern School of Mediaeval Indian Painting." In *Chhavi: Golden Jubilee Volume*, edited by Anand Krishna, 91–103, figs. 208–36. Banaras: Bharat Kala Bhavan, Banaras Hindu University, 1971. [Jai, Klg, Min, Pur, 2DP]

———."Heritage of Indian Pats." *Oh Calcutta* (Calcutta) 2, no. 4 (summer 1973): 13, 30. [Ben, Jad, Klg]

———. "An Illustrated Rāmāyana Manuscript of Tulsīdās and Paṭs from Bengal." *Journal of the Indian Society of Oriental Art* (Calcutta) 13 (1945): 130–38ff. [Ben]

———. *Mediaeval Indian Painting, Eastern School (13th Century to Modern Times, Including Folk Art)*. Delhi: Sundeep Prakashan, 1982. [Ben, Jad, Klg, Min, Pur, Rit, 2DP, 3DP]

———. "Orissan Paintings." *Journal of the Indian Society of Oriental Art* (Calcutta) 9 (1941): 194–200. [Pur]

Ghosh, Prodyot. *Kalighat Pats: Annals and Appraisal*. Calcutta: Shilpayan Artists Society, [1967?]. [Ben, Klg]

Gittinger, Mattiebelle. *Master Dyers to the World: Technique and Trade in Early Indian Dyed Cotton Textiles*. Exh. cat. Washington, D.C.: Textile Museum, 1982. [PPC]

Gopinath, C. Y. "Madhubani Paintings—An Ancient Art Form." *Indian and Foreign Review* (New Delhi) 12, no. 16 (June 1975): 13–16. [Mad]

Graburn, Nelson H. H. "Introduction: Arts of the Fourth World." In *Ethnic and Tourist Arts, Cultural Expressions from the Fourth World*, edited by Nelson H. H. Graburn, 1–32. Berkeley and Los Angeles: University of California Press, 1976.

Granoff, Phyllis. "Jain Pilgrimage: In Memory and Celebration of the Jinas." In *The Peaceful Liberators: Jain Art from India*, by Pratapaditya Pal et al., 63–75. New York and London: Thames and Hudson; Los Angeles: Los Angeles County Museum of Art, 1994. [Jai]

———. "Reverse Glass Paintings from Gujarat in a Private Collection: Documents of British India." *Artibus Asiae* (Ascona) 40, nos. 2–3 (1978): 204–14. [Gla]

Grunfeld, Frederic V., ed. "Snakes and Ladders." In *Games of the World: How to Make Them, How to Play Them, How They Came to Be*, 131–33. New York: Holt, Rinehart and Winston, 1975. [2DP]

Guha-Thakurta, Tapati. "Artisans, Artists, and Popular Picture Production in Nineteenth-Century Calcutta." In *The Making of a New 'Indian' Art: Artists, Aesthetics, and Nationalism in Bengal, c. 1850–1920*, 11–44. Cambridge: Cambridge University Press, 1992. [Ben, BWc, Klg, Prn]

Gupta, R. P. "Future of Madhubani Painting." *Economic Times* (Bombay), 7 October 1988, 20. [Mad]

Guy, John. "Jain Manuscript Painting." In *The Peaceful Liberators: Jain Art from India*, by Pratapaditya Pal et al., 89–99. New York and London: Thames and Hudson; Los Angeles: Los Angeles County Museum of Art, 1994. [Jai]

Guy, John, and Deborah Swallow, eds. *Arts of India: 1550–1900*. London: Victoria and Albert Museum, 1990. [Ben, 2DP]

Hacker, Katherine F., and Krista Jensen Turnbull. *Courtyard, Bazaar, Temple: Traditions of Textile Expression in India*. Exh. cat. Seattle: University of Washington Press, 1982. [Nth, PPC]

Hadaway, W. S. *Cotton Painting and Printing in the Madras Presidency*. Madras: Superintendent, Government Press, 1917. [PPC]

Hall, Margaret. "Painters on Cotton: Collection in the Victoria and Albert Museum, London." In *Homage to Kalamkari*, 95–114. Bombay: Marg Publications, [1978]. [PPC]

Handa, O. C. *Pahāri Folk Art*. Bombay: D. B. Taraporevala Sons and Co., 1975. [Min, Mur, Rit, 2DP, 3DP]

Handicrafts and Handlooms Exports Corporation of India, *Aditi*. Exh. publ., Festival of India in Britain, Barbican Centre, London. New Delhi: Handicrafts and Handlooms Exports Corporation of India, 1982. [Ben, Mad, Min, Mur, Nth, Pai, Par, Pur, Rit, TaM, Tri, War, 2DP, 3DP]

Harinarayana, N. "Tanjore Painting on Glass: A Selection from the Madras Museum Collection." *Nunkalai* (Madras) 1, no. 1 (December 1981): 19–25. [Gla, TaM]

Harle, J. C., and Andrew Topsfield. *Indian Art in the Ashmolean Museum*. Oxford: Ashmolean Museum, 1987. [Klg, Par, PPC, Pur, 3DP]

Hartnoll and Eyre. *An Exhibition of Mid-Nineteenth Century Kalighat Drawings*. Catalogue 20. Exh. cat. London: Hartnoll and Eyre, 1971. [Klg]

Hebbar, Archana. "Tambekarwada: A Painted *Haveli* in Baroda." *India Magazine* (Bombay) 3, no. 5 (April 1983): 24–29, 30–33. [Mur]

Helstein, Mel. "India." In *Asian Puppets: Wall of the World*, [by Mel Helstein et al.], 10–43. Los Angeles: UCLA Museum of Cultural History, University of California, 1976. [PSPu, 3DP]

———. "The Other Self." In *Puppetry of India: An Exhibition of Figures Celebrating India's Culture*, 4–9. Atlanta, Ga.: Center for Puppetry Arts, 1986. [PSPu]

Home of Folk Art (Gurgaon, Haryana). *A Catalogue of Indian Folk and Tribal Art in the Collection of Home of Folk Art, Museum of Folk, Tribal, and Neglected Art*. Gurgaon (Haryana): Home of Folk Art, 1990. [Ben, Jad, Klg, Mad, Min, Pai, Par, Prn, Rit]

Huyler, Stephen P. "Clay, Sacred and Sublime: Terracotta in India." In *Mud, Mirror, and Thread: Folk Traditions of Rural India*, edited by Nora Fisher, 204–24. Middletown, N.J.: Grantha Corporation in association with Museum of New Mexico Press, 1993; Ahmedabad: Mapin Publishing, 1993. [Rit, 3DP]

———. "Creating Sacred Spaces: Women's Wall and Floor Decorations in Indian Homes." In *Mud, Mirror, and Thread: Folk Traditions of Rural India*, edited by Nora Fisher, 172–91. Middletown, N.J.: Grantha Corporation in association with Museum of New Mexico Press, 1993; Ahmedabad: Mapin Publishing, 1993. [Mad, Rit]

———. "Folk Art in India Today." In *The Arts of India*, edited by Basil Gray, 191–201. Ithaca, N.Y.: Cornell University Press, 1981. [Mur, Rit, 3DP]

———. *Painted Prayers: Women's Art in Village India*. New York: Rizzoli, 1994. [Rit]

———. "Rural Wall Decorations: A Comparison of Four Villages." In *The Impulse to Adorn: Studies in Traditional Indian Architecture*, edited by Jan Pieper and George Michell, 79–90. Bombay: Marg Publications, 1982. [Rit, Tri]

———. *Village India*. New York: Harry N. Abrams, 1985. [Mur, Rit, Tri, 2DP, 3DP]

Inglis, Stephen. *A Village Art of South India: The Work of the Velar*. Publication no. 41, Folklore no. 7. Madurai: Publication Division, Madurai Kamaraj University, Department of Tamil Studies, 1980. [3DP]

Inter-National Cultural Centre. *Folk Paintings of India*. New Delhi: Inter-National Cultural Centre, 1961. [Ben, Jad, Jai, Klg, Mad, Min, Mur, Pai, PSPu, Pur, Rit, Tri, 2DP, 3DP]

Irwin, John. "The Folk-Art of Bengal." *Studio* (London) 132, no. 644 (November 1946): 129–36. [Ben, Min, Rit, 3DP]

———. "Golconda Cotton Paintings of the Early 17th Century." *Lalit Kalā* (New Delhi), no. 5 (April 1959): 11–48, figs. 1–27. [PPC]

Irwin, John, and Margaret Hall. *Indian Painted and Printed Fabrics*. Historic Textiles of India at the Calico Museum, vol. 1. Ahmedabad: Calico Museum of Textiles, 1970. [Nth, PPC]

Iyer, E. Krishna. "Puppet Shows in South India." In *Puppet Theatre around the World*, edited by Som Benegal et al., 96–99. New Delhi: Bharatiya Natya Sangh, 1960. [PSPu]

Jacobs, Julian, Alan MacFarlane, Sarah Harrison, and Anita Herle. *The Nagas, Hill Peoples of Northeast India: Society, Culture, and the Colonial Encounter*. London and New York: Thames and Hudson, 1990. [3DP]

Jain, Jyotindra. "Ancestor Worship and Ritual Painting: The Legend of Pithoro." In *Gods of the Byways: Wayside Shrines of Rajasthan, Madhya Pradesh, and Gujarat*, [by Komal Kothari et al.], 53–62. Oxford: Museum of Modern Art, 1982. [Tri]

———. *Folk Art and Culture of Gujarat: Guide to the Collection of the Shreyas Folk Museum of Gujarat*. Ahmedabad: Shreyas Folk Museum of Gujarat, 1980. [Gla, Mur, PPC, 3DP]

———. "Ganga Devi: Tradition and Expression in Madhubani Painting." *Third Text* (London), no. 6 (spring 1989): 43–50. Also published as "*Ganga Devi: tradition et expression dans la peinture Madhubani*." Translated by Suzanne Bernard. *Les Cahiers du Musée National d'Art Moderne* (Paris) 28 (summer 1989), 32–41. [Mad]

————. "The Implicit and the Manifest in Indian Folk Art and Mythology." In *Mud, Mirror, and Thread: Folk Traditions of Rural India*, edited by Nora Fisher, 46–65. Middletown, N.J.: Grantha Corporation in association with Museum of New Mexico Press, 1993; Ahmedabad: Mapin Publishing, 1993. [Gar, Par, PPC, 3DP]

————. *Painted Myths of Creation: Art and Ritual of an Indian Tribe.* Loka Kala Series. New Delhi: Lalit Kala Academy, 1984. [Tri]

————. "Painted Panels and Scrolls from Western Indian Villages: Their Mythology and Rituals." In *The Cultural Heritage of the Indian Village*, edited by Brian Durran and T. Richard Blurton, British Museum Occasional Paper No. 47, 119–34. London: British Museum, 1991. [Gar, Par, 2DP]

————. "The Painted Scrolls of the Garoda Picture-Showmen of Gujarat." *Quarterly Journal* (National Centre for Performing Arts, Bombay) 9, no. 3 (September 1980): 3–23. Revised and enlarged as "Survival of the 'Yamapattika' Tradition in Gujarat," in *Dimensions of Indian Art: Pupul Jayakar Seventy*, ed. Lokesh Chandra and Jyotindra Jain (Delhi: Agam Kala Prakashan, 1986), vol. 1, 173–87, vol. 2, 58–67. [Gar, Jai, Min, 2DP]

————. "*Vergleich der Motive auf chandarvo-Tüchen mit denen der Bildrollen der Garoda-Bilderzähler,*" appendix 2 to *Tempeltücher für die Muttergöttinnen in Indien: Zeremonien, Herstellung und Ikonographie gemalter und gedruckter Stoffbilder aus Gujarat*, by Eberhard Fischer, Jyotindra Jain, and Haku Shah, 238–42. Zurich: Rietberg Museum, 1982. [Gar, PPC]

————. "The Visual Vocabulary of Craft: Some Motifs from Gujarat." In *Shilpakār*, edited by Carmen Kagal, 5–20. Bombay: Crafts Council of Western India, 1982. [Mur, PPC, Rit, Tri]

Jain, Jyotindra, and Aarti Aggarwala. *National Handicrafts and Handlooms Museum, New Delhi.* Museums of India Series. Ahmedabad: Mapin Publishing, 1989; Middletown, N.J.: Grantha Corporation, 1989. [And, Ben, Gar, Jad, Klg, Mad, Min, Mur, Nth, Pai, Par, PPC, PSPu, Pur, Rit, TaM, Tri, War, 2DP, 3DP]

Jain, Jyotindra, and Eberhard Fischer. *Jaina Iconography.* Vol. 1, *The Tīrthaṅkara in Jaina Scriptures, Art, and Rituals.* Vol. 2, *Objects of Meditation and the Pantheon.* Leiden: E. J. Brill, 1978. [Jai, Rit, 2DP, 3DP]

[Jain, Jyotindra, et al.]. *The Master Weavers.* Edited by Pria Devi. Exh. cat., Festival of India in Britain, Royal College of Art, London. Bombay: Subrata Bhowmick, 1982. [And, Jai, Nth, Par, PPC, Pur]

Jain-Neubauer, Jutta. "The Caitra-Gaurī Paṭa." In *Treasures of Everyday Art, Raja Dinkar Kelkar Museum*, by Jyotindra Jain and Jutta Jain-Neubauer, 15, 107–8. Bombay: Marg Publications, [1978]. Also published, *Mārg* (Bombay) 31, no. 3 (June 1978): 15, 107–8. [Rit]

————. "Citrakathi Paintings of Maharashtra." In *Treasures of Everyday Art, Raja Dinkar Kelkar Museum*, by Jyotindra Jain and Jutta Jain-Neubauer, 109–21. Bombay: Marg Publications, [1978]. [Pai]

[Jain-Neubauer, Jutta?]. "*Ramavijaya* (Victory of Rama)—Chitrakathi Paintings from Maharashtra." In *Treasures of Everyday Art, Raja Dinkar Kelkar Museum*, by Jyotindra Jain and Jutta Jain-Neubauer, 30–31, 35–42. Bombay: Marg Publications, [1978]. [Pai]

James, David. "Islam." In *Erotic Art of the East: The Sexual Theme in Oriental Painting and Sculpture*, by Philip Rawson [et al.], 205–19. New York: G. P. Putnam's Sons, 1968. [Min, 2DP]

Jayakar, Pupul. *The Earthen Drum: An Introduction to the Ritual Arts of Rural India.* New Delhi: National Museum, [1981]. Revised edition published as *The Earth Mother*, with a foreword by Stella Kramrisch, New Delhi: Penguin Books, 1989. [Ben, Jad, Klg, Mad, Min, Nth, Pai, Par, PPC, Tri, War, 2DP, 3DP]

————. "Gaiety in Colour and Form: Painted and Printed Cloths." In *Homage to Kalamkari*, 23–34. Bombay: Marg Publications, [1978]. Also published, *Mārg* (Bombay) 31, no. 4 (September 1978): 23–34. [Nth, PPC]

————. "An Introduction to Adivasi Art." In *The Art of the Adivasi (Indian Tribal Art)*, [by J. Swaminathan, Jyotindra Jain, and Haku Shah], 14. Tokyo: Yomiuri Shimbun and Japan Association of Art Museums, 1988. [Tri]

————. "Painting: Colour in the Hands of Folk Makes Holy Mandalas and Gay Spirits." *Mārg* (Bombay) 22, no. 4 (September 1969): 35–48. [Mad, Rit, Tri]

———. "Paintings of Mithila." In *Times of India Annual* (Bombay), 1971, 29–36. [Mad]

———. "Paintings of Rural India." *Times of India Annual* (Bombay), 1975, 53–62. [Ben, Jad, Mad, Min, Nth, Pai, Rit, Tri, War, 2DP]

———. "Sources of Rural Arts of India." In *Chhavi: Golden Jubilee Volume*, edited by Anand Krishna, 290–308. Banaras: Bharat Kala Bhavan, Banaras Hindu University, 1971. [Rit, 2DP, 3DP]

———. "Technique of Kalamkari." In *Homage to Kalamkari*, 129–34. Bombay: Marg Publications, [1978]. [PPC]

Johari, Harish. *Leela: Game of Knowledge*. London and Henley: Routledge and Kegan Paul, 1980. [2DP]

Jones, Clifford Reis. "*Dhūlicitra*: Historical Perspectives on Art and Ritual." In *Kalādarśana, American Studies in the Art of India*, edited by Joanna G. Williams, 69–75. New Delhi: Oxford and IBH Publishing Co., in collaboration with the American Institute of Indian Studies, 1981. [Rit]

Joshi, O. P. *Painted Folklore and Folklore Painters of India (A Study with Reference to Rajasthan)*. Delhi: Concept Publishing Co., 1976. [Nth, Par]

Karanth, Shivarama. *Karnataka Paintings*. Mysore: Prasaranga, University of Mysore, 1973. [Jai, Mur, PSPu]

Kaul, Manohar. "Indian Painting—IV: Jaina or Gujarati School." *Kalā Darshan* (Delhi) 1, no. 4 (October-December 1988): 59–62. [Jai]

Kayal, Akshaykumar. "Illustrated Manuscripts (*Puthi*) and Cover-Designs (*Paataas*) in Bengal." *Folklore* (Calcutta) 13, no. 9 (September 1972): 352–57. Reprinted as "*Chitrita Puthi* or Illustrated Hand-Written Manuscripts and *Paataa* or Their Cover Designs," in *The Patas and the Patuas of Bengal*, ed. Sankar Sen Gupta (Calcutta: Indian Publications, 1973), 101–6. [Min, 2DP]

Khanna, Balraj. *Kalighat: Indian Popular Painting, 1800–1930*. 2 vols. Exh. cat. London: Redstone Press in association with the South Bank Centre, 1993. [Klg]

Khanna, Madhu. *Yantra: The Tantric Symbol of Cosmic Unity*. London: Thames and Hudson, 1979. [Mad, Rit, 2DP, 3DP]

Khanna, Sudarshan. *Dynamic Folk Toys: Indian Toys Based on the Application of Simple Principles of Science and Technology*. New Dehli: Office of the Development Commissioner for Handicrafts, 1983. [3DP]

Knížková, Hana. "Bengali Pictures of Kalighat style." *New Orient* (Prague) 6, no. 3 (June 1967): 70–84. [Klg]

———. *The Drawings of the Kālīghāṭ Style: Secular Themes*. Prague: National Museum, 1975. [BWc, Klg]

———. "The Folk Coloured Drawings of the Kālīghāṭ Style (from the Náprstek Museum Collection)." *Annals of the Náprstek Museum* (Prague) 3 (1964): 43–63ff. [Klg]

Knížková, Hana, and Dušan Zbavitel. "Come and Hear the Story . . . (The Drama of a Hypocritical Brahmin)." *New Orient* (Prague) 6 (1967): 142–45. [BWc, Klg]

Konishi, Masatoshi A. "A Sketch on the Tribal Masks in India." In *Kusumāñjali: New Interpretation of Indian Art and Culture, Sh. C. Sivaramamurti Commemoration Volume*, edited by M. S. Nagaraja Rao, vol. 2, 373–81. Delhi: Agam Kala Prakashan, 1987. [3DP]

Koppar, D. H. *Forgotten Art of India*. Baroda: Department of Museums, 1989. [Tri, War, 3DP]

———. *Tribal Art of the Dangs*. Edited by V. L. Devkar. Baroda: Department of Museums, 1971. [Tri, War, 3DP]

Kothari, Komal. "The Shrine: An Expression of Social Needs." Translated by Uma Anand. In *Gods of the Byways: Wayside Shrines of Rajasthan, Madhya Pradesh, and Gujarat*, [by Komal Kothari et al.], 4–31. Oxford: Museum of Modern Art, 1982. [Par, 3DP]

[Kothari, Komal, Stephen Fuchs, Haku Shah, Jyotindra Jain, and Vivek Anand]. *Gods of the Byways: Wayside Shrines of Rajasthan, Madhya Pradesh, and Gujarat*. Exh. publ. Oxford: Museum of Modern Art, 1982. [Par, Rit, Tri, 3DP]

Kramrisch, Stella. "Artist, Patron, and Public in India." *Far Eastern Quarterly* (Ann Arbor) 15, no. 3 (May 1956): 335–42. Reprinted in *Exploring India's Sacred Art: Selected Writings of Stella*

Kramrisch, ed. Barbara Stoler Miller (Philadelphia: University of Philadelphia Press, 1983), 51–58.

—————. *Exploring India's Sacred Art: Selected Writings of Stella Kramrisch*. Edited by Barbara Stoler Miller. Philadelphia: University of Pennsylvania Press, 1983. [Ben, Jad, Klg, Mad, Min, Pai, Par, PSPu, Pur, Rit, TaM, 3DP]

—————. *Painted Delight: Indian Paintings from Philadelphia Collections*. Exh. cat., Festival of India 1985–86. Philadelphia: Philadelphia Museum of Art, 1986. [Klg, Pai]

—————. "The Ritual Arts of India." In *Aditi: The Living Arts of India*, by the Smithsonian Institution, 247–69, 276. Washington, D.C.: Smithsonian Institution Press, 1985. [Mad, Rit, Tri, War]

—————. "Traditions of the Indian Craftsman." Reprinted in *Traditional India: Structure and Change*, ed. Milton Singer (Austin: University of Texas Press, 1959), 18–24; *Exploring India's Sacred Art: Selected Writings of Stella Kramrisch*, ed. Barbara Stoler Miller (Philadelphia: University of Philadelphia Press, 1983), 59–66. First published, *Journal of American Folklore* (Washington) 71, no. 281 (July-September 1958): 224–30.

—————. *Unknown India: Ritual Art in Tribe and Village*. Exh. cat. Philadelphia: Philadelphia Museum of Art, 1968. Reprinted, catalogue essay only, in *Exploring India's Sacred Art: Selected Writings of Stella Kramrisch*, ed. Barbara Stoler Miller (Philadelphia: University of Philadelphia Press, 1983), 85–120. [Ben, Jad, Klg, Mad, Min, Pai, Par, PSPu, Pur, Rit, TaM, 3DP]

Krishna, Nanditha. "Terracottas." In *Arts and Crafts of Tamil Nadu*, by Nanditha Krishna [et al.], 86–101. Middletown, N.J.: Grantha Corporation in association with Mapin Publishing, Ahmedabad, 1992. [3DP]

Krishna, Nanditha, [et al.]. *Arts and Crafts of Tamilnadu*. Living Traditions of India Series. Middletown, N.J.: Grantha Corporation in association with Mapin Publishing, Ahmedabad, 1992. [Gla, PPC, Rit, TaM, 3DP]

Krishna Murthy, A. "Note on the Floor Drawings of Karnataka." In *Folk Art and Craft*, edited by Karuna Sagar Behera, vol. 3, *Folk Culture*, 86–88. Cuttack (Orissa): Institute of Oriental and Orissan Culture, [1983?]. [Rit]

Kumar, Pramod. "The Folk Murals of Shekhawati." *Arts of Asia* (Hong Kong) 11, no. 1 (January-February 1981): 96–104. [Mur]

—————. "Terracottas of Molela: A Simple Expression of the Religious Values of a People." *India Magazine* (Bombay) 2, no. 11 (October 1982): 72–75. [3DP]

Kumar, Ram. "Famous Fresco-Paintings in 'Havelis' of Rajasthan." *Indian and Foreign Review* (New Delhi), 15 July 1985, 10–13. [Mur]

—————. "Pad Paintings of Rajasthan: A Unique form of Indian Art." *Arts of Asia* (Hong Kong) 18, no. 1 (January-February 1988): 138–41. [Par]

—————. "'Pichhawais'—A Tradition in Ritual Cloth Paintings." *Oriental Art* (London), n. s., 32, no. 3 (autumn 1986): 284–87. [Nth]

Kumar, S. Bharat. "Home of Traditional Paintings." *Hindu* (Madras), 9 September 1990, 1–2. [TaM]

Kundu, Kamal Kumar. "Contributions of Sutradharas to the Folk Arts and Crafts of Bengal." In *Folk Art and Crafts*, edited by Karuna Sagar Behera, vol. 3, *Folk Culture*, 128–32. Cuttack (Orissa): Institute of Oriental and Orissan Culture, [1983?]. [Ben, Min, 2DP, 3DP]

Lalit Kala Akademi. *Traditional Paintings: Old and New. An Exhibition of Existing Schools of Traditional Paintings in India*. Exh. cat. New Delhi: Lalit Kala Akademi, 1989. [And, Gar, Gla, Jad, Klg, Mad, Pai, Par, PPC, PSPu, Pur, TaM]

—————. *Wall Paintings from Amber*. Lalit Kalā Series Portfolio No. 13. [Text by Karl Khandalavala.] [New Delhi]: Lalit Kala Akademi, [1974?]. [Mur]

Lalit Kalā Contemporary (New Delhi), nos. 12–13 (April-September 1971) (special issue: Tantra). [2DP]

Lanius, Mary C. "Mithilā Painting." In *Making Things in South Asia: The Role of Artist and Craftsman*, edited by Michael W. Meister, Proceedings of the South Asia Seminar 4, 1985–86, 135–46. Philadelphia: University of Pennsylvania, Department of South Asia Regional Studies, 1988. [Mad]

Larson, Gerald James, Pratapaditya Pal, and Rebecca P. Gowen. *In Her Image: The Great Goddess in Indian Asia and the Madonna in Christian Culture.* Exh. cat. Santa Barbara: UCSB Art Museum, University of California, Santa Barbara, 1980. [Rit, 2DP]

Layard, John. "Labyrinth Ritual in South Asia: Threshold and Tattoo Designs." *Folklore* (London) 48 (1937): 115–82. [Rit]

Leach, Linda York. *Indian Miniature Paintings and Drawings.* Cleveland Museum of Art Catalogue of Oriental Art, pt. 1. Cleveland: Cleveland Museum of Art in cooperation with Indiana University Press, 1986. [Klg, Min, Pur]

Leyden, N. von, and R. von Leyden. "Ganjifa: The Playing Cards of India." *Mārg* (Bombay) 3, no. 4 (1949): 36–56. [2DP]

Leyden, Rudolf von. *Ganjifa, The Playing Cards of India: A General Survey, with a Catalogue of the Victoria and Albert Museum Collection.* With contributions by Michael Dummit. Exh. cat., Festival of India in Britain. London: Victoria and Albert Museum, 1982. [TaM, 2DP, 3DP]

———. "Indian Playing Cards." *Orientations* (Hong Kong) 13, no. 10 (October 1982): 14–23. [2DP, 3DP]

———. *Indische Spielkarten: Inventarkatalog der indischen Sammlung des Deutschen Spielkarten-Museums.* Leinfelden-Echterdingen: Deutsches Spielkarten-Museum, 1977. [2DP, 3DP]

Lutgendorf, Philip. "Banking on the Name." *Journal of Vaiṣṇava Studies* (Brooklyn) 2, no. 2 (spring 1994): 147–62. [2DP]

Maduro, Renaldo. *Artistic Creativity in a Brahmin Painter Community.* Research Monograph Series, no. 14. Berkeley: Center for South and Southeast Asia Studies, University of California, 1976. [Mur, Nth, Par, Prn, Rit]

———. "The Brahmin Painters of Nathdawara, Rajasthan." In *Ethnic and Tourist Arts, Cultural Expressions from the Fourth World,* edited by Nelson H. H. Graburn, 226–44. Berkeley: University of California Press, 1976. [Mur, Nth, Prn]

Mahapatra, Sitakant. "Art and Ritual: A Study of Saora Pictograms." In *Dimensions of Indian Art: Pupul Jayakar Seventy,* edited by Lokesh Chandra and Jyotindra Jain, vol. 1, 265–77; vol. 2, 92–95. Delhi: Agam Kala Prakashan, 1986. [Tri]

———. "Orissa." *Mārg* (Bombay) 43, no. 4 (June 1992): 57–72. [Tri, 3DP]

Maity, Pradyot Kumar. "Folk Entertainment and the Role of the Patuas." *Folklore* (Calcutta) 13, no. 12 (December 1972): 484–88. Reprinted as "Religious Pata and the Role of Patuas as Entertainers," in *The Patas and the Patuas of Bengal,* ed. Sankar Sen Gupta (Calcutta: Indian Publications, 1973), 72–76. [Ben, Jad]

Mārg (Bombay) 11, no. 3 (June 1968) (special issue: Indian Puppets). [PSPu, 3DP]

Mārg (Bombay) 22, no. 4 (September 1969) (special issue: The Forgotten Arts of India). [Mad, PPC, Rit, Tri, 2DP, 3DP]

Mārg (Bombay) 43, no. 3 (June 1992) (special issue: Tribal Arts of Eastern India). [Jad, Rit, Tri, 3DP]

Marg Publications. *Homage to Kalamkari.* Bombay: Marg Publications, [1978]. [Jai, Nth, PPC, Pur]

[Mashe, Jivya Soma, Balu Mashe, and Lakshmi Lal]. *The Warlis: Tribal Paintings and Legends.* Edited by Lakshmi Lal. Bombay: Chemould Publications and Arts, [1982]. [War]

Mate, M. S. "The Tradition of Painting: Its Origin and Continuity." *Mārg* (Bombay) 34, no. 2 [1982?] (special issue: The Art of Chhatrapatis and Peshwas): 59–64. [Rit, 2DP]

Mathur, J. C. "Domestic Arts of Mithila: General Note." *Mārg* (Bombay) 20, no. 1 (December 1966): 44–46. [Mad]

McCutchion, David. "Recent Developments in Patua Style and Presentation." In *Patua Art: Development of the Scroll Paintings of Bengal Commemorating the Bicentenary of the French Revolution,* by Alliance Française of Calcutta and Crafts Council of West Bengal, 16–22. Calcutta: Alliance Française, [1991]. [Ben]

[McDougall, Douglas]. *An Exhibition of Kalighat Drawings.* Exh. cat. London: Hartnoll and Eyre, 1969. [Klg]

[McInerney, Terence, Cynthia Hazen Polsky, et al.]. *Indian Paintings from the Polsky Collections.* Exh. cat. Princeton: Art Museum, Princeton University, 1982. [Pai]

Mehta, R. N. "An Annakūṭa *Picchavāi.*" *Bulletin of the Baroda State Museum and Picture Gallery* (Baroda) 20 (1968): 33–35, pls. 22–24. [Nth]

———. "A Set of Decorative Textiles of *Pushṭimārgīya* Vaishṇavas in the Baroda Museum." *Bulletin of the Baroda State Museum and Picture Gallery* (Baroda) 14 (1962): 19–22, pls. 11–16. [Nth]

Mehta, Rustam J. *The Handicrafts and Industrial Arts of India.* D. B. Taraporevala Sons and Co., 1960. [Mur, PPC, 3DP]

Meister, Michael W., ed. *Making Things in South Asia: The Role of Artist and Craftsman.* Proceedings of South Asia Seminar 4, 1985–86. Philadelphia: University of Pennsylvania, Department of South Asia Regional Studies, 1988. [Mad]

Michell, George. "Related Arts." In *Brick Temples of Bengal: From the Archives of David McCutchion,* edited by George Michell, 177–84, figs. 791–802. Princeton: Princeton University Press, 1983. [Ben, BWc, 2DP]

Miller, Joseph Charles, Jr. "The Twenty-Four Brothers and Lord Devnarayan: The Story and Performance of a Folk Epic of Rajasthan, India." Ph.D. diss., University of Pennslyvania, 1994. [Par]

Miller, Joseph C., and Axel Horn. *Tales of Pābūjī.* Produced and directed by Joseph C. Miller and Axel Horn. 50 minutes. The *paṛ*-Paintings of Rajasthan Video Project, 1994. Videocassette. [Par]

Mingei International Museum of World Folk Art. *India—Village, Tribal, Ritual Arts.* Exh. cat. La Jolla, Calif.: Mingei International Museum of World Folk Art, 1981. [Ben, Nth, Par, PPC, Pur, 3DP]

Ministère de la Culture, Direction des Musées de France. *Dieux de l'Inde du Sud dans l'imagerie populaire.* Exh. cat. [Paris]: Sitecmo, Vauban Dieppe, 1982. [Gla, PPC, Prn, TaM]

Ministry of Education and Culture, Government of India. *Folk Entertainment in India.* New Delhi: Ministry of Education and Culture, Government of India, 1981. [PSPu]

Mishra, Sudhakanta. "The Folk-Art of Mithila." *Folklore* (Calcutta) 1, no. 5 (September-October 1960): 319–24. [Mad, 3DP]

Misra, Umesh Chandra. *Tribal Paintings and Sculptures.* Delhi: B. R. Publishing Corporation, 1989. [Tri, 3DP]

Mitra, Asok. "The Present State of Handicrafts." *Mārg* (Bombay) 22, no. 4 (September 1969), 58–60.

Mittal, Jagdish. "Glass Paintings of Hyderabad." *Mārg* (Bombay) 16, no. 2 (March 1963): 57. [Gla]

———. "Scrolls: Narrative Paintings." *India Magazine* (Bombay) 7, no. 5 (April 1987): 72–80. [And]

[Mittal, Jagdish]. *Indian Folk Paintings, 15th to 19th Century, from the Collection of Jagdish and Kamla Mittal Museum of Art, Hyderabad.* Exh. cat. New Delhi: CMC Art Gallery, 1990. [And, Ben, Gar, Jad, Jai, Klg, Min, Pai, Pur, 2DP]

Mitter, Partha. "Arts of Bengal Exhibition at the Whitechapel Gallery." Review of the art exhibition "Arts of Bengal: The Heritage of Bangladesh and Eastern India" at the Whitechapel Gallery, London. *Lalit Kalā Contemporary* (New Delhi) 29 [April 1980]: 40–41. [Ben, BWc, Jad, Klg, Prn, 3DP]

Mode, Heinz. "'Highway and Byway' ('High-Art and Folk-Art')." *Folklore* (Calcutta) 6, no. 4 (April 1965): 147–51.

Mode, Heinz, and Subodh Chandra. *Indian Folk Art.* Translated by Peter and Betty Ross. Bombay: D. B. Taraporevala Sons and Co., 1985; New York: Alpine Fine Arts Collection, 1985. First published as *Indische Volkskunst,* Leipzig: Edition Leipzig, 1984; Hanau: Muller and Kiepenheuer, 1984. [Ben, BWc, Gla, Jad, Klg, Mad, Min, Mur, Nth, Pai, Par, PPC, PSPu, Pur, Rit, TaM, Tri, War, 2DP, 3DP]

Mohanty, B. *Pata-Paintings of Orissa.* New Delhi: Publications Division, Ministry of Information and Broadcasting, Government of India, 1984. [Mur, Pur, Rit, 2DP, 3DP]

Mohanty, Bijoy Chandra. *Patachitras of Orissa.* Study of Contemporary Textile Crafts of India [Series], edited by Alfred Buhler. Ahmedabad: Calico Museum of Textiles, 1980. [Mur, Pur, 2DP, 3DP]

Mohapatra, R. P. "Two Pata Paintings on Jagannath in Orissa State Museum." *Orissa Historical Research Journal* (Bhubaneswar) 13, no. 4 (1965): 43–48. [Pur]

Mookerjee, Ajit. *The Arts of India from Prehistoric to Modern Times*. Revised and enlarged edition. Calcutta: Oxford and IBH Publishing Co., 1966. First published as *Art of India*, Calcutta: Oxford Book and Stationery Co., 1952. [Ben, Klg, Tri, 3DP]

———. "Bengal Folk Art." *Modern Review* (Calcutta) 73, no. 4 (April 1943): 271–75. [Ben, Klg, Rit, 3DP]

———. *Crafts Museum*. New Delhi: Crafts Museum, 1971. [And, Gla(?), Klg, PPC, PSPu, Pur, Rit, TaM, 2DP, 3DP]

———. *Folk Art of Bengal: A Study of an Art for, and of, the People*. Revised edition, with a foreword by William Rothenstein. Calcutta: University of Calcutta, 1946. First published, Calcutta: University of Calcutta, 1939. [Ben, Jad, Klg, Rit, 3DP]

———. *Folk Art of India*. New Delhi: Clarion Books, 1986. [Ben, Klg, Jad, Mad, Pai, PPC, PSPu, Pur, Rit, 3DP]

———. "Folk Art of the Lower Ganges." *Asia* (New York), January 1941: 27–30. [Jad, Rit, 3DP]

———. "Folk Crafts of India." *Roopa-Lekhā* (Delhi) 38, nos. 1–2 [1968?]: 216–29. [Rit, PPC, 3DP]

———. *Folk Dolls and Toys*. New Delhi: Crafts Museum, 1968. [3DP]

———. *Folk Toys of India*. Calcutta and New Delhi: Oxford Book and Stationery Co., 1956. [3DP]

———. "Handicraft Traditions." *Cultural Forum* (New Delhi) 4, no. 4 (1964): 71–73.

———. "Indian Dolls and Toys." *Mārg* (Bombay) 4, no. 4 [1950?]: 30–33. [3DP]

———. *Indian Primitive Art*. Calcutta and New Delhi: Oxford Book and Stationery Co., 1959. [Jad, Tri, 3DP]

———. "Kalighat Folk Painters." *Horizon: Review of Literature and Art* (London) 5, no. 30 (June 1942): 417–19. [Klg]

———. *Modern Art in India*. Calcutta: Oxford Book and Stationery Co., 1956. [Ben, Jad, Klg, Mad, Mal, Rit, Tri, 2DP, 3DP]

———. *Ritual Art of India*. London: Thames and Hudson, 1985. [Klg, Mad, Min, Mur, Nth, Pur, Rit, 2DP, 3DP]

———. "Tantra: Art as a Path to Spiritual Self-Fulfilment." *Graphis* (Zurich) 22, no. 127 (1966): 442–53, 460, 462, 464–65. [Jai, 2DP]

———. *Tantra Art in Search of Life Divine*. Paris and New Delhi: Ravi Kumar, 1966. [2DP]

———. "Tantra Art in Search of Life Divine." In *Indian Aesthetics and Art Activity, Proceedings of a Seminar*, vol. 2, 55–69. Simla: Indian Institute of Advanced Study, 1968. [2DP]

———. "Tantra Art in Search of Life Divine." *Lalit Kalā Contemporary* (New Delhi), nos. 12–13 (April-September 1971): 8–10. [2DP]

———. *Tantra Art: Its Philosophy and Physics*. New Delhi: Ravi Kumar, 1966. [Jai, Tri, 2DP, 3DP]

———. *Tantra Asana: A Way to Self-Realization*. Basel: Ravi Kumar, 1971. [Jai, 2DP]

———. *Tantra Magic*. New Delhi: Arnold-Heinemann, 1977. [Jai, Mad, Pur, 2DP]

———. "Tantric Art." In *Times of India Annual* (Bombay), 1965, 49–58. [Jai, 2DP, 3DP]

———. *Yoga Art*. London: Thames and Hudson, 1975; New York: New York Graphic Society, 1975. [Jai, 2DP]

Mookerjee, Ajit, and Madhu Khanna. *The Tantric Way: Art, Science, Ritual*. London: Thames and Hudson, 1977. [Jai, Klg, Mad, Min, Pur, 2DP, 3DP]

Mookerjee, Priya. *Pathway Icons: The Wayside Art of India*. London and New York: Thames and Hudson, 1987. [Mur, Rit, 3DP]

Moser-Schmitt, Erika. "Traditional and Commercial Female Folk Paintings of Mithila." In *Folk Art and Craft*, edited by Karuna Sagar Behera, vol. 3, *Folk Culture*, 115–22. Cuttack (Orissa): Institute of Oriental and Orissan Culture, [1983?]. [Mad]

Mukharji, T. N. *Art-Manufactures of India {Specially Compiled for the Glasgow International Exhibition, 1988}*. Calcutta: Superintendent of Government Printing, India, 1888. [Ben, BWc, Gla, Klg, Mur, Prn, Pur, TaM, 2DP, 3DP]

Mukherjee, B. N. "The Kālighāṭa (Kalighat) Style—The Theory of British Influence." *Indian Museum Bulletin* (Calcutta) 19 (1984): 7–13. [Klg]

———. "Pictures from Woodcut Blocks: An Iconological Analysis." In *Woodcut Prints of Nineteenth Century Calcutta*, edited by Ashit Paul, 108–21. Calcutta: Seagull Books, 1983. [BWc]

Murray, H. J. R. "Snakes and Ladders." In *A History of Board-Games Other than Chess*, 143. Reprinted, New York: Hacker Art Books, 1978. First published, Oxford: Clarendon Press, 1952. [2DP]

Musée des Arts Décoratifs de la Ville de Lausanne. *Citrakaras: L'Imagerie populaire de l'Inde/Citrakaras: Indian Popular Images*. Translated by Catherine Debaca. Exh. cat. [Lausanne]: Musée des Arts Décoratifs de la Ville de Lausanne, 1981. [Jai, Min, Par, Rit, 2DP, 3DP]

Muthiah, Meena, and Nanditha Krishna. "Thanjavur Paintings." In *Arts and Crafts of Tamilnadu*, by Nanditha Krishna [et al.], 130–39. Middletown, N.J.: Grantha Corporation in association with Mapin Publishing, Ahmedabad, 1992. [Gla, TaM]

Nagabhushana Sarma, M. *Tolu Bommalata: The Shadow Puppet Theater of Andhra Pradesh*. New Delhi: Sangreet Natak Akademi, 1985. [PSPu]

Nagarajan, Vijaya. "Hosting the Divine: The *Kolam* in Tamilnadu." In *Mud, Mirror, and Thread: Folk Traditions of Rural India*, edited by Nora Fisher, 192–203. Middletown, N.J.: Grantha Corporation in association with Museum of New Mexico Press, 1993; Ahmedabad: Mapin Publishing, 1993. [Rit]

Nagaswamy, R. "Tamil Paintings." *Mārg* (Bombay) 33, no. 1 [1981?]: 73–94. [PPC, TaM]

Naidu, M. Reddappa, and Nanditha Krishna. "Textiles." In *Arts and Crafts of Tamilnadu*, by Nanditha Krishna [et al.], 22–39. Middletown, N.J.: Grantha Corporation in association with Mapin Publishing, Ahmedabad, 1992. [PPC]

Nandi, Sipra. "A Scroll Painting on the Story of Kamalekāminī or Dhanapati-Śrīpati-Kāhinī in the Indian Museum." *Indian Museum Bulletin* (Calcutta) 5, no. 2 (July 1970): 151–54ff. [Ben]

Nanjunda Rao, M. S. "Leather Puppetry." *Lalit Kalā Contemporary* (New Delhi), no. 11 (April 1970): 35–38. [PSPu]

Nath, Aman. "Ornamentation." In *Arts and Crafts of Rajasthan*, edited by Aman Nath and Francis Wacziarg, 75–91. New York: Mapin International, 1987. First published, London: Thames and Hudson, 1987. [Rit, Mur]

Nath, Aman, and Francis Wacziarg, eds. *Arts and Crafts of Rajasthan*. New York: Mapin International, 1987. First published, London: Thames and Hudson, 1987. [Min, Nth, Par, PPC, 3DP]

Nath, Chaubey Bisvesvar. "Calligraphy." With an introduction and notes by T. H. Hendley. *Journal of Indian Art* (London) 16, nos. 122–28 (October 1914): 31–32, pls. 9–13. [2DP]

Neven, Armand. *Peintures des Indes: Mythologies et legendes*. Exh. cat. Brussels: Credit Communal de Belgique, 1976. [Ben, Jai, Klg, Mad, Nth, Pai, Par, PPC, Prn, Pur, TaM, 2DP, 3DP]

Noey, Christopher, and Janet Temos. *Art of India from the Williams College Museum of Art*. Exh. cat. Williamstown, Mass.: Williams College Museum of Art, 1994. [Nth, 2DP]

October House. *The Arts of India and Nepal: The Nasli and Alice Heeramaneck Collection*. Exh. cat. Boston: Museum of Fine Arts, 1966. [Ben, Jai, Pai]

Pal, Mrinal Kanti. *Catalogue of Folk Art in the Asutosh Museum, Part 1*. Calcutta: Asutosh Museum of Indian Art, University of Calcutta, 1962. [3DP]

———. *Crafts and Craftsmen in Traditional India*. New Delhi: Kanak Publications, 1978. [PPC, 3DP]

Pal, Pratapaditya. "Indian Art from the Paul Walter Collection: Catalogue." Exh. cat. *Allen Memorial Art Museum Bulletin* (Oberlin, Ohio) 28, no. 2 (winter 1971): 66–103. [Pai]

———. "Kali, Calcutta, and Kalighat Pictures." In *Changing Visions, Lasting Images: Calcutta through 300 Years*, edited by Pratapaditya Pal, 109–24. Bombay: Marg Publications, 1990. [Ben, Klg]

Pal, Pratapaditya, and Vidya Dehejia. *From Merchants to Emperors: British Artists and India, 1757–1930*. Exh. cat., Festival of India [1985–86], Pierpont Morgan Library, New York. Ithaca and London: Cornell University Press, 1986. [Ben, BWc, Klg, Min, Prn]

Pal, Pratapaditya, et al. *The Peaceful Liberators: Jain Art from India*. Exh. cat. New York and London: Thames and Hudson; Los Angeles: Los Angeles County Museum of Art, 1994. {Jai, 2DP, 3DP]

Palchowdhury, Ruby. "The French Revolution as Interpreted by the Scroll Painters of Bengal." In *Patua Art: Development of the Scroll Paintings of Bengal Commemorating the Bicentenary of the French Revolution*, by Alliance Française of Calcutta and Crafts Council of West Bengal, 42–43. Calcutta: Alliance Française, [1991]. [Ben]

———. "Natural Dyes Used by the Patuas." In *Patua Art: Development of the Scroll Paintings of Bengal Commemorating the Bicentenary of the French Revolution*, by Alliance Française of Calcutta and Crafts Council of West Bengal, 44. Calcutta: Alliance Française, [1991]. [Ben]

Panchali Publications. *Rāmayana in Ordisi Pata Painting*. Text by Krushna Chandra Kar (Oriya), Surendra Kumar Das (English), Kumari Shantilata Sahu (Hindi). Cuttack (Orissa): Panchali Publications, 1977. [Pur]

Pandey, Ranjana. "The Ethereal World of Shadow Puppets." *India Magazine* (Bombay), no. 1 (December 1980): 74–78, 81. [PSPu]

Pani, Jiwan. "Shadow Theater." In *Living Dolls: Story of Indian Puppets*, 29–52. New Delhi: Publications Division, Ministry of Information and Broadcasting, Government of India, 1986. [PSPu]

Pargiter, R. E. "An Indian Game: Heaven or Hell." *Journal of the Royal Asiatic Society of Great Britain and Ireland* (London), July 1916: 538–42. [2DP]

Parmar, Shyam. "The Magic World of Puppets." *Folklore* (Calcutta) 17, no. 2 (February 1975): 41–49. [PSPu, 3DP]

Pathy, Dinanath. *Mural Paintings in Orissa*. Bhubaneswar: Orissa Lalit Kala Akademi, 1981. [Mur, Pur]

Pattrea, Purendu. "The Continuity of the Battala Tradition: An Aesthetic Revaluation." In *Woodcut Prints of Nineteenth Century Calcutta*, edited by Ashit Paul, 50–79. Calcutta: Seagull Books, 1983. [BWc]

Paul, Ashit, ed. *Woodcut Prints of Nineteenth Century Calcutta*. Calcutta: Seagull Books, 1983. [BWc, Klg, Prn]

Pischel, Richard. *The Home of the Puppet-Play*. Translated by Mildred C. Tawney. London: Luzac and Co., 1902. [PSPu]

———. "The Shadow-Play in Ancient India." Translated by S. N. Ghosal. *Journal of the Oriental Institute* (Baroda) 26, no. 3 (March 1977): 217–37. [PSPu]

Pramar, V. S. "Woodwork." In *Crafts of Gujarat*, edited by Jasleen Dhamija, 99–108. New York: Mapin International, 1985. [3DP]

Publications Division, Ministry of Information and Broadcasting, Government of India. *Alpana*. [Compiled by S. Das Gupta et al.]. New Delhi: Publications Division, Ministry of Information and Broadcasting, Government of India, 1960. [Rit]

Rajaiah, R. "Precious Patt Paintings of Telengana, Andhra Pradesh." Translated by K. Y. Giri. In *Traditional Paintings: Old and New, An Exhibition of Existing Schools of Traditional Paintings in India*, [n.p.]. New Dehli: Lalit Kala Akademi, 1989. [And]

Ram, Gita, Sreelatha Vasudevan, and K. E. Supriya. "Festival Crafts and Folk Toys." In *Arts and Crafts of Tamil Nadu*, by Nanditha Krishna [et al.], 152–64. Middletown, N.J.: Grantha Corporation in association with Mapin Publishing, Ahmedabad, 1992. [3DP]

Ramanamurthy, M. V. "Shadow Play of Andhra: *Tholubommalatta*." In *Puppet Theatre around the World*, edited by Som Benegal et al., 102–4. New Delhi: Bharartiya Natya Sangh, 1960. [PSPu]

Ramana Murty, M. V. "The Art and Science of Leather Puppetry." *East Asian Cultural Studies* (Tokyo) 15, nos. 1–4 (March 1976): 67–71. [PSPu]

Ramaswami, Meenakshi. "Threshold Design: Makolam." *Folklore* (London) 49 (1938): 181. [Rit]

Ramaswami, N. S. *Tanjore Paintings: A Chapter in Indian Art History*. Madras: A. Kora's Indigenous Arts and Crafts Centre, 1976. [TaM]

Rane, Anita, and Walter Spink. "The Sweep of Life." *Pathik* (Bombay) 3, no. 3 (April 1992): 4–10. [War]

Rao, S. R., and B. V. K. Sastry. *Traditional Paintings of Karnataka*. Bangalore: Karnataka Chitrakala Parishath, 1980. Revised edition, 1989. [TaM, 2DP]

Rawson, Philip S. *The Art of Tantra*. Greenwich, Ct.: New York Graphic Society; London: Thames and Hudson, 1973. Revised edition, London: Thames and Hudson, 1978. [Jai, Mad, Min, Nth, Pur, 2DP, 3DP]

———. "Cracking the Code of Tantrism." Review of *Tantra Art* by Ajit Mookerjee. *Realities* (English edition) (London), no. 215 (October 1968): 46–49. [2DP]

———. *Erotic Art of India*. New York: Universe Books; London: Blacker Calmann Cooper, 1977. [Min, Nth, 2DP]

———. "India." In *Erotic Art of the East: The Sexual Theme in Oriental Painting and Sculpture*, by Philip Rawson [et al.], 29–204. New York: G. P. Putnam's Sons, 1968. [Jad, Min, Pur, 2DP, 3DP]

———. *Indian Painting*. Paris: Pierre Tisné; New York: Universe Books, 1961. [Ben, Klg, Mur, Pur, Tri, 3DP]

———. *Tantra*. Exh. cat. London: Arts Council of Great Britain, 1971. [Jai, Klg, Mad, Nth, Pur, 2DP, 3DP]

———. *Tantra: The Indian Cult of Ecstasy*. New York: Avon Books; London: Thames and Hudson, 1973. [Jai, Klg, Min, Pur, 2DP, 3DP]

Ray, Eva. "Documentation for Paiṭhān Paintings." *Artibus Asiae* (Ascona) 40, no. 4 (1978): 239–82. [Ben, Jad, Pai, Par, PPC, PSPu]

Ray, Pranabranjan. "Printmaking by Woodblock up to 1901: A Social and Technological History." In *Woodcut Prints of Nineteenth Century Calcutta*, edited by Ashit Paul, 80–107. Calcutta: Seagull Books, 1983. [Ben, BWc, Klg, Prn]

Ray, Sudhansu Kumar. "The Artisan Castes of West Bengal and Their Craft." In *The Tribes and Castes of West Bengal*, by A. Mitra, Census 1951, West Bengal, Land and Land Revenue Department, 293–349, pls. 1–16. Alipore, West Bengal: Superintendent, Government Printing, West Bengal Government Press, 1953. [Ben, Jad, Min, Rit, 2DP, 3DP]

———. *The Folk-Art of India*. Calcutta: Yogalayam, 1967. [Pur, 3DP]

———. *The Ritual Art of the Bratas of Bengal*. Calcutta: Firma D. L. Mukhopadhyay, 1961. [Ben, BWc, Jad, Prn, Rit, 3DP]

———. "What Is Folk Art?" *Art in Industry* (Calcutta) 8, no. 3 (1967): 3–8. [3DP]

Reeves, Ruth. *Folk Arts of India: Metal, Ceramics, Jewelry, Textiles, and Wood*. Edited by Alexandra K. Schmeckebier. Exh. cat. Syracuse, N.Y.: School of Art, Syracuse University, 1967. [Nth, PPC, Pur, 3DP]

Robbins, Kenneth X. "Indo-Asian Shadow Figures." *Arts of Asia* (Hong Kong) 13, no. 5 (September-October 1983): 64–75. [PSPu]

Robinson, J. D. "Village Tradition and Historical Sources in West Bengal." In *The Cultural Heritage of the Indian Village*, edited by Brian Durran and T. Richard Blurton, British Museum Occasional Paper No. 47, 135–39. London: British Museum, 1991. [Ben, Klg, Rit, 3DP]

Robinson, Kenneth X. "Kalighat Painting." *Highlights: Notes, News and Views on Arts, History and Letters of India* (Bethesda, Md.) 5, nos. 1–2 (1990) (special issue: Calcutta Heritage, From Thames to Hooghly, 1690–1990, edited by Raj Krishna): 61–74. [Klg]

Rosen, Elizabeth S. *The World of Jainism: Indian Manuscripts from the Spencer Collection*. Exh. cat., Festival of India, 1985–86. New York: New York Public Library, 1986. [Jai]

Routroy, Binode. "The Place of Painting in the Handicrafts of Orissa." *Rhythm* (Calcutta) 17, nos. 1–2 (1969): 68–69. [3DP]

Roy, Chhandra. "Folk Art and Craft of the Santhals of West Bengal." In *Folk Art and Craft*, edited by Karuna Sagar Behera, vol. 3, *Folk Culture*, Cuttack (Orissa): Institute of Oriental and Orissan Culture, [1983?]. [Tri]

Roy, Jamini. "On the Patua-Art of Bengal." Article compiled by Debiprasad Chattopadhyaya from interviews of Jamini Roy. *Enquiry* (Delhi), no. 3 (April 1960): 1–5. [Ben, Klg]

Roy, Nilima. "Some Declining Arts and Crafts of India." *Man in India* (Calcutta) 51, no. 1 (March 1971): 60–66. [Ben, Jad, PSPu, Pur, 2DP]

Sabavala, Radhika. "Experiments in a Tradition: The Art of the Warlis." In *The Impulse To Adorn: Studies in Traditional Indian Architecture*, edited by Jan Pieper and George Michell, 137–52.

Bombay: Marg Publications, 1982. Also published, *Mārg* (Bombay) 34, no. 4 [1982?]: [n.p.]. [War]

Saksena, Jogendra. *Art of Rājasthān: Henna and Floor Decorations*. Delhi: Sundeep Prakashan, 1979. [Rit]

———. *Mandana: A Folk Art of Rajasthan*. Edited by Mrinal Kanti Pal. New Delhi: Crafts Museum, 1985. [Rit]

———. "Mandana: A Women's Art of Rajasthan." *Kalā Darshan* (Delhi) 1, no. 4 (October-December 1988): 55–58. [Rit]

———. "Mandana Art of Rajasthan." *Roopa-Lekhā* (New Delhi) 42, nos. 1–2 (1972): 50–57. [Rit]

———. "Place of *Paglyas* in Mandana, A Folk Art of Rajasthan." *Roopa-Lekhā* (New Delhi) 23, nos. 1–2 (1952): 51–57. [Rit]

———. "*Sanjhi*: Art and Symbolism." In *Cultural Contours of India: Dr. Satya Prakash Felicitation Volume*, edited by Vijai Shankar Srivastava, 216–22. New Delhi: Abhinav Publications, 1981. [Rit]

Samanta, Sailendra Nath. "Some Wooden Dolls of Boro-Balaram." *Indian Folk-Lore* (Calcutta) 1, no. 2 (January-March 1958): 43–47. [3DP]

Santa Barbara Museum of Art. *Tantra from the Collection of Blanche Manso*. Exh. cat. Santa Barbara, Calif.: Santa Barbara Museum of Art, 1970. [Jai, Min, 2DP]

Saraf, D. N. *Arts and Crafts, Jammu and Kashmir: Land, People, Culture*. New Delhi: Abhinav Publications, 1987. [Mur, Rit, 3DP]

———. *Indian Crafts: Development and Potential*. New Delhi: Vikas Publishing House, 1982. [Ben, Jad, Mad, Mur, Nth, Par, PPC, Pur, Rit, Tri, War, 2DP, 3DP]

Sarkar, Nikhil. "Calcutta Woodcuts: Aspects of a Popular Art." In *Woodcut Prints of Nineteenth Century Calcutta*, edited by Ashit Paul, 11–49. Calcutta: Seagull Books, 1983. [BWc, Klg, Prn]

Sarkar, Sabita Ranjan. "Bengal." *Mārg* (Bombay) 43, no. 4 (June 1992): 45–56. [Jad, 3DP, Tri]

Seltmann, Friedrich. "*Schattenspiel in Mysore und Āndhra Prasdeś*." *Bijdragen tot de Taal-, Land-en Volkenkunde* ('s-Gravenhage [The Hague]), no. 127 (1971): 452–89. [PSPu]

———. *Schatten- und Marionettenspiel in Savantvadi (Süd-Maharastra)*. Stuttgart: Franz Steiner Verlag Wiesbaden GmbH, 1985. [Pai, PSPu, 3DP]

Sen, Geeti. "Paintings of an Epic: The Ramayana through Miniatures." *India Magazine* (Bombay) 2, no. 5 (April 1982): cover, 32–39. [Pai]

Sen Gupta, Sankar. "Domestic Arts, Crafts, and Artisans of Rural Bengal." *Folklore* (Calcutta) 14, no. 12 (December 1973): 452–75. [Ben, Min, Rit, 2DP, 3DP]

———. "Secular Pata—A Study of Classification and Dating." *Folklore* (Calcutta) 13, no. 9 (September 1972): 324–51. Revised as "The Patas of Bengal in General and Secular Patas in Particular: A Study of Classification and Dating," in *The Patas and the Patuas of Bengal*, ed. Sankar Sen Gupta (Calcutta: Indian Publications, 1973), 39–71. [Ben, Jad, Klg, Min, Rit, 2DP, 3DP]

Sen Gupta, Shankar, ed. *The Patas and the Patuas of Bengal*. Foreword by Niharranjan Ray. Calcutta: Indian Publications, 1973. [Ben, Jad, Klg, Min, Rit, 2DP, 3DP]

Seth, Mira. *Dogra Wall Paintings in Jammu and Kashmir*. Delhi: Oxford University Press, 1987. [Mur]

———. *Wall Paintings of the Western Himālayas*. New Delhi: Publications Division, Ministry of Information and Broadcasting, Government of India, 1976. [Mur]

Seth, Pepita. "A Dialog with Serpents: A Snake Ritual of Kerala." *Asian Art* (New York) 5, no. 3 (summer 1992): 53–79. [Rit]

Sethna, Nelly H. *Kalamkari: Painted and Printed Fabrics from Andhra Pradesh*. Living Traditions of India Series. New York: Mapin International, 1985. [PPC]

Shah, Haku. "Contemporary Terracotta of India." In *The Art of the Adivasi (Indian Tribal Art)*, [by J. Swaminathan, Jyotindra Jain, and Haku Shah], 114–17. Tokyo: Yomiuri Shimbun and Japan Association of Art Museums, 1988. [3DP]

———. *Form and Many Forms of Mother Clay: Contemporary Indian Pottery and Terracotta*. Exh. cat. New Delhi: National Crafts Museum, 1985. [3DP]

————. "Man and Clay: Tribal Ritual and Folk Myth in Rural Gujarat." In *God of the Byways, Wayside Shrines of Rajasthan, Madhya Pradesh and Gujarat*, [by Komal Kothari et al.], 48–51. Oxford: Museum of Modern Art, 1982. [3DP]

————. "On Art and Ritual: Haku Shah Interviewed by Geeti Sen." *India International Centre Quarterly* (New Delhi) 11, no. 4 (December 1984): 15–34. [Rit, Tri, War, 3DP]

————. "The Ritual Painting of the God Pithora Baba: A Tribal Ritual in Central Gujarat." *Ethnologische Zeitschrift Zurich* (Bern), 1980, no. 2 (1982): 7–62. [Tri]

————. "Tribal Art in Gujarat." In *Tribal Arts and Crafts of India*, Our Cultural Fabric [Series], edited by P. N. Chopra, 14–27. New Delhi: Ministry of Education and Culture, Government of India, 1982. [3DP, Tri]

Shah, Umakant Premanand. *Studies in Jaina Art*. Banaras: Jaina Cultural Research Society, 1955. [Jai]

Shah, Umakant Premanand, ed. *Treasures of Jaina Bhaṇḍāras*. L. D. Series, no. 69, edited by Dalsukh Malavnia and Nagin J. Shah. Ahmedabad: L. D. Institute of Indology, 1978. [Jai, 2DP, 3DP]

Sharma, G. N. "Nathdwārā Paintings from the 17th to 20th Century A.D." In *Indian History Congress, Proceedings of the 21st Session, 1958, Trivandrum*, edited by G. M. Morares et al., 558–64. Bombay: G. M. Morares for the Indian History Congress, 1959. [Nth]

Sharma, O. P. *Thanjavur Painting*. New Delhi: National Museum, 1981. [TaM]

[Sharma, O. P., Kapila Vastsyayan, et al.]. *Krishna of The Bhāgavata Purāṇa, The Gīta Govinda, and Other Texts*. Exh. cat. New Delhi: National Museum, 1982. [Min, Nth, Pur, TaM, 3DP]

Sharma, Shiv Kumar. *The Indian Painted Scroll*. Varanasi: Kala Prakashan, 1993. [And, Ben, Gar, Jad, Jai, Klg, Mad, Nth, Pai, Par, PPC, PSPu, Pur, 2DP]

Shastri, Archana. "Ward off the Evil Eye: Charms, Symbols, Rituals, and Beliefs." *India Magazine* (Bombay) 3, no. 9 (August 1983): 70–73. [Rit]

Sheikh, Gulam Mohammed. "Among Several Cultures and Times." In *Contemporary Indian Tradition: Voices on Culture, Nature, and the Challenge of Change*, edited by Carla M. Borden. Washington: Smithsonian Institution Press, 1989. [Ben, Jad, Par]

————. "Not by Eyes Alone: Notes on Shekhawati Murals." In *Dimensions of Indian Art: Pupul Jayakar Seventy*, edited by Lokesh Chandra and Jyotindra Jain, vol. 1, 425–26. Delhi: Agam Kala Prakashan, 1986. [Mur]

————. Preface to *Krishna as Shrinathji: Rajasthani Paintings from Nathdvara*, by Amit Ambalal, 7–8. Ahmedabad: Mapin Publishing, 1987. First published, New York: Mapin International, 1987. [Gla, Nth]

Shimkhada, Deepak. "A Preliminary Study of the Game of Karma in India, Nepal, and Tibet." *Artibus Asiae* (Ascona) 44, no. 4 (1983): 308–22. [2DP]

Singh, Jagat Pal. "Traditional Crafts of Rajasthan: Perspective and Prospects (Languishing Art but Flourishing Trade)." In *Cultural Contours of India: Dr. Satya Prakash Felicitation Volume*, edited by Vijai Shankar Srivastava, 227–41. New Delhi: Abhinav Publications, 1981. [Mur, Nth, Par, 3DP]

Singh, Mandanjeet. "*Les femmes artistes de Mithila: peintures cérémonielles d'un royaume millénaire de l'Inde.*" *Cultures, Dialogue entre les Peuples du Monde* (Paris) 8, no. 4 (1982): 29–34. [Mad]

Sivaramamurti, C. *Indian Painting*. New Delhi: National Book Trust, India, 1970. [TaM]

————. *South Indian Painting*. New Delhi: National Museum, 1968. [TaM]

————. "*Yamapaṭa.*" In *Some Aspects of Indian Culture*, 49–50. New Delhi: National Museum, 1969.

Skelton, Robert. "Folk Art Other than Paintings and Textiles." In *Arts of Bengal, The Heritage of Bangladesh and Eastern India*, edited by Robert Skelton and Mark Francis, 57–58. London: Whitechapel Art Gallery, 1979. [Rit, 3DP]

————. *Rājāsthānī Temple Hangings of the Kṛṣṇa Cult from the Collection of Karl Mann, New York*. Exh. cat. New York: American Federation of Arts, 1973. [Nth, Mur]

Skelton, Robert, and Mark Francis, eds. *Arts of Bengal: The Heritage of Bangladesh and Eastern India*. Exh. cat. London: Whitechapel Art Gallery, 1979. [Ben, BWc, Jad, Klg, Mal, Prn, Rit, 2DP, 3DP]

Smita, Charu. "Wall Paintings in a Gujarat Village—An Appraisal of Folk Traditions." *Folklore* (Calcutta) 18, no. 11 (November 1977): 352–58, 365. [Mur, Rit, Tri]

Smith, John D. *The Epic of Pābūjī: A Study, Transcription, and Translation*. Cambridge: Cambridge University Press, 1991. [Mur, Par]

————. "How to Sing a Tale: Epic Performance in the Pābūjī Tradition." In *Traditions of Heroic and Epic Poetry*, edited by A. T. Hatto, vol. 2, *Characteristics and Techniques*, edited by J. B. Hainsworth, 29–41. London: Modern Humanities Research Association, 1989. [Par]

————. "Where the Plot Thickens: Epic Moments in Pābūjī." *South Asian Studies* (London) 2 (1986): 53–64. [Par]

Smithsonian Institution. *Aditi: The Living Arts of India*. Exh. publ., Festival of India 1985–86, National Museum of Natural History, Smithsonian Institution. Washington, D.C.: Smithsonian Institution Press, 1985. [Ben, Mad, Mur, Pai, Par, PPC, PSPu, Rit, Tri, War, 2DP, 3DP]

Solomon, W. E. Gladstone. *The Charm of Indian Art*, figs. 1–22, 136–42. London: Adelphi Terrace, T. Fisher Unwin, 1926. [Rit]

Som, Sovon, ed. *Monograph on Art and Artists of West Bengal {Pots and Potuas}*. Artist and Craftsmen Series. Calcutta: West Bengal State Akademi of Dance, Drama, Music, and Visual Arts, Rabindra Bharati University, 1992. [Ben, Jad]

Sorensen, Niels Roed. "Shadow Theatre in Andhra Pradesh: *'Tolu Bommalu Kattu'.*" *Sangeet Natak* (New Delhi), no. 33 (July-September 1974): 14–39. [PSPu]

Souza, F. N. "Tantra Art: A Review Article." Review of *Tantra Art* by Ajit Mookerjee. *Studio International* (London) 172, no. 884 (December 1966): 306–11. [2DP]

Spink, Walter M. *The Axis of Eros*. New York: Schocken Books, 1973. [Klg, Mad, Pur, 2DP]

————. *Krishnamandala: A Devotional Theme in Indian Art*. Exh. cat. Ann Arbor: Center for South and Southeast Asian Studies, University of Michigan, 1971. [Ben, Klg, Min, Nth, Pai, Pur]

Srinivasarao, N. "The Folk-Art of Orissa." *Folklore* (Calcutta) 1, no. 3 (May-June 1960): 144–47. [Mur, Pur, Rit]

Stache-Rosen, Valentina. "On the Shadow Theatre in India." In *German Scholars on India*, edited by the Cultural Department of the Embassy of the Federal Republic of Germany, New Delhi, vol. 2, 276–85. Bombay: Nachiketa Publications, 1976. [Pai, PSPu]

————. "Shadow Players and Picture Showmen." *Quarterly Journal of the Mythic Society* (Bangalore) 66, nos. 3–4 (July-December 1975): 43–55. [Ben, Pai, Par, Pur, PSPu]

————. "Survival of Some Ancient Forms of Audio-Visual Education in Present-Day India." *Studies in Indo-Asian Art and Culture* (New Delhi) 5 (1977): 141–50, pls. 1–10. [Ben, Jad, Jai, Klg, Pai, Par, PPC, Prn, PSPu, Pur, 3DP]

Starza-Majewski, O. M. "The Sacred Geography of Puri." In *Shastric Traditions in Indian Arts*, edited by Anna Libera Dallapiccola in collaboration with Christine Walter-Mendy and Stephanie Zingel-Avé Lallemant, vol. 1, 253–59; vol. 2, figs. 118–25. Stuttgart: Steiner Verlag Wiesbaden GMBH, 1989. [Pur]

Steinmann, Ralph M. "Kolam: Form, Technique, and Application of a Changing Ritual Folk Art of Tamil Nadu." In *Shastric Traditions in Indian Arts*, edited by Anna Libera Dallapiccola in collaboration with Christine Walter-Mendy and Stephanie Zingel-Avé Lallemant, vol. 1, 475–91; vol. 2, figs. 45–54, 180–89. Stuttgart: Steiner Verlag Wiesbaden GMBH, 1989. [Rit]

Stooke, H. J. "Kalighat Paintings in Oxford." *Indian Art and Letters: India, Pakistan, Ceylon* (London) 20, no. 2 (1946): 71–73ff. [Klg]

Subramanyan, K. G. "Folk Art and the Modern Artist in India." *Lalit Kalā Contemporary* (New Delhi) 10 (1969): 15–20.

Swali, Nalini, and Haidas Swali. "Metamorphosis in Myth: Composite Animal Forms in Vaishnava Art." In *Symbols and Manifestations of Indian Art*, edited by Saryu Doshi, 21–30. Bombay: Marg Publications, 1984. [Min, Pur]

Swaminathan, J. "The Image of Reality and Reality of Image." In *The Art of the Adivasi (Indian Tribal Art)*, [by J. Swaminathan, Jyotindra Jain, and Haku Shah], 36–38. Tokyo: Yomiuri Shimbun and Japan Association of Art Museums, 1988. [Tri]

————. *The Magical Script: Drawings by the Hill Korwas of Jashpur, Raigarh, M. P.* Bhopal: Roopankar, Museum of Fine Arts, Bharat Bhavan, 1983. [Tri]

————. *The Perceiving Fingers: Catalogue of Roopankar Collection of Folk and Adivasi Art from Madhya Pradesh, India*. Bhopal: Bharat Bhavan, 1987. [Rit, Tri, 3DP]

[Swaminathan, J., Jyotindra Jain, and Haku Shah]. *The Art of the Adivasi (Indian Tribal Art)*. Exh.

cat., *Festival of India in Japan*. Tokyo: Yomiuri Shimbun and Japan Association of Art Museums, 1988. [Rit, Tri, War, 3DP]

Swarup, Shanti. *The Arts and Crafts of India and Pakistan: A Pictorial Survey of Dancing, Music, Painting, Sculpture, Architecture, Art-Crafts, and Ritual Decorations from the Earliest Times to the Present Day*. Bombay: D. B. Taraporevala Sons and Co., 1957. [Ben, Jad, Jai, Rit, 3DP]

Tagore, Abanindranath. *L'Alpona, ou les décorations rituelles au Bengale*. Translated by Andrée Karpelès and Tapanmohan Chatterji. Paris: Éditions Bossard, 1921. [Rit]

Talwar, Kay, and Kalyan Krishna. *Indian Pigment Paintings on Cloth*. Historic Textiles of India at the Calico Museum, vol. 3. Ahmedabad: Calico Museum of Textiles, 1979. [And, Jai, Nth, Par, Pur, 2DP]

Tana, Pradumna, and Rosalba Tana. *Folk Designs from India in Color*. Dover Pictorial Archive Series. New York: Dover Publications, 1987.

Tankha, Brij. "Paintings of Thanjavur." *Pratibha India* (Delhi) 10, no. 3 (April-June 1991): 33–36. First published, *Swagat* (New Dehli). [Gla, TaM]

Thakur, Upendra. "An Introduction to Madhubani Painting." In *Ludwig Sternbach Felicitation Volume*, edited by J. P. Sinha, vol. 2, 763–81. Lucknow: Akhila Bharatiya Sanskrit Parishad, 1979. [Mad]

———. *Madhubani Painting*. New Delhi: Abhinav Publications, [1981]. Also published, Atlantic Highlands, N.J.: Humanities Press, 1982. [Mad]

Thiagarajan, Deborah, and T. Loganatha Sharma. "Woodcrafts and Musical Instruments." In *Arts and Crafts of Tamil Nadu*, by Nanditha Krishna [et al.], 102–15. Middletown, N.J.: Grantha Corporation in association with Mapin Publishing, Ahmedabad, 1992. [3DP]

Thiagarajan, K. M. "Tribal Art: Beyond the Mask of Civilization." *India Magazine* (Bombay) 12, no. 4 (March 1992): 18–23, 26–28, 30–31. [Jad, Tri, War]

Tilakasiri, J. "India." In *Puppet Theatre of Asia*, 17–28. Ceylon: Department of Cultural Affairs, [1970?]. [PSPu, 3DP]

———. "Origin and Spread of the Art in Asia" In *Puppet Theatre of Asia*, 1–16. Ceylon: Department of Cultural Affairs, [1970?]. [PSPu, 3DP]

Tooth, Arthur, and Sons. *Indian Paintings from the 17th to the 19th Centuries, Including Examples from Rajasthan, the Punjab Hills, and Other Areas*. Exh. cat. London: Arthur Tooth and Sons, 1974. [Nth, Pai, TaM]

Topsfield, Andrew. "The Indian Game of Snakes and Ladders." *Artibus Asiae* (Ascona) 46, no. 3 (1985): 203–14, figs. 1–14. [2DP]

———. "Painting." In *Arts of Bengal, The Heritage of Bangladesh and Eastern India*, edited by Robert Skelton and Mark Francis, 34–38. London: Whitechapel Art Gallery, 1979. [Ben, BWc, Jad, Klg, Mal, Prn, 2DP]

Trustees of the Victoria Memorial. *Chitpur Relief Prints*. 2 folios, each with 6 plates and identical introduction. Calcutta: Trustees of the Victoria Memorial, 1985. [BWc]

[Tuchman, Maurice, Gail Scott, and Pratapaditya Pal]. *Fifty Tantric Mystical Diagrams*. Exh. cat. Los Angeles: Los Angeles County Museum of Art, 1969. [2DP]

Tugores, Mathias. "Art populaire des paysannes du Mithila." *Sudestasie* (Paris), no. 15 (September 1981): 63–67. [Mad]

———. "Women Painters of Mithila." *Orientations* (Hong Kong) 11, no. 5 (May 1980): 49–53. [Mad]

Untract, Oppi. "Ritual Wall and Floor Decorations in India." *Graphis* (Zurich) 24, no. 136 (1968): 148–59, 176. [Rit]

Upadhyaya, Daya Shankar. "The Folk-Paintings of Mithilā." *Journal of the Bihar Research Society* (Patna) 53 (1968): 306–18. [Mad]

Upreti, Nathu Ram. *Folk Art of Kumaon*. Amsterdam: Department of Anthropology, Royal Tropical Institute, 1957. First published, *Indonesie* (The Hague) 10 (1957): 177–201. [Rit, 3DP]

———. *Folk Art of Kumaon*. Edited by Ruth Reeves. Census of India 1961, vol. 1, Monograph Series, part 7–A (Monograph 5). New Delhi: Office of the Registrar General, India, Ministry of Home Affairs, 1969. [Mur, Rit, 2DP, 3DP]

University Gallery and Jacksonville Art Museum. *Jamini Roy and Bengali Folk Art: A Special Exhibition of Works in the Collection of Mr. and Mrs. Thomas J. Needham of Jacksonville, Florida*. Exh.

cat. [Gainesville]: University Gallery, University of Florida, 1971. [Ben, BWc, Jad, Klg, Pur, 3DP]

Varadarajan, Lotika. *South Indian Traditions of Kalamkari*. Ahmedabad: National Institute of Design, 1982. [PPC]

———. "Towards a Definition of Kalamkari." In *Homage to Kalamkari*, 19–21. Bombay: Marg Publications, [1978]. Also published, *Mārg* (Bombay) 31, no. 4 (September 1978): 19–21. [PPC]

Véquaud, Yves. "Colors of Devotion." *Portfolio* (New York) 2, no. 1 (February-March 1980): 60–67.

———. *The Women Painters of Mithila*. Translated by George Robinson. London: Thames and Hudson, 1977. Also published as *The Art of Mithila: Ceremonial Paintings from an Ancient Kingdom*. First published as *L'Art du Mithila*, Paris: Les Press de la Connaissance, 1976. [Mad]

Verma, Bimla. "U. P. Folk Paintings: From the Dot to the Sublime." *India Magazine* (Bombay) 2, no. 9 (August 1982): 46–55. [Rit]

Victoria and Albert Museum. *Bazaar Paintings from Calcutta: Catalogue of an Exhibition Lent by the Victoria and Albert Museum, London*. Exh. cat. London: Her Majesty's Stationery Office, 1955. [Klg]

Wacziarg, Francis. "Woodwork." In *Arts and Crafts of Rajasthan*, edited by Aman Nath and Francis Wacziarg, 207–17. New York: Mapin International, 1987. First published, London: Thames and Hudson, 1987. [3DP]

Wacziarg, Francis, and Aman Nath. *Rajasthan: The Painted Walls of Shekhavati*. Lingfield, Surrey: BLA Publishing, Francis Wacziarg, Aman Nath, 1982; New Delhi: Vikas, 1982. [Mur]

Wasserman, Emily. "Tantric Art." *Artforum* (New York), January 1970, 46–50. [Jai, 2DP]

Watson, Francis. "Kalighat Painting." Review of the art exhibition "Kalighat Painting" at the Victoria and Albert Museum. *Listener* (London), 17 December 1953, 1039–40, 1049. [Klg]

Welch, Stuart Cary. *A Flower from Every Meadow: Indian Paintings from American Collections*. With contributions by Mark Zebrowski. Exh. cat. New York: Asia Society, 1973. [Jad, Klg, Min, Pai]

———. Foreword to *Rajasthan, the Painted Walls of Shekhavati*, by Francis Wacziarg and Aman Nath, 7–9. Lingfield, Surrey: BLA Publishing, Francis Wacziarg, Aman Nath, 1982; New Delhi: Vikas, 1982. [Mur]

———. *India: Art and Culture, 1300–1900*. Exh. cat., Festival of India 1985–86. New York: Metropolitan Museum of Art, 1985. [And, Jad, Min, PPC, Pur, 3DP]

———. *Indian Drawings and Painted Sketches, 16th through 19th Centuries*. Exh. cat. New York: Asia Society, 1976. [Klg, Min, Pur, 2DP]

———. *Room for Wonder: Indian Painting during the British Period, 1760–1880*. New York: American Federation of the Arts, 1978. [BWc, Klg, Min]

Welch, Stuart Cary, and Milo Cleveland Beach. *Gods, Thrones, and Peacocks. Northern Indian Painting from Two Traditions: Fifteenth to Nineteenth Centuries*. Exh. cat. New York: Asia Society, 1976. [Min]

[Welch, Stuart Cary, George D. Bearce, et al.]. *Painting in British India, 1757–1857*. Exh. cat. Brunswick, Maine: Bowdoin College Museum of Art, 1963. [Klg, Mur, Pai, Pur, Rit, TaM, 3DP]

Wiener Gallery, Doris. *Indian Miniature Paintings*. Exh. cat., 5th annual exhibition. New York: Doris Wiener Gallery, 1969. [Jai, Klg, Pai]

———. *Indian Miniature Paintings*. Exh. cat., 10th annual exhibition. New York: Doris Wiener Gallery, 1974. [Nth, Pai, TaM]

Wilkinson, J.V. S. "Indian Painting." In *Indian Art*, edited by Richard Winstedt, 105–50. London: Faber and Faber, 1947. [Ben, Jai, Rit, 2DP]

Williams, Joanna Gottfried. "Śiva and the Cult of Jagannātha: Iconography and Ambiguity." In *Discourses on Siva: Proceedings of a Symposium on the Nature of Religious Imagery*, edited by Michael W. Meister, 298–311. Philadelphia: University of Pennsylvania Press, 1984. [Pur, 3DP]

Winstedt, Richard, ed. *Indian Art*. Essays by H. G. Rawlinson, K. de B. Codrington, J. V. S. Wilkinson, and John Irwin. London: Faber and Faber, 1947. [Ben, Jai, PPC, Rit, 2DP, 3DP]

Photographic Credits

Please note that measurements are given in inches and centimeters and that height precedes width precedes depth.

No. 77, photograph © 1996, The Art Institute of Chicago. All rights reserved.

Nos. 6 and 15, by permission of The British Library, Oriental and India Office Collections.

Nos. 39 and 40, Courtesy of the Trustees of the British Museum.

Ill., p. 9, and nos. 62 and 93, Roy C. Craven, Jr.

Nos. 43 and 98, The Denver Art Museum.

Nos. 24, 48, and 50, Samuel P. Harn Museum of Art, University of Florida.

No. 59, photograph © 1996 Lynton Gardner, Courtesy of Mingei International Museum.

Nos. 25, 52, 56, 71, 74a, 74b, 76a, 76b, 83, 84, 85, 87, 91, and 94, Courtesy of Arthur M. Sackler Museum, Harvard University Art Museums, Loan from Private Collection.

Nos. 55a, 55b, and 57, Museum Associates, Los Angeles County Museum of Art. All rights reserved.

No. 53, Philadelphia Museum of Art.

No. 54, Courtesy of Cynthia Hazen Polsky.

Ills., pp. 21 and 22, Barbara Rossi.

No. 63, photograph © 1996, The David and Alfred Smart Museum of Art, The University of Chicago.

Nos. 1, 2, 3, 4, 5, 7, 16, 18, 23, 26, 27, 29, 30, 31, 32, 35, 36, 37, 41, 42, 44, 45, 46, 47, 51, 58, 60, 65, 68, 70, 72, 75, 78, 79, 80, 82, 86, 88, 97, and 99, Michael Tropea, Chicago.

Photographic
Credits

Nos. 8, 9, 10, 11, 12, 13, 14, 17, 19, 20, 21, 22, 28, 33, 34, 49, 61, 64, 66a-b, 67, 69, 73, 81, 89, 90, 92, 95, 96, 100, and 101, Ecco Wang, The University of Iowa Museum of Art.

No. 38, Victoria and Albert Museum.

Index

Page numbers on which photographic illustrations or pertinent maps appear are in italics; figure numbers are in italics.

283

Chandraprabha, 155, *fig. 65a (det.)*

chauka (or *chaukash*) *pata*, 99, 111. *See also* Bengali single-image painting

Chedi Mali, 55; family of, 53, 55

Chelaiyyo, legend of, 113

Cheriyal, 90, 93, 95, *214*, 226, 229

Chhipa caste, 19, 139

Chiman Rama, 193, 195

Chitpur prints, 59, 60. *See also* Battala woodcuts

chitraji, 159, 161

Chitrakars, painters called, and Bengali scroll tradition, 98–99 (*see also* Gauri Chitrakar, Patuas); and Jadupatuas in Bihar, 117; and Kalighat tradition, 59; and Puri tradition, 19, 73

Chitrakathi caste, painter-performers of, 128, 131

Chittorgarh, 90, 139

Company paintings, 166, 167, 168, 177; as influence on Battala woodcuts, 60. *See also* East India Company; Indian art of the British period

composite pictorial forms, 38, 40, 72, 79, 182, 190, *figs. 6, 28*

conch shell. *See* shell

Coomaraswamy, Ananda, 4

cosmic man, 152, 154, *fig. 63*

costumes of temple icons, at Nathadwara, 159, 160, 161, 162, *figs. 66a, 66b, 67, 68*; at Puri, 80, 81–82, *figs. 29, 30*

courtesan(s), and cult of Kali, 58, 61; in Kalighat paintings, 58, 60–62, 65, *figs. 17, 20*; Muslim, portrayed with rose, 13, 187, *fig. 81*; portrayed with rose, 61; portrayed with rose and sitar, 185–86, *fig. 80*; portrayed with stringed instrument associated with Sarasvati, 13, 61

court traditions of miniature painting, 13–14, 166–67. *See also* Deccani court miniatures; Mughal court miniatures; Pahari court miniatures; Rajasthani court miniatures

cow(s), 31, 44, 95, 125, 127, *figs. 1, 10, 36, 51*; barrenness in, and inablity of, to lactate, and *ghazi*'s powers, 104; as Deval's cattle, 140, 141; human holding the tail of, 113, 122, 210, *fig. 93 (det.)*. *See also* Krishna, milking a cow, with Yashoda

cowherd(s), female, 31, 85, *figs. 1, 32* (*see also under* Krishna). *See also* Krishna, as cowherd

Crafts Museum (National Handicrafts and Handlooms Museum), 5, 7

creation, Santal story of, 116, 121, 122–23

crocodile(s), 31, 103–4, *figs. 1, 39 (det.)*; as mount of Khodiar, 215, 218, *fig. 97*

Dakshin Ray, 103

D[analakota] Chandraiah, 95, 229

darshana, 73

Dashahara (festival), 28, 82

Dasharatha, arrow of, 113; sons of, 106; wives of, 106

dashavatara ganjifa, 192, 212–13, *fig. 96 (det.)*. *See also* playing cards

Davidson, J. LeRoy, 7

death, god of, 119–20, *fig. 45. See also* Death's kingdom, scenes from; Yama

death-delivering demon, 23, 116. *See also pishacha; pishachi*

Death's kingdom, scenes from, in Garoda scrolls, 111, 112, 113; in *ghazi patas*, 101, 104; in Jadupatua scrolls, 116, 119–20, 120, 121, 122, 123, 124, *fig. 45. See also* punishments and rewards, illustrations of

Deccan or Deccan Plateau, 90, 91, 128, *146*, 166. *See also* Western Deccan

Deccani court miniatures, 13, 166

deer, golden the (*see* Maricha as the golden deer; Rama, pursuing the golden deer; Rama and Lakshmana, pursuing the golden deer); spotted, 96, *fig. 37*

Delhi, 7, 9; paintings, 4

demon(s), 96. *See also* buffalo demon; death-delivering demon; Mahishasaura; Maricha as the golden deer; *pishacha; pishachi;* Ravana; Shumba; Shuparnaka; Tataka

design for ritual wall painting, 20, 28, 32–33, *figs. 2, 3. See also* aide-mémoire

Deval, 141

Devi Mahatmya, folio from manuscript illustrating, 170–71, *fig. 72*; image composed with inscribed text of, 193, 195, *fig. 82*

Devnarayan or Devji, 137; story of, 142–43; *par* of, 137–38, 139, 142–44, *fig. 59*

Devu Rama Dhodhade, 48

Dhana Bhagat of Dhola, 113

didactic, divinatory, and other cultural functions, paintings serving, 24, 189–93, 195–99, 201–13, *figs. 82, 83, 84, 85, 86, 87, 89 (det.), 90, 91, 92 (det.), 93 (det.), 94, 95, 96 (det.). See also* calendar, astrologer's; images composed with inscriptions; omens, book of; punishments and rewards, illustrations of; Shri Rama Knowledge Game Board; Vallabhacharya and descendants, genealogical tree of; *yantras; see under* playing cards

didactic function, paintings serving, 24, 111, 112, 127, 128, 192, 204–5, 205–6. *See also* Death's kingdom, scenes from; game board; punishments; punishments and rewards, illustrations of